If we, as theists, believe that the universe is fundamentally personal in character, it follows that our ultimate understanding will not be in terms of things, which occupy space and may or may not possess certain properties, but of persons, who characteristically *do* things. Action, not substance, will be our most important category of thought. It is a truth too long neglected by philosophers.

—J. R. Lucas, *Freedom and Grace*, p. 111

ART in ACTION

Toward a Christian Aesthetic

by

NICHOLAS WOLTERSTORFF

GRAND RAPIDS, MICHIGAN
WILLIAM B. EERDMANS PUBLISHING COMPANY

Reprinted 1996

Library of Congress Cataloging in Publication Data

Wolterstorff, Nicholas.
 Art in Action.

 Bibliography: p. 239.
 1. Christianity and the arts. I. Title.
BR115.A8W64 700'.1 79-22358
ISBN 0-8028-1816-1

The author and publisher wish to thank the following for permission to quote from these books:

Excerpted and reprinted from THE CITY IN HISTORY, © 1961 by Lewis Mumford.
Reprinted by permission of Harcourt Brace Jovanovich, Inc.

Excerpted from THE VOICES OF SILENCE by Andre Malraux (translated by Stuart Gilbert and Francis Price).
Published 1953 by Doubleday & Company, Inc., New York.
British edition published by Martin Secker & Warburg, Ltd.
Reprinted by permission of Doubleday & Company, Inc. and Martin Secker & Warburg, Ltd.

Excerpted from THE AESTHETIC DIMENSION by Herbert Marcuse.
Published 1978 by Beacon Press.
Reprinted by permission of Beacon Press and Peter Marcuse.

for Claire,
in whom so much of God's
art is displayed

Contents

Preface

IN AN essay composed some thirty years ago Dorothy Sayers remarked that

> In such things as politics, finance, sociology, and so on, there really is a
> philosophy and a Christian tradition; we do know more or less what the Church
> has said and thought about them, how they are related to Christian dogma, and
> what they are supposed to *do* in a Christian country.
>
> But oddly enough, we have no Christian aesthetic—no Christian philosophy
> of the Arts. The Church as a body has never made up her mind about the Arts, and
> it is hardly too much to say that she has never tried. She has, of course, from time
> to time puritanically denounced the Arts as irreligious and mischievous, or tried
> to exploit the Arts as a means to the teaching of religion and morals. . . . And
> there have, of course, been plenty of writers on aesthetics who happened to be
> Christians, but they seldom made any consistent attempt to relate their aesthetic
> to the central Christian dogmas.[1]

The essay that follows represents an attempt on my part to relate my "aesthetic
to the central Christian dogmas," which I hold for true. Or better, it
represents an attempt to articulate how I as a Christian see art and the
aesthetic dimension of reality. For I find that my thoughts about art and the
aesthetic do not arise independently of my Christian convictions. I do not find
myself with two separate things in hand that must somehow be related. On the
contrary, those Christian convictions contribute to the formation of those
thoughts about the arts. Accordingly, this book is not an attempt to relate
Christianity to the arts nor the arts to Christianity. It is the record of
reflections on the arts by someone who stands within the Christian tradition
and identifies himself with the Christian community.

The book is closely related to another book of mine which is shortly to be
published, *Works and Worlds of Art* (Oxford University Press). The latter
book is addressed to philosophers and develops in much more intricate detail
and with much more careful justification certain of the positions taken up here
in Part One, and in Chapter III of Part Three, along with developing positions
on issues not even broached here. On the other hand, the present book,

addressed to a much wider audience than philosophers, gives my deep-lying religious reasons for the approach I adopt in the philosophical book. The two works are thus an interlocking pair.

In recent years it has become the habit of those Christians writing about the arts who are not simply culture-avoiders or aesthetic conservatives to take for granted the basic lineaments of our contemporary Western way of thinking about the arts, to propose revisions here and there in that way of thinking, and then to urge that Christians get involved in the arts thus understood. Customarily this injunction is buttressed with a "theological interpretation" of art and implemented with a "theological criticism."

By contrast, I shall contend that there are serious defects in our contemporary Western way of thinking about the arts, so that *reconsideration* rather than theological *interpretation* is first of all required. At the foundation of the alternative which I propose is the thesis that works of art are instruments and objects of action—and then, of an enormous diversity of actions. Hence the title: *Art in Action*. What I propose is a *functional* approach to art.

My thanks are due the many students to whom I have taught aesthetics over the years for stimulating my thought, often in ways they did not realize, with their provocative questions and sturdy objections. And to the Institute for Advanced Christian Studies for their financial support which enabled me to take a semester's leave of absence to complete the writing of the book. My thanks also to the genuine community of Christian scholars which exists at Calvin College, and of which I am privileged to be a member, for countless acts of assistance and observations of insight; and to Edgar and Ervina Boevé, Phyllis Mouw, and Jon Pott, all of whom read the manuscript with perceptive care and offered helpful criticisms. Lastly, my thanks to the artists of the world for what they have composed, without which my own life would be radically impoverished. When I now listen to, or read, or look at, or otherwise participate in what they have made, I sometimes feel that these words of mine are but straw and that there is no other truly appropriate response to the great art of the world than to cease our chatter and give thanks to God our Creator—to whose glory all good art contributes, sometimes even, one must say with deep sadness, in spite of what the makers intended—for having granted to us his favored creatures that there should be art in our lives.

Grand Rapids, Michigan
June, 1979

PART ONE
Artistically Man Acts

W 1. ART IN ACTION

E HAVE all heard it said that the proper approach to a work of art consists in abstracting the object from its context of action, isolating the work from its fabric of intention, and focussing one's attention on the object itself—discerning and revelling in its play of sounds or colors or textures or metaphors. We have all been told that to do otherwise is to commit the "intentional fallacy." We all live in the fading glow of that movement which told us to treat the work of art *as* a work of art—to regard it for its own sake and not for the sake of some ulterior end, to treat it autonomously.

Art, we have been told, is useless. "The most evident characteristic of a *work of art* may be termed *uselessness* . . . " said Paul Valery.[1] Naturally Valery knew that art is useful for many things—paintings for covering nail holes in one's living room wall, music for sedating factory workers. What he meant is that to put a work of art to some use is to fail to acknowledge and respect the reason for that thing's existence in our midst. What he meant is that to put it to some use is to fail to treat the work of art *as* a work of art.

In this essay, I want to argue, on the contrary, that works of art are objects and instruments of action. They are all inextricably embedded in the fabric of human intention. They are objects and instruments of action whereby we carry out our intentions with respect to the world, our fellows, ourselves, and our gods. Understanding art requires understanding art in man's life.

Of course the person who recommends that we focus all our attention on the work itself is not really recommending that we abstract the work *entirely* from the context of action. Rather he is recommending that we give preferential status to one action—that of *focussing* on the work. He is not recommending that we put the work of art to *no* use. He is recommending that we give preference to the use of serving as object of *contemplation*. That explains why the autonomist movement has provided us not only with analyses of works of art but also with theories of contemplation—disinterested contemplation, aesthetic contemplation, and the like.

3

The perspective of this essay is different. Serving as object of the action of contemplation is but one among other ways in which works of art enter, in fact and by intent, into the fabric of human action.

2. THE UNIVERSALITY OF ART

I well remember the museum director remarking to me that the American pioneers travelling westward across the prairies had no art, since they lacked leisure. My response was that in all likelihood they had work songs and voyage songs—music for which leisure was the last thing needed.

The truth is that in discussing the arts we are discussing something universal to mankind. We know of no people which has done without music and fiction and poetry and role-playing and sculpture and visual depiction. Possibly some have done without one or the other of these; none to our knowledge has done without all. Indeed—to single out just one of the arts—none to our knowledge has done without visual depiction. "There were," says the anthropologist Paul S. Wingert, "no primitive peoples, however meager their cultural attainments, who offered no patronage to the artist."[2] Another anthropologist, Raymond Firth, agrees:

> It is commonly held that economic activity is a necessity, but that art is a luxury. Yet we can assert empirically the universality of art in man's social history. Paleolithic man ten thousand years or more ago had his statuettes and his cave-paintings, of which some still preserved for us are of such aesthetic mastery and dynamic skill that they evoke the admiration of modern artists. Even in the hardest natural environments, art has been produced. . . . It is easy, then, to refute the idea that at the primitive stages of man's existence the theme of subsistence dominated his life to the exclusion of the arts."[3]

3. THE PURPOSE OF ART

What then is art for? What purpose underlies this human universal?

One of my fundamental theses is that this question, so often posed, must be rejected rather than answered. The question assumes that there is such a thing as *the* purpose of art. That assumption is false. There is no purpose which art serves, nor any which it is intended to serve. Art plays and is meant to play an enormous diversity of roles in human life. Works of art are instruments by which we perform such diverse actions as praising our great men and expressing our grief, evoking emotion and communicating knowledge. Works of art are objects of such actions as contemplation for the sake of delight. Works of art are accompaniments for such actions as hoeing cotton and rocking infants. Works of art are background for such actions as eating meals and walking through airports.

Works of art equip us for action. And the range of actions for which they equip us is very nearly as broad as the range of human action itself. The purposes of art are the purposes of life. To envisage human existence without

art is not to envisage human existence. Art—so often thought of as a way of getting out of the world—is man's way of acting *in* the world. *Artistically man acts*.

Any aesthetic which neglects the embeddedness of art in action is bound either to distort the arts or to find them inscrutable. Likewise, any aesthetic which neglects the enormous *diversity* of actions in which art plays a role, in fact and by intent, is bound to yield distortion or inscrutability.

At this point someone might protest. What we have shown, he might say, is that human actions of a wide range cannot be understood without understanding the role of works of art in those actions. What we have not shown is the converse point: that works of art cannot be understood without understanding their role in action, and, more specifically, their role in a wide diversity of actions.

The whole of the essay which follows will serve to display the untenability of this objection. We shall see, for example, that the arts of the modern West cannot be understood without perceiving that they are mainly meant to give satisfaction when used as objects of contemplation.

But perhaps the point can be made more swiftly and persuasively by glancing at the phenomenon of pictorial representation. On the primary concept of a picture, a certain design is a picture of so-and-so only if the person who produced or presented it *pictured* so-and-so by so doing. When in the American Southwest we come across some incised pattern on a rock and wonder whether or not it is a picture, we are wondering whether someone performed the action of picturing something by incising this pattern. And when, further, we wonder whether it is a picture of a condor or of a horse, that is determined by reference to what its maker pictured with it. We may for years take it to be a picture of a horse. But if someone then presents evidence to show that its maker probably pictured a condor thereby, that establishes that it is probably a picture of a condor and not of a horse. Thus an object's being a picture of so-and-so is parasitic on the phenomenon of someone's performing the action of picturing so-and-so with that object.

It is true that we speak of "seeing pictures" in the clouds, or on damp walls. But in speaking thus we are using a secondary sense of "picture." One can see a picture of so-and-so in such-and-such without there being a picture that one sees.

Fundamental in any full-fledged attempt to understand works of arts will be what might be called a *role analysis* of those works—by which I mean an analysis of the *role* that those works play and are intended to play in human action.[4]

4. THE ARTS

By now the reader will be asking what I take the arts to be. So let me halt the progress of my argument to answer.

Suppose you were asked to list the major (fine) arts. What would appear on your list? I dare say that everyone would unhesitatingly cite music, poetry, drama, literary fiction, visual depiction, ballet and modern dance, film, and sculpture. None of us would have any doubt whatsoever about regarding each of these eight phenomena as an art, and as a *major* art.

Beyond those eight, some would hesitate. We might even fall into disagreements. Some of us would have no problem adding additional phenomena, such as architecture. But for each of those, others of us would pause. Some might even resist.

Someone who wished to promote unanimity might suggest that for these additional phenomena we ought to differentiate various species of the phenomenon from the phenomenon itself—distinguish, for example, architect-designed buildings from buildings in general. Perhaps by thus differentiating we could indeed expand our initial list. But still, those eight are what initially we would all regard as major arts.

Now look closely at those eight. Though we naturally group them together, they are in fact very diverse phenomena. Singing a song, depicting a horse, telling a story—those are very different things. The familiarity of our grouping of the arts, according to which these eight phenomena are paradigm examples and a number of other phenomena are more or less controversial borderline examples, conceals from us how remarkable the grouping is.

Not only is it remarkable. It is of relatively recent origin. In the long history of human use of the arts and reflection upon them, only modern man has found the grouping compelling. Paul Oskar Kristeller in his essay "The Modern System of the Arts"[5] traces the development of the combination and shows that it was in the eighteenth century that writers first began to group together painting, sculpture, architecture, music, and poetry. Until that time people would have felt, for example, that music has closer affinities with mathematics than it has with painting. Says Kristeller:

> The basic notion that five "major arts" constitute an area all by themselves, clearly separated by common characteristics from the crafts, the sciences and other human activities, has been taken for granted by most writers on aesthetics from Kant to the present day. It is freely employed even by those critics of art and literature who profess not to believe in "aesthetics"; and it is accepted as a matter of course by the general public of amateurs who assign to "Art" with a capital A that ever narrowing area of modern life which is not occupied by science, religion, or practical pursuits.
>
> . . . [T]his system of the five major arts, which underlies all modern aesthetics and is so familiar to us all, is of comparatively recent origin and did not assume definite shape before the eighteenth century, although it has many ingredients which go back to classical, medieval and Renaissance thought.[6]

You will notice that my own list of what we today would all regard as major arts differs a bit from Kristeller's list. It differs in that I have on my list the new phenomena of ballet and film. It also differs in that Kristeller has architecture

on his list, whereas I do not have it on mine. For I judge that you and I would have doubts that architecture is really an art. Also, I have fiction and drama on my list, whereas Kristeller, somewhat curiously, omits them from his. (Perhaps they are included under poetry.) What we agree on, however, is the grouping together of poetry, music, and visual depiction. And it is a striking fact that when we go back behind the eighteenth century we never find these three grouped together as having anything of importance in common. The emergence of this triple-membered core was the decisive step in the emergence of our modern grouping of the arts.

Contrary to what one might first expect, the emergence of our modern grouping has little to do with the birth of new phenomena. All but two of the phenomena that we would regard as paradigm arts were present in culture before the eighteenth century, and all the phenomena that pre-eighteenth-century thinkers listed as arts are present in ours. Furthermore, our word "art" and its synonyms in other languages were available to them. What was missing was just our modern *concept* of the arts. The gradual emergence of that concept seems to have resulted from the emergence of a new view as to the primary intended use for such things as music, visual depiction, and poetry. In turn, the emergence of that new view seems to have resulted from that use itself coming into prominence among the cultural elite of the eighteenth century.[7]

In Part Two of my discussion I will be in a position to *explain* our modern concept of *an art*. Meanwhile, I shall nevertheless use the concept on the assumption that the reader has an intuitive grasp of it. And I shall assume that among the major fine arts are to be found music, poetry, drama, literary fiction, visual depiction, ballet and modern dance, film, and sculpture.

5. THE ESSENTIAL PURPOSE OF ART

We had arrived at the point of seeing that works of art, in fact and by intent, are used to perform an enormous diversity of actions. May it not be the case, though, that beneath the flux and diversity there is *one* action which is characteristic of art? May it not be that there is *one* action which is unique to, and pervasive within, the arts?

Certainly that is the unquestioned assumption of nearly all our modern theorists. Examples can be found almost at random. Here is what the Marxist theorist George Thomson says:

'Bright star, would I were stedfast as thou art!' *Den lieb' ich, der Unmögliches begehrt.* Why do poets crave for the impossible? Because that is the essential function of poetry, which it has inherited from magic. In the wild transport of the mimetic dance the hungry, frightened savages express their weakness in the face of nature by a hysterical act of extreme mental and physical intensity, in which they lose consciousness of the external world, the world as it really is, and plunge into the subconscious, the inner world of fantasy, the world as they long for it to

be. By a supreme effort of will they strive to impose illusion on reality. In this they fail, but the effort is not wasted. Thereby the psychical conflict between them and their environment is resolved. Equilibrium is restored. And so, when they return to reality, they are actually more fit to grapple with it than they were before.[8]

Though it is clear that Thomson regards "the essential function of poetry" as not wholly unique to poetry but as shared with primitive dance at least, yet Thomson is speaking directly here not about the arts in general but about poetry. And his claim is that poets "by a supreme effort of will . . . strive to impose illusion on reality."

But is it clear that the purpose of all poetry is to impose illusion on reality? Is it not rather that if we understand these hazy words so that they do indeed apply to all poetry, then we have understood them in such a way that they apply to vastly more than poetry, and vastly more than art? To philosophy as well, for example? Whereas if we understand them in such a way that they apply only to poetry, or only to art, then they do not apply to all poetry and all art?

In that respect these words of Thomson are paradigmatic. Over and over one comes across claims to the effect that such-and-such is "the essential function of art." "Art is mimesis." "Art is self-expression." "Art is significant form." All such formulae fall prey to the same dilemma. Either what is said to be characteristic of art is true of more than art. Or, if true only of art, it is not true of all art.

The universality of art corresponds only to a diversity and flux of purposes, not to some pervasive and unique purpose.

6. INTENDED PUBLIC USE OF ART

Not only do multiple purposes underlie the production and use of art, with none constant and unique amidst the flux and diversity. So too, more narrowly, the *public uses* intended by artist or distributor are multiple and various, with none constant and unique.

Consider, as an interesting example, the masks of the Papuan Gulf people. We go to Chicago or to London, walk into an art or ethnological museum, and there find them hanging in climate-controlled cases—these from the Papuan Gulf next to some from the Cameroons, those from Alaska next to some from the Benin tribe. We go from one to the other, admiring their aesthetic qualities, finding ourselves powerfully moved. Then we proceed to another room, there to contemplate a Rembrandt or a display of sarcophagi. The use to which we put those masks is the use of serving as objects of the action of aesthetic contemplation. And that is clearly the public use *intended* by the museum directors who present them to us.

How different was the intended public use of those masks among their originators, the people who lived along the Papuan Gulf in South New Guinea. Because that use is profoundly strange and foreign to us, it will be

worth taking a bit of time to scrutinize it. Let me follow the description given by Paul S. Wingert in his book *Primitive Art*.[9]

"If crops had been meager, or an unusual number of persons had died over a span of time, the elders of a clan, realizing that the security and survival of their group were threatened, would decide that a ceremony honoring beneficent, traditional, supernatural beings must be held in order to avert total disaster. Each clan had as its special benefactors a certain number of these supernatural spirits and possessed the right to represent them by constructing and painting tall, oval-shaped masks.

". . . a large house was erected with a prescribed amount of wood for the heavy log framework and a heavy thatch covering for the roof. In this house, each clan would make its own masks, keeping them out of sight of the women and children." The particular shape and decoration of the masks were chosen so that each could function in representing a distinct spirit. "But all were made in the same way and were decorated with a shared vocabulary of geometric symbols. . . . The making of the masks was a cooperative clan endeavor under the direction of an elder who dictated the designs from memory. Because of the many interdicts and restraints associated with the mask-making, plus the necessity to grow and accumulate the quantities of food required for the feasts which accompanied the ceremony, preparations frequently lasted as long as five years.

"When everything was finally ready, the masks were ritually indoctrinated; and on the following day, at sunup, the ceremony began. From the great, high door of the special house where they had been secretly made, each mask, worn by a clan member, emerged individually to take its proper place in the ritual proceedings. For several days, the clan members walked around the villages and along the shore grouped around one or another of their own masks, singing and rejoicing in their presence." Thus at the heart of the whole mask enterprise was a particular combination of uses: Each was worn by one clan member in the ritual proceedings, and each was honored by the other clan members by means of singing and dancing. The masks represented spirits. But the primitive artist did not represent just because he was fond of representing. He did so for the purpose of the mask's being worn and honored in the ritual. Honoring the mask was in turn connected with paying homage to the god. For it was the belief of the Papuan people that the mask, when worn by the clan member, served to bring about the presence of the represented spirit. The mask went proxy for the spirit. And so, as one might expect, the mask when worn and honored throughout the days of ritual had the effect of producing "almost hysterically charged excitement and exuberance."

"During these few days other ceremonies were held for the initiation of the young into adult society, at which time still other spirits, represented by conical masks of similar construction, were in attendance. At the end of the ceremonial period, all of the great masks re-entered the special house for the last time and continued through to a sacred court behind it, where they were

ritually thanked for their presence and were then destroyed by fire."

The ultimate purpose behind the use of masks by the Paupan Gulf people was to alleviate the threat of disease and starvation. For it was their belief that by paying homage to the supernatural spirit "in the mask" they would induce the spirit to work on their behalf. The mask functioned, so they believed, to secure the favor of the spirit.

In short, their masks entered deeply and richly into the lives of the Papuan Gulf people. But at the center of it all was a certain intended public use: The mask was to be *honored*, and thereby the god-in-the-mask was to be paid homage.

Those very same masks now have among us an intended public use as well. That use is of course not the action of honoring. It is the action of aesthetic contemplation.

7. OUR BLINDNESS

Seldom do we have before our mind's eye the whole broad sweep of the purposes of art. And in particular, seldom do we acknowledge that the intended public uses for art are diverse and multiple, with none constant. To the contrary, all of us, theorists and non-theorists alike, assume that beneath the flux and diversity of purpose there is just one intended public use. Only such diversity of purpose is acknowledged as is compatible with that supposed singleness of intended public use.

For the art of music, we assume that the public use intended is just that of listening. Music is for listening to. For the art of painting, just that of looking. Painting is for looking at. For poetry, only that of reading or listening. Poetry is for reading or listening to. No matter what the art, in each case the action that you and I tend to regard as intended is a species of what I shall call *perceptual contemplation*. We differ in our views as to why artists compose works for that intended use, or as to what of benefit is gained by submitting works of art to that use. But we share the assumption that works of art are composed and presented to the public for their perceptual contemplation. Virtually every statement concerning the purposes of the arts which comes from the hands of our aestheticians, our art theorists, our critics, makes this assumption. Only among anthropologists is there significant resistance to the consensus.

Yet the assumption is surely false. The masks of the Papuan Gulf people were not intended for looking at but to be worn and honored. The songs and dances of primitive people were not meant to be contemplated but to be performed by all so as to make crops grow or rains fall. The small clay figurines made by ancient Mexicans and now being unearthed from burial sites were not intended for looking at but to accompany the dead in their afterlife. And if the standard view concerning the paintings in the Lascaux caves is correct, they too were not intended for looking at but, in magical fashion, to help achieve success in the hunt.

But if it is indeed true that the intended public uses of works of art cover so broad a range as that, plus many others besides, why then is our *view* of the intended public uses so constricted? Why is our vision so confined? Could it be that most of us don't know enough about other societies to realize that in them the intended public uses of works of art comprise vastly more than perceptual contemplation? Surely not. We all know, at least in a general way, that in societies other than our own, works of art have a broad range of intended public uses. Then could it be that when you and I think about the intended public uses of works of art it is exclusively our own society that we have in mind? No, that cannot be the explanation either. After all, there are hymns in our society. But hymns are not intended to be listened to but rather to be sung by an entire cultic gathering in order to give praise to its god. And in our society are bits of poetry children recite when playing games. But obviously these are not meant for listening to but rather to serve one or another role in playing the game. Then too, for the most part the music composed for our contemporary films is not intended to be listened to but to function as auditory background. All this we all know. The world is filled with works of art never intended for perceptual contemplation.

Why then do we all so regularly take for granted that works of art *are* intended for contemplation? What induces us to ignore the obvious?

The suggestion I wish to develop is that our thought on these matters has in large measure been determined by the social realities of the role of art in a certain segment of our society. You and I are participants in what I shall call our society's *institution of high art*. Our participation in this situation has cast a spell over us. In large measure we think as we do about the arts because we consider only the role of the arts in this institution, though in the back of our minds we know that they have other roles in life as well.

It is my goal in this book to dig beneath the particulars of how art functions in our society, and beneath the particulars of how art functions in other societies, down to what is universal in art. The situation of most of us in our society, however, is that we persistently mistake the particular for the universal. Accordingly, before we can even begin the positive task of constructing a perspective which will hold for the arts universally we must engage in critique, in unmasking, for the sake of liberation. We must break the spell which our participation in the institution of high art has cast over us. We must look the spellbinder in the face, taking note of some of her salient but idiosyncratic features, casting a glance aside every now and then to assure ourselves that the features we have noted are indeed, in spite of all their beckoning familiarity, not universal but idiosyncratic.

A word of explanation: By listening, I of course don't mean simply *hearing*. Those who sing the hymn hear what they are singing though they do not listen to it. And by looking at, I do not mean merely *noticing*. Posters are of course to be noticed even though they are not meant to be looked at. And so forth. To listen to something, to look at something, to read something, is to have it occupy the focus of our perceptual attention. It is to *attend* to it. It is to

set it out from its penumbral background and to *concentrate* on it itself. When I say that works of art are not in general intended for contemplation, neither in our own society nor any other, I mean that they are not in general intended to be the focus of our perceptual attention. Naturally there are gradations. Listening shades into hearing, looking into noticing.

8. THE STRUCTURE OF ART IN ACTION

Before we turn to an analysis of our institution of high art, we must, however, tend to a certain preliminary matter which is a bit technical but important to the argument. Not only do works of art enter into a wide variety of human action. They enter into those actions in a variety of structurally different ways. It will be important for our subsequent purposes to have some awareness of this latter variety. In developing the structure of art in action I shall at first avoid taking examples from the field of art. For the structure in question is a structure that works of art share with cultural artifacts generally.

Suppose I assert in your presence that all philosophy is abstract. Suppose I do so by uttering the English sentence "All philosophy is abstract." And suppose that thereupon you come to believe that all philosophy is abstract. In this simple situation I will have performed three distinct actions: that of uttering the English sentence "All philosophy is abstract," that of asserting that all philosophy is abstract, and that of informing you that all philosophy is abstract.

Most of us today are parsimonious in nature, not indeed about our possessions but certainly in our ontology. We are suspicious of the claim that in this simple situation there really are these three distinct actions performed. But if the existence of actions is acknowledged at all, that conclusion is irresistible. This can be seen as follows.

An action A is distinct from an action B if it is possible for someone to perform A and not B, or B and not A. For if A was the very same action as B, then if one performed A one would perforce have performed B, and if one performed B one would perforce have performed A. Consider then the actions before us. I could have performed the action of asserting that all philosophy is abstract without performing the action of uttering the English sentence "All philosophy is abstract." For I might have made that very same assertion with some other English words, or in a different language. Conversely, I might have performed the action of uttering those English words without performing the action of making that assertion. I might have uttered the words for the sake of their sound, let us say. And quite obviously I might have performed both of these actions without having had any effect whatsoever on your beliefs, and so without performing the action of informing you that all philosophy is abstract. So we are indeed dealing with three distinct actions in the simple case before us.

But though distinct, these three actions are related in a most intimate way

in the situation envisioned. For it is *by* performing the action of uttering those words that I perform the action of making that assertion. And likewise it is *by* performing the action of uttering those words that I perform the action of informing you of that. Now when a person on a certain occasion performs one action *by* performing another, let us say that he has on that occasion *generated* the one action by performing the other. In our thought-example we have then two specimens of action-generation. By performing the action of uttering the English sentence "All philosophy is abstract," I generated the action of asserting that all philosophy is abstract. And secondly, by performing the action of uttering that English sentence, I generated the action of informing you that all philosophy is abstract.

It may prove helpful to have a diagrammatic way of displaying the fact that a person on a certain occasion generates one action by performing another. To show that I generated the action of asserting that all philosophy is abstract by performing the action of uttering the English sentence "All philosophy is abstract," we can use this diagram:

 ○ Asserting that all philosophy is abstract

I: ○ Uttering the sentence "All philosophy is abstract"

And similarly, to show diagrammatically that John informed Pete that all philosophy is abstract by uttering the English sentence "All philosophy is abstract," we can use this diagram:

 ○ Informing Peter that all philosophy is abstract

John: ○ Uttering the sentence "All philosophy is abstract"

Our two specimens of action-generation, asserting by uttering and informing by uttering, differ in a significant way which we must now note. Informing you of something is an action that occurs only if my performance of the generating action causes a certain effect in you. If my uttering had had no effect on you, I would not have informed you. Specifically, I inform you that all philosophy is abstract only if I do something which causes the event of your being informed that all philosophy is abstract. In the case before us, it was my uttering the English sentence "All philosophy is abstract" that caused you to be informed that all philosophy is abstract. Let us call action-generation which thus involves causality *causal* generation.[10]

Our other specimen of action-generation is different. My asserting that all philosophy is abstract does not consist in my bringing about some event which is *caused* by my performance of the generating action, this latter being the action of uttering the English sentence "All philosophy is abstract." Rather, my performing the action of uttering the English sentence "All philosophy is abstract" *counts as* my asserting that all philosophy is abstract. The connection here does not come about by virtue of the causal texture of nature but by virtue of my performance of the one action's *counting as* my

performance of the other.[11] We can easily display this difference on our diagrams by placing "ca" opposite the arrowed line for causal generation and "co" opposite that for what we may call count-generation.

The application to art is this: By performing one and another action with or on his work of art, the artist generates a variety of other, distinct, actions. Some of those generated actions are count-generated, some are causally generated. By shaping and designing the masks as he did, the Papuan Gulf artist count-generated the action of representing one of the clan's guardian spirits. By wearing the mask and walking among his clan members, he causally generated the action of producing almost hysterical excitement. Thus works of art are what we might call *instruments* in the performance of generated actions; alternatively expressed, they *function in* our performance of generated actions.

But even more basic than the phenomenon of works of art being *instruments* of action is the phenomenon of works of art being *objects* of action. Works of art are objects on which we perform actions. They are things to which we do things. By using works of art as *objects* of action we generate other actions, for which those works are then the *instruments*. When I generate the action of informing you that all philosophy is abstract by uttering the sentence "All philosophy is abstract," the sentence "All philosophy is abstract" is the *object* of the action of uttering and *instrument* of the action of informing you.

Look once against at our first diagram. To show that the sentence is object of the action of uttering, as when I perform the generating action of uttering the sentence "All philosophy is abstract," we can put a rectangle around the expression which stands for the object of the action, thus:

O Asserting that all philosophy is abstract

I: O Uttering the sentence "All philosophy is abstract"

This now shows that the sentence is the object of the action of uttering. Likewise it shows that that sentence is an instrument for, or functions in, my performance of the generated action of asserting that all philosophy is abstract. For the sake of having a convenient terminology, let us say that an entity is *used* to perform whatever action it is an *object* for.

Perhaps what should be added is the rather obvious point that both generating actions and generated actions may be performed either intentionally or non-intentionally. What should also be added is the related point that often one action is performed for the *purpose* of performing another. What we have then is this:

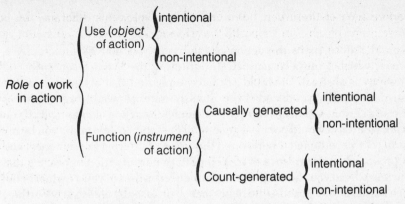

I have concentrated so far on the actions of the speaker—and, correspondingly, on the actions of the artist. But the structure uncovered also shows up when we look at the role of works of art in the actions of the public. Works of art serve as objects of certain actions on the part of the public; they are things on which the public performs various actions. Among the Papuan Gulf people, for example, the masks were honored by the cult members; that was one of the uses to which they were put, one of the actions performed on them, one of the actions for which the work was object. But the people believed that by submitting the mask to the action of honoring they would in turn count-generate the action of paying homage to the god, since they believed that the mask went proxy for the god. And they believed that by paying homage to the god they in turn would induce the god to act beneficently toward them. Thus they believed that the work of art was instrument for (i.e., functioned in) the performance of those two generated actions of paying homage to the god and of inducing him to act beneficently toward them.

If in turn it be asked how they generated the action of honoring the mask, the answer is that they did it by singing certain words and performing certain dances. On the (no doubt false) assumption that they did in fact honor a god and induce him to act beneficently towards them, the entire structure can be displayed as follows:


○ Inducing the god to act beneficently

↑ ca

○ Paying homage to the god

↑ co

○ Honoring the mask

↑ co

The people: ○ Singing and dancing


The role of a work of art in the actions of the artist is to be distinguished from the role of that work of art in the actions of the public. That is important to keep in mind, though, as we have just seen, the *structure* of those roles is the same. But while these roles are distinct, characteristically they are closely

connected. We can return to our thought-example to see in what way this is true.

Consider once more the action of informing you that all philosophy is abstract, which I causally generate by uttering the English sentence "All philosophy is abstract." I would not have generated that action unless that occurrence which I produced of the English sentence would have served as object of a certain action on *your* part—namely, the action of hearing it. If you had not heard it, I would not have generated the action of informing you by my uttering of this sentence. *I* performed the action of uttering the sentence, and so I produced an occurrence of it. *You* performed the action of hearing that occurrence. And your hearing of what I produced causes in you a certain belief which formerly you lacked—the belief that all philosophy is abstract. Further, I may have uttered the English sentence I did for the *purpose* of causing that belief in you. If so, then my purpose in producing it presupposes my wanting you to perform, on that occurrence of the sentence which I produce, the action of hearing it. Thus your hearing was my intended public use, presupposed by my wish to inform you.

So it also goes in art. The Papuan Gulf artist produced his work so as to induce the clan's spirit to act beneficently. That was his ultimate purpose. But in the Papuan scheme of things, achieving that purpose presupposed the mask's being put to the public use of being honored by the clan members. So that was the artist's intended public use for his work of art. Similarly, Rembrandt causally generated, and perhaps intended to generate, the action of giving people aesthetic delight by creating and presenting to the public his *St. Paul*. But his generation of this action presupposes that people use his painting as object of the action of aesthetic contemplation. Accordingly, if Rembrandt intended that his painting function in giving people aesthetic delight, then the intended public use that he had in mind was that of people using the painting as object of aesthetic contemplation.

Underlying the artist's creative activity will characteristically be a certain intended public use. And he gives his work the properties he does in part because he makes it for that use. If he had made it for a different public use, he would have made it different. Of course, he fully expects that the public will also use his work in ways he never intended.

So in fact and by intent the role of works of art in the actions of the artist is interlocked with the role of works of art in the actions of the public. The actions of the artist in which the work plays a role are often actions which, if they are to be performed by him at all, presuppose that the public use the work in certain ways. And often that is not merely how things do in fact go. It is how the artist intends that they shall go. The artist intends a public use. The Romantic notion that the artist simply pours his soul into his work with no thought of any public use for that work is wildly false to the realities of art.

9. WORKS OF ART

Earlier I cited what I take to be the arts—the major fine arts, that is. Before I turn to an analysis of our institution of high art, a word must also be said concerning what I take *works of art* to be.

Dense thickets of controversy surround the question of how "work of art" is properly to be defined. The truth of the matter, it seems to me, is that our English phrase "work of art" is associated with a number of distinct concepts; and most of the controversies surrounding the definition of the phrase are rooted in the fact that one writer has one of the associated concepts in mind and another, another. Let me distinguish some of these diverse concepts.

Every phenomenon that any of us would regard as a fine art is a phenomenon which manifests itself in the form of particular products. For an art is an art *of making*. The art of music manifests itself in performances and in entities susceptible of performance; the art of visual depiction, in paintings; etc. And one concept of a work of (fine) art is just that of *a product of one of the (fine) arts*.

To see another way of conceiving of work of art, put the concept of the arts out of mind for a moment and notice that such things as paintings, but also such things as barns and trees, have many different *dimensions*. They have an economic dimension, for they enter in various ways into the economic affairs of men. They have a moral dimension, for they enter in various ways into the moral dimension of human life. They have a psychic dimension: we feel various emotions toward them. And they enter into the aesthetic dimension: they have aesthetic qualities.

Now the way in which a painting or barn enters into the economic dimension may be good. Likewise the way it enters into the moral dimension may be good; the painting may in many people produce effects which are morally desirable. So too, a barn or painting may be aesthetically good. Having noticed this, we now have the material to formulate a second concept of work of art: A work of (fine) art is *an entity which is good in the aesthetic dimension*. Such a definition, including as it does a reference to goodness, may be called a "normative" definition.

As this definition stands, it applies not only to human artifacts but also to things not produced by human endeavor: mountains, sunsets, eucalyptus seed pods, bird songs, rock strata. For these may all be aesthetically good. Seeing this, yet another concept of work of art comes at once to mind, narrower but closely related: A work of (fine) art is a *human artifact which is good in the aesthetic dimension*.

None of these ways of conceiving work of art refers at all to human intention. But often the concept used in discussion on the arts does incorporate such reference. Let us say that aesthetic contemplation is contemplation undertaken for the sake of the satisfaction to be gotten in the

contemplation, provided the satisfaction is grounded in the aesthetic qualities of the object. Here then is a concept which combines the idea of the aesthetic dimension with the idea of human intention: A work of (fine) art is *an entity made or presented in order to serve as object of aesthetic contemplation*.

In these various definitions, four different ideas enter: the idea of a product of one of the fine arts; the idea of aesthetic goodness; the idea of a human artifact; and the idea of producing something with the intent of its serving as object of aesthetic contemplation. Obviously these four ideas can be combined in yet other ways to yield concepts in addition to the four I have offered. And probably some of these additional concepts can also be found in writings on the arts. One might combine the first and the second to give this concept: A work of (fine) art is *an aesthetically good product of one of the (fine) arts*. Or one might combine the first and the fourth: A work of (fine) art is *a product of one of the (fine) arts intended for aesthetic contemplation*. Perhaps also there are concepts associated with the phrase "work of art" which use some idea beyond the four I have singled out.

Given this array of interconnected concepts, the question "Which definition is correct?" is ill-conceived. For, to say it once more, the English phrase "work of art" is associated with all these different concepts I have articulated. One can find all four of those definitions in use in discussions on art. Accordingly, when setting out on a discussion about art, one must always ask oneself, "Which of the concepts associated with the phrase 'work of art' shall I make use of in the particular discourse ahead of me?" In each case the answer to that question must be arrived at by considering the points to be made in the discourse. To make one sort of point it's best to use one of the concepts. To make another, another.

For the purposes of my discussion in this essay it will prove best to use the phrase "work of art" in the first sense, so that it expresses the concept of *a product of one of the (fine) arts*. Thus I shall use the phrase in a sense which is both non-normative and non-intentional.[12] In that lies the utility of using it thus. Since it is non-normative, I can speak of aesthetically poor works of art, whereas that would be impossible on the second and third definitions that I framed. And since it is non-intentional, I can speak of liturgical art. That would be impossible on the fourth definition, since liturgical art is, in the main, not produced with the intent that it shall serve as object of aesthetic contemplation.

PART TWO
Our Institution of High Art

I 1. OUR INSTITUTION OF HIGH ART ─────────

N EVERY society in which the arts put in their appearance—and we have
seen that there is none in which they do not—we can pick out what may be
called that society's *institution of art*. By this I mean the characteristic
arrangements and patterns of action whereby works of art are produced in that
society, whereby they are made available for the use of members of that
society, and whereby members of that society are enabled to make use of
them.

A full description of any society's institution of art would require attention
to such factors as these:

(1) The characteristic types of works of art to be found in that society.

(2) The characteristic functions of works of art in the actions of artists in
that society, and the characteristic intended public uses for which those works
of art are produced and distributed.

(3) The characteristic social and physical situations in which works of art
are put to their intended public uses.

(4) The characteristic distribution and reward systems whereby works of
art are made available to the users.

(5) The characteristic arrangements for inducing the production of works
of art.

(6) The characteristic makeup of those who use, of those who distribute,
and of those who compose or otherwise make available for distribution, the
various types of works of art, and the characteristic training (if any) which the
members of each group undergo.

(7) The characteristic types of evaluation which the society makes of its
works of art, and the criteria on which these evaluations are characteristically
based.

Now from a society's total institution of art one can pick out various
component institutions. For example, one can pick out that component which
consists of arrangements and patterns of action oriented around the single art

of the theater. From our society's total institution of art I propose to pick out a component which I shall call our society's *institution of high art*.

A striking feature of how the arts occur in our society is that there is among us a cultural elite, and that from the totality of works of art to be found in our society a vast number are used (in the way intended by artist or distributor) almost exclusively by the members of that elite. I shall call those works our society's *works of high art*. The works of Beethoven, of Matisse, of Piero della Francesca, are examples. Correspondingly, our society's *institution of high art* consists of the characteristic arrangements and patterns of action pertaining to the production, distribution, and use in our society of those works of art.

Many members of our cultural elite never think of themselves as members of some elite. They think of themselves as humble, timid concertgoers and gallery-visitors. But in fact the vast majority of people in our society never set foot inside a concert hall or art gallery. And if one looks at the cultural status and influence of the group as a whole which does frequent such places, one sees that they constitute an influential elite in our society. Naturally some people are near the center of the elite in their tastes, predilections, and influence, while others are on the edge.

In addition to our society's works of high art there are also works in our society used (in the way intended) almost exclusively by persons outside the cultural elite. Those we may call our society's *works of popular art*. And then thirdly there are in our society works whose use (in the way intended by artist or distributor) is shared in common by elite and nonelite. Borrowing from Francis Bacon's phrase "idols of the *tribe*" we may call such works our society's *works of the tribe*.*

No sharp lines divide from each other our society's work of high art, popular art, and art of the tribe. The one sort shades into the other. Further, over the course of time some works shift from one group to another. Though jazz originated as popular art, it now, as a whole, belongs to the art of the tribe. Seldom, though, does a work of high art in our society later become a work of the tribe, let alone a work of popular art (not, anyway, without its intended use being altered). And works among us which originated in non-Western

*A work may be used in the way intended *by the artist* almost exclusively by the cultural elite, whereas those who use it in the way intended *by some distributor* may not be exclusively the elite. A similar discrepancy may arise between two distributors: Our concert-hall performers and entrepreneurs may present some Mozart work to the cultural elite for their careful listening, whereas the Muzak company may present the same work to the public in general for use as auditory background. This makes it clear that a work is not a work of high art *per se*. Rather, it is a work of high art *relative to* (or *in*) a certain use. So too, a work will be a work of popular art, or of tribal art, only relative to a certain use. Though I intend this qualification always to be kept in mind by the reader, I shall forego inserting it into the language of the text.

societies, or in the distant past of Western society, there having served as works of the tribe, serve us for the most part as works of high art. Bach's cantatas are to be found among our works of high art, not among our works of the tribe.

Our society is far from the first to have a cultural elite with works of art reserved for its relatively exclusive use. To cite but one of many examples: Around the papal court of Avignon in the fourteenth century there arose a highly complex, mannered body of music which was used only by the members of a few princely and ecclesiastical courts of Europe. But in two fundamental ways our cultural elite is relatively unique. It is *open*, in the sense that membership depends neither on heredity, wealth, nor occupation. Secondly, and even more importantly, it has close ties to our *intellectual* elite. To achieve membership in our cultural elite one attends college and university. Those who function as critics for our cultural elite are centered in our colleges and universities. And even our artists today hover around, or are nested within, our academic establishments.

Never is the cultural elite of a society totally cut off artistically from the non-elite. Always there is a sizeable body of works of the tribe. In Western society until perhaps the seventeenth century it was principally works of liturgical art that constituted the works of the tribe. All men met in the church; and the enormous body of works of art called forth by the Christian liturgy was shared in common by all. Though all men no longer meet in the church, it is still true that our liturgical art belongs to our art of the tribe, since those who make use of it are from elite and non-elite alike. We sing our hymns together. The art of our tribe *as a whole*, however, is today mainly the art produced by our commercial establishments. Marketplace has replaced church as artistic unifier. The advertising art, the background art, the display art of our commercial establishments, presented to us on radio, on television, in newspapers, on billboards, through loudspeakers, is what today constitutes the art of our tribe as a whole. Where once the spire of the cathedral or the steeple of the church gave the first glimpse of city or village, today it is the Sears and Hancock buildings.[1]

It was in the nineteenth century that our society's institution of high art acquired the characteristic form that it now presents to us. Since then no fundamental changes have taken place. Though naturally the institution did not appear full grown, I shall here make no attempt to trace its growth to maturity. Neither, to the best of my knowledge, has anyone else made the attempt. The history as well as the comprehensive sociology of our institution of high art remains to be written.[2] Thus what I say in description of it will not be supported by detailed evidence. On the other hand, the characteristics of our institution of high art that I shall note seem so obvious as to be more like features to be accounted for, than generalizations to be supported, by historical and sociological research.

2. ART FOR CONTEMPLATION

In the preceding section I spoke here and there of "uses intended by artist or distributor." In doing so I was making use of points developed in Part One. An artist characteristically makes his works for some intended public use (and function). Naturally he realizes that his work may be put to other uses as well. But he intends his work to fit into the fabric of human action in certain rather definite ways. Of course he may have several uses in mind, not just one. And these may be ordered in a certain priority for him. An architect may intend both that his building be used by a family for living and that it serve as object of perceptual contemplation; of these the latter may have priority for him in that he concerns himself most with making the work satisfactory in that dimension. The same holds, *mutatis mutandis*, for the distributor. He will distribute works to the public for certain intended uses. These may either coincide with or diverge from the public uses that the artist intended. Particularly will there be divergence if the artist lived and worked within one society while the distributor lives and works within another.

Now if one looks at our society's works of high art one is at once struck by the fact that they are almost exclusively intended, by producer or distributor, for contemplation. Almost invariably that is their dominant intended public use. Hardly anything else gets in. It is hard even to think of counterexamples. The vast diversity of intended uses of works of art is here narrowed down to just this one: perceptual contemplation. In that respect our institution of high art is highly idiosyncratic as among institutions of art generally. To my knowledge its only near counterparts in the course of history are the institution of high art in ancient Roman imperial society and the institutions of high art to be found at various times and places in Oriental society.

As already remarked, you and I, along with the rest of those who think and write about the arts, are participants in our society's institution of high art. And the basic reason we all endemically overlook the fact that the intended public uses of art are multitudinous, thinking instead that music is for listening to, painting for looking at, and poetry for reading, is that we are so deeply immersed in our own institution of high art, where indeed almost all art *is* art for contemplation, that we find it virtually impossible to rise up far enough to get a perspective on the landscape surrounding, where not only is art for contemplation to be seen but very much else besides. To revert to my earlier metaphor, we have been bewitched by participating in our own institution of high art.

Not only does the highly contemplative and intellectual character of our institution of high art make it relatively idiosyncratic. It also gives it a good deal of internal coherence, so that in singling it out from our society's total institution of art we are not merely ripping a fragment from a larger cloth but removing for inspection something which is a cloth of its own, bound into unity by the fact that it is the arrangements and patterns of action pertaining to

the art of a cultural elite highly intellectual in its interests and attitudes and concerned above all else to have art for contemplation.

Let us then focus our attention for a while on those features of our institution of high art which are connected with the central impulse toward art for contemplation satisfying to the intellectual. By doing so we shall discern some of the inner coherence of the institution.

3. SEPARATION OF ART FROM LIFE

One characteristic feature of our institution of high art is the important role played within it by special separated rooms and buildings—concert halls, art galleries, theaters, reading rooms. It is not difficult to discern the reason. If the action of perceptual contemplation is to be performed at all satisfactorily, particularly when its satisfactory practice requires mental concentration, rather special physical conditions are required. To listen to a work of music intently one needs a quiet place—exactly what a concert hall undertakes to furnish. To look at a painting intently one needs a well-lighted space—exactly what a gallery undertakes to provide.

The growth of concert halls is thus intimately connected with the phenomenon described by the American composer Roger Sessions in these words:

> Listening to music, as distinct from reproducing it, is the product of a very late stage in musical sophistication, and it might with reason be maintained that the listener has existed as such only for about three hundred and fifty years. The composers of the Middle Ages and the Renaissance composed their music for church services and for secular occasions, where it was accepted as part of the general background, in much the same manner as were the frescoes decorating the church walls or the sculptures adorning the public buildings. Or else they composed it for amateurs, who had received musical training as a part of general education, and whose relationship with it was that of the performer responding to it through active participation in its production. . . . By a "listener," I do not mean the person who simply hears music—who is present when it is performed and who, in a general way, may either enjoy or dislike it, but who is in no sense a real participant in it. To listen implies rather a real participation, a real response, a real sharing in the work of the composer and of the performer, and a greater or less degree of awareness of the individual and specific sense of the music performed.[3]

Of course the need for the appropriate physical circumstances did not by itself lead to the erection of our *public* halls and galleries. Before the founding of these, the nobility already had such rooms. For they were then the cultural elite, and could afford the requisite spaces and the art to put into them. It was the breakdown in the cultural dominance of the hereditary nobility and its replacement by a much more intellectual and socially open elite, coupled with the desire of that elite to have art for intellectualized contemplation, that led

to the construction of our public concert halls and galleries around the beginning of the nineteenth century. A new democratization may lead to their demise as anything more than storehouses of art and gathering places for people. The development of techniques for reproducing works of art has now made it possible for each of us to fill the spaces in our own private homes with exceedingly accurate replicas of the world's art in conditions nearly optimal for contemplation. We are all becoming princes.*

By way of contrast it should be noticed that for most uses of art special separated rooms and buildings are beside the point. For incantatory poetry, lecture halls are useless. For the use to which the ancient Egyptians put the art of painting when they decorated their mummy cases, galleries were irrelevant. And for background music, concert halls are the last thing wanted. Thus it will not surprise us to learn that concert halls and galleries are not found at all in most societies, and that in no society do they occupy the prominent role that they do in our own post-eighteenth-century Western society. The famous opening of André Malraux's *Voices of Silence* is worth quoting in this regard:

> So vital is the part played by the art museum in our approach to works of art today that we find it difficult to realize that no museums exist, none has ever existed, in lands where the civilization of modern Europe is, or was, unknown; and that, even amongst us, they have existed for barely two hundred years. They bulked so large in the nineteenth century and are so much part of our lives today that we forget they have imposed on the spectator a wholly new attitude towards the work of art. For they have tended to estrange the works they bring together from their original functions and to transform even portraits into "pictures."[4]

Another important and characteristic feature of our institution of high art is that, with the exception of the art professionals and art students, our commerce with the high arts occurs during our leisure time. The reason is obvious. If a persons spends almost all his available time working at his vocation or profession and tending to his essential social tasks, then he cannot engage very much in perceptual contemplation of works of art, let alone perceptual contemplation requiring intellectual attentiveness. Even those of us who love the high arts have all had days and even weeks in which we had no time for artistic contemplation—perhaps, ironically, because we have been too busy talking about art.

Though art for contemplation, especially intellectualized contemplation, requires leisure, it should be obvious that leisure is not in general a condition for commerce with the arts. Within the body of the world's music are to be found work songs. Work and not leisure is needed if weaving songs, spinning songs, etc., are to find their intended public uses.[5]

*It is fascinating to observe that now some performers—e.g., Glenn Gould—perform only for records, and that some music—e.g., electronic—is meant exclusively for records and not at all for the concert hall.

If we now put together what I have said about the physical conditions necessary to participate satisfactorily in our institution of high art with what I have said about the social conditions necessary, we see that we are confronted with a sizeable separation between ordinary life on the one hand and the circumstances in which we participate in the institution of high art on the other. But there is yet a third way, perhaps even more fundamental, in which separation of art from life is endemic to our institution of high art; namely, there is a degree of separation inherent in the very nature of perceptual contemplation. To engage in perceptual contemplation one must focus one's attention on the work of art, immerse oneself in it; and that requires disregarding for a time all else that beckons for one's attention. To one who contemplates, life is a distraction.

Often it is said that the separation of art from life characteristic of our institution of high art must be *overcome*—as if it were an accidental development or one perpetrated on us by misguided men. We have seen on the contrary that in the respects cited it is an inevitable feature. But also it must be noticed that the separation of art from ordinary life that I have noted as characteristic of our society's institution of high art is characteristic neither of institutions of art in other societies nor of our own society's total institution of art. Art in general is not thus divorced from life, and never has been. Yet when we in our society think about the arts we persistently think of them thus.

Two specific examples of bewitchment on this matter may be in order. Among those aestheticians who have most successfully resisted bewitchment is certainly Gerardus van der Leeuw, the Dutch theologian and anthropologist. Yet even he, in his fascinating book *Sacred and Profane Beauty*, gets things not quite right. Van der Leeuw takes six of the arts in succession, describes for each the unity of that art with religion in primitive societies, and then traces what he describes as the "breakup" of that unity in modern society. But even if we limit religion to cultic practices, it is clear that men today use the arts in their cultic exercises as much as they ever did. Only haltingly could they manage without them. It is true that our participation in our society's institution of high art is clearly separated from our participation in the practices of our several cults. It is also true that cultic practices themselves have been increasingly separated from the rest of life. It may even be true that our institution of high art has in certain ways been destructive of traditional cultic practices. But the use of the arts in our cults has not, I should think, significantly diminished.

However, the classic example of myopia on the issue of separation of art from life is the English critic Clive Bell, in this famous passage from the opening chapter of his *Art*:

Art transports us from the world of man's activity to a world of aesthetic exaltation. For a moment we are shut off from human interests; our anticipations and memories are arrested, we are lifted above the stream of life. . . . [T]he rapt philosopher, and he who contemplates a work of art, inhabit a world with an

intense and peculiar significance of its own; that significance is unrelated to the signficance of life. In this world the emotions of life find no place. It is a world with emotions of its own.

If one construes Bell as having his eye on our institution of high art one can see why he says what he does, though his claims are excessive and misleading. But he speaks of art in general. And what he says is a patent falsification of the use and function of art in human life.

4. IMMENSITY OF REPERTOIRE

It has often been remarked that for about a century now the artists in our institution of high art have been on a march never ceasing toward destinations unknown, led forward by a search party known as the *avant-garde*. No sooner does a member of the party come to rest at some spring of delight than another steps into his place in line so that the march may continue forward uninterrupted. I suggest that this idiosyncratic phenomenon of the avant-garde should in part be seen as the result of a powerful, relentless, insatiable impulse in our institution of high art to expand our repertoire of works of art for contemplation, the result of this impulse being the characteristic though idiosyncratic presence of an incredibly expansive repertoire of works of art available to those who participate in our institution of high art, expansive both in the number of such works and in their stylistic diversity.

The impulse is manifested in three ways. First, in our institution of high art we place high value on the production of new works of art, on stylistic pluralism among those new works, and on radical stylistic innovation. The result is that our institution of high art is characterized by an ever flowing stream of newly made works, stylistically diverse and—some of them—radically innovative.

Secondly, we do our best to preserve and recover from our own Western tradition works of art which prove satisfactory for contemplation, whether or not they were originally so intended, not to let them fall into decay or oblivion, and to bring them into, or to keep them in, use as objects of contemplation. We try to preserve the autographa of our writers and composers, we try to halt the deterioration of our paintings and sculptures; and then in our concert halls, galleries, and libraries we make these works from the tradition regularly available to participants in our institution of high art. Our galleries, concert halls, and libraries groan under the weight of history.

Third, we ruthlessly expropriate works of art from non-Western societies, whether or not those works were intended for contemplation, and bring them into our institution of high art, there using them as objects of contemplation. We take the marbles from the Parthenon and put them into a splendid room in the British Museum. We take the masks of the primitives and the altar pieces of the medievals and put them into display cases in New York. We send recording engineers into African tribes and so make it possible for us all to hear

in our suburban living rooms the music of the traditional African ceremonials. We ransack the world to feed the insatiable appetite of our institution of high art.

Thus not only do we keep a search party out ahead of our main body of artists. We ask our rear guard to carry along our discoveries from the past; and our entrepreneurs fan out into the surrounding tribes to see what booty they can bring back. What makes it seem best not to treat the presence of an avant-garde in our institution in isolation, as so often is done, but to consider all three of these phenomena together, is that all three first began to flourish together in the nineteenth century.

Extrapolating from my own experience, let me offer some speculations as to the sources of this impulse toward repertoire expansion so characteristic of our institution of high art. In the first place, contemplation is the most catholic of all uses of works of art. No longer can we use burial art after the fashion of the Egyptians and Incas, no longer can we build temples to gods and goddesses after the fashion of the Greeks, no longer can we attempt to invoke the presence of the saints by depicting them in mosaic after the manner of the Byzantines. The requisite framework of beliefs has disappeared. But what we *can* do, and satisfactorily so, is *look at* all these works of art.

A second factor is what might be called *the jading principle*. It is my own experience—and the experience of others as well—that after I have repeatedly contemplated a work of art I get bored with it. No matter how magnificent the work, my interest wanes, delight vanishes, and I must move on to something else. The time it takes to reach this point varies from work to work, but for every work there comes such a point. Not only do I lose interest for a while in single works of art but in whole styles of work. I become jaded. I think it is in good measure our attempt to cope with jading that impels us to expand our repertoire by such devices as encouraging pluralism and innovation, preserving works of art from the past, and expropriating. The medieval music now being recovered, performed, and recorded is a wonderful new savor for our jaded palates.

But thirdly, the satisfactory contemplation of radically innovative works of art by our own artists, of works of art from our own distant past, and of works of art from alien cultures, requires considerable study and reflection. Otherwise they simply remain closed books. So it is the markedly intellectual nature of those who participate in our institution of high art that makes the radical expansion of repertoire in the ways indicated even a possibility.

Perhaps yet another factor is operative. Diversity of taste seems to me a phenomenon more directly relevant to the use of works of art as objects of contemplation than to any other use. If so, then what we see operating in our institution of high art is also the attempt to satisfy the diversity of tastes among us. Nineteenth-century Romantic music is to one person's taste, Stravinsky to another person's taste, Guillaume de Machaut to yet another's; and each now finds it easy to have his taste satisfied. Indeed, it is difficult to think of any taste

in the fine arts which cannot now be satisfied inexpensively and easily in our society (architecture constitutes an interestingly intractable exception).

But whatever the correct explanation, though the existence of an immense and continually expanding repertoire is an important characteristic of our institution of high art, it is nonetheless idiosyncratic to it. In most societies there is virtually no attempt at expropriation; the culturally familiar is preferred—indeed, it is all that can satisfactorily be used. In most societies preserving works of art is at best a haphazard procedure; the Northwest Indians never minded if their totem poles deteriorated in the weather. And in many if not most societies no premium has been placed on stylistic pluralism and innovation. Of course there has always been change. But seldom has artistic change been self-consciously cultivated. More often it has been self-consciously resisted.

Yet on these matters too we are bewitched. We take the salient characteristics of our institution of high art as non-idiosyncratic normalities. We regularly assume, for example, that where there is no deliberate change and development in the arts, there the arts are dead. This opinion both reflects the high valuation placed on innovation which is characteristic of our institution of high art, and it is patently false. Egyptian art was no less vital for being relatively static for centuries. It changed, but usually very slowly, and seldom because the Egyptians wanted it to change.

5. THE CRITIC IN OUR INSTITUTION OF HIGH ART

Yet a third salient but idiosyncratic feature of our institution of high art is the important place occupied within that institution by critics.

The public's mental picture of the critic is that of one who comes plodding along, earth-bound and leaden-footed, behind the artist, who soars aloft on wings of creative imagination. Nothing could be farther from the truth. In our institution of high art artist and critic exist in symbiotic relationship. Neither could get on without the other.

Customarily the critic is regarded as an *evaluator*. The music critic for *The Chicago Tribune* is thought of as one who tells us which performances in Orchestra Hall were good and which not so good. The art critic for *The New York Times* is thought of as one who tells us which exhibitions in the galleries are worth seeing and which not. And indeed it is true that critics evaluate works of art, particularly those critics who write for newspapers and magazines. But if one actually scrutinizes the practice of the major critics in our society it soon becomes clear that evaluation is only a relatively minor part of what they do.

If the critic's major task is not evaluation, what is it then? To answer, I must call attention to an important fact about human psychology.

It is impossible to look at a work of art and not look *for* something. Always certain features of what we are looking at stand out in the beam of our attention

while others recede into the shadows. So too for listening. It is impossible to listen to a work of music and not listen *for* something. Certain of its features are always in the center of our attention and others off on the edge. Perceptual contemplation is always *abstractive* in character.

This abstractive character of perceptual contemplation is what in good measure gives the critic his work. For a central part of the critic's task is to advise us on what to look *for*, what to listen *for*, what to read *for*, in the work under consideration. The critic guides us in our contemplation.

But why does our institution of high art give so important a position to those who give guidance in abstractive contemplation? Critics teach us how to focus our contemplation. So the centrality of contemplation in our institution is what makes the critic's task relevant. And we have now seen that never is there contemplation which is not focussed, abstractive, contemplation. But why can't we learn *informally* what to attend to in a work of art? Why do we need the elaborate, formal guidance of critics?

No doubt we *can* learn informally. No doubt we often do. But just as our society finds it necessary in general to place heavy emphasis on formal instruction, so too the institution of high art finds it necessary to offer formal instruction to its members in what to attend to in works of art. The necessity springs mainly from the immensity and rapid expansion of the repertoire. In an institution of art where the repertoire for contemplation is small and expanding only slowly, informal learning would be satisfactory. But given the size and rapid expansion of repertoire in our high art, if there were no critics to guide us, learning what to attend to in works of art would take much too long, and by many would never get done.

We can now see why artist and critic exist symbiotically in our institution of high art. To derive worth from contemplating a body of art new to me I must attend to different features from those I customarily attend to. In that way I must acquire new ears, new eyes, a new mentality. If I listen to Anton Webern with the ears appropriate for Tchaikovsky I will hear only meaningless plinks. The critic assists me in acquiring these new sensibilities—and sometimes in applying already acquired sensibilities to new works. The critic depends on the artist to provide him with fresh material. The artist depends on the critic to make his work accessible to the public.

This symbiotic relationship of artist and critic is particularly clear in the case of the critics and the avant-garde artist. The avant-garde artist produces objects which require historically untried ways of listening, looking, reading, yy anything of worth is to be achieved. The critic's task, with respect to such an artist, is then to help us acquire those historically novel eyes, ears, and minds. Indeed, so important—even indispensable—is this function of the critic to the avant-garde artist that almost all the great avant-garde artists of our century have themselves functioned as critics, particularly for their own works. To pesky inquirers they have said that their art speaks for itself. In actual fact, almost all have spoken for their art.

There is another action belonging to the task of the critic, distinct from, though not independent of, that of offering us guidance in our abstractive attention; and it is even clearer why our intellectual and contemplative institution of high art has called forth this other action. Often we are baffled by a work of art. We do not understand it, in the sense that we do not grasp what purposes lie behind its being as it is, and in the sense that we do not grasp its structure. We do not apprehend the rationality embedded within it. Popular art and the art of the tribe tax our understanding very little. We learn the necessary lessons at our mother's knee and then simply live with the slow changes. But art from other cultures, art from the distant past of our own culture, and avant-garde art, require sustained effort to understand. The critic offers to help.[6]

In these several ways, the presence of critics in our institution of high art is closely connected both with the contemplative and with the intellectual character of that institution. Given that our institution of high art is relatively peculiar in its heavily intellectual and contemplative cast, it will then not surprise us to learn that in most societies critics are either nonexistent or very subordinate in importance; and that, though they are to be found in our own institution of popular art, most participants pay scant attention to them. Once again we have discovered the idiosyncrasy of one of the salient features of our institution of high art.

6. THE PURPOSE FOR THE USES

André Malraux remarks in one place that

> The reason why the art museum made its appearance in Asia so belatedly (and, even then, only under European influence and patronage) is that for an Asiatic, and especially the man of the Far East, artistic contemplation and the picture gallery are incompatible. In China the full enjoyment of works of art necessarily involved ownership, except where religious art was concerned; above all it demanded their isolation. A painting was not exhibited, but unfurled before an art-lover in a fitting state of grace; its function was to deepen and enhance his communion with the universe.[7]

The museum did not arise among the Chinese. Yet their institution of high art was both contemplative and intellectual in orientation. So I spoke a half-truth in saying that galleries, concert halls, and poetry-reading rooms, and the growth of a repertoire of immense proportions, flow forth inevitably from a commitment to the intellectualized contemplation of works of art. The (almost) full truth is that these phenomena flow forth inevitably only when the use of works of art is practiced, dominantly, for certain quite specific purposes. When this same use is practiced for other purposes, these results will not show up. We must turn, then, to a discussion of the purposes dominant among us for putting works of art to the use of intellectualized perceptual contemplation.

One may look at a painted scroll for the purpose of deepening and enhancing one's communion with the universe—as Malraux suggests the Chinese did. One may look at a painting in order to come into touch with the soul of the great artist there expressed. One may listen to music to relish the emotions it evokes. One may read a novel for the purpose of attaining a new vision of life and reality. One may view a drama to escape for a while the grubby tedium of ordinary life by entering a world where all is bright and ordered. One may look at a sculpture to see how faithfully it renders the stance of a man in contraposto posture. Except for the first, all these purposes for contemplation have had in the past, and have yet today, their partisans within our institution of high art. All have contributed to shaping the institution as we know it. And around each, elaborate theories concerning the function and purpose of art have been spun. There are expressionist theories of art, evocationist theories, cognitivist theories, escapist theories, representational theories.

But none of these purposes has been decisive in calling forth museums among us where the Chinese had none. That role belongs to yet another purpose for contemplation: the purpose of finding *aesthetic satisfaction* in the contemplating.

The concept of aesthetic satisfaction first began to receive articulate formulation in eighteenth-century Europe. No doubt before that time people derived aesthetic satisfaction from contemplating works of art and other objects, and no doubt they sometimes contemplated *for the purpose of* achieving aesthetic satisfaction. Franz Boas in his *Primitive Art* remarks that "In one way or another aesthetic pleasure is felt by all members of mankind."[8] But in earlier centuries people lacked the conceptual equipment necessary to make clear to themselves that the purpose and function of their contemplation was aesthetic satisfaction. The construction of that equipment seems to have begun in eighteenth-century Europe. And along with the beginnings of its construction arose the widespread feeling that one *ought* above all to contemplate works of art for the sake of aesthetic satisfaction. It was shortly thereafter, at the beginning of the nineteenth century, that our museums began to arise. That was no coincidence. It is only when people are widely interested in practicing contemplation of works of art for the sake of aesthetic satisfaction that the museum with its horde of works from all times and places, most of them ripped from their original intended uses, becomes a possibility. And in general, the emergence of our awareness of the aesthetic dimension of things has profoundly altered our thought and practice concerning the arts. It has been decisive in giving to our institution of high art the particular form that it finds among us.

In turn, decisive in the emergence of our awareness of the aesthetic dimension of things was the emergence of the concept of disinterested contemplation. Thus I agree with Jerome Stolnitz when he says at the

beginning of his well-known essay "On the Origins of 'Aesthetic Dis-
interestedness' ":

> We cannot understand modern aesthetic theory unless we understand the
> concept of "disinterestedness." If any one belief is the common property of
> modern thought, it is that a certain mode of attention is indispensable to and
> distinctive of the perception of beautiful things. . . . The signficance of
> "disinterestedness" is not, however, confined to aesthetic theory proper.
> Filtered down into art criticism and the quotidian appreciation of art and nature,
> the idea has also transformed habits of seeing and judging. It is, in our own time,
> so much a commonplace that the work of art and the aesthetic object generally is
> "autonomous" and "self-contained," and must be apprehended as such, that we
> have to catch ourselves up. This has not always been a commonplace. Indeed,
> throughout most of the history of Western art, this notion would have seemed not
> so much false as incomprehensible. During these periods the values of art are
> iconic or otherwise cognitive, or moral, or social, with nothing left over that art
> can call its own. To repudiate this conception of art is "the most tremendous
> change . . . in the whole history of art."[9]

I turn, then, to a consideration of the nature of disinterested
contemplation, as a step on the way to discovering the nature of the aesthetic.
For it is by no means evident what exactly the aesthetic is.

7. CONTEMPLATION FOR ITS OWN SAKE

Earlier we saw that often we human beings perform one action B by
performing another action A. We generate B by A.

Now sometimes a person's *reason* for performing A is the combination of
his *wanting* to perform B and his *believing* that by performing A he may
possibly generate B. I flip the switch for the reason that I want the light to go
on and believe that *by* flipping the switch I will make it go on. So suppose that
on a given occasion someone performs A, and that a reason he has for
performing A is that he believes that by performing A he may possibly
generate some other action X which he wants to perform. Let us then say that
he has performed A *instrumentally*. By contrast, suppose he wants to perform,
and does in fact perform, A, and that he has a reason for wanting to perform A
which does *not* consist of wanting to perform something else which he believes
he may generate by performing A. Then let us say that he has performed A *for
its own sake*. A legislator may vote for a certain bill because he judges that by
voting for it he will please his constituents and thus maintain himself in office.
Then his voting for it will be instrumental to the action of pleasing his
constituents and remaining in office. By contrast, his reason for voting for it
may just be that he believes it *right* to do so. (I have defined doing something
"instrumentally" and doing something "for its own sake" in such a way that it is
possible to perform a given action both instrumentally and for its own sake.
One may have reasons of both sorts for performing it.)

When one listens to a piece of music for the purpose of coming into touch with the great soul who composed it, one is listening instrumentally. One's reason for listening is that one wants to come into touch with the soul of the artist, and one believes that by listening to his composition one probably will. But once it is seen that our listening is sometimes instrumental, the possibility immediately comes to mind that perhaps we sometimes contemplate a work of art for its own sake—that is, for the sake of the contemplating. It is this idea of *contemplating something for its own sake* that constitutes one of the major components in the concept of aesthetic contemplation.

Seeing that perceptual contemplation of an object may be undertaken for its own sake enables us to understand what Paul Valery had in mind when he said that "the most evident characteristic of a *work of art* may be termed *uselessness*. . . ."[10] No doubt what Valery meant was that one of the most evident characteristics of a work of art is that it is intended to serve as object of contemplation for its own sake. Along the same lines, we can also now see what those have in mind who draw a contrast between using a work of art to serve the purposes of daily life and treating the work of art autonomously (that is, treating it *as* a work of art). To treat the work autonomously is to submit it to the action of contemplation for its own sake. Here is how Jerome Stolnitz draws the distinction:

> We usually see the things in our world in terms of their usefulness for promoting or hindering our purposes. If ever we put into words our ordinary attitude toward an object, it would take the form of the question, "What can I do with it, and what can it do with me?" I see the pen as something I can write with, I see the oncoming automobile as something to avoid; . . . Thus, when our attitude is "practical," we perceive things only as means to some goal which lies beyond the experience of perceiving them. . . .
>
> But nowhere is perception exclusively "practical." On occasion we pay attention to a thing simply for the sake of enjoying the way it looks or sounds or feels. This is the "aesthetic" attitude of perception. . . . *[11]

In that last paragraph Stolnitz introduced the concept of *the aesthetic*. I shall postpone a consideration of that for a short while yet. But also he slipped in, almost as a matter of no importance, the note of attending for the sake of *enjoyment*. What is the relation of enjoyment to the action of contemplation for its own sake?

Well, why do people want to perform the action of contemplating a work of art for its own sake? If someone wanted to generate the action of acquiring knowledge of English country life, presumably that would be because he

*In the deletions from the passage quoted in the text, Stolnitz says that when we use objects to serve the purposes of daily life we "do not concentrate" our "attention upon the object itself." That seems to me mistaken. If one reads Homer for the "practical" purpose of composing a scholarly article, one may read him very closely indeed. To contemplate something instrumentally is certainly not incompatible with close attention to the object, and may in fact require it.

regarded knowing something about English country life as desirable. And if someone wanted to generate the action of calming his jangled nerves, presumably that would be because he regarded having calm nerves as desirable. In both these cases, the goal of the endeavor would be to bring about a state of consciousness which endures beyond the occasion of contemplating. But what is there about the action of contemplating a work of art that would ever make us want to perform it wholly apart from whatever might be generated thereby?

The answer of course is that sometimes we find delight, satisfaction, enjoyment, in so doing. We enjoy listening to the music. We find satisfaction in reading the novel. We get delight in looking at the painting.

This satisfaction must not be thought of as some more or less enduring state of consciousness that *results from* the contemplation. Knowing something about English country life is indeed a state of consciousness that may *result from* contemplation. So too, having calm nerves may *result from* contemplation. But satisfaction in contemplation is not a satisfaction that *results*. It is a satisfaction *in* listening rather than a satisfaction *resulting from* listening. Sometimes we find delight just *in* listening to the music, a delight which accordingly ceases when the music ceases.

Now if someone's reason for listening to some music is the satisfaction that he gets *in* the very listening, then of course he is not listening to that music merely because he believes that by so doing he will generate some other action that he wants. He is not listening to it merely instrumentally. He is listening to it for the sake of listening. Accordingly, we can speak henceforth just of *satisfaction in contemplating*. We need not add "for its own sake." There is no contemplation undertaken for satisfaction in the contemplating which is not contemplation undertaken for its own sake.

8. DISINTERESTED CONTEMPLATION AND THE FINE ARTS

The concept of contemplation for its own sake does not, in my judgment, constitute the whole of the concept of aesthetic contemplation. But certainly it constitutes a major component in it. And Stolnitz argues that it was first in the eighteenth century, among British writers, that the concept emerged. Admittedly the British writers did not use the words "contemplation for its own sake." They spoke rather of "disinterested attention" and "disinterested contemplation." But the concept was the same. Speaking of Archibald Alison, who wrote late in the eighteenth century, Stolnitz says that "The governing idea remains, as it was in the predecessors, attending to an object with no interest other than that in perceiving itself."[12]

Hearing that the concept of disinterested contemplation first emerged into daylight in the eighteenth century, the attentive reader will naturally wonder whether the emergence of this concept had anything to do with the

emergence of our modern concept of the fine arts. For that too, as we saw in Part One, first emerged in the eighteenth century from the chrysalis in which it had been readying itself. The answer is that these two historical events were indeed related. Our concept of the fine arts is parasitic on the concept of disinterested contemplation.

Earlier I appealed to what all of us would regard as paradigm examples of the major fine arts. But I made no attempt to explain the concept of a fine art. I simply used the concept. With the concept of disinterested contemplation in hand, an explanation can now be given. For the purposes of the explanation I shall presuppose that the reader has in mind the concept of *an art*, be it a useful art, a fine art, or whatever. I shall here make no attempt to explain that concept, other than to remark that an art is a skill, a craft, a competence at making. My suggestion, then, is that an art is a *fine* art in a given society *if in that society products of that art are regularly (though not necessarily exclusively)* produced or distributed with disinterested contemplation as one of the primary intended public uses.

By this criterion music proves to be a fine art in our society. For products of music are regularly produced and distributed in our society with disinterested contemplation as one of their primary intended public uses. Also novelistic fiction is a fine art in our society. And by this criterion it too proves to be that. Products of novelistic fiction are regularly produced or distributed in our society with contemplation for its own sake as one of their primary intended public uses. On the other hand, philosophy is not a fine art in our society. And by this criterion it proves not to be that. For though perhaps there are some works of philosophy which reward contemplation for its own sake, works of philosophy are seldom if ever produced with such contemplation as one of their primary intended uses. Philosophy is for increased insight.*

Thus it is far from accidental that the concept of a fine art emerged at the same time as the concept of disinterested contemplation. Some of the eighteenth-century writers were themselves aware of the connection. Says Stolnitz:

> Alison does not use the locution "fine art," but he treats together all of the arts which are now classified in this way, i.e., literature, music, and painting, sculpture and architecture. This is a staple of modern aesthetics but, in Alison, it occurs almost for the first time in Western thought. A "statue, picture, description, or sound" are brought together because they all have common

*The definition of "work of art" which I am using in this book is that of *a product of one of the (major) fine arts in our society.* I think that the definition which many of the members of our institution of high art now work with is, instead, that of *an object presented (or intended to be presented) to the public for disinterested contemplation.* It is the actual or intended presentation for that purpose that makes things works of art. On this definition, objects which can scarcely be viewed as products of any of the major fine arts—certain "ready-mades," for example—may yet be works of art.

effects upon the imagination. Therefore the modern notion that art is "fine" when it is addressed to aesthetic perception is also prefigured in Alison. (Among the later British aestheticians, Burke speaks of "the works of imagination and the elegant arts"; Kames says that "The fine arts are intended to entertain us, by making pleasant impressions; and, by that circumstance, are distinguished from the useful arts"; and Alison says of "the Fine Arts" that "The object of these arts is to produce the emotions of taste.")[13]

I suggested earlier that architecture was a borderline example of a fine art in our society, in that some people would be inclined to regard it as a paradigm example of a fine art and others would not be inclined so to regard it. If the explanation I have offered of a fine art is correct, we can readily explain why there are these conflicting inclinations. Buildings are not regularly produced (though they are sometimes preserved) in our society with disinterested contemplation as a primary intended use. They are in general much too expensive to be produced for that purpose. So by the criterion offered, architecture is not a fine art in our society. But on the other hand, architecture *is* regularly produced in our society for, *among other* intended public uses, disinterested contemplation. And this explains our feeling that architecture, though perhaps not a fine art in our society, is closely related to the fine arts.

When the concept of fine art is understood as suggested, we can also understand our somewhat ambivalent feelings about such "crafts" as hand-weaving and handmade ceramics. In the past, hand-weavings and handmade pots were normally produced with primarily "utilitarian" uses in mind. But more and more it is the case that weavers and ceramicists are producing their works with disinterested contemplation as one of the primary intended public uses. Their weavings are not to be worn or placed under foot but to be hung on walls for delight in contemplation. And their pots are not to hold liquids but to be placed on pedestals for satisfaction in looking. In so far as weavings and ceramics are more and more regularly produced with disinterested contemplation as a primary intended public use, these crafts are moving in the direction of becoming fine arts.

It should be noticed that on the definition I have offered of "fine art," an art is a *fine* art only relative to a particular society. An art which is a fine art in one society may not even occur in another. Or it may occur but not be a fine art there. In our society music, painting, drama, sculpture, fiction, and poetry are all clearly fine arts. In other societies the list would be different. And perhaps in some societies there are no arts whatsoever which are fine arts in that society (even though the phenomena which are fine arts in our society all occur there). For perhaps in some societies there are no arts, products of which in that society are regularly produced or distributed with disinterested contemplation as one of their primary intended public uses. Perhaps some primitive societies are like that.[14]

Almost certainly, however, there is no society totally devoid of satisfaction in contemplation. I think it even unlikely that there is any society

in which the *intent* to produce something satisfying as an object of disinterested contemplation is completely missing. And if indeed there is no such society, then the difference between us and the primitive lies only in the fact that in our society, unlike his, there are arts the products of which we *regularly* produce for disinterested contemplation as a *primary* intended public use. What he practices without highlighting, we bring to center stage. And whereas his use of artifacts as objects of disinterested contemplation is tightly bound up with other actual and intended uses and almost always subordinate, we pull it loose from the others and give it prominence.

9. THE AESTHETIC

Many writers on the arts would bring our discussion on the aesthetic to a halt at this point and say that contemplation of a work of art for its own sake, or more specifically, for the sake of the satisfaction to be found in the contemplating, is *aesthetic* contemplation, the satisfaction itself being *aesthetic satisfaction*. They would identify aesthetic contemplation with disinterested contemplation. From various remarks of his that I have quoted, it can be gathered that Stolnitz is such a writer.

This identification seems to me not quite an accurate account of what most people in practice mean by "aesthetic." Suppose I find satisfaction in reading *The Brothers Karamazov*, and that in particular what I like about it is the remarkable way in which the story reflects our human condition. It is easy to misconstrue this situation and to think that I have then been reading for the purpose of gaining insight into our human condition. But this may not be so. I may already have that insight. My reading is thus for its own sake. Yet hardly anyone would regard this as a case of aesthetic contemplation, the reason being that the ground of my satisfaction in reading the story, namely, its truth to actuality, is not an aesthetic aspect of it.

Or suppose that I find satisfaction in contemplating a work of visual art by some friend of mine, and that in particular what gives me satisfaction is that the work is so fine an expression of my friend's artistic convictions. That too would not be regarded as a case of aesthetic contemplation, again for the reason that the work's being an expression of its maker's convictions is not an aesthetic aspect of it. Yet my contemplation is disinterested. I do not look at the painting in order to discover my friend's convictions, for presumably I already know them. Coming with that knowledge, I now enjoy seeing the painting because his convictions are so well embodied there.

Often the satisfaction that we experience in contemplating works of art is grounded in our apprehension of the work's truth to actuality, or in its being an expression of the personality of the artist, or in its fine craftsmanship. But such contemplation and such satisfaction would seldom be called aesthetic. Fully to explain aesthetic contemplation and satisfaction we must pick out the aesthetic aspects of things from the others—the aesthetic dimension of

actuality from its many other dimensions. Doing this does not prove easy.

Begin by noticing that whenever we look at something, it, conversely, looks a certain way to us. And depending on how much standard terminology is available and how gifted we are with words, we can describe with more or less accuracy *how* it looks. It looks red, shimmery, and so forth. So too whenever we listen to something, it, conversely, sounds a certain way to us—and with greater or less aptness we can describe *how* it sounds. Even when we just *read* a poem instead of hearing it read aloud, we can describe how it sounds (strictly, how it *would* sound).

So suppose that some evening the song of the mourning dove sitting on the wire outside my room sounds melancholy to me. Suppose further that I enjoy listening to the song for its own sake, and that it is especially its melancholiness that gives me delight. In such a case I am getting enjoyment out of *how the song sounds*. And that makes it aesthetic enjoyment. In general it can be said that if in contemplating something for its own sake we get enjoyment out of how it looks or sounds, then we have *aesthetic satisfaction*. (We will see shortly that the converse cannot be affirmed.)

But we must tread very carefully here lest we shortly find ourselves on a wrong track. For when asked to describe how something looks to us we often substitute a statement of what it looks *as if it is really like* for a description of how it looks. Suppose for example that some blue object is seen by me through a yellow glass which I know to be a yellow glass, and that I know a bit about the result of looking at things through colored glass. Asked then to describe how it looks I might say, "It looks as if it's blue." But in fact *green* is how it looks, though it's true that it looks *as if* it's blue. An object may look as if it's blue when how it looks is green; it may look as if it's tall and square when how it looks is small and round. Or take another example: Suppose I am thoroughly versed in the history of Western painting and well experienced in what those paintings look like whose pigment is suspended in tempera. I know what the characteristic "tempera-ish" look is. Then when looking at one of Jan van Eyck's tempera paintings and asked to describe how it looks I might reply, "It looks as if the pigment is suspended in tempera." But the truth is that on a certain occasion it may look *as if* the pigment is suspended in tempera without "tempera-ish" being how it looks. Something may look *as if* it's made of wood without on that occasion having a "woody" look; and conversely a piece of formica-covered furniture may look "woody" but not look as if it's made of wood.

When I said that satisfaction gotten from how something looks or sounds is aesthetic satisfaction I meant to exclude satisfaction gotten from what a thing looks or sounds *as if it really is*. I meant to include just *how* it looks or sounds in the strict sense.

Now we are all aware that it is one thing for an object on a certain occasion to look or sound a certain way to a certain person, and quite another thing for the object to actually be that way. It may look blue to someone sometime and

not be blue. The relevance of this observation here is this: We do not confine ourselves to referring to some feature of *how an object looked or sounded to us on a given occasion* in specifying what it is that gave us enjoyment in contemplation of it. Instead we often refer to some feature of *how the object is*. We speak of *the painting's* taut tension of line as what gave us enjoyment when we looked at it—we do not confine ourselves to saying that we got enjoyment out of its *looking* tautly tense of line to us on a certain occasion.

Now if what grounds one's delight in contemplating some painting is its taut tension of line, *that*, I would say, is aesthetic delight. For the painting's actually being tautly tense of line is an aesthetic aspect of it. Accordingly, fully to explain the aesthetic we must move beyond speaking of how things look and sound to specific persons on specific occasions to the aesthetic qualities and aspects of the things themselves.

And yet, we must not simply part ways from the looks and sounds of things. For the aesthetic, as I conceive it, though it does indeed go beyond looks and sounds (as we shall eventually see), is nonetheless *grounded* in looks and sounds. I suggest, then, that to get at the aesthetic aspects of things themselves we make reference to certain *preferred* looks of those things. If each thing had just one look or just one sound, then without further ado we could show in just what way the aesthetic aspects of things are to be read off from how they look or sound. But most emphatically that is not the case. An object looks or sounds an indefinite number of different ways to different people under different conditions. Thus our first step must be to pick out the preferred looks and sounds.

Notice in the first place that when an object is made or presented to us for a certain purpose, the maker or presenter has in mind certain ways in which the object is to be handled or treated if the purpose is to be achieved. When pills are made and sold to us for putting us asleep, the assumption is that we will swallow them; otherwise the purpose will not be achieved. When a shovel is sold to us for digging up the garden, the assumption is that we will use it in a certain fairly obvious way; otherwise its purpose will not be achieved.

So too with objects made or presented to us for satisfaction in contemplation. The maker or presenter has in mind certain ways in which that contemplation must be conducted for the purpose to be achieved. For one thing, he has in mind that it be practiced by observers who are *qualified* in ways appropriate to that work. And secondly, he has in mind that it be practiced under *conditions* appropriate to that work. When Cézanne presented his paintings to the public for their satisfaction in contemplation, he had in mind that people whose visual apparatus was in normal condition and who knew certain things about the recent history of Western art would look at them under good but not dazzling light, at roughly eye level, from a distance of six feet or so, with the painted surface showing, and so forth.

The qualifications of observers and the range of conditions that makers and presenters of works of art assume are usually so normal or obvious that we

never notice the assumptions. Without realizing that we are doing so, we all take for granted that the range of conditions appropriate for viewing a painting does not include looking at it with its painted surface to the wall! It is the eccentric assumptions that first alert us. Some eighteenth-century painters were fond of anamorphic paintings—paintings that must be viewed under extraordinary conditions if one is to discern what is represented. Some must be viewed in curved mirrors, some at extremely acute angles almost against one's eye, etc. Such paintings alert us to the fact that always there is a range of conditions appropriate to a work's being contemplated in the way intended, along with certain appropriate qualifications in the observers.

Let me now for the sake of convenience introduce a bit of terminology. When someone contemplates a work of art on some occasion, let me say that the work then *presents* itself to him. Beethoven's String Quartet, Opus 132 presents itself to me when I listen to it. And secondly, when someone possesses the qualifications appropriate for contemplating a work in the way intended, and when in addition he contemplates it under the circumstances appropriate to that work, let me say that the work then *presents* itself to him *canonically*.

And now for my thesis: If a work cannot present itself to someone canonically without looking or sounding so-and-so, which we will designate with the symbol φ, then φ-*ness* is one of its *aesthetic qualities*. (And the work may be said to aesthetically possess φ-*ness*.) For example, if a Raphael painting cannot present itself canonically to someone without looking tranquil, then tranquility is one of its aesthetic qualities. Correspondingly, where φ-*ness* is one of a thing's aesthetic qualities, the *fact* that it looks φ may be called *an aesthetic aspect* of the thing. Thus the aesthetic qualities and aesthetic aspects of perceptible objects are to be read off from how they look or sound when presenting themselves canonically. Let us also say that the totality of a thing's aesthetic aspects is its *aesthetic character;* and that the totality of all the aesthetic aspects of things is the *aesthetic dimension* of reality.

It is of prime importance to notice that some property φ-*ness* may be such that a thing may aesthetically possess φ-*ness* without that property being one of those that the thing has or exemplifies or possesses as such. This can be seen by adapting an example from the English philosopher R.G. Collingwood. Collingwood observes that by virtue of the physical facts of sound-production in pianos, the sounds of a piano begin to fade away as soon as they have been initiated. There are no sustained legato passages. They all proceed in saw-tooth motion. If one wishes to do so one can concentrate on this feature of the sounds in listening to some piano performance. But if one did so, one would certainly not be listening to it in the way appropriate to that music. In canonical presentations the sounds do not all begin fading as soon as initiated. We overlook this feature of them, do not even hear it, the result being that often the property that a certain passage aesthetically possesses is that of *being*

sustained in sound, though indeed that is not a property that the sounds possess as such. Another example of this very same point—that a work of art may look or sound ф when presenting itself canonically without actually being ф—may be taken from the Polish aesthetician Roman Ingarden:

> Those of us who have been in Paris and have looked at the piece of marble called the "Venus of Milo" know this piece to have various properties which, far from coming into account in an aesthetic experience, obviously hinder its accomplishment, in consequence of which we are inclined to *overlook* them, e.g., a dark stain on the nose of Venus, which impedes an aesthetic perception of its shape, or various rough spots, cavities, and holes in the breast, corroded probably by water, etc. In an aesthetic experience we overlook these particular qualities of the stone. . . .[15]

What is also worth observing is that many of the words we predicate of works of art are true of those works only if they look or sound a certain way under canonical presentation. The phrase "is well organized" is true of a work of art only if in canonical presentations to someone it looks or sounds well organized. "Is full of taut tension" is true of a work of art only if in canonical presentations it looks or sounds full of taut tension. And so forth, for very many other examples. In this pattern there is a close analogy to color words: "Is red" is true of an object just in case it looks red to a "normal" observer under "normal" conditions.

I have said what it is for a property to be an aesthetic quality of some particular thing. I have not said which properties are to be accounted as aesthetic qualities *as such.* But that is now easily come by. If it is possible for a property ф-*ness* to be an aesthetic quality of something or other, on the explanation already offered, then ф-*ness* is an aesthetic quality, as such.[16]

My strategy has been to suggest that the aesthetic qualities and aspects of things are to be read off from their canonical presentations; and the canonical presentations, I have said, are to be determined by reference to how the object sounds or looks when contemplated in the way intended by maker or distributor. But what if these intentions diverge? What if the maker intended that we should contemplate the work in one way and the distributor in another?

Well, as I have explained canonical presentation, this is a *preferred* presentation—preferred *relative to* certain intentions. In the straightforward case, these are the intentions of maker and distributor concerning the appropriate use of the object. But in cases of divergent intentions, a presentation which is canonical relative to one person's intentions will not be canonical relative to another's. In such cases we must simply distinguish. The aesthetic qualities of the object relative to one person's intentions concerning appropriate use are to be distinguished from those properties which are the object's aesthetic qualities relative to another person's intentions. Having distinguished, we will have to leave the matter there. Or alternatively, we

could use some additional ground for preference among the appearances of the object—for example, we could prefer one of these conflicting appearances to another on the ground that it is more aesthetically rewarding.

There is a long history of dispute among aestheticians as to whether aesthetic delight is confined to the perceptible. Is aesthetic contemplation a *species* of perceptual contemplation or is it not? Can the contemplation of a mathematical proof yield aesthetic satisfaction or not? Often it is hard to see in these disputes any issue of substance; they seem wholly linguistic. But what can appropriately be observed is that many of those properties which are aesthetic qualities, by the explanation offered, can be properties of such nonperceptible entities as stories and proofs. Stories and proofs can be dramatic, awkward, coherent, elegant, convoluted, and so forth. Accordingly I shall say that if some nonperceptible entity has one of the properties which, by the explanation offered, is an aesthetic quality, that property is an aesthetic quality of that nonperceptible entity. Correspondingly, the fact that the thing has that property will be said to be one of its *aesthetic aspects;* and the totality of a nonperceptible thing's aesthetic aspects will be said to be its *aesthetic character*. It follows, I think, that *being coherent* may well be an aesthetic quality of some story,* whereas *being true to reality* will not be an aesthetic quality of a story or of anything else; for things do not and cannot *sound* or *look* true to reality. It is never a feature of how a buzzing sound sounds that it sounds true to reality.

Lastly, if in contemplating some nonperceptible entity for its own sake one gets satisfaction in contemplation, this satisfaction being grounded in something in the aesthetic character of the entity, we shall call that form of satisfaction *aesthetic satisfaction*. Thus aesthetic satisfaction comes in two forms. It is the satisfaction one experiences in (perceptually) contemplating some nonperceptible entity for its own sake, when the satisfaction is grounded in how the thing looks or sounds; or it is the satisfaction one experiences in (nonperceptually) contemplating some nonperceptible entity for its own sake, when the satisfaction is grounded in the aesthetic character of the entity. And when contemplation of an object is undertaken for its own sake in the expectation that aesthetic satisfaction will be achieved, we shall call it *aesthetic contemplation*.

I have isolated the aesthetic qualities of a work of art by appealing to the conditions and qualifications appropriate to contemplating the object in the manner intended by artist or distributor. But of course there are no such conditions and qualifications in the case of natural objects, since no maker or distributor presents them to us for contemplation in a certain way. Yet do not bird songs and eucalyptus seed pots have aesthetic qualities?

Yes certainly. Suppose that in the case of some object not made or

*However, *being coherent by virtue of consistent character development, being coherent by virtue of a single sustained point of view*, etc., are not aesthetic qualities; for they never belong to how a perceptible thing sounds or looks.

presented for contemplation there are what might be regarded as *standard* conditions for contemplating, these determined by reference to the normal human interests which govern our commerce with that object. The aesthetic qualities of such an object are then the qualities constituting how it looks or sounds when contemplated under standard conditions by a normal percipient. To determine the aesthetic qualities of an automobile one does not crawl underneath and look at it from the underside.

Very roughly speaking, I have explained *the aesthetic* by reference to the looks and sounds of things. I am thereby following one important strand in the tradition.* But the tradition also contains quite a different way of going about explaining the aesthetic. Sometimes the aesthetic qualities of an entity are regarded as those qualities which it has by virtue of how its own parts are related to each other rather than by virtue of how the entity is related to things outside itself. The main difficulty in this line of approach lies in the extreme haziness of the idea of a part of a work of art. Take the property of a Van Eyck painting of *having its pigment suspended in tempera*. No one would regard this as an aesthetic quality of the painting. So the question becomes whether the painting's having this property consists in its bearing a relation to something outside itself. That certainly is not very clear. To have this property, Van Eyck's painting must bear a certain relation to tempera. Is tempera outside the painting or not? I think it best not even to enter this morass of problems. But I also think it is clear that all those properties the having of which consists in bearing some relation to something unmistakably outside the work of art turn out not to be aesthetic qualities on our definition, so that the goal of this alternative line of thought is achieved, though indirectly. *Being painted by Rembrandt, evoking emotions in me, causing moral deterioration in the public*—none of these is an aesthetic quality.

10. INSCAPE

Some readers will have found the preceding explanation of the aesthetic dizzying. For their benefit and relief let me observe that what Gerard Manley Hopkins spoke of so vividly and feelingly as the *inscapes* of things is precisely what I call the *aesthetic character* of things—provided just that the character be *distinctive*. Let me string together a number of quotations from Hopkins:

> One day early in March when long streamers were rising from over Kemble End one large flake loop-shaped, not a streamer but belonging to the string, moving too slowly to be seen, seemed to cap and fill the zenith with a white shire of cloud. I looked long up at it till the tall height and the beauty of the scaping—regularly curled knots springing if I remember from fine stems, like

*However, those who work in this strand have usually held that the bearers of aesthetic qualities are not objective entities like lumps of bronze and patterns of sound, but *mental entities* of one sort and another. I have assiduously avoided going down that trail.

foliation in wood or stone—had strongly grown on me. It changed beautiful changes, growing more into ribs and one stretch of running into branching like coral. Unless you refresh the mind from time to time you cannot always remember or believe how deep the inscape in things is.

This is the time to study inscape in the spraying of trees, for the swelling buds carry them to a pitch which the eye could not else gather—for out of much much more, out of little not much, out of nothing nothing: in these sprays at all events there is a new world of inscape.

The sharp nape of a drift is sometimes broken by slant flutes or channels. I think this must be when the wind after shaping the drift first has changed and cast waves in the body of the wave itself. All the world is full of inscape and chance left free to act falls into an order as well as purpose: looking out of my window I caught it in the random clods and broken heaps of snow made by the cast of a broom.

The ashtree growing in the corner of the garden was felled. It was lopped first: I heard the sound and looking out and seeing it maimed there came at that moment a great pang and I wished to die and not to see the inscapes of the world destroyed any more.

Stepped into a barn of ours, a great shadowy barn, where the hay had been stacked on either side, and looking at the great rudely arched timberframes—principals (?) and tie-beams, which make them look like bold big As with the cross-bar high up—I thought how sadly beauty of inscape was unknown and buried away from simple people and yet how near at hand it was if they had eyes to see it and it could be called out everywhere again.

No doubt my poetry errs on the side of oddness. I hope in time to have a more balanced and Miltonic style. But as air, melody is what strikes me most of all in music and design in painting, so design, pattern or what I am in the habit of calling 'inscape' is what I above all aim at in poetry. Now it is the virtue of design, pattern, or inscape to be distinctive and it is the vice of distinctiveness to become queer. This vice I cannot have escaped.

. . . he [Sir Samuel Ferguson, promoter of Yeats] was a poet as the Irish are—to judge by the little of his I have seen—full of feeling, high thoughts, flow of verse, point, often fine imagery and other virtues, but the essential and only lasting thing left out—what I call *inscape*, that is species or individually-distinctive beauty of style. . . .[17]

11. STYLISTIC DIVERSITY

I have suggested that it is the centrality of aesthetic contemplation, among the various purposes for engaging in perceptual contemplation, that accounts for such features in our institution of high art as the rise of galleries and concert halls and the immensity of repertoire available to us—a centrality evidenced by the fact that if we become persuaded of the aesthetic inferiority of some artifact it disappears from, or never enters, the repertoire. But one last feature must be noted to complete the explanation.

Necessary in addition to what I have noted is that the public be willing to

acknowledge aesthetic excellence as coming in a diversity of styles. As long as critics and public judged sculpture by the degree of its approach to ideal specimens in the style of the classical Greeks, it was impossible that anything like our present museums should arise. And as long as critics and public saw music as on a single-file march forward, judging everything by reference to ideal specimens in the most recent style, anything like our concert halls and record stores was impossible. A crucial factor in shaping our institution of high art is thus the demise of the habit of making aesthetic judgments by referring to some ideal examples within some paradigm style, and the replacement of that habit with the conviction that within each style aesthetic excellence is attainable. As long as Praxiteles functioned as the ideal, primitive masks had no chance whatsoever of entering our art museums.

This change in critical habits took place during the nineteenth century, and is nicely described by Malraux. It will be worth quoting a bit of what he says:

> From the sixteenth to the nineteenth century the masterpiece was a work that existed "in itself," an absolute. There was an accepted canon preconizing a mythical yet fairly well-defined beauty, based on what was thought to be the legacy of Greece. The work of art constantly aspired towards an ideal portrayal; thus, for Raphael, a masterpiece was a work on which the imagination could not possibly improve. . . .
>
> The revision of values that began in the nineteenth century and the end of all *a priori* theories of aesthetics did away with the prejudice against so-called clumsiness. That disdain for Gothic art which prevailed in the seventeenth century was due, not to any authentic conflict of values, but to the fact that the Gothic statue was regarded at that time, not as what it really is, but as a botched attempt to be something quite different. Starting from the false premise that the Gothic sculptor aimed at making a classical statue, critics of those days concluded that, if he failed to do so, it was because he could not.[18]

12. MYSTICISM AND THE RELIGION OF THE AESTHETIC

I have described disinterested contemplation of an object as contemplation undertaken for its own sake—or more specifically, as contemplation undertaken for the satisfaction to be found in the contemplating. Thus I have described it by emphasizing how it fits into the structure of human action. But disinterested contemplation requires, by its very nature, that one focus one's attention on the object. And often this feature of the situation is instead picked out for emphasis. Disinterested contemplation is said to be object-centered contemplation. And the criticism appropriate to such contemplation is often described as criticism in which the work itself is "the central concern of criticism"—criticism in which the "critic is concerned primarily with the work itself."[19] This way of describing the situation was already expressed in the eighteenth century. Stolnitz quotes Archibald Alison as saying, "That state of

mind . . . is most favorable to the emotions of taste . . . in which the attention
is so little occupied by any private or particular object of thought, as to leave us
open to all the impressions, which the objects that are before us can
produce."[20] When aesthetic contemplation is described along such lines, the
emphasis is on the lure of the object rather than on the structure of the action.*

Given this way of looking at the situation, one can see why, over and over
again in contemporary writing on the arts, the image occurs of leaving behind
the actual world and entering the world of the object. Watch, for example,
how the critic A. C. Bradley moves from abolition of ulterior ends to
submission to the object:

> The consideration of ulterior ends, whether by the poet in the act of composing or
> by the reader in the act of experiencing, tends to lower poetic value. It does so
> because it tends to change the nature of poetry by taking it out of its own
> atmosphere. For its nature is to be not a part, nor yet a copy, of the real world (as
> we commonly understand that phrase), but to be a world by itself, independent,
> completely autonomous; and to possess it fully you must enter the world, conform
> to its laws, and ignore for the time the beliefs, aims, and particular conditions
> which belong to you in the other world of reality.[21]

Corresponding to this emphasis on submission to the object is one sense
of the ambiguous phrase "to contemplate an object for its own sake." When I
have used this phrase I have meant by it: to contemplate an object *for the sake
of the contemplating*. Equally, though, it is possible to use it to mean: to
contemplate an object *for the sake of the object*. This seems indeed to have
been what some writers intended. Correspondingly, they have thought that
what was of worth in the situation was not first of all the action of
contemplation but rather the object contemplated. They have spoken of the
object "as an end in itself," thus as something of intrinsic worth; and they have
urged us to treat it accordingly. Some have even spoken of the *rights* of works
of art.[22]

To think of objects as ends in themselves, that is, as things that have
claims on us, is to think of them as if they were persons. It is to think of
aesthetic contemplation as satisfying the claims of objects on our adoration
rather than as the performance of an action of worth. Thus does the autonomist
ideology go over into an oriental-like mysticism. One can see all the dynamics
at work in this passage from Clive Bell:

> Occasionally when an artist—a real artist—looks at objects (the contents of a
> room, for instance) he perceives them as pure forms in certain relations to each
> other, and feels emotion for them as such. These are his moments of inspiration:
> follows the desire to express what has been felt. The emotion that the artist felt in
> his moment of inspiration he did not feel for objects seen as means, but for objects
> seen as pure forms—that is, as ends in themselves. . . .
> Now to see objects as pure forms is to see them as ends in themselves. For

*The footnote on p. 35 should once again be consulted.

though, of course, forms are related to each other as parts of a whole, they are related on terms of equality; they are not a means to anything except emotion. But for objects seen as ends in themselves, do we not feel a profounder and a more thrilling emotion than ever we felt for them as means? All of us, I imagine, do, from time to time, get a vision of material objects as pure forms. We see things as ends in themselves, that is to say: May we go on to say that, having seen it as pure form, having freed it from all casual and adventitious interest, from all that it may have acquired from its commerce with human beings, from all its significance as a means, he has felt its significance as an end in itself?

What is the significance of anything as an end in itself? What is that which is left when we have stripped a thing of all its associations, of all its significance as a means. What is left to provoke our emotion? What but that which philosophers used to call "the thing in itself" and now call "ultimate reality"? . . .

If this suggestion were accepted it would follow that "significant form" was form behind which we catch a sense of ultimate reality.[23]

Even if we restrain ourselves from going along with Bell and seeing in aesthetic contemplation an apprehension of divinity, still there is an inherent similarity, worth noting, between aesthetic and mystical contemplation. The art lover, like the mystic, turns away from ordinary concerns to be caught up in the bliss of contemplation. A friend of mine related to me once his experience of going to the Mauritshuis in The Hague, there for the first time to see Jan Vermeer's *Young Woman in Front of a Window*. He reported being so gripped and moved that he had to sit down. For twenty minutes he could not tear himself away. He was caught up in a rapture of contemplation. Of course the mystic will suspect idolatry when he observes the rapture of the art lover, and the art lover will suspect self-intoxication when he observes the rapture of the mystic. So for all their affinities these two will more often be combatants than friends. Yet theirs is a family feud. When the object is attended to, said Alison, the aesthetic response takes place "spontaneously . . . in a kind of bewitching reverie."[24]

There is another path from aesthetic contemplation to religious veneration than that travelled by Bell, one which has proved far more seductive to man in the modern world. Bell believed that in aesthetic contemplation the object becomes transparent, revealing to us the divinity in all things; and that this religious experience of the divine is of ultimate worth for mankind. Much more common is the secular vision that aesthetic contemplation of works of art is itself of ultimate worth. Works of art are not windows onto a divinity beyond. They are themselves divine. "Art for art's sake's."

The sociologist Max Weber spoke perceptively on the fundamental dynamics of this view in remarking that when "art becomes a cosmos of more and more consciously grasped independent values which exist in their own right," then "art takes over the function of a this-worldly salvation, no matter how this may be interpreted. It provides a *salvation* from the routines of everyday life, and especially from the increasing pressures of theoretical and

practical rationalism."[25] Picasso expresses pungently what Weber had in
mind: "I'm no pessimist, I don't loathe art, because I couldn't live without
devoting all my time to it. I love it as the only end of my life."[26]

Thus works of art become surrogate gods, taking the place of God the
Creator; aesthetic contemplation takes the place of religious adoration; and
the artist becomes one who in agony of creation brings forth objects in
absorbed contemplation of which we experience what is of ultimate
significance in human life. The artist becomes the maker of the gods, we their
worshippers. When the secular religions of political revolution and of
technological aggrandizement fail their devotees, when they threaten to
devour them, then over and over the cultural elite among modern secular
Western men turn to the religion of aestheticism.[27]

> The gestures we make when holding pictures we admire (not only masterpieces)
> are those befitting precious objects: but also, let us not forget, objects claiming
> veneration. Once a mere collection, the art museum is by way of becoming a sort
> of shrine, the only one of the modern age; the man who looks at an *Annunciation*
> in the National Gallery of Washington is moved by it no less profoundly than the
> man who sees it in an Italian church. True, a Braque still life is not a sacred object;
> nevertheless, though not a Byzantine miniature, it, too, belongs to another world
> and it is hallowed by its association with a vague deity known as Art, as the
> miniature was hallowed by its association with Christ Pantocrator.
>
> In this context the religious vocabulary may jar on us; but unhappily we have no
> other. Though this art is not a god, but an absolute, it has, like a god, its fanatics
> and its martyrs and is far from being an abstraction. . . .
>
> From the Romantic period onward art became more and more the object of a
> cult; the indignation felt at Jan Van Eyck's having been employed to design stucco
> decorations came from a feeling that this was nothing short of sacrilege. . . .[28]

13. ARTISTIC CREATION

Scrutinizing our institution of high art from the perspective of the public use
intended for works of high art, we have seen that there is among us a body of
thought and action surrounding our central commitment to having works of art
available as objects of perceptual contemplation. To complete the picture we
must now observe that there is also present among us a body of thought and
action oriented around a characteristic and idiosyncratic understanding of the
nature of artistic creation.

These two complexes of thought and action—that oriented around the
intended *use* of art and that oriented around the *creation* of art—exist in
uneasy tension with each other. Normally the artist produces and publishes
his art with the intent that it be used for contemplation. That remains central
and decisive. Yet our characteristic way of thinking about the nature of artistic
creation makes the artist uneasy with that fact, makes him regard it as a deep
irrelevance to his aims as an artist—even an interference—relevant only to the
hard fact that he must earn a living.

A passage in a letter of Paul Gauguin, dated 1888, goes as follows: "Some advice: do not paint too much after nature. Art is an abstraction; derive this abstraction from nature while dreaming before it, and think more of the creation which will result than of nature. Creating like unto our Divine Master is the only way of rising toward God."

Until recently I had read that passage as an expression on Gauguin's part of anti-realism—"do not paint too much after nature"—and of aesthetic mysticism—"rising toward God." Those elements are indeed present. But Gauguin is here expressing something of more profound significance than either of those, something which explains those. He is expressing the conviction that the artist is a creator like unto God. And what I wish now to suggest is that this image of the artist as one who vaults the heavens is far from peculiar to Gauguin. On the contrary, it is our most pervasive image of the artist, at the root of much of the thought and practice that takes place within our institution of high art. It was apparently in the late fifteenth century that the artist was first compared to God the Creator, by Christoforo Landino in his discussion of the poet.[29] Before that, the analogy was always explicitly resisted as impious. Now it is commonplace.

How does our Divine Master create? Or better, how does Western man understand Him as creating? We can best get hold of the essentials if we first turn, by way of contrast, to Plato's understanding. In the *Timaeus* Plato suggested that our spatio-temporal world came into being when some god, confronted on the one hand by space and on the other by the realm of eternal Forms, did his best to produce in space accurate instances of the Forms. He failed, and his failure was inevitable. For to be spatial and temporal is to be inherently imperfect, and so to be capable of nothing more than blurred mirroring of the Forms. Creation, on Plato's view, cannot be other than a noble failure.

St. Augustine rightly saw this understanding of the creating god as alien to the Christian scriptures. He located the decisive error in Plato's conviction that the creating god was limited by the preexistent material of space and obligated by the preexistent Forms. God creates *ex nihilo*, said Augustine. And though He creates according to patterns, those patterns are not obligating ideals existing apart from Him. They are ideas in His own mind. God creates in sovereign freedom.

In His essence God is love. And as the expression of His own self, God creates from nothing our whole array of things in space and time. Created in accord with God's own ideas, these things are not pale copies of eternal paradigms but full-bodied realities in their own right. They are creations. They do not have their existence independent of God; yet they are not identical with God. One who gives free, untrammelled expression to His inner self by bringing into existence new realities—that is Augustine's image of God the Creator. Ever since Augustine, it has been the image of Western man as well.

I suggest that it is this image to which Gauguin was alluding when he spoke of the artist as creating like unto our Divine Master. And this image, I want to suggest, is the fundamental understanding of the artist held by Western man for some two centuries now, and which lies deep within our institution of high art.

The artist is a center of consciousness. His business is to bring forth an expression of himself in the form of a new creation. In distinction from God, however, that requires struggle. God creates in sovereign, untrammelled freedom. But confronting the artist is an actuality which exists apart from his will, threatening him with constriction: the constricting actuality of aesthetic norms, the constricting actuality of artistic and social traditions, the constricting actuality of the institution of high art itself, the constricting actuality of materials, the constricting actuality of the fact that unless the artist finds acceptance for his work he cannot live. Thus the obverse side of his urge to create is the artist's need to fight for liberation from the prime evil of constrictions on his freedom. We in the West are confident that the struggle for liberation can be won. We are confident that actuality will prove permeable by the will of the artist.

This struggle to create in freedom must ever be renewed. Each artist must do it over again. Each must begin at the beginning. For no two centers of consciousness are alike. Each must free himself from the residue of his predecessor's efforts. Each must pursue novelty, originality, innovation. Thus it is that art is endlessly in motion, led forward on the trek by the great souls who are the avant-garde, always forsaking home, never arriving at the promised land. For the trek is the Promise.

This sounds like an extravagantly speculative interpretation. Naturally some of our artists hold none of it, some hold but part of it, perhaps none consciously holds all of it. But with an assemblage of quotations I shall confirm that its various parts have indeed entered into our Western image of the artist. I shall deal mainly with visual art; but similar points could be made with citations from workers in the other arts. Within visual art I shall try to cite as wide a representation as possible, acknowledging that some schools are more attracted to one facet of the image, others, to another.

Begin with the idea of the individual human consciousness as center of the universe. I quote from Oskar Kokoschka:

> The life of the consciousness is boundless. It interpenetrates the world and is woven through all its imagery. . . . Therefore we must harken closely to our inner voice. We must strive through the penumbra of words to the core within. "The Word became flesh and dwelt among us." And the inner core breaks free—now freely and now violently—from the words within which it dwells like a charm. . . . Consciousness is the source of all things and of all conceptions. It is a sea ringed about with visions.[30]

And here are the cubists Gleizes and Metzinger: "There is nothing real

outside ourselves; there is nothing real except the coincidence of a sensation and an individual mental tendency."[31]

Artistic creation is understood then as having two faces, on analogy with God's creation. When we look at its one face, we see it as an expression of a center of consciousness. When we look at its other face, we see it as the bringing forth of a new thing. Begin with the former.

"The encompassing, creative mind," says Hans Hofman, "recognizes no boundaries. The mind has ever brought new spheres under its control. All our experiences culminate in the perception of the universe as a whole with man at its center."[32] Explicitly drawing the analogy to God the creator, Paul Klee says, "Art is a simile of the Creation. Each work of art is an example, just as the terrestrial is an example of the cosmic."[33] And Picasso adds, "The important thing is to create. Nothing else matters; creation is all."[34] But the classic passage comes from Barnett Newman:

> The earliest written history of human desires proves that the meaning of the world cannot be found in the social act. An examination of the first chapter of Genesis offers a better key to the human dream. It was inconceivable to the archaic writer that original man, that Adam, was put on earth to be a toiler, to be a social animal. The writer's creative impulses told him that man's origin was that of an artist and he set him up in a Garden of Eden close to the Tree of Knowledge, of right and wrong, in the highest sense of divine revelation. The fall of man was understood by the writer and his audience not as a fall from Utopia to struggle, as the sociologicians would have it, nor, as the religionists would have us believe, as a fall from Grace to Sin, but rather that Adam, by eating from the Tree of Knowledge, sought the creative life, to be, like God, "a creator of worlds," to use Rashi's phrase, and was reduced to the life of toil only as a result of a jealous punishment.
>
> In our inability to live the life of a creator can be found the meaning of the fall of man. It was a fall from the good, rather than from the abundant, life. And it is precisely here that the artist today is striving for a closer approach to the truth concerning original man than can be claimed by the paleontologist, for it is the poet and the artist who are concerned with the function of original man and who are trying to arrive at his creative state. What is the *raison d'etre,* what is the explanation of the seemingly insane drive of man to be painter and poet if it is not an act of defiance against man's fall and an assertion that he return to the Adam of the Garden of Eden? For the artists are the first men.[35]

That is one pole: Art is an expression of self on analogy to the creative self-expression of God the Creator. The other pole is the insistence that the work of art is first of all not an imitation of nature, nor a bearer of a message, but a new reality. There is in modern art a "horror of the object," a horror just as deep as Augustine's horror at the thought of a preexistent reality to which the creating God must accommodate himself.[36] "Art," said Maurice Denis, "is no longer only a visual sensation which we record, only a photograph, however refined it may be, of nature. No, it is a creation of our spirit of which nature is only the occasion."[37] Archibald MacLeish, in a line now tedious

through repetition, remarked that "A poem must not mean but be." And giving voice to the hatred of the world which often underlies this attitude is the saying attributed to Virginia Woolf: "Art is not a copy of the real world. One of the damn things is enough."

Creation thus conceived, as producing an expression of one's unique self-consciousness by bringing forth a new reality, requires in our world a struggle for liberation. For over and over surrounding reality proves to be out of accord with the artist's self. The theme of liberation, of freedom, runs like a sustained pedal point through all modern writing on the arts. In that deep way, modern art is protest art, with high art itself not impervious to the acid of its repudiation.

The struggle for free creation is understood in the first place as requiring liberation from aesthetic norms, outside of, objective to, and impinging on, the artist. Again Barnett Newman: ". . . here in America, some of us, free from the weight of European culture, are finding the answer, by completely denying that art has any concern with the problem of beauty and where to find it."[38] Here is John Ferren: "I remember that around the Club in the late forties the word 'evaluation' was taboo. We looked, and we liked it or did not: we did not give it a value."[39] And finally John Cage: "Value judgments are not in the nature of this work as regards either composition, performance, or listening. . . . 'mistake' is beside the point, for once anything happens it authentically is."[40]

Also required is liberation from artistic traditions, the freedom each time to start over. Again John Ferren: "In this period, if a picture looked like a picture, i.e., something you already knew, it was no good. We tried to make a clean slate, to start painting all over again."[41] From a futurist manifesto: "All forms of imitation must be despised, all forms of originality glorified."[42] And here is Clyfford Still: "I held it imperative to evolve an instrument of thought which would aid in cutting through all cultural opiates, past and present, so that a direct, immediate, and truly free vision could be achieved, and an idea be revealed with clarity."[43]

While existing within the institution of high art, one must declare one's freedom from it as well, by pressing and stretching its limits, by constructing parodies of it, by producing anti-art, by bringing art into life or life into art, or by simply ignoring it. From a futurist manifesto:

> To admire an old picture is to pour our sentiment into a funeral urn instead of hurling it forth in violent gushes of action and productiveness. Will you thus consume your best strength in useless admiration of the past from which you will forcibly come out exhausted, lessened, and trampled? . . . In truth, this daily frequenting of museums, libraries, and academies (those graveyards of vain efforts, those Mount Calvaries of crucified dreams, those registers of broken-down spring! . . .) is to the artist as the too-prolonged government of parents for intelligent young people, inebriated with their talent and ambitious will. . . . Therefore welcome the kindly incendiarists with the carbon fingers.

. . . Here they are. . . . Here. . . . Away and set fire to the bookshelves. . . .
Turn the canals and flood the vaults of museums. . . . Oh! Let the glorious old
pictures float adrift. Seize pickax and hammer. Sap the foundations of the
venerable towns.[44]

Or as Cage puts it:

When we separate music from life what we get is art (a compendium of
masterpieces). With contemporary music, when it is actually contemporary, we
have no time to make that separation (which protects us from living), and so
contemporary music is not so much art as it is life and any one making it no sooner
finishes one of it than he begins making another just as people keep on washing
dishes, brushing their teeth, getting sleepy, and so on.[45]

Likewise one must free oneself from the limitations of materials, by
endlessly inventing new ones, by breaking down the genres, or even by
insisting that the object does not count. What was of importance in the "action
painters," for example, was just the act of creating. Here is how Harold
Rosenberg speaks of it:

The new American painting is not "pure" art, since the extrusion of the object was
not for the sake of the aesthetic. The apples weren't brushed off the table in order
to make room for perfect relations of space and color. They had to go so that
nothing would get in the way of the act of painting. In this gesturing with
materials the aesthetic, too, has been subordinated. Form, color, composition,
drawing, are auxiliaries, anyone of which—or practically all, as has been
attempted logically, with unpainted canvases—can be dispensed with. What
matters always is the revelation contained in the act.[46]

Even more radically, what matters is just the idea, says Duchamp:

I wanted to get away from the physical aspect of painting. I was much more
interested in recreating ideas in painting. For me the title was very important. I
was interested in making painting serve my purposes, and in getting away from
the physicality of painting. For me Courbet has introduced the physical emphasis
in the nineteenth century. I was interested in ideas—not merely in visual
products. I wanted to put painting once again at the service of the mind. And my
painting was, of course, at once regarded as "intellectual," "literary" painting.
. . . [Picabia] had more intelligence than most of our contemporaries. The rest
were either for or against Cézanne. There was no thought of anything beyond the
physical side of painting. No notion of freedom was taught.[47]

Thus far, then, reality is regarded as through and through permeable by
the will of the artist. But there is one harsh exception. The artist must live.
And in our society, if he is to make a living at his art, that implies that he must
somehow induce his public to pay him money for his work. Is this not a
question of an intractable constriction, thus an ineradicable evil? Not entirely.
The artist can make his living at something else—teaching, say. Or he can seek
to influence his audience. He need not passively accept actuality as it is. Like

our capitalist advertisers, he can try to *create* the audience for his product. This, from one of the Futurist manifestoes: "The public must also be convinced that in order to understand aesthetic sensations to which one is not accustomed, it is necessary to forget entirely one's intellectual culture, not in order to *assimilate* the work of art, but to *deliver one's self up* to it heart and soul."[48]

In summary, the basic image of the artist underlying modern Western art is that of the artist as a center of consciousness who challenges God by seeking to create as God creates. Such creation has two sides: it consists of freely producing an expression of the inner self, and it consists of freely bringing into existence a new creation. But for the human being, surrounded by actuality in whose making he had no hand, creation thus conceived always requires the struggle for liberation—unless of course he has first gotten himself in tune with surrounding existence. Otherwise freedom must be attained, achieved. It is the deep faith of modern Western man that such freedom can be achieved. Actuality, albeit with struggle, is permeable by the artist's will—with one exception: if the artist is to live by his art he has no choice but to appeal to the attention of the public.

There appears indeed to be a prominent alternative image held among artists in the modern world—even an opposite image. This is the image of the artist as one who seeks to bring forth works in which there is no trace of his consciousness, works which give chance a chance, works which sound or look as if they were simply of nature. Edgard Varèse, said John Cage, was one of his most significant predecessors. Yet Varèse still lacked the one essential thing: "Rather than dealing with sounds as sounds, he deals with them as Varèse."[49] "Edgard Varèse . . . fathered forth noise into twentieth-century music. But it is clear that ways must be discovered that allow noises and tones to be just noises and tones, not exponents subservient to Varèse's imagination."[50] And speaking of Cage along with others, Ernst Krenek remarks that

> One of the most anti-traditional features common to all of these new endeavors is a tendency toward depersonalization of the act of composing. Whether the composer subjects his creative activity to a set of self-chosen rules preordering every phase of the work-in-progress, or whether he limits his action to registering the results of chance operations that by definition are beyond his control, in any event he does not present any longer the image (established by tradition of long standing) of the sovereign master who under the uplifting power of free inspiration, creates at will new and original musical shapes that will transmit the message of his heart to properly attuned audiences.[51]

Similar views have been expressed in visual art, already early in our century. Witness Hans Arp's program for "concrete art":

> I wanted to find another order, another value for man in nature. He was no longer to be the measure of all things, no longer to reduce everything to his own

measure, but on the contrary, all things and man were to be like nature, without measure.

we do not want to copy nature. we do not want to reproduce, we want to produce. we want to produce like a plant that produces a fruit and not to reproduce. we want to produce directly and not through inspiration.

as there is not the slightest trace of abstraction in this art, we call it: concrete art.

the works of concrete art should not be signed by their creators. These paintings, these sculptures, these objects, should remain anonymous in the great studio of nature, like clouds, mountains, seas, animals. Yes, men should return to nature. . . .[52]

No doubt this anti-humanistic image of the artist is in part a reaction to the dominant image. Yet there is in those who espouse this image a strange self-deception, which shows it to be a variant and not an alternative. If one really wished to let nature take its course with sounds, then one would be content with the birds singing and the janitors making their noises. But that is not what these composers do. They devise elaborate programs for computers, they prepare pianos, they specify just how and where the random noises are to occur. So too, if one really wished to let nature take its course with shapes, one would be content with letting the wind and rain carve the rocks and decay the wood. But that is not the way of these artists. With great care they carve their natural forms and construct their sculptures within whose operation chance is to come into its own. The anti-humanist is a humanist *malgré lui*.

One more note must be sounded. In his passionate pursuit of a creation freed from the trammels of actuality, the artist sees himself as coming in touch with a deeper existence—an existence ever beckoning, never threatening. He sees himself as passing beyond the gulf of alienation and arriving home to a father who asks of him nothing but that he continue his fight for liberation. In this Heraclitean vision heaven is entered by struggle, and he who ceases to struggle once there is forthwith turned out. Creating like unto our Divine Master is our "way of rising toward God." Robert Motherwell puts it well:

If I were asked to generalize about this condition as it has been manifest in poets, painters, and composers during the last century and a half, I should say that it is a fundamentally romantic response to modern life—rebellious, individualistic, unconventional, sensitive, irritable. I should say that this attitude arose from a feeling of being ill at ease in the universe, so to speak—the collapse of religion, of the old close-knit community and family may have something to do with the origins of the feeling. I do not know.

But whatever the source of this sense of being unwedded to the universe, I think that one's art is just one's effort to wed oneself to the universe, to unify oneself through union. . . . If this suggestion is true, then modern art has a different face from the art of the past because it has a somewhat different function for the artist in our time. I suppose that the art of far more ancient and "simple" artists expressed something quite different, a feeling of *already* being at one with the world. . . .

One of the most striking of abstract art's appearances is her nakedness, an art stripped bare. How many rejections on the part of her artists! Whole worlds—the world of objects, the world of power and propaganda, the world of anecdotes, the world of fetishes and ancestor worship. One might almost legitimately receive the impression that abstract artists don't like anything but the act of painting. . . .

Everything that might dilute the experience is stripped away. The origin of abstraction in art is that of any mode of thought. Abstract art is a true mysticism—I dislike the word—or rather a series of mysticisms that grew up in the historical circumstance that all mysticisms do, from a primary sense of gulf, an abyss, a void, between one's lonely self and the world. Abstract art is an effort to close the void that modern men feel. Its abstraction is its emphasis.[53]

What should be added, in conclusion, is that the artist is not unique among us in living by this heaven-storming vision of man as creating like unto our Divine Master, thus "rising toward God." All of us together in the West since the days of the Enlightenment have lived with this vision of man as called to express his inner self by bringing forth a new creation, all the while fighting for liberation from extraneous constrictions as he seeks to impose his consciousness on the actuality surrounding him, persuaded that actuality is through and through permeable by his will, convinced that in thus creating-by-rejecting he attains the ultimate. At most the artist holds our common vision with greater self-consciousness.

We have lived thus in the realm of technology. We have not sought to dwell on earth at peace with our environment, respecting its limitations, but in the boundless confidence that nature is a putty of infinite malleability we have sought without restraint to impose our will upon our environment, so that nowhere do we fail to see our own image as we look about. It has never occurred to us that at some point God's over-weary creation might react and turn upon us the aggressors.

We have lived thus in the realm of politics. We have not lived in the realization of the limits of political reconstruction but instead, in our liberal and radical traditions, have viewed all social problems as amenable to the efforts of governmental planners. It has never occurred to us that at some point the weary social body might collapse, or rise up in anger.

It was in the writings of Hume and Kant that this Promethean vision of man first received its articulate philosophical expression. Kant, remember, was the one who said that we do not derive laws from, but prescribe them to, nature. And Kant it also was who said that we are obliged to obey no laws but those we have given to ourselves. There, already, man was seen as confronted by an actuality wholly permeable, wholly malleable. Ever since, our Western philosophers have rejected the vision of man as dwelling and acting within God's structured world and in its place have promoted the vision of man as maker of his own world.

14. THE INTERIORIZING OF THE ARTIST COMMUNITY

Around the time of the Renaissance a profound and fateful alteration, localized in the West, began to occur in the consciousness of mankind. Normally man has preferred routine. He has expected from his actions certain quite definite results; and he has preferred that his actions have the results expected. But some five centuries ago explorers began to set forth with no very definite expectations as to what they would find beyond the horizon—and precisely *because* they had no very definite expectations. They relished the unexpected. Artists, rather than following in the footsteps of their masters, began to set out on courses of "exploration" with no very definite expectations as to the kind of art they would end up producing—and precisely *because* they had no very definite expectations. They too relished the appearance of what was not expected.

This desire for the innovative, the non-routine, the unexpected, has by now shaped our entire culture. Whatever the scholar may himself think about his social responsibility as scholar, and whatever others may say to him about his social responsibility, in good measure he does what he does because he relishes the experience of thinking what was never thought before. Similarly, whatever the artist may think about his social responsibilities as artist, and whatever others may say to him about his social responsibilities, what exhilarates him is that at dawn he knows not what new images await him at noonday.

But the scholar does not merely engage in random daydreaming, nor the artist in random imagistic revery. The pursuit by each of what he or she does not anticipate is conducted within channels. *Directed* innovation is what takes place. Within the art community this channelled, directed innovation repeatedly takes the form of solutions to problems, problems set to the artist by himself, characteristically problems suggested to the artist by the prior history of art, his own and that of others. The art of the West has become intensely problem-oriented at the same time that it has broken free from the routine of guilds and academies. And given that the problems are so characteristically suggested by the preceding history of art, rather than by surrounding social realities and expectations, the art of the West has become an art that feeds self-consciously on its own history.

The result is a striking interiorizing of the community of artists. Unless one knows the history of art, and unless one knows which problems suggested by that history are being addressed in the work at hand, one is often simply at a loss for understanding. The artist is cut off from his potential public, unless there be those "in the know" who inform the public.

Let us take an example. The Byzantine artist characteristically wished his figures to be seen as standing in a plane in front of the background. But then there slowly emerged in the Western Renaissance the challenge of

reversing that mode of seeing, the challenge of constructing the painting so that the viewer would see the designs-on-surface as figures *behind* the plane of the picture's surface. The painting was to be seen as a window onto a reality beyond. By the dawning of the twentieth century this problem no longer held any interest for artists of the West. The challenge it once presented had been met: even moderately competent artists could now make "window-pictures" as well as the best of Renaissance artists. In its place there emerged among artists a new problem, the problem of constructing paintings midway between Byzantine art and Renaissance art. Artists set themselves the problem of constructing a *flat* canvas—that is, a canvas which did not invite three-dimensional seeing, and even more radically, a canvas which *resisted* three-dimensional seeing. That problem proved to have complexities at first undreamt of; and the challenge of finding solutions to it has inspired a great many of our twentieth-century painters. It is a problem suggested to the artist by the history of his own art, so that concern with the problem represents an interiorizing of the artist community within the institution of high art generally. And it is a problem such that without the knowledge that the artist whose work one is considering was channelling his innovations into a solution to this problem, one may well find his production baffling and without rationale.

This same interiorizing of the artist community, as the result of the artist channelling his pursuit of innovation by way of setting for himself problems suggested not by society at large but by the history of his own art, is present in all the arts in our century. Here, for example, is a passage chosen almost at random from pianist and musicologist Charles Rosen's book on Schoenberg:

> By the end of the [nineteenth] century, the final appearance of the tonic chord in many works of Strauss, Reger, and others sounded like a polite bow in the direction of academic theory; the rest of the music has often proceeded as if it made no difference with what triad it ended. The music is, much of the time, in some key or other, but there is no longer any sense of direction. . . . The degree of stability has become only a localized effect, never a generalized one.
>
> Schoenberg's sense of the irrelevance of this occasional and superficial return to the formal clarity of tonal harmony was decisive for the step he took in 1909. As he himself wrote about his String Quartet no. 2 in F-sharp minor of 1908: "In the third and fourth movements the key is presented distinctly at all the main dividing points of the formal organization. Yet the overwhelming multitude of dissonances cannot be balanced any longer by occasional returns to such tonal triads as represent a key. It seemed inadequate to force a movement into the Procrustean bed of a tonality without supporting it by harmonic progressions that pertain to it. This was my concern, and it should have occupied the mind of all my contemporaries also."[54]

Naturally the internalized, problem-oriented character of the art produced within our institution of high art has had an impact on our way of assessing greatness in artists, or at least on the way in which *artists* assess

greatness in artists. The great artist is the one who sets to himself problems which are strikingly new, and problems which prove fertile in the variety of solutions they allow of and the number of new problems they suggest. Again we can take Schoenberg as an illuminating example:

> As long as no substitute had been found for the absolute final consonance of tonal music, the creation of large forms would remain a problem: absolute consonance is a final demarcation of form. . . . To see Schoenberg's extraordinary substitute for the tonic chord, the absolute consonance of traditional Western music, we must turn to the last bars of [his *Erwartung*]. . . . "Oh, are you there," cries the woman about her dead lover, and then adds softly, "I searched," as the low woodwinds begin, triple *pianissimo*, a rising chromatic series of six-note chords. The other intruments enter with similar chords moving up or down the chromatic scale, each group moving at different rates of speed; . . . This massed chromatic movement at different speeds, both up and down and accelerating, is a saturation of the musical space in a few short seconds; and in a movement that gets ever faster, every note in the range of the orchestra is played in a kind of *glissando*. The saturation of musical space is Schoenberg's substitute for the tonic chord of the traditional musical language. The absolute consonance is a state of chromatic plenitude.
>
> This concept of the saturation of chromatic space as a fixed point toward which the music moves, as a point of rest and resolution, lies behind not just *Erwartung* alone but much of the music of the period. Its importance for the future of music was fundamental. It can take two forms, strong and weak. The weak form is the more common, and became, indeed, canonical by the 1920's, although it was influential long before then: this is the filling out of chromatic space by playing all twelve notes of the chromatic scale in some individual order determined by the composer but without regard to the register, high or low. The strong form, found in *Erwartung* and in a very few other works, fills out the whole of the space in all the registers, or approaches this total saturation.[55]

The work of the high-art artist may be an expression and affirmation of the convictions of some religious community—Rouault, Messiaen, Penderecki, Eliot, are examples. But that is fundamentally irrelevant to his acceptance and position as artist. What counts is simply his contribution to the community of his fellow artists. In that way the institution of high art, for all its residual mysticism, is a profoundly secular institution—with the result that the artist who identifies himself deeply with some religious community will constantly have the experience of being a divided self living in two worlds. The institution of high art is a jealous god!

15. ANTI-ART AND DE-AESTHETICIZATION

Earlier I remarked that the image of the artist I have outlined is in tension with the notion of art for aesthetic contemplation. Sometimes there is not only tension. Sometimes the struggle of the artist for liberation and innovation leads him to a *repudiation* of the aesthetic. The Dadaists are the prime

examples, with Marcel Duchamp as their acknowledged leader. Duchamp's work *Fountain,* consisting simply of a commercially produced urinal, is the classic case in point.

What is going on when Duchamp presents for display in a museum an ordinary urinal? Is it his intent that we should find satisfaction in contemplation? I think not. We may in fact *get* such satisfaction. But Duchamp's point is something else. The category of the interesting is here replacing the category of "the aesthetic." And what is interesting is not primarily the object but rather the fact that Duchamp presented this object, for the reason that he did. Thus Duchamp's *Fountain* is an example of *anti-art*—an object presented to us not that we should find it satisfying to contemplate but rather that we should find it interesting *that it is presented* as if for contemplation, and for the reasons that it is. What counts is the *gesture* along with the reasons for the gesture, not the object with which the gesture is made. In such gestures there is a repudiation of the aesthetic.

Referring to such goings-on, the critic Harold Rosenberg spoke in some of his late essays of "de-aestheticization," meaning by this the deliberate attempt on the part of artists to avoid introducing into their productions qualities which would yield aesthetic satisfaction. Here is some of what he says:

> For works to be empty of aesthetic contents, it seems logical that they be produced out of raw rocks and lumber, out of stuff intended for purposes other than art, such as strips of rubber or electric bulbs, or even out of living people and animals. Better still, non-aesthetic art can be worked into nature itself, in which case it becomes, as one writer recently put it, "a fragment of the real within the real." Digging holes or trenches in the ground, cutting tracks through a cornfield, laying a square sheet of lead in the snow (so-called earth works art) do not in their de-aestheticizing essence differ in any way from exhibiting a pile of mail sacks, tacking a row of newspapers on a wall, or keeping the shutter of a camera open while speeding through the night (the so-called anti-form art). Aesthetic withdrawal also paves the way for "process" art in which chemical, biological, physical, or seasonal forces affect the original materials and either change their form or destroy them as in works incorporating growing grass and bacteria or works inviting rust—and random art, whose form and content are determined by chance. Ultimately, the repudiation of the aesthetic suggests the total elimination of the art object and its replacement by an idea for a work or by the rumor that one has been consummated—as in conceptual art.[56]

An example or two of the kind of productions Rosenberg has in mind may be helpful. At the Museum of Modern Art's Spaces exhibition, Robert Morris had an exhibit consisting of 144 Norway spruce seedlings planted in bins of peat moss each a foot deep, the humidity and the temperature in the room controlled so that the seedlings would grow. Another example by Robert Morris was in the Leo Costelli Gallery in New York in 1968. By his own description it was composed of the following: threads, mirrors, asphalt,

aluminum, lead, felt, copper, and steel. It consisted of bits and pieces of these, sprinkled randomly on a large canvas on the floor of the gallery. It was the same Robert Morris who on November 15, 1963, executed before a notary public the following:

> *Statement of Aesthetic Withdrawal:* The undersigned, Robert Morris, being a maker of the metal construction entitled 'Litanies' described in the annexed Exhibit A, hereby withdraws from said construction all aesthetic quality and content, and declares that from the date hereof said construction has no such quality and content.[57]

This tendency toward de-aestheticization reveals itself in all the contemporary arts. In music the classic example is the work *4-33*, a composition for piano by the American composer John Cage. A performance of it proceeds as follows: A pianist comes out on stage, sits down at the piano, opens a score, holds hands suspended above the keyboard for four minutes and thirty-three seconds, shuts the score, arises, and leaves the stage—thus "4-33." This is interesting. But what is interesting is certainly not the work. What is interesting is the fact *that* this particular work is presented to us for the reasons that it is—along, no doubt, with the audience reaction that its performance characteristically evokes among the unwitting.

In this tendency toward de-aestheticization one sees our image of the artist as one who creates in sovereign freedom like unto our Divine Master, winning out over our image of the public as those who engage in perceptual contemplation for the purpose of gaining aesthetic satisfaction. Civil war within the institution!

PART THREE
Art in Christian Perspective

CHAPTER ONE

The Artist as Responsible Servant

T 1. TOWARD A CHRISTIAN AESTHETIC

THOSE IN our century who have tried to develop a Christian aesthetic have almost invariably taken for granted that art is for contemplation. In that way they have betrayed their embeddedness within our institution of high art. I know of only one exception, Gerardus van der Leeuw in his book *Sacred and Profane Beauty*. To cite but one small bit of evidence: All the writers anthologized in Nathan Scott's *The New Orpheus* share this assumption.

It may be helpful to cite one example from Scott's anthology. In his essay "Religion and the Mission of the Artist," Denis de Rougemont describes a work of art as a "calculated trap for meditation." Stating more elaborately what he has in mind, he says that

> whether it consists in a structure of meanings, or forms, or sounds, or ideas, the work of art has for its specific function the bribing of the attention, the magnetizing of the sensibility, the fascinating of the meditation, the ensnaring—and at the same time it must orient existence toward something which transcends sounds and forms, or the words so assembled. It is a trap, but an oriented trap.

In uttering those eloquent words, de Rougemont is simply taking for granted that art is for contemplation. Thus we see once again the bewitchment exercised by our institution of high art. The strength of the bewitchment is evident from the fact that it is effective even in the face of the immense importance of liturgical art in the Christian community. Whatever the function of authentic liturgical art, certainly it is not to serve as a "calculated trap for meditation."

Equally striking in Christian theorizing about the arts in the twentieth century is the frequency with which theorists have followed the strategy of adapting the Enlightenment conviction that artistic creation is like unto the creating of our divine master. Dorothy L. Sayers, in her essay "Towards a Christian Aesthetic," is a good example. "The true work of art," says Sayers,

"is something *new*—it is not primarily the copy or representation of anything. It may involve representation, but that is not what makes it a work of art. . . . Something has been created." And she continues, "This word—this idea of Art as *creation* is, I believe, the one important contribution that Christianity has made to aesthetics." She then goes on to develop what she takes to be the analogy between artistic and divine creation.

> How do we say that God creates, and how does this compare with the act of creation by an artist? To begin with, of course, we say that God created the universe "out of nothing"—He was bound by no conditions. . . . Admitting that, let us ask in what way God creates. Christian theology replies that God, who is a Trinity, creates by, or through, His second Person, His Word or Son, who is continually begotten from the First Person, the Father, in an eternal creative activity. And certain theologians have added this very significant comment: the Father, they say, is only known to Himself by beholding His image in His Son.
>
> Does that sound very mysterious? We will come back to the human artist, and see what it means in terms of *his* activity. But first, let us take note of a new word that has crept into the argument by way of Christian theology—the word *Image*. Suppose, having rejected the words "copy," "imitation" and "representation" as inadequate, we substitute the word "image" and say that what the artist is doing is *to image forth* something or the other, and connect that with St. Paul's phrase: "God . . . hath spoken to us by His Son, the brightness of this glory and *express image* of His person."—Something which, by being an image, *expresses* that which it images. Is that getting us a little nearer to something? . . .
>
> Now for our poet. We said, when we were talking of the *Agamemnon*, that this work of art seemed to be "something happening in the mind of Aeschylus." We may now say, perhaps, more precisely, that the play is the *expression* of this interior happening. But *what*, exactly, was happening? . . .
>
> The poet will say: "My poem is the expression of my experience." But if you then say, "What experience?" he will say, "I can't tell you anything about it, except what I have said in the poem—the poem *is* the experience." The Son and the Father are *one*: the poet himself did not know what his experience was until he created the poem which revealed his own experience to himself.[1]

Part of what is fascinating about this passage is the imaginative way in which Sayers has adapted the Western post-Enlightenment image of the artist. We find here the familiar themes: the artist expresses his inner *consciousness* by making a new *creation*. Missing, though, is the theme of liberation. In its place is the doctrine of God as creating through His Son. In that substitution we see Sayers' break with the Gauguin image of the artist.

Yet this will not do as a starting point. For once again there is the limitation. Rather than keeping before our eyes the multiplicity of actions that works of art are used to perform, Sayers ignores all but that of expression. And though I agree that the systematic reflections of the Christian on the arts must begin with the "doctrine" of creation, I think the existence of a significant similarity between man's composing and God's creating is only a peripheral component in that doctrine. Man's *embeddedness* in the physical creation,

and his creaturely *vocation* and creaturely *end* within that creation, are where we must begin if we are to describe how the Christian sees the arts, provided, in turn, that the arts are seen as instruments and objects of action. To begin there is to begin at the center of the Christian's convictions concerning God the Creator and man His creature.

2. MAN AN EARTHLING

This world in which we live is an artifact brought into being by God. It represents a success on the part of God—God who is love—not a failure. In contemplation of what he had made God found delight. But also God knew that what He had made would serve well his human creatures. So God pronounced His "Yes" upon it all, a "Yes" of delight and of love. You and I must do no less. Of course, nothing in this created world is worthy of religious veneration—neither sun nor moon, trees nor hills. Its maker alone is, and He is distinct from the world. But He the Creator is worthy of religious veneration in part *because* of the magnificence and benefit of this which He has made. "The heavens tell out the glory of God,/ the vault of heaven reveals his handiwork," says the Psalmist.

Not all that God created is physical. There is, for example, the consciousness of man. But very much of it is physical. And characteristic of many religions and philosophies, characteristic also of Christianity at many points throughout its history, is a devaluation of the physical side of God's creation, a devaluation just because of its physicality. Such devaluation has taken many forms. It has taken the form of persons arguing, as Augustine did, that God is to be worshipped because He is nonphysical. It has taken the form of persons longing for disembodiment. It has taken the vague and curious form, so characteristic of American culture, of persons holding that "spiritual values" are higher than "material values." It has taken the form of persons arguing, as did the Byzantines about their glittering mosaics, that what counts is not at all the visible image but the invisible saint whose presence is invoked by the image. It has taken the form of persons arguing that the nonmaterial arts of music and poetry are superior to the material arts of painting, sculpture, architecture, and dance.

Every such form of devaluation flies in the face of God's affirmation of His creation. The sheer physicality or materiality of something is never a legitimate ground for assigning to it a lower value in our lives.

To this claim some Christians will raise a host of objections. "Is it not man's authentic hope to be freed from his body and then to live in disembodied bliss?" "Does not St. Paul enjoin us to avoid the works of the flesh and to perform the works of the spirit?" "Is not the soul to be valued more than the body?" "Are we not to worship God in spirit?"

Here I cannot even begin to give careful and detailed answers to these objections. Let it simply be said that when St. Paul insists on our avoiding the

works of the flesh, he is not preaching that the physical is evil, nor even that it is inferior to the nonphysical. He is not following in the footsteps of the Socrates of Plato's *Phaedo*. Rather, he is urging us to avoid lives of total secularity and worldliness, to live lives open to the Spirit of God. He cites jealousy, scarcely a sin of sensuality, as one of the works of the flesh.

And when Paul speaks of the soul of a person he does not refer to some component of the person distinct from, and superior to, his body. This is at once and decisively clear from the fact that in his first letter to the Corinthians he goes so far as to speak of *soulish (psychic)* bodies. A soulish body is a *living* body, more specifically, one whose life has been obtained by normal genetic processes. Paul contrasts it with the spiritual *(pneumatic)* bodies that we will have upon resurrection, these not being obtained by normal genetic processes. Invariably in Pauline thought, and normally in biblical thought in general, soul is associated with *physical life*, not with some immortal center of consciousness.

So the artist who sees life and reality as a Christian will not despise the creation in which he finds himself. He will not see it as something from which to be liberated. If he is a painter, he will have no horror of the object. He will, it is true, as we shall see later, not regard himself as bound to copy the object as faithfully as he can. He will be free to make his art abstract if he wishes. But also he will be free to dwell in loving detail on the object, trying to capture it, to render it. And though he may on occasion produce highly intellectual, even perhaps conceptual, art, he will not do so because he wants to free himself from the constrictions of materials. Instead he will see the world as a storehouse of materials out of which he can select so as to make his work. He will think of those materials more as something whose potentials are to be realized than as something constricting the scope of his own self-expression.

To speak of physical reality only thus, however, is to speak of it in a tone of distance and detachment, whereas in fact you and I are related in the most intimate way to such reality.

We fit into the *spatial* structure of physical reality. I am at such-and-such a distance and direction from this desk, and at such-and-such a distance and direction from that plant. In addition we fit into the *causal* structure of physical reality. We interact causally with the things around us. To express the intimacy and also the fragility of this interaction, Pascal once remarked that a drop of water can kill a man. But thirdly, and more importantly, we in our bodily composition are made of the same stuff as the rest of the physical creation. There is in us no peculiar element, no quintessence. We are made of dust—that is how *Genesis* puts it. Having said that, *Genesis* goes on to say that we are ensouled bodies. But that does not point to some peculiar composition we have. It points rather to the fact that we are biologically alive (cf. *Genesis* 7:21-22).

So when you and I carve wood, apply paint to canvas, pile stone on stone, or inscribe marks on paper, we are dealing with things which bear to us the

most intimate of relations. To an angel art must seem a very foreign thing indeed. With us it shares its substance. As the architect Rudolph Schwartz puts it, in a passage delightful in its unemphatic obviousness:

> The art of building is . . . done with the whole body. The laborers lift up the materials, place them one on top of the other and join them together. They execute movements which correspond to the forms of the growing part of the building and then deposit these movements in the building materials. In this way the act of raising turns to upright structure. The workers go over the wall with the trowel, and out of their stroking motion comes a skin of color or plaster. They saw and plane the wood, draw and forge the iron. Each limb of the body moves in its particular way and all of them together create the building as a second body . . .
>
> What then comes into being is first and foremost circumscribed space— shelter, living space, ceremonial space, a space which replaces the space of the world. We could almost say, and indeed it is true, that building is based on the inner spaciousness of the body, on the knowledge of its extent and the form of its growth, on the knowledge of its articulation and of its power to expand. Indeed it is with the body that we experience building, with the outstretched arms and the pacing feet, with the roving glance and with the ear, and above all else in breathing. Space is dancingly experienced.[2]

That we ourselves are physical is a point that must explicitly be tied in with our earlier strictures against the devaluation of the physical. One's attitude toward the physical incorporates an attitude toward oneself. We are not angels hovering lightly over the earth. Denigration of the physical implies denigration of oneself. Correspondingly, any denigration of art on account of its physicality is a form of self-denigration. To denigrate the dance, for example, because it so intimately involves the body, is to denigrate a whole dimension of oneself. Van der Leeuw speaks cogently on the matter:

> At times the dance, as an independent art form, has been lost. But only at times, for it cannot die. The more one becomes conscious of the unity of body and soul, the more the dance will again achieve its rightful position as a function of life. It will not be the first time that it has vanished, only to reappear. Even in ancient Egypt, the consciousness of the unbroken unity of life was so weakened that only the children danced spontaneously. The Egyptian himself did not dance, but watched the professional dancers who appeared at all important events, both happy and sad. But the dance is truly alive only when one not merely stages dance productions, but dances himself; when the dance is the natural expression of the man who is just as conscious of his body as he is of his soul. In the dance, the boundaries between body and soul are effaced. The body moves itself spiritually, the spirit bodily.[3]

At this point some of my fellow Christians may think that they spot a crack where a wedge of disagreement can be inserted. Granted that in all the ways cited we ourselves are related to physical reality. Can we not exist without standing in these relations? We stand in these intimate relations because we

have bodies. Can we not exist without bodies? And is that not a huge difference between us and the rest of physical reality?

Perhaps we can exist without bodies. I myself see nothing impossible in that. And on what seems to me the most plausible interpretation of New Testament thought, this is in fact the status of those who die before the Day of Resurrection. So, yes, there is a profound difference of nature between us and the rest of physical reality. Yet that is nothing against my insistence that you and I are now intimately related to the physical. Nor does it imply any devaluation of the physical. For even if we accept the possibility of disembodied existence, we must nonetheless resist the idea that such existence is better. Not disembodied immortality but bodily resurrection is the consummation to be anticipated. With our bodies, among rocks and trees, among colors and fragrances, we find our fulfillment; and only thus do we find it fully. Earthly existence is one of God's favors to us. When the Christian affirms the goodness of the physical creation, he is not just praising its magnificence. He is saying that the physical creation is good *for human beings*. It serves human fulfillment. Earth is man's home, the world his dwelling place.

There is yet one more way, of importance to note, in which you and I are related intimately to the physical. Early in my discussion I introduced the concept of *count-generation*, a mode of connection between actions which consists in someone's performance of one action counting as his performance of another. My inscribing certain marks on paper counts as my asserting that spring is late; my producing certain sounds counts as my asking the way to the store; your making a certain gesture counts as your bidding ten dollars. What must now be noticed is that in count-generation a bit of natural reality which is in itself of minor significance—marks on paper, sounds, gestures—is caught up into the fabric of human action and given a significance which bears no relation whatsoever to its inconspicuousness in the natural order of things. The making of a mark spells a man's doom; the voicing of a quiet sound springs him free. There is in man the marvellous ability to take fragments of natural reality, to embed them in action, and so to produce a seamless fabric of consciousness and physicalness. In man, nature speaks. Without nature, man could not speak.

3. MAN'S VOCATION

Man is an earthling, sister to the birds of the air, brother to the beasts of the field. Yet he is unique among earthlings. Of course every species is unique. The Ladybug is a unique species of insect. What I mean is that man is *uniquely* unique.

His uniqueness cannot be obliterated. Even if he wants, man cannot sink ripple-less into nature. Neither is his uniqueness to be lamented. It is his

glory, not his misery, the ground of his dignity, not the sign of his fallenness, the mark of his favor before the divine, not of his alienation.

Western thinkers have been virtually unanimous in the conviction that there is indeed something uniquely unique about man. There have been exceptions. Bertrand Russell in "A Free Man's Worship" denies man's uniqueness with ringing rhetoric. But mainly the conviction that man is unique unites reflective men and women of the West. Western thinkers have also been virtually unanimous in their attempt to locate man's uniqueness in some capacity on his part, some capacity both unique to man and such that in its use lies man's most significant attainment. To this too there have been exceptions. Kant located man's uniqueness in his capacity for self-consciousness, Heidegger, in his being that entity to whom Being reveals itself. But mainly the quest for man's uniqueness has been the quest for some unique and supremely significant capacity on man's part.

We all know the traditional answers. For the Greeks of the Periclean age it was man's ability to reason, a view which has more profoundly shaped Western thought and practice than any other. Man, they said, was the rational animal. Following Francis Bacon, modern man has tended rather to locate man's uniqueness in his tool-making and tool-using capacity, and his accompanying ability to shape and manipulate nature. Ernst Cassirer saw man's capacity for language, or rather, his capacity for communicating with symbols, as constituting his uniqueness. And, as one would expect, some have seen man's uniqueness in his capacity for art.

In our century these traditional answers have all fallen on hard days. The more we have learned about the animals, the more irresistibly we have been led to conclude that man is not unique in any of the ways traditionally thought. Capacities taken to be supremely significant and ennobling are all shared—to a degree anyway—with our relatives the animals.

Deeply embedded in the Christian confession concerning creation is the conviction that man is indeed uniquely unique among his fellow earthlings. "What is man that thou art mindful of him," asks the song writer of Old Israel, "and the son of man that thou dost care for him?" He finds it astonishing that from the vast cosmic array God should have singled out man for special attention. But his astonishment does not shake his conviction that this is exactly what has happened. For at once he goes on to say, "Thou hast made him little less than God, and dost crown him with glory and honor."

In the Psalmist's vision of human existence man's uniqueness lies not in some capacity unique to him among earthlings. It lies in man's having been singled out in some special way by God. To the secularist, man's true uniqueness must go unnoticed.

Specifically, man at creation is singled out as the creature who alone among earthlings is *responsible*. He alone is accountable. Very often animals do what you and I wish they wouldn't. And very often we institute procedures to check, or change, their behavior. Sometimes animals even exhibit fear that

they will be punished for having done something forbidden by some person. But what animals never are is guilty. They are not guilty because they are not responsible. In so far as we eliminate from our handling of criminals all notion of guilt, of punishment for guilt, *and of forgiveness for guilt*, and in so far as we regard the actions of criminals as nothing but anti-social behavior to be checked and modified, we are treating men as animals. The dignity of man calls for recognizing that man is responsible, and so for recognizing guilt, which is the dark side of responsibility.

In saying that man's uniqueness lies not in some capacity he possesses but in the fact of his being responsible, I do not, of course, wish to deny that to be responsible requires certain capacities. Nobody can be responsible unless he or she is capable of causally free action on principles. Responsibility requires freedom. And nobody can be responsible unless he is capable of envisaging states of affairs distinct from those which his experience has led him to believe obtain. We human beings have the marvellous capacity of envisaging states of affairs which for all we know are merely possible, and even states of affairs which are impossible. Being responsible presupposes this capacity for envisagement. So it is true that being responsible presuppose capacities. And some of these presupposed capacities may even be unique to man among earthlings. Perhaps we alone are capable of free, principled, action; perhaps we alone are capable of envisagement. But all such capacities receive their fundamental significance from the fact of our being responsible.

However, we do not just *come* as responsible creatures. Our being such inheres in God's *holding* us responsible. What we are responsible for doing is what God holds us responsible for doing. Thus all human responsibilities are ultimately responsibilities to God. To fail in one's responsibilities is to let God down. It is in holding us responsible to Himself that, above all, God dignifies us. Man's uniqueness lies in being bound to God by cords of responsibility.

It is helpful to think of this on analogy with the relation of a sovereign to the citizens of his realm. The sovereign has power, and so can enforce obedience. That is the dimension of sovereignty to which our contemporary political theorists call our attention. But of equal significance is the fact that the sovereign has *authority*. He can genuinely hold his citizens responsible to him and not merely threaten suffering or deprivation if they do not submit to his will. The sovereign is lord of the realm and not just supreme power in the realm. So too, God is man's lord and can genuinely hold him responsible.

What must be added at once is that the ultimate authentication of God's authority over us is the fact that He has made us and seeks our good, also in what He holds us responsible for. In obedience to God's law is man's delight. One can go farther. The biblical writers had the religious courage to say that God has *pledged* Himself to His people, so that He is now responsible to them as well as they to Him.

Having seen that our uniqueness consists in our being responsible, that this inheres in the fact that God *holds us* responsible, and that this in turn is

grounded in the fact that God has authority over us, we can summarize by saying that man is unique among earthlings in that God is his lord—lord in the sense of sovereign. God is lord over the plants and the animals too. But only as a potter over his pots is God lord over them. In that way as well God is lord over man. But unique to man among earthlings is that God is his sovereign. As a sovereign is lord of his subjects, so is God lord of man; God has the right to ask obedience, man the responsibility to obey.

To be responsible to someone is always to be responsible *for doing* something. Always it is to *have responsibilities*. And we will come to a better and richer understanding of our uniqueness if we now look at the fundamental pattern of our human responsibilities.

We have responsibilities, in the first place, with respect to the natural world surrounding us. We are to *subdue* it—that is, to tame it, to eliminate its unruliness, to order it, to place our imprint upon it. And with respect to the animals, more specifically, we are to rule over them, to be masters over them. We are to "have dominion over the fish of the sea and over the birds of the air and over every living thing that moves upon the earth." It is especially in the authorization and injunction to have dominion that the song writer of Old Israel saw the dignity and glory of man. "Thou hast crowned him with glory and honor," he says to God. And then at once he goes on to say, "Thou hast given him dominion over the works of thy hands; thou hast put all things under his feet." Is it fanciful to hear in these words a note of incredulity over the fact that God would have been willing to entrust *His* creatures to man's dominion?

It was the conviction of Karl Marx that, at the most basic level, man is to be understood as a worker, a laborer—one who humanizes the world by putting the stamp of his labor upon it, thereby achieving his own humanity. Accordingly, Marx regarded the institutional structures and relationships within which men and women labor as the clue to the whole cultural edifice of mankind; and he saw the alienation of a man from the products of his labor as the deepest affront to his dignity. To this, the Christian wishes to say No, but also Yes—No to Marx's absolutizing of what is just one phase of man's vocation, but Yes to Marx's opposition to all idealizing notions which see in man's labor, and his *need* to labor, an affront to his dignity rather than a component in his dignity. In man's vocation as worker lies (part of) his dignity.

There is, however, no point in circling delicately round the fact that to us in the last half of the twentieth century it sounds deeply offensive to speak of man as called to subdue and dominate. When we hear of "subduing the earth" we think of woodsmen hacking down trees and of bulldozers making all the "rough places plain" by flattening out hills, damming up streams, and filling in marshes. When we hear of "ruling the animals" we think of extinct and endangered species, and of the sad spectacle of those bears incarcerated in the pit in Berne for the sake of some hard-to-fathom, perverse, human satisfaction. No doubt we think thus because that is the form of subduction that our technology has made us most conscious of, and the form of dominion

that our rulers most customarily display for us. So we hear the biblical words about subduing and ruling as the authorization of man's sadistic self-aggrandizement against nature. And we are horrified.

But let us set off to the side for a moment what you and I think of when we hear the word "subdue" and ask what the biblical writer is likely to have had in mind when he said that God enjoins man to subdue the earth. I think we must hear in this passage an echo of the opening of *Genesis*—"the earth was without form and void"—and thus the suggestion that man is to continue God's work of bringing forth order, cosmos—of bringing forth that about which it can be said that it is "very good." What is even clearer, though, is a second point, that man is not to impose form out of infatuation with seeing the imprint of his own self on the world around but is to do so *for human benefit*. His imposition of order is to be for the sake of human livelihood and delight. For after His injunction to subdue the earth, God says, "Behold, I have given you every plant yielding seed which is upon the face of all the earth, and every tree with seed in its fruit; you shall have them for food." And then in the second chapter of *Genesis* we find it said, about the garden of Eden, that "the Lord God made to grow every tree that is pleasant to the sight and good for food." Subduing, then, is the imposition of order for the purpose of serving human livelihood and delight. (No doubt also for the purpose of rendering honor to God, though that happens not to be mentioned in the texts before us.) When the imposition of order goes beyond what serves human benefit and God's honor, then it goes beyond our authorization. Today we are beginning to see just how far we in the West have gone beyond.

The image appropriate to subduing—to ordering nature for the benefit of man—is that of *gardening*. Man's vocation is to be the world's gardener. The cultivator is his proper implement, not chainsaw and bulldozer: "And the Lord God planted a garden in Eden, in the east; and there he put the man whom he had formed. And out of the ground the Lord God made to grow every tree that is pleasant to the sight and good for food. . . . The Lord God took the man and put him in the garden of Eden to till it and keep it."

It seems clear from the text of *Genesis* that the ruling of the animals is to be understood as a specific form of subduing. When speaking of that form of subduing which consists in subduing the animals, it is appropriate to use the political image of ruling, of being master of, of having dominion over. The same criterion applies. Ruling the animals is not to be done wantonly, viciously, aggressively, but for human benefit and to honor God. When the imposition of man's will on the kingdom of the animals goes beyond what serves human fulfillment or God's honor, then it becomes illicit. The animals, though graciously offered to man for his mastery, remain the creatures of God's hand, for Him to dispose of as He wishes.

In his letter dated April 8, 1873, Gerard Manley Hopkins expressed his grief over the destruction of an ash tree in this touching language:

> The ashtree growing in the corner of the garden was felled. It was lopped first: I heard the sound and looking out and seeing it maimed there came at that moment a great pang and I wished to die and not to see the inscapes of the world destroyed any more.

In those words, and in the hymns of St. Francis, and in the grief of a boy over the death of his dog, we have expressed the authentic human attitude toward God's creatures. The earth and all that dwells therein is for man's use and at his disposal. But he is to use it in the spirit of a devoted gardener tending his plot.

It is not difficult to see how man's vocation of master, of subduer, of humanizer of the world, of one who imposes order for the sake of benefitting mankind or honoring God, applies to the artist. The artist takes an amorphous pile of bits of colored glass and orders them upon the wall of the basilica so that the liturgy can take place in the splendor of flickering colored light and in the presence of the invoked saints. He takes a blob of clay and orders it into a pot of benefit and delight. He takes a disorderly array of pigments and a piece of canvas and orders them into a painting richly intense in color and evocative of the South Seas. He takes a piece of stone rough from the quarry and by slowly chipping away orders it into a representation of mother and child. He makes from our huge store of words—of sounds with meanings—a selection and puts them into an order so as thereby to inspire his fellow men to "not go gentle into that good night." The artist, when he brings forth order for human benefit or divine honor, shares in man's vocation to master and subdue the earth.

But there is more to human responsibility than responsibility with respect to nature. This more can be treated more briefly, not because it is less important, nor because it is easier to carry out, but rather because it is easier for us to comprehend. We have responsibilities with respect to each other: We are to love our neighbor as ourselves. This presupposes that each is to love himself. To despise oneself, to hate oneself, to long to be what one cannot be and so to neglect becoming what one can become, to squander one's life instead of nourishing one's potential—that is to fail in one's responsibility to God. Each is to seek his own fulfillment. But equally each is to exhibit solidarity with the other, to stand in his stead, to love him as he loves himself, to seek his fulfillment as he seeks his own. Indeed, in seeking the other's, he will find his own.

Need it be emphasized that the artist shares in this human vocation to love one's neighbor as one's self? As we have seen repeatedly, without the artist human life would be impoverished, almost impossible. Much of what we find worth doing could not be done at all; much else, only limpingly.

There is yet a third phase of human responsibility. Not only are we responsible to God for subduing the earth and for loving our neighbor as ourselves. We are also responsible to God for actions with respect to Himself as the Creator. We are responsible to Him for acknowledging Him—praising Him for the magnificence and goodness of His deeds, trusting Him that He

will lead His creatures into green pastures. Dietrich Bonhoeffer, during his imprisonment, explored for a while the possibility of "religionless Christianity." Though he never succeeded in making clear what a religionless Christian life would be, it sometimes appears that what he had in mind is a life of obedience to God but devoid of any *address* to God, a life in which one keeps God always behind one's back and never turns to face Him. It seems to me that such a life would be incomplete—even a defection from responsibility. We are called to turn and face our Lord. Need I emphasize that the artist shares in this human responsibility to turn around and honor God, with images of glory and songs of thanksgiving?

We have seen, then, that man's responsibilities to God are of a triplicate pattern: He is responsible to God for subduing the earth, he is responsible to God for loving his neighbor as he loves himself, and he is responsible to God for acknowledging Him.

Early in my discussion I argued that works of art are objects and instruments of action. What has now been added is that those actions, like all other actions, are to be *responsible* actions. Whether they be those of the artist who composes or those of the public which uses, they are to be actions in which the earth is responsibly mastered, actions in which the fulfillment of ourselves and others is responsibly served, actions in which God is responsibly acknowledged. The artist is not to pick up his responsibilities when he lays aside his art—he is to exercise his responsibilities in the very production of his art. And we who make use of his art are not to leave responsibility behind when we enter art. In our very use of it we are to exercise our responsibilities.

Undoubtedly it is on this point of art and responsibility that the Christian image of the artist diverges most sharply from the heaven-storming image of post-Enlightenment Western man. For where the Christian sees the artist as a responsible agent before God, sharing in our human vocation, Western man in the Gauguin-image sees him as freed from all responsibility, struggling simply to express himself in untrammelled freedom. Though often it is assumed that the public has responsibilities to the artist (as man has responsibilities of gratitude to God!), even more often it is assumed that the artist has none to the public. Indeed, it is often suggested that if the artist so much as thinks in terms of responsibility his flow of creativity will be stanched. One might ask why, then, the architect remains creative? But more profoundly, our discussion enables us now to put this question: Why should the artist, an earthling with the rest of us, be seen as deprived of that human dignity which resides in the fact that man and man alone among earthlings is a responsible creature?

4. MAN'S END

My discussion in the preceding section has a "Calvinistic" sternness about it. If art is instrument and object of action, and if man in his actions is always the

responsible agent, then art will indeed occur within, and so must be seen within, the context of actions to which the categories of responsibility apply. True enough. But one wants to shout: "What about delight?" Of course it's true that such delight fits into the context of action; for it is delight that comes when we engage in the action of contemplation in a certain way. It may even fit into the context of *responsible* action; for it may conduce to the fulfillment of ourselves and our fellows. So everything is nicely in order. Yet the tone of my discussion thus far is that of unrelieved seriousness. Even if nothing I have said contradicts the legitimacy and worth of aesthetic delight, even if aesthetic contemplation can nicely find its place in the structure I have provided, it remains true nonetheless that I have *said* nothing about it. I have not affirmed its worth. I have only left room for such affirmation.

The corrective needed is the introduction of another theme concerning man in creation, a theme as prominent in the biblical writers as the theme of man the responsible agent, yet a theme scarcely noticed in the Christian tradition. It is the theme of *shalom, eirenē,* peace—of man dwelling at peace in all his relationships: with God, with himself, with his fellows, with nature. Shalom is a peace which is not merely the absence of hostility, though certainly it is that, but a peace which at its highest is *enjoyment.* To dwell in shalom is to *enjoy* living before God, to *enjoy* living in nature, to *enjoy* living with one's fellows, to *enjoy* life with oneself.

Responsible action is the vocation of man; shalom is his end. And in his end lies his uniqueness as much as in his vocation. It is true that a condition of shalom is responsible action; where righteousness is missing, there shalom is grievously wounded. Yet responsible action, though a condition of shalom, is not a guarantee of it. Peace may elude us as we pursue our duty; joy may escape us even as we seek it out.

It may come as a surprise to us that the prophets, those who speak most emphatically and intensely about man's ethical obligations, are also the ones who speak most concretely and explicitly about shalom. Isaiah hears God speaking thus:

> Then justice shall make its home in the wilderness,
> and righteousness dwell in the grassland;
> when righteousness shall yield peace
> and its fruit be quietness and confidence for ever.
> Then my people shall live in a tranquil country,
> dwelling in peace, in houses full of ease. (32:15-20)

And later:

> For behold I create new heavens and a new earth.
> Former things shall no more be remembered
> nor shall they be called to mind.
> Rejoice and be filled with delight,
> you boundless realms which I create;

>for I create Jerusalem to be a delight
>and her people a joy;
>I will take delight in Jerusalem and rejoice in my people;
>weeping and cries for help
>shall never again be heard in her. (65:17-25)

And in the best-known passage of all, Isaiah describes the anticipated shalom with a multiplicity of images of harmony—among the animals, between the animals and man:

>Then a shoot shall grow from the stock of Jesse,
>and a branch shall spring from his roots.
>The spirit of the Lord shall rest upon him,
>a spirit of wisdom and understanding,
>a spirit of counsel and power,
>a spirit of knowledge and the fear of the Lord.
>Then the wolf shall live with the sheep,
>and the leopard lie down with the kid;
>the calf and the young lion shall grow up together,
>and a little child shall lead them;
>and their young shall lie down together.
>The lion shall eat straw like cattle;
>the infant shall play over the hole of the cobra,
>and the young child dance over the viper's nest. (11:1-8)

That shoot of which Isaiah spoke is He of whom the angels sang in celebration of His birth: "Glory to God in highest heaven, and on earth his *peace* for men on whom his favor rests" (Luke 2:24). He is the one of whom the priest Zechariah said that He "will guide our feet into the way of *peace*" (Luke 1:79). He is the one of whom Simeon said, "This day, Master, thou givest thy servant his discharge in *peace*; now thy promise is fulfilled" (Luke 2:29). He is the one of whom Peter said that it was by him that God preached "good news of *peace*" to Israel (Acts 10:36). He is the one of whom Paul, speaking as a Jew to the Gentiles, said that "he came and preached *peace* to you who were far off and *peace* to those who were near" (Ephesians 2:17). He is in fact Jesus Christ, whom Isaiah called the "prince of *peace*" (Isaiah 9:6). How sad it is that the church so often fails to see in the Prince of Peace whom she preaches the one who offers the promise of peace in all dimensions—not only in the religious, but in the physical, the social, and the psychological as well.

In Karl Barth's discussion of creation in the *Church Dogmatics*[4] there is a brilliant passage on the place of joy in human life (III,4, pp. 374-385). Since the topic is of prime importance for explicating how the arts look to the Christian, and since I can hardly improve on what Barth says, I shall quote him at some length, though even so, this is only the beginning of the passage. The style of the passage is baroque in its plenitude, and that itself is fitting to the topic of joy. Barth does not explicitly set his discussion within the context of

the biblical vision of shalom as the fulfillment of man's existence; but that, certainly, is where it belongs.

In every real man the will for life is also the will for joy. In everything that he wills, he wills and intends also that this, too, exist for him in some form. He strives for different things with the spoken or unspoken but very definite if unconscious intention of securing for himself this joy. He does not merely wish to satisfy his impulses or to be well. Even the most primitive of men does not really wish no more. Nor does he merely want to work and to contend for that which is good, true and beautiful. Even at the highest level, he does not merely want "to love God and man." Even the most objective man of action, the strictest scholar, the most serious theologian burning perhaps with asceticism or philanthropy, does not really want only this, not to speak of artists who are usually the sincerest in this matter. No, in and with all these things, or side by side with them, at certain intervals or interludes, he also wants to have a little, and perhaps more than a little, enjoyment. It is hypocrisy to hide this from oneself. And the hypocrisy would be at the expense of the ethical truth that he should will to enjoy himself, just as he should will to eat, drink, sleep, be healthy, work, stand for what is right and live in fellowship with God and his neighbour. A person who tries to debar himself from joy is certainly not an obedient person. And the question what it means to will to be happy in obedience is in its place just as serious, and its correct answering is just as important and as little self-evident, as any ethical question.

It is astonishing, and certainly does not need to be verified by quotations, how many references there are in the Old and New Testaments to delight, joy, bliss, exultation, merry-making and rejoicing, and how emphatically these are demanded from the Book of Psalms to the Epistle to the Philippians. The binding seriousness of the covenant relationship between Yahweh and His people, the gloom of the indictment continually brought against this people, the terror of the divine judgment proclaimed and executed on them, the final call to repentance with which John the Baptist introduces the New Testament, and at the heart of the New Testament the darkness of the day on which the Son of God is nailed to the cross—all these do not signify a suppression of the joy to which there is constant reference, nor of the summons to rejoice, but it seems rather as if this joy and summons arise from these dark places, and that what is declared from this centre is glad tidings. Why? Because God the Creator and Lord of life acts and speaks here, taking the lost cause of man out of his hand, making it His own, intervening majestically, mercifully and wisely for him. Now obviously what arises at this dark source is not a random or arbitrary joy. It is not unqualified, but supremely qualified. What is here regarded as joy, and is this, has obviously passed through a catalysator. It has been destroyed on the one hand, and reconstituted on the other. But it has been reconstituted, and validated, and even raised to the level of a command. Christ is risen; He is truly risen. Joy is now joy before the Lord and in Him. It is joy in His salvation. His grace, His law, His whole action. But it is now genuine, earthly, human joy: the joy of harvest, wedding, festival and victory; the joy not only of the inner but also of the outer man; the joy in which one may and must drink wine as well as eat bread, sing and play as well as speak, dance as well as pray. We must not forget the catalysator without which it cannot be the obedient joy demanded. But we must also

remember that the man who hears and takes to heart the biblical message is not only not permitted but plainly forbidden to be anything but merry and cheerful. . . .

We can close ourselves to joy. We can harden ourselves against it. We can be caught in the rut of life in movement. We can try to be merely busy and therefore slothful in the expectation of fulfilments. We can regard life as such a solemn matter that there is no desire for celebration. We can look upon an icy seriousness as the highest duty and virtue. On the basis of experienced disappointments we can try to establish that our only right is to bitterness. Is it not obvious that we can never really have joy? Does not joy really consist only in the joy of anticipation? But the fact that we actually become joyless is only a symptom that in self-embitterment we do violence to life and to God as its Creator. And this is the very thing which must not happen at this point.

After this, only two matters need further comment. Joy comes in a multiplicity of forms, among them the joy of aesthetic satisfaction. Such joy is not the sole form worth man's pursuit and acceptance. Neither is it the ultimate form. Certainly, though, it is one among others.

However, these comments leave open the question whether aesthetic satisfaction grounded in the *sensory* artifact is legitimate. Earlier we saw that aesthetic satisfaction is not confined to the sensory; one can derive aesthetic satisfaction from the *world* of a work of art. And the abhorrence of the physical and the sensory is so deeply ingrained within Western Christendom that there will be those who agree that aesthetic delight is legitimate while continuing to believe that delight in the words or the paint or the sounds is to be scorned, devoting all their attention to the scene or the story.

But the case against this view has already been argued. For if the physical creation available to our sensory apparatus is good, and if joy is not only permitted man but is in fact his fulfillment, then there is no further charge to be brought against joy grounded in the sensory and the physical. So it can be said emphatically: This world of colors and textures and shapes and sounds is good for us, good for us in many ways, good also in that it provides us with refreshing delight. It is the Platonist and not the Christian who is committed to avoiding the delights of the senses, to taking no joy in colors, to avoiding the pleasures to be found in sounds. Delight in the colors and textures of eucalyptus seed pods, as well as in the sculptures of Henry Moore; delight in the sounds of the sea, as well as in the music of Debussy's *La Mer*; delight in the rhythms of John Donne's poetry, as well as in the movements of flowing streams—all contribute to human fulfillment. The tragedy of modern urban life is not only that so many in our cities are oppressed and powerless, but also that so many have nothing surrounding them in which any human being could possibly take sensory delight. For this state of affairs we who are Christians are as guilty as any. We have adopted a pietistic-materialistic understanding of man, viewing human needs as the need for a saved soul plus the need for food, clothes, and shelter. True shalom is vastly richer than that.

The practice, in one's contemplation of a work of art, of looking only for

the message and of fixing only on the world projected, of taking no delight in the artifact which bears the message and presents the world, might be called a "docetic" approach to the arts—on analogy to an early Christian heresy that denied the genuine bodily nature of Christ. All such docetism must be rooted out of our commerce with the arts. The person who in looking at the paintings of Paul Klee looks only for the threateningly mystical message and never notices the wondrousness of the colors is practicing an heretical approach to the arts. Equally, though, the person who only revels in the colors and never discerns what it is that Klee is using his art to express, is practicing an heretical approach.

Of course sensory delight can be a threat to one's obedience to God. It can function as a distraction from one's other responsibilities. Worse, it can function as a surrogate God, as we saw in Part Two. But the Christian's repudiation of this must not obscure from him the fact that the structure of this idolatry, as of every other, is that of a limited good's being treated as an ultimate good. Its structure is not that of something evil's being treated as good.

One other matter pertaining to joy and art merits brief consideration. Not only does the joy of aesthetic delight have its legitimate place in human life. So too does the joy which the artist experiences in creating his work. Of course we must keep in mind Barth's point that we are allowed to "have joy, and therefore will it, only as we give it to others." And it must be admitted that the contemporary artist's intense concern with solving artistic problems set to him by himself and his fellow artists sometimes excludes the note of "rejoice along with me." When that happens, the artist has fallen into irresponsible self-indulgence. Yet in posing and solving artistic problems because one *enjoys* doing so, there is nothing wrong. Life is not meant to be grim.

In conclusion, though, we must come back to insist on the opposite point, so often denied in the contemporary arts—namely, that one can find joy in carrying out one's responsibilities to one's fellows. Indeed, is it not true here too that he who loses himself will find himself? And is it not precisely the artist narcissistically concerned to find himself who will at last discover that he has irretrievably lost himself? The Byzantine artist placed himself humbly at the service of the church, invoking the presence of the departed saints by depicting them, so that the liturgy could take place in their presence as well as in the presence of men on earth. Is it likely that he found less joy in his work than does the contemporary artist who sets himself his own problems in the hope that in solving them he will find joy? And is it not a specious concept of *integrity* that is used when it is said that for the artist to bend his talents to the service of others is to sacrifice his personal integrity?

5. REDEMPTION

The Christian speaks of more than creation. He speaks also of man's rejection of God's sovereignty, with its attendant defection from responsibility and its

consequent evils. And he sees that art over and over has served the cause of that rejection and defection. To read, for example, Lewis Mumford's *The City in History* is to read the long tale of the ever novel ways in which man in building his cities has used art to mutilate nature, to oppress his fellows, to serve idols, and even to thwart his own fulfillment. The art you and I now admire in the scrubbed stillness of the museum once dripped with blood, reeked of idolatry, or caused its makers suicidal depression and anguish. Art is not isolated from the radical fallenness of our nature. It is an instrument of it. Art does not lift us out of the radical evil of our history but plunges us into it. Art is not man's savior but a willing accomplice in his crimes.

But the Christian speaks also of redemption. He dares to say that the ultimate drift of history is toward the attainment of justice in shalom; for he believes that God Himself is working toward that goal, not being willing to abandon His favored creatures with justice never won and peace never attained. The Christian holds out hope for the coming of "the Kingdom of God," where God is acknowledged as Lord.

Admittedly there are those who perceive the message of the Christian gospel as the message of escape from our creaturely, earthly existence. Naturally, in such a view art will be seen in a radically different light from that in which I have placed it. But such a view can make no sense of those factors in the Christian confession to which I have been calling attention. The Kingdom of God is not escape from our earthly condition; it is that state in which men acknowledge God's sovereignty and carry out their creaturely responsibilities. Such a state is not merely the *restoration* of some Edenic situation; for what has taken place in history will play its constructive role in the character of life in the Kingdom. Rather it is the *renewal* of human existence, so that man's creaturely vocation and fulfillment may be attained, already now and in the future.

This acknowledging God at work in human redemption does not compromise our contention that art is an indispensable instrument in the fulfillment of our responsibilities and a crucial component in the shalom for which men and women were made. Rather, since we are now called to be God's agents in His cause of renewal, of whose ultimate success He has assured us, art now gains new significance. Art can serve as instrument in our struggle to overcome the fallenness of our existence, while also, in the delight which it affords, anticipating the shalom which awaits us.

6. THE PROTESTANT VIEW

Not a word has been said about religion. I have spoken of God and man, of animals and plants, of peace and responsibility. But nothing about religion. To many that will have been surprising. For it is with religion that most contemporary Protestants begin in speaking about art, developing the thesis that a work of art is always *an expression of* its composer's religion, or that it is

expressive of its composer's religion, or that its composer created it so as *to express* his religion.* This, they say, is the *religious dimension* of art. And they go on to suggest that fundamental in a Christian perspective on art will be attention to this.

After emphasizing that man is an earthling among earthlings, I went on to consider his uniqueness, arguing that it consists in his *vocation* and in his *end*. I suggested that this is the fundamental context within which to consider art. Thus I set art within the context of the Christian confession of creation.

Though it isn't always evident on the surface, our contemporary Protestant who begins his reflections on art with considerations about religion also wishes to set art within the context of the Christian confession of creation. More specifically, he too wishes to focus on a Christian understanding of man's uniqueness. Where we differ is over the location of that uniqueness. I locate it in man's calling and intended end. He locates it in a certain in-created *tendency* which he claims to be ineradicable and irresistible.

Man, he says, is a *religious creature*. His being so belongs to the very structure of his being and is unique to him among earthlings. He is incurably religious. And in the existence of this tendency lies man's fundamental significance. Not only is this tendency ineradicable, it cannot be resisted. Always it finds realization. It can be turned in different *directions*, with the result that different religions emerge. But man can no more choose not to have a religion than he can choose not to have the religious tendency. All that is open to him is the choice of *which* religion to have. Only therein lies his freedom.

So wide a consensus does this view enjoy that a Protestant feels heretical opposing it. Safer to ignore it, so much has it become part of the standard Protestant apologetic strategy. One observes of the unbeliever that he too is religious, indeed, that he too has a religion, so that he is not an unbeliever after all but only a different kind of believer. Nonetheless, I believe and shall contend that though there may indeed be in man that which the contemporary Protestant identifies as the religious tendency, that tendency is not irresistible. Not everyone, accordingly, has a religion. Nor is there any reason to think that every artist has a religion, of which his art is then an expression.

The contemporary Protestant knows as well as the rest of us that under the ordinary concept of a religion, many people in the modern secularized West cannot be said to have a religion. There is simply no religion that they practice. It is the contention of the contemporary Protestant, however, that if we penetrate beneath the variable surface phenomena of what are customarily called religions, to the *essence* of these phenomena, we will find something

*I intend these three phrases, "an expression of," "expressive of," and "to express," to stand for three different concepts. For an articulation and differentiation of the concepts, see the Appendix. Part of the plausibility of "the Protestant view" lies in the fact that those who espouse it typically waffle back and forth among these three distinct concepts.

that is exhibited in every human being. And whether that "something" finds its manifestation in cultic practices, in worship of a supreme being, etc., is then a matter of no great theoretical interest.

There is even a standard view among contemporary Protestants as to what this "essence of religion" is—a view whose antecedents lie in Augustine's claim that in everyone's life there is something which he loves ultimately. Tillich calls it one's "ultimate concern." In every man there is an ineradicable and irresistible tendency to fix on an ultimate unifying concern for his life, thus to attempt to find the "rest" of which Augustine spoke in the opening pages of his *Confessions*.

For my purposes here it will not be important to clarify just what is meant by the claim that one thing or another is "the essence of religion." Nor will it be important to decide whether it is true that the essence of religion lies in fixing on something as providing ultimate unifying meaningfulness to one's life. Nor even will it be important to decide whether there is such a *tendency* in all human beings. I am inclined to think there is. But the question relevant to our purposes here is whether all men do *in fact* fix on something as providing ultimate unifying meaningfulness to their lives, thus exhibiting, if not a religion in the usual sense, at least the supposed "essence" of religion. My question is just whether this supposed tendency is irresistible of fulfillment. Is everyone religious in the sense of exhibiting the supposed essence of religion? If not, then, unless artists are different in this regard from human beings generally, we have no reason for thinking that all art can be viewed as an expression of its maker's Religion. For some will have no Religion to express. (Henceforth, when I use "religion" not in its normal sense, but rather for that on which a person fixes as his ultimate concern, I shall capitalize the word.)

It seems to me that we would be giving a distorted description of the structure of the lives of many in our modern secularized West if we claimed that they did in fact all fix on something which functions for them as ultimate unifying concern. Let it be acknowledged that many do. Let it further be said that of those who do, many are not practitioners of anything that would normally be called a religion. They are dedicated Leninists, or dedicated Nazis, or dedicated behaviorists, or whatever. Yet we would be trying to fit square pegs into round holes if we contended that *all* human beings are thus. Is it not rather the case that many live their lives with a *multiplicity* of concerns, shifting about from time to time, with no one concern ever being ultimate? Such people care a bit for their families, a bit for material possessions, a bit for country, a bit for personal esteem, and so forth. Always of course there is the threat of conflict among these partial concerns. And if some situation would arise forcing them to choose, then one or more of those conflicting concerns would, for the time being at any rate, be subordinated. But for many, no such agonizing, clarifying conflict ever arises. They remain people of divided heart. Their life displays a fractured multiplicity of

concerns. And what they would do if some such conflict arose, they do not know.[5]

What especially makes it seem heretical to oppose the consensus is the belief of many that this allegedly ineradicable and irresistible religious tendency in all men is a basic *biblical* teaching. I think there is no such biblical teaching. The Bible speaks about the true worshippers of the true God, and describes their unity-in-variety. But it never attempts to locate some ineradicable religious tendency which, though it can be turned in different directions, can never be resisted. It never tries to pinpoint some tendency such that what ultimately differentiates the true worshipper of the true God from all other men is that the former turns that universally shared tendency in a different direction from all the others—namely, in the *right* direction. It never contends that all those who are not true worshippers of the true God nevertheless have a Religion. It simply regards them as falling away in a vast multiplicity of different ways.

The crucial passage, of course, is the opening chapter of Paul's letter to the Romans. For there Paul says, in verse 25, that "they worshipped and served the creature rather than the Creator." Ever since the days of Augustine it has been thought that Paul is here teaching that there is a universal, ineradicable, and irresistible tendency in man to worship and serve something or other, and that this tendency will be actualized by worshipping and serving either the Creator or some creature. And indeed, if this is what Paul is teaching, we might reasonably call this indigenous tendency the "religious" tendency.

But is this Paul's teaching? Throughout the entire passage of verses 18 through 32 the reference of Paul's "they" apparently remains the same. The question then is whether he is referring to all men, or to some particular group of men he has in mind. It seems clearly to be the latter. In verse 23 Paul says that they "exchanged the glory of the immortal God for images resembling mortal man or birds or animals or reptiles." So in all likelihood what Paul meant when in verse 25 he spoke of "serving the creature" is *image* worship. Yet Paul knew, as our contemporaries know, that the alternative to the true worship of the true God does not always take the form of image worship. Again, in verse 24 Paul says that "God gave them up in the lusts of their hearts to impurity, to the dishonoring of their bodies among themselves, because they exchanged the truth about God for a lie and worshiped and served the creature rather than the Creator." And then, making clear what he has in mind by "dishonoring their bodies," he goes on in 26 and 27 to say, "for this reason God gave them up to dishonorable passions. Their women exchanged natural relations for unnatural, and the men likewise gave up natural relations with women and were consumed with passion for one another." Then in verses 28 through 31 he gives a lengthy list of other evils into which these people fell. Is it not clear that Paul has in mind here a group of image worshippers who, on account of "worshipping and serving creatures," had fallen into blatant and

rampant homosexuality, plus a host of other evils? In speaking of worshipping and serving the creature rather than the Creator, Paul is not making some generalization about the invariant structure of human nature.

But there is one thing Paul says about this group of image-worshipping homosexuals that he appears to believe holds true for all human beings. In verse 19 he says that "what can be known about God is plain to them." And then in verses 20-21 he goes on to say that "ever since the creation of the world his invisible nature, namely, his eternal power and deity, has been clearly perceived in the things that have been made. So they are without excuse; for although they knew God they did not honor him as God or give thanks to him." Here too it is some image-worshipping group of homosexuals to which Paul is referring. Nonetheless, the way in which he refers here to creation makes it clear that he would be willing to say about *all* human beings, not just those he has in mind, that they know about God, though indeed they do not all acknowledge him.

Now it is a good question how we are to understand the sort of knowledge that Paul is speaking of here. My colleague Richard Mouw has made the interesting suggestion that we should probably not understand Paul as claiming that all men *consciously* know God, but rather that the knowledge often takes a form rather like the self-deception which Sartre so subtly analyzes in the chapter on "Bad Faith" in *Being and Nothingness*. Be that as it may, *knowing* God is in any case not a *tendency*, and certainly not a tendency which can be turned in one direction or another for its satisfaction. We do not have in Paul's teaching about the universal knowledge of God the doctrine of a "religious" tendency in man which is universal, ineradicable, and irresistible, allowing us the freedom only of turning it in one direction or another.

Clearly it is part of the biblical teaching that all men stand responsible before God. That—if we wish to speak thus—constitutes man's religious nature. His religious nature is his vocation. But there is no reason to think that man's response to his calling—whether the response of obedience or the response of rebellion—always takes the form of satisfying some in-created tendency which is irresistible of fulfillment in a Religion. Neither experience nor Scripture teaches that there is in us any such "religious tendency." Neither teaches that all men inescapably have a Religion. The tendency to have a religion—in the straightforward sense of "religion"—is pervasive and strong in mankind. Yet some men are irreligious. In their irreligion—rather than in their false religion—lies their rebellion.

7. THE WORLD BEHIND THE WORK

The Protestant view which sees every work of art as expressing the Religion (i.e., ultimate concern) of its maker, will not do as a comprehensive approach to the arts. Yet there is something of fundamental importance to be learned from this view—namely, that there is always *a world behind* the work, of

which the work is an expression; and that often the religion of the artist, or his particular version of secularism, has a central role in that world.

Suppose we mean by *the world behind* a work of art, that complex of the artist's beliefs and goals, convictions and concerns, which play a role in accounting for the existence and character of the work.* The beliefs in question may range all the way from relatively trivial and passing convictions to the artist's world-and-life view, his or her *Weltanschauung;* the goals, all the way from minor transitory aims to an ultimate concern. Then certainly it is true that the religion of the artist often occupies a central position in the world behind the work; and where the artist lacks a religion, then often the artist's particular version of secularism occupies a central position in that world. Contrary to Freud, religion is not always rationalization for psychological drives; nor, contrary to Marx, is it always ideology concealing economic interests. Religion does not have the status of always needing to be accounted for while itself accounting for nothing. The religions of mankind account for the actions of mankind.

If we wish, we may speak of the work as *an expression of* the world behind it—meaning simply that the convictions and concerns belonging to that world account for the artist's making the work, and for his making it as he did. What must be added at once, however, to forestall misunderstanding, is that the work by no means always fully *reveals* the world behind it. Even the most perceptive apprehension of the work may leave us uninformed as to crucial elements in the world behind it. A work may be an expression of the world behind itself without fully revealing that world.

What the Protestant view rightly and forcefully calls to our attention is the presence of a world behind each work of art, of which the work is an expression. Works of art are not simply the oozings of subconscious impulses; they are the result of beliefs and goals on the part of the artist. What the Protestant view also calls to our attention is that the religion of the artist often occupies a central position in that world. Without an understanding of the religions of mankind, vast stretches of art remain inexplicable—as indeed, without an understanding of the secularisms of mankind, vast stretches remain inexplicable.

Nonetheless, distortion will result if we take as the basic framework of our approach to art, this phenomenon of the work's being an expression of the world behind it. Works of art are instruments and objects of action, actions on the part of the artist and actions on the part of the public. Given this, there will of course be an important relation between the work and the convictions or

*Almost never will this wholly account for the work. Almost always there will be elements in the work which cannot be accounted for by reference to the artist's states of consciousness. They may, for example, be due to "ways of seeing" of which the artist is scarcely aware, which he has learned from his prior experience with art. This is one of the main points developed with great richness of example in Ernst Gombrich's *Art and Illusion.*

concerns of the artist—a relation which I have described as that of the work's being an expression of the world behind it. But to focus just on this relation of work to consciousness of artist is to overlook all the rest of the rich embeddedness of art in the life of mankind. If this is all one attends to, an extremely truncated, reduced understanding of the arts will result. We must not obscure the wider scene of art in action.

The Given With Which the Artist Works

T HE ARTIST is placed on the stage of existence by God, there to do his or her work of making and selecting so as to bring forth something of benefit and delight to other human beings, something in acknowledgement of God. In this and the succeeding section I shall speak of two different "levels" in that with which the artist works. Here I shall discuss that *out of which* the artifact is made, looking at some of the ways in which the artist works with a medium. In the next I shall discuss the pervasive phenomenon of what I shall call "fittingness," seeing in what ways the artist is a worker in fittingness as well.

1. THE ARTIST AND HIS MEDIUM—MASTERING

It is not only tempting but customary to speak in lofty abstract tones about art—to spiritualize it, etherealize it, de-materialize it. But a work of art emerges only when an artist takes chisel in hand and chips away at stone, heats up a furnace and pours bronze, picks up a lump of clay and turns a pot, takes up brush or knife and spreads paint around, takes burin or acid and makes recessions in copper plates, selects from the verbal stock of his language a specific sequence of words, selects from the enormous array of diverse sounds that the instruments at his disposal can produce a sequence of just a few of them, selects from the infinite array of states of affairs just a few to make a story. The fundamental fact about the artist is that he or she is a worker in stone, in bronze, in clay, in paint, in acid and plates, in words, in sounds and instruments, in states of affairs. On some bit of the concrete materials of our stage he imposes order. He "humanizes" clay. He *masters* bronze. From those enormous arrays of abstract entities constituting our arena, he extracts an ordered few. He "humanizes" sounds, *masters* words. Let us pinpoint some of the central features of this action of mastering.

As the artist works with his chosen medium, he gradually comes to *know*

it. He learns what can be done and what cannot be done with it, what can be done readily and with ease and what only with great difficulty. He discovers new things to do with it, things that never occurred to anyone else to do. He learns and discovers various ways of using his material so as to achieve his goals; and he learns which of those ways are better and which worse. A furniture maker learns and perhaps discovers various ways of making the corners for drawers. He learns that some are better for one purpose and some for another, some in one respect and some in another, some for one kind of wood and some for another. And he learns that some are always bad—such as simply nailing the drawer together. The artist learns that she must avoid even trying to do some things with her material. She learns that if she wants a pot two feet high with walls a sixteenth of an inch thick (thin) she had best forget about clay and order the pot from a plastics factory. All such things she can learn because her material is not some infinitely protean stuff. It has a nature. There are laws holding for it. The stage of actuality is God's structured creation.

When the artist first begins to work in his material, someone may speak to him about the "properties" of wood, the "characteristics" of clay. That may be helpful. But what he thereby learns is as vague an adumbration of what he later comes to *know* about his material as a description of the characteristics of one's husband or wife is a vague adumbration of what one comes to know of him or her.

As he acquires knowledge of his material he also builds up *skill* in using it to accomplish his purposes. From the beginning he can see how a dovetailed drawer looks. Yet for a long time it proves beyond his ability to bring off. And when he first makes one, it turns out messy, sloppy, inelegant. Gradually he learns how. Gradually the artist acquires the skill to make a pot which isn't lumpish at its base and with sides varying arbitrarily from thick to thin and back again.

And as he acquires knowledge of his material and builds up skill in using it, something develops in him that can best be called *respect* for his material. He learns that he can go only so far in imposing his will upon it. Or to put it from the other side, he learns that his material will be receptive only to certain aims on his part. Others it will permanently frustrate. And to others it will yield only with enormous reluctance.

This combination of knowledge, skill, and respect is presupposed in what we know as *craftsmanship*. Craftsmanship consists in how well one's work meets certain standards in one's use of the material, these being the standards of a certain community. Their origination within the community presupposes that whatever the general goals of those who work in a certain material may be, there will be certain subsidiary aims which repeat themselves over and over for which standards of excellence in achieving can be established. No matter what the style of furniture, drawers will have to be made; so a community can adopt standards for excellence in the construction of drawers. If regularly

repeated subsidiary aims disappear from the activities of those who work in a certain material, then considerations of craftsmanship become irrelevant. Almost all the traditional standards of craftsmanship in the art of the painter are irrelevant in the face of abstract expressionist paintings. *All* the standards of craftsmanship in the art of the musician are irrelevant in the face of some of the music of John Cage.

Often, when standards of craftsmanship are operative in a particular community for those who work in a certain material, skill in accomplishing some of these subsidiary aims becomes the decisive test of the artist's craftsmanship in general. The apprentice furniture maker ready to move on is set the problem of making a dovetailed drawer. The music student before she is allowed to graduate is set the problem of composing a fugue on a preselected theme. And so we acquire a simple way of dismissing those whose craftsmanship is poor: "She can't even draw." "He can't even compose a decent fugue." "She can't even write a respectable vilanelle."

It is easy but calamitous to confuse high craftsmanship with the ability to bring off a tour-de-force. A tour-de-force is the achievement of something which stretches the abilities of the material to its uttermost. In those who know the material it produces a combination of astonishment and uneasiness.[6] The craftsman has learned if at all possible to avoid the tour-de-force. He or she prefers the sense of well-being produced by executing superbly what is well within the capabilities of the material. The statuary on the face of Chartres cathedral manifests superb craftsmanship in stone. By contrast, the east wall in Gloucester cathedral is a tour-de-force in stone. The wall is so vast, the amount of glass in it so great, the stone members supporting it so thin, that one stands aghast at both the daring and the success. The chairs of Hans Wegner are superbly crafted; those of Finn Juhl are tours-de-force. Those marvellously uniform expanses of solid color in the lithographs of Paul Wünderlich, difficult as they are to achieve, are not tours-de-force but examples of high craftsmanship; whereas Olivier Messiaen's *Vingt regards sur l'enfant Jesus,* though extraordinarily moving, has in it a good deal of the tour-de-force, even, to speak paradoxically, of the *unachievable* tour-de-force. That the opening piece, "The perspective of the Father on the Son," should come as close to standing still as music can come, thus to fit eternity, is astonishing in view of the fact that it is played on the piano, an instrument whose sound is not sustained. In this respect the tour-de-force is successful. Where it is unsuccessful is in the use of chords so broad in span that only the hand of a giant could play them without rolling them.

The tour-de-force is a sign of exasperation with one's material; craftsmanship, the sign of respect.

Of course craftsmanship has nothing much to do with creativity. There are superb craftsmen who have little imagination and superbly imaginative people who display little craftsmanship. The works of Immanuel Kant, to take an example from outside the arts, are a staggering manifestation of intellectual

imagination; but in the quality of their philosophical craftsmanship they are much below the works of the high and late medievals.

There has indubitably been a decline of craftsmanship in the contemporary arts, due in part to our willingness to give up good craftsmanship for the sake of creativity.[7] But also considerations of craftsmanship are frequently just irrelevant to the contemporary arts, due to the fact, already observed, that the artist's creative exploration of her material takes her beyond the applicability of the community's standards—justifiably so.[*] It's not that she and we tolerate low craftsmanship in her work for the sake of the creativity there manifested. It's rather that considerations of craftsmanship no longer apply. She doesn't aim at representation, and so the comment "She can't even draw accurately" is irrelevant. That does not necessarily mean that artists who have moved beyond the applicability of standards of craftsmanship no longer have knowledge of, skill in, and respect for their material. But that too is often the case. Under the pressure of the Enlightenment urge to be liberated from all that limits, thus to be able to create like unto our Divine Master, many of our contemporary artists repudiate the *mastering* of which I am speaking.

Yet we must not exaggerate the decline and disappearance of craftsmanship. Much is left. The poems of Dylan Thomas, for all their Romantic effusion, are paradigms of craftsmanship, as are W. H. Auden's. And possibly our performing musicians today meet higher standards of craftsmanship than musicians ever did before.

Surely much of the delight to be derived from contemplating a work of art—or from performing it—derives from our appreciation of the craftsmanship displayed. We enjoy playing the works of those who "know how to write for the instrument," those who, though they may confront us with difficult passages, don't confront us with unavoidably awkward fingering; and we enjoy the effortless ease of Nathan Milstein's playing of the Bach sonatas and partitas for violin, knowing as we do something of the extraordinary craftsmanship needed to achieve such "effortless ease." In one of his interviews pianist Glenn Gould suggests that live concerts fulfill in us a kind of gladiatorial instinct to see the performer bungle the job. Surely that's not the whole of the matter.

There is also a kind of respect the artist shows for his material—often anyway—that goes beyond the respect of refusing to press the material beyond its points of resistance. This other kind of respect is also comprised in *mastering*. It's easy—easy because we've been taught—to think that the artist has in mind a clear image of what he or she wants and then, having acquired an assortment of skills, deftly imposes that image on the material. Most of the time the truth is far other. The work of art emerges from a *dialogue* between

* Perhaps here it should be said explicitly that craftsmanship is but one manifestation of respect for materials. The avant-garde artist may respect his materials while going beyond the community's established standards for good craftsmanship.

artist and material. The printmaker has in mind certain ideas and images for what she wants her print to be like. Usually they are vague, not sharp and precise. She then picks up burin and gouges a line in the plate before her. But it doesn't turn out exactly as she wanted; or it does, but suddenly she notices something about it that she hadn't had in mind. So she revises her intent ever so slightly and when gouging the next line makes it somewhat different from what she had anticipated. And so it goes. No sovereign godlike freedom! Rather a conversation between herself and her material, leading her along, not quite ineluctably, toward an outcome that she never clearly had in mind, possibly an outcome that fits well within her original vague ideas but possibly also an outcome that she never anticipated, perhaps even one that surprises her. And at last, having been led along in conversation with her material to a point never anticipated, she is faced with a decision: Is she to approve of what has been given birth or to disapprove? Does she keep it or does she toss it out and begin over?

This fascinating, mysterious, frustrating, exhilarating experience of being led along in conversation with one's material is an experience that turns up in all the arts. Stories once begun, sonatas once started, performances of sonatas once started, poems once initiated, all acquire a life and a speech of their own, so that the feeling one has when ready to begin the composition or performance of a work of art is almost always apprehensive anticipation. One doesn't know what will develop. One anticipates finding out; yet at the same time one feels apprehensive. Perhaps what will develop will be almost exactly what was hoped for, and splendid. Perhaps it will be something surprising, though good nonetheless, maybe even better than what was hoped for. On the other hand, what develops may fit nicely within one's original images and ideas but prove bad, in its concreteness showing up the poverty of one's original ideas. Or one's conversation may turn into a wholly unanticipated direction and the result prove unredeemable and intolerable. If one is genuinely willing to hold conversation with one's material and not determined, come what may, to wrest it into shape, then to set about creating a work of art is to be willing, with apprehensive anticipation, to be led along in conversation to destinations unknown.

One more experience is to be brought under what I have in mind by *mastering*. W. H. Auden once spoke to the issue of what was necessary to become a good poet. Part of his answer was: You must like "hanging around words listening to what they say."[8] The love of one's materials, the opposite of the Enlightenment abhorrence of materials, also goes within mastering. The potter loves clay, not so much indeed for what it is as for what it can become; he or she longs to nurture it into pots. The musician loves sounds, wishing to see them develop into music. And the painter loves paint, wanting to assist it in finding its fulfillment in paintings.

Quite obviously, as I have noted, the artist can take other attitudes toward his material than those appropriate to mastering. There is the attitude

of abhorrence for materials which earlier we heard expressed by Marcel Duchamp—the "Duchamp attitude" we may call it. There is the attitude of total subservience to materials, of simply wishing to let the sounds be sounds—the "Cage attitude" it may be called. And there is the attitude that what counts is just the mental image or message, and that the material is nothing more than a totally subservient bearer of this image or message to someone else than the artist. This we may call the "Croce attitude." For the Italian aesthetician Benedetto Croce went so far as to say that the work of art *is* the mental image, that the material is nothing more than mere stuff out of which to make something that will transmit the work of art from one mind to another.

I have explained what I mean by "mastering" by highlighting certain experiences of the artist as he works with his material. Those who hold these other attitudes would no doubt admit that these experiences occur. But they would downplay their significance, highlight other experiences, even say that such experiences should be eliminated from our commerce with the arts. I doubt that we can ever eliminate them entirely and still have much left that satisfies us. But still, it should now be clear that when in the last chapter I spoke of the artist as participating in our calling to be masters of God's creation, I was both adopting a perspective on art to which there are alternatives and making tacit recommendations.

The Christian confession of God as Creator and man as responsible earthling leads us to place the artist's working with materials at the heart of the artistic enterprise. It does not allow us to overlook his working with materials, nor to spiritualize it. And then it leads the artist toward trying to master those materials, for the benefit of himself and his fellows, and to the honoring of God. It leads him away from abhorring those materials, away also from abject submission to them, away too from seeing them as nothing but slaves for transmitting mental images and messages from one person to another.

2. THE ARTIST AND FITTINGNESS

a. The Nature of Fittingness: Sometimes artists bring into existence what did not exist before, and so create. Sometimes they select from what did exist, and so compose. But whether they create or compose, always they make their work *out of* something—out of wood or stone or bronze or words or pigment on canvas.

But also artists are workers in *fittingness*—all artists, inescapably, not indeed in the sense that their work is *made out of* fittingness, but rather in the sense that fittingness is a feature of the reality within which we all exist. It is a feature of which we are all aware, artist and non-artist alike, and which the work of art inescapably shares in, partly by the artist's intent, partly not.

But what is fittingness? Before I proceed to a somewhat technical explanation, let me offer some playful examples in which perceptions of fittingness are called for. In his book *Art and Illusion* Ernst Gombrich

describes a ping-pong game which is to be played as follows: Take the two words "ping" and "pong," and then for pairs of contrasting objects or qualities have the players say which member of the pair fits best with "ping" and which fits best with "pong." Here are some pairs arranged in columns according to how most people in my experience would arrange them (and how I would do so as well):

"PING"	"PONG"
light	heavy
small	large
ice cream	warm pea soup
pretty girl	matron
trumpet sound	cello sound
Mozart's music	Beethoven's music
Matisse's paintings	Rembrandt's paintings

Secondly, consider these lines:

Everybody in my experience judges that the former fits better with restlessness and the latter with tranquility. So too everyone judges that a straight vertical line fits better with restlessness and a straight horizontal line with tranquility.

Or thirdly, consider various gaits, various ways of walking; and then match up, according to fittingness, pairs of these with pairs of nonsense lines from fairy tales and nursery rhymes. (I take my examples from an essay of O. K. Bouwsma.) Take the pair leaping/stomping. Which member fits better with "Hi diddle diddle" and which with "Fee, fi, fo, fum"? In my experience everybody matches up "Hi diddle diddle" with leaping and "Fee, fi, fo, fum" with stomping. Or take the pair mincing/shuffling. Most people in my experience say that the former member fits better with "Intery mintery" and the latter better with "Abra ca da bra" (though this case produces more disagreement than the other).

Fourth, consider Gustave Flaubert's statement that "The story, the plot of a novel is of no interest to me. When I write a novel I aim at rendering a color, a shade. . . . In *Madame Bovary*, all I wanted to do was to render a grey color, the mouldy color of a wood-louse's existence."[9] On first hearing, this may strike one as fanciful nonsense. To see that it is not nonsense consider a counterpart example from a work more familiar to most of us—say, Shakespeare's *Hamlet*. Does *Hamlet* fit better with purple or with yellow, with green or with burgundy? In my experience everyone offers purple and burgundy as the answers.

In music too we perceive fittingness. Everyone in my experience judges

that tones an octave apart fit better with tranquility, tones a seventh apart with restlessness. And though both Olivier Messiaen's "Les Anges" (from his *La Nativité du Seigneur)* and Bach's "Lass O Führst der Kerubinnen" (section 5 from his cantata 130) are about angels, everybody judges that Messiaen's piece fits better with archangels and that the instrumental introduction (and accompaniment) to Bach's piece fits better with cherubim. In Bach's case the words provide us with the clue that he himself was striving for fittingness between the character of his music and the nature of cherubim. No accompanying words and no attached program tell us that Messiaen had archangels in mind. But in fact there is probably no better way to apprehend the character of archangels than to listen with care to Messiaen's piece. Words are mute where Messiaen's music speaks.

Enough of examples. In each of these cases we are judging as to the fittingness between qualities or complexes of qualities. More precisely, we are comparing the *closeness* of fittingness between qualities or complexes of qualities. For not only is fittingness a relation; it is a relation that comes in degrees. It's not that *large* either fits or doesn't fit with *loud*. Rather, *large* has to *loud* a certain closeness of fittingness. And specifically, it has a closer fittingness to *loud* than it does to *soft* (in sound). Because fittingness comes in degrees, we can compare the closeness of fittingness within one pair of qualities or quality-complexes with that within another pair. Normally it is by making such comparisons that we specify a particular closeness of fittingness. Of course one can also just say that *large* fits with *loud,* meaning thereby that *large* has to *loud* a relatively close fittingness. But in fact all our examples were explicitly of the form "*x* is more fitting to *y* than it is to *z*" or "*w* is more fitting to *x* than *y* is to *z.*"

That tells us something of the logical structure of fittingness. It does not yet tell us what it is. So consider any relation that comes in degrees—being taller than, being smoother than, etc. Now for any such relation, *being Φ-er than,* there is another, *being Ψ-er than,* such that for *x* to be Φ-*er* than *y* is for *y* to be Ψ-*er* than *x*. Paired off thus with the relation of *being longer than* is the relation of *being shorter than;* for if one thing is longer than another then the other is shorter than it. Paired off thus with *being harder than* is the relation of *being softer than;* and paired off with *being sweeter than* is the relation of *being sourer than*. Let us call any such pair, a *modality*. Often the opposite poles of a modality can be specified in our language with antonyms. The first modality cited can be specified with the antonym-pair "long/short," the second with the pair "hard/soft," and the third with "sweet/sour."

Now things that stand to each other in the relations belonging to a modality have degrees of similarity to each other with respect to that modality—*intra-modal* similarity we may call it. With respect to the long/short modality the members of a pair of objects may be *very* similar to each other, *not so* similar to each other, etc.; and they may be more similar to each other than are the members of another pair of objects which participate in

that modality. Thus it is that entities which participate in a modality may be ordered with respect to their participation in that modality. Physical objects may be ordered with respect to the long/short modality, sounds with respect to the loud/soft modality, tastes with respect to the sweet/sour modality, and so forth.

Furthermore, when entities are ordered with respect to a given modality in which they participate, the sweet/sour modality, let us say, that will be because each has a *specific* sweet-sourness. For some modalites we have names for these specifics—"one foot in length," "three pounds in weight," etc. For others we do not. In ordinary life, at least, we have no names for the specific sweet-sourness of things. In any case, however, not only are objects which participate in a certain modality ordered with respect to that modality; derivatively the *specific qualities* determining their ordering are also ordered with respect to that modality, intrinsically so. One foot in length is closer to two feet in length than it is to three feet. Thus we may speak of intra-modal similarity among specific qualities as well as among objects having those qualities.

But not only is similarity to be found *within* modalities. There is also *cross-modal* similarity. Something's being larger than something is (intrinsically) more like something's being louder than something than it is like something's being softer than something. Something's being faster than something is (intrinsically) more like something's being sharper than something than it is like something's being duller than something. And so forth. In such situations as these there is similarity aross modalities, holding between cases of relations. There is also a derivative relation, holding between the relations themselves which constitute the modalities, which we may likewise refer to as *cross-modal* similarity. The relation of *larger than* bears a stronger cross-modal similarity to *louder than* than it does to *softer than, faster than* a stronger cross-modal similarity to *sharper than* than it does to *duller than*, etc.

And now it can be said: Fittingness is similarity across modalities. *Fittingness is cross-modal similarity*. To say that *large* fits better with *loud* than with *soft* (in sound) is to say that the cross-modal similarity between *large* and *loud* is closer than that between *large* and *soft*.

Fundamental questions come at once to mind. Always when things are similar, they are similar *with respect* to something—size, temperature, speed, or whatever. With respect to *what*, then, is *large* more like *loud* than like *soft* (in sound)? That question will come to the minds of some. And to everyone's mind will come this question: To what extent do people from different cultures, or even from the same culture, agree in their judgments concerning fittingness?

In recent years a sizeable body of fascinating psychological material bearing on these questions has grown up, most of it derived from experiments conducted or directed by C. E. Osgood. Osgood's experiments arose out of

the context of studies conducted in the 1930's concerning *synesthesia*—the phenomenon in which stimulation in one sense modality produces a sensation or vivid "image" in a different sense modality, as when upon hearing music a person has bright visual imagery. Apparently it was Goethe who first remarked on this phenomenon of synesthesia. He reported that in the experience of some people, musical sounds produce various visual impressions: color impressions, two-dimensional pattern impressions, etc.

What is also sometimes called synesthesia is that phenomenon in which a sensation or vivid image in one sense modality is produced merely by *thinking* of something not in that modality, without any sensory stimulus actually occurring. I shall call this *loose* as opposed to *strict* synesthesia.

On into the 1930's a substantial number of reports on synesthetic individuals appeared in the psychological literature.[10] In all this literature synesthesia is treated as an unusual and freakish phenomenon. The following description of a subject who was both a loose and a strict synesthete is characteristic:

> Color plays a very important part in S's life, and she is always conscious of a colored background. She is never without this color background, which is part of herself, and she finds it difficult to imagine what other people's minds can be like devoid of this color. The color does not remain constant, but varies in regular manner according to the person spoken to, the conversation listened to, the music heard, or according to the task in which S is engaged. In listening to a lecture, for example, the topic of the lecture evokes a definite color; this color will form the background as long as S is interested in the lecture. If S changes her attention from lecture to lecturer, the color of the lecturer predominates. Different subjects call up differently colored backgrounds, and different persons cause different colors to appear in the mind of S. For example, Chemistry is green, and while she is listening to lectures on Chemistry, green is the pervading color atmosphere. Anatomy is red, Ethics white, Metaphysics is a nice gray; Psychology is white, but subjects in Psychology may have their own colors: Psychology of Suggestion would be brown.[11]

Beginning in the 30's some serious attempts were made to go beyond merely describing notable cases of strict synesthesia to discerning some pattern or law therein. In the course of discussing a seven-year-old synesthete, the researchers Riggs and Karwoski suggested that "there are two fundamental characteristics of synesthesia which set it apart as a single phenomenon." One of these, they said, is that synesthesia originates in childhood. The other and more important is that "every case of synesthesia . . . consists essentially of a parallel arrangement of two gradient series. They may be series of pitches, intensities, wave lengths, forms, etc."[12] Obviously what Riggs and Karwoski call "gradient series" is the same as what I called "modalities." Shortly we shall see more of this idea that synesthesia consists of the "parallel arrangement" of "gradient series."

It was also discovered in the 30's that strict synesthesia is not as rare as

had been assumed. In 1938 it was reported that 13 percent of Dartmouth College students said they regularly associated color with musical selections, and that a much larger percentage said they did so occasionally. Furthermore, it was discovered that music/photism synesthesia is not idiosyncratic in the particular cross-modality connections which are made. Surveying their own data and that of others, Karwoski and another psychologist, Odbert, arrived at the following general relationships between music and elicited photisms:

a) Increase in brightness tends to accompany rise in pitch. b) Increase in brightness tends to accompany quickening of tempo. c) Pattern of the photism frequently is related to 'pattern' of the music—graceful lines accompany smooth music, jagged lines accompany staccato music or syncopation. d) Position and direction in the visual field vary with pitch for some subjects. e) Photisms sometimes expand over greater area with an increase in the volume of the music. f) Movement around a center mass may accompany turns or trills. g) Lines of different color may represent instruments of different timbre. h) Colors may fit the 'mood' of the music, or its pleasantness. [13]

At the same time as these reports and analyses of strict and loose synesthesia were taking place, a related though distinct phenomenon was being analyzed. Already in 1921 [14] data on the "affective tone" of lines was reported. Subjects tend to represent *sadness* with large downward-directed curves, *merriment* with small upward-directed curves, *gentleness* with large horizontally directed curves, etc. And in 1942 Karwoski, Odbert, and Osgood reported on an experiment in which subjects were presented with short snatches of music and were then asked to draw something representing what they heard. Again there was a great deal of commonality in their responses. [15] Many other experiments come to the same conclusion concerning the commonality of such responses to stimuli.

What makes it clear that in all these reports something different from either strict or loose synesthesia is being discussed is that no sensation or vivid image was required. There may in some cases have been such; but certainly this was not required of the subject. So let us speak of *expanded* synesthesia when the response called for is neither a sensation nor a vivid image but merely some sort of indication of a quality of experience.

We need not content ourselves with speculating as to whether expanded synesthesia is related to strict synesthesia. For one of the aims of the Karwoski, *et al*. experiment was to explore this very point. It was discovered that there is no significant difference between those who are strict synesthetes and those who are not: the designs they draw to represent the musical selections tend to have the same characteristics. The same conclusion was drawn from another experiment reported in 1942. The subjects were presented with ten short excerpts from classical music. They were then asked to indicate the dominant mood of each by checking adjectives arranged in a "mood circle"; and then, on a second hearing, to give the name of the color

(from a list) which was most appropriate to the music.[16] It was again found that there was considerable intersubject agreement in the judgments connecting music and mood, music and color, and especially mood and color. Specifically, Delius's *On Hearing the First Cuckoo in Spring* was by most judged leisurely in mood and green in color; and part of Wagner's *Overture to Rienzi* was judged vigorous or exciting in mood and red in color. But equally important, it was found that non-synesthetic subjects generally produced the same results as those who claimed vivid synesthesia. "Subjects who are forced to relate colors to music give responses very similar to those of subjects who react readily to music with vivid visual imagery. The chief difference is in the richness of the response."[17]

The Karwoski, *et al.* experiment explored one other matter: whether, in connecting colors to music, it made any significant difference whether the response was given by indicating a patch of color or by using a word to name a color. It was discovered that there was none.

> The technique of doing the same experiment on two different psychological levels—the sensory level and the verbal level—has given us information concerning the relation of words to direct experience. The word tests yield very much the same results as actual sensory experience. . . . The close similarity of the results from these different levels of experience raises some doubt as to how different the levels are. . . . The problem of synesthesia has been obscured by paying too much attention to verbal distinctions such as sensory vs. non-sensory.[18]

But to call a snatch of music *red* is obviously to use "red" as a metaphor; and so also for "exciting." Thus, coming out of this experiment is evidence of a connection between expanded synesthesia and at least some metaphors—call them synesthetic metaphors. It seems to be a trivial difference whether one specifies the character of a snatch of music by indicating a certain color or mood as the one most fitting, or whether one does so by applying a color or mood adjective to the music. Indeed, in most of the literature cited there is no attempt to distinguish expanded synesthesia from synesthetic metaphor.

We can pull together what all these experiments indicate concerning the relation between synesthesia and metaphor by quoting C. E. Osgood's summary:

> The regular photistic visualizers varied among themselves . . . as to the vividness of their experiences, and their difference from the general population seemed to be one of degree rather than kind. Whereas fast, exciting music might be pictured by the synesthete as sharply etched, bright red forms, his less imaginative brethren would merely agree that words like "red-hot," "bright," and "fiery," as verbal metaphors, adequately described the music; a slow, melancholic selection might be visualized as heavy, slow-moving "blobs" of somber hue and be described verbally as "heavy," "blue," and "dark." The relation of this phenomenon to ordinary metaphor is evident.[19]

Karwoski, *et al*. argued for an even closer relation between synesthesia and metaphor. They argued that the *Principle of Parallel Polarities and Gradients* holds for metaphor and analogy as well as for synesthesia, and that it holds for expanded synesthesia as well as for strict:

> In color-hearing a linkage of an auditory pole with a visual pole implies a linkage of their opposites. Gradations along an auditory continuum may be paralleled by gradations along a visual continuum. The synesthetic or analogical process appears to be the parallel alignment of two gradients in such a way that the appropriate extremes are related, followed in some cases by translations in terms of equivalent parts of the two gradients thus paralleled.[20]

Thus, for example,

> it was noted . . . that most subjects translated *fast* music into *light* colors, while *slow* music appropriately became *dark* colors. Here fast and slow are the psychological opposites of one experimental gradient (stimulus) and light and dark are the opposites of another (response). The synesthetic or analogical process appears to be the parallel alignment of two such gradients in such a way that the appropriate extremes are related.[21]

None of the experiments thus far reported has pretended to be intercultural. Their subjects were all members of contemporary Western culture. The well-known fact that certain metaphors pervade human culture—good things are *up* and *light* in color, bad things are *down* and *dark*, etc.—is some evidence of intercultural commonality. But something of a less impressionistic sort would be more convincing. In recent years, C. E. Osgood and associates have conducted a number of experiments relevant to the cross-cultural issue. It is to this body of experiments that I now turn.

We can begin our survey of Osgood's work by looking at the data which he and his associates published in the mid-50's on what they called the *semantic differential technique*. In the earliest uses of this technique, Osgood would take a more or less randomly selected list of antonyms. For each pair of these he would then make a 7-place scale. Then for each of a list of what he called "concepts" he would ask the subject to indicate where on each antonym scale he thought the concept fitted best. Here, for example, is one of Osgood's early experiments:

LADY, BOULDER, SIN, FATHER, LAKE, SYMPHONY, RUSSIAN, FEATHER, ME, FIRE, BABY, FRAUD, GOD, PATRIOT, TORNADO, SWORD, MOTHER, STATUE, COP, AMERICA

1. good ____:____:____:____:____:____:____ bad
2. large ____:____:____:____:____:____:____ small
3. beautiful ____:____:____:____:____:____:____ ugly
4. yellow ____:____:____:____:____:____:____ blue
5. hard ____:____:____:____:____:____:____ soft
6. sweet ____:____:____:____:____:____:____ sour

 7. strong ____: ____: ____: ____: ____: ____: ____ weak
 8. clean ____: ____: ____: ____: ____: ____: ____ dirty
 9. high ____: ____: ____: ____: ____: ____: ____ low
10. calm ____: ____: ____: ____: ____: ____: ____ agitated
11. tasty ____: ____: ____: ____: ____: ____: ____ distasteful
12. valuable ____: ____: ____: ____: ____: ____: ____ worthless
13. red ____: ____: ____: ____: ____: ____: ____ green
14. young ____: ____: ____: ____: ____: ____: ____ old
15. kind ____: ____: ____: ____: ____: ____: ____ cruel
16. loud ____: ____: ____: ____: ____: ____: ____ soft
17. deep ____: ____: ____: ____: ____: ____: ____ shallow
18. pleasant ____: ____: ____: ____: ____: ____: ____ unpleasant
19. black ____: ____: ____: ____: ____: ____: ____ white
20. bitter ____: ____: ____: ____: ____: ____: ____ sweet
21. happy ____: ____: ____: ____: ____: ____: ____ sad
22. sharp ____: ____: ____: ____: ____: ____: ____ dull
23. empty ____: ____: ____: ____: ____: ____: ____ full
24. ferocious ____: ____: ____: ____: ____: ____: ____ peaceful
25. heavy ____: ____: ____: ____: ____: ____: ____ light
26. wet ____: ____: ____: ____: ____: ____: ____ dry
27. sacred ____: ____: ____: ____: ____: ____: ____ profane
28. relaxed ____: ____: ____: ____: ____: ____: ____ tense
29. brave ____: ____: ____: ____: ____: ____: ____ cowardly
30. long ____: ____: ____: ____: ____: ____: ____ short
31. rich ____: ____: ____: ____: ____: ____: ____ poor
32. clear ____: ____: ____: ____: ____: ____: ____ hazy
33. hot ____: ____: ____: ____: ____: ____: ____ cold
34. thick ____: ____: ____: ____: ____: ____: ____ thin
35. nice ____: ____: ____: ____: ____: ____: ____ awful
36. bright ____: ____: ____: ____: ____: ____: ____ dark
37. bass ____: ____: ____: ____: ____: ____: ____ treble
38. angular ____: ____: ____: ____: ____: ____: ____ rounded
39. fragrant ____: ____: ____: ____: ____: ____: ____ foul
40. honest ____: ____: ____: ____: ____: ____: ____ dishonest
41. active ____: ____: ____: ____: ____: ____: ____ passive
42. rough ____: ____: ____: ____: ____: ____: ____ smooth
43. fresh ____: ____: ____: ____: ____: ____: ____ stale
44. fast ____: ____: ____: ____: ____: ____: ____ slow
45. fair ____: ____: ____: ____: ____: ____: ____ unfair
46. rugged ____: ____: ____: ____: ____: ____: ____ delicate
47. near ____: ____: ____: ____: ____: ____: ____ far
48. pungent ____: ____: ____: ____: ____: ____: ____ bland
49. healthy ____: ____: ____: ____: ____: ____: ____ sick
50. wide ____: ____: ____: ____: ____: ____: ____ narrow

It is worth noting that the randomness of the scale selection and the vagueness of the instructions result in the subject's making judgments of several different sorts as he proceeds. Sometimes the scale has a straightforward literal application to the thing named by the "concept." This is true, for example, when "boulder" is ranked on the hard/soft scale and when "Russian" is ranked on the good/bad scale. In other cases, the result may reflect a straightforward case of concomitance in experience. If, perchance, the only symphonies some subject had ever heard were performed in red

concert halls, then "symphony" might on that ground alone be rated heavily toward the red end of the red/green scale. In most cases, though, the subject is forced to treat the antonyms specifying the scale as metaphors. Some such metaphors will turn out to be canonized in the culture of the subject. Many, though, will not be.

What chiefly interested Osgood in his early studies was the fact that some scales showed a fairly high degree of correlation with each other. For example, concepts placed toward the left on the good/bad scale tended also to be placed toward the left on such scales as beautiful/ugly, sweet/sour, kind/cruel, and pleasant/unpleasant. Concepts placed toward the left on the sharp/dull scale tended also to be so placed on the fast/slow scale. And so forth. In short, the scales had a tendency to fall into more or less stable clusters, though the scales belonging to a cluster varied somewhat in the degree to which they acted in concert with the other members of the cluster.

This clustering effect emerged when Osgood analyzed the complex correlations of scales with each other across subjects and across concepts by using the statistical procedure of "factor analysis." This procedure assumes the existence of certain "factors" which determine the placement of concepts on scales, a given factor significantly determining the results on only some of the scales, and then doing so to a degree which varies for different scales. A given factor is like a thread on which we string as many as we can of the beads which are the scales of the experiment, each thread penetrating some of the beads it catches at or near their center and others well off towards the edge. (Where the analogy falls short is that, for the factors and the scales, *we* determine what is to count as still catching the bead.)

Osgood and his associates discovered in their early work that over and over again, across subjects and across concepts, three factors emerged. They called these, *Evaluative*, *Potency*, and *Activity*. Specifically, around the Evaluative factor were clustered such scales as good/bad, pleasant/unpleasant, and positive/negative. Around the Potency factor were clustered such scales as strong/weak, heavy/light, and hard/soft. And around the Activity factor were clustered such scales as fast/slow, active/passive, and excitable/calm.*

* In the experiment reported above, the following scales had a significant loading on the Evaluative factor: good/bad, beautiful/ugly, sweet/sour, clean/dirty, tasty/distasteful, valuable/worthless, kind/cruel, pleasant/unpleasant, sweet/bitter, happy/sad, sacred/profane, nice/awful, fragrant/foul, honest/dishonest, fair/unfair. On the Potency factor the following had a significant loading: large/small, strong/weak, heavy/light, thick/thin, hard/soft, loud/soft, deep/shallow, brave/cowardly, bass/treble, rough/smooth, rugged/delicate, wide/narrow. And on the Activity factor these had a significant loading: fast/slow, active/passive, hot/cold, sharp/dull, angular/rounded, red/green, young/old, ferocious/peaceful, and tense/relaxed.

Presumably it was the Activity factor which was operating when, in one of our opening examples, we judged that a vertical line fits better with restlessness and a horizontal one with tranquility. As evidence, we may note that invariably one would rate a vertical line toward the left on each of the scales connected here with the Activity factor.

It should be emphasized that the emergence of these three factors does not mean that subjects tend to judge stimuli alike. They may or may not. It simply means that scales tend to fall into three identifiably similar clusters no matter who the subject. Some subjects may rate "Russian" more good than bad. If so, they will tend also to rate it more pleasant than unpleasant and more positive than negative. Others may rate Russian more bad than good. If so, then they will tend merely to reverse the rating on those same scales, rating it more unpleasant than pleasant and more negative than positive.

After the initial studies a large number of variants were developed. Different scales were used, and sometimes the scales were presented by means of polarity pictures rather than polarity words. Various other "stimuli" were used, not only other concepts than the twenty we cited but also things other than "concepts": color patches, sounds, phonemes arranged in nonsense sequences, facial expressions, etc. Likewise the subjects were varied. Different age levels were compared, different educational levels, different cultures, and in at least one case schizophrenics were compared with normal subjects. What invariably showed up, provided that the scales were randomly chosen and not deliberately set up to keep out one of the factors, were the same three factors.

The fact that these same three factors emerge in different cultures does not yet tell us, though, that people in different cultures judge qualities in the same way. For example, among us the Potency factor collects together the scales strong/weak, heavy/light, and hard/soft. For all we know, however, it might have little to do with those particular scales among the Japanese. That would be significant. And then secondly, even if it did collect together pretty much the same scales among the Japanese, they might scale things in such a way that *strong* is allied with *light* and with *soft*, whereas we ally it with *heavy* and with *hard*. The fact that two scales occur together in the Potency cluster in each of two cultures does not mean that their *directionality* within the clusters is the same in the two cultures. Some may be flipped with respect to others. That too would be significant.

In actual fact, however, the extent of intercultural agreement on these matters is astonishing. In his article "Cross-Cultural Generality of Visual-Verbal Synesthetic Tendencies,"[22] Osgood reported on a significant cross-cultural experiment. To reduce problems of translation, the scales were in the form of thirteen pairs of polarity pictures—a pair of drawings illustrating thick/thin, a pair illustrating blunt/sharp, a pair illustrating up/down, etc. The following 28 concepts, mainly names of qualities now rather than of objects, were then given for evaluation: heavy, good, fast, happy, up, energetic, loose, black, woman, lazy, tight, green, noisy, grey, slow, white, calm, man, yellow, weak, and sad. The test was given to English-speaking Americans, to Mexican-Spanish in the American Southwest, to Navajos, and to Japanese. The appraisal of the results went as follows. First, for each culture the experimenters picked out those concept-scalings on which there was

significant intracultural agreement. Then pairs of cultures were taken, and those particular concept-scalings which received significant intracultural agreement in *both* cultures were singled out. That then left the crucial question of whether the concepts were scaled in the same direction in both those cultures. Suppose, for example, that among the Navajos there was significant agreement on whether heavy was more thick than thin or vice versa. And suppose that among the Japanese there was significant agreement on the very same matter. That, then, poses the question of whether, let us say, the Navajos thought that heavy was more thick than thin whereas the Japanese thought that it more thin than thick. The results were as follows: For Anglos vs. Navajos there were 73 concept-scalings in which both groups yielded significant agreement within the group; of these, 86 percent were in the same direction of synesthetic connection. For Anglos vs. Mexican-Spanish, 67 concept-scalings gained significance in both groups; and 100 percent of these were in the same direction of connection. For Anglos vs. Japanese, 98 concept-scalings were significant for both, and 99 percent of these were in the same direction. For Navajos vs. Mexican-Spanish, 49 concept-scalings yielded 96 percent agreement in direction. For Navajos vs. Japanese, 90 percent of 71 concept-scalings showed the same direction of choice. And for the Mexican Spanish vs. Japanese comparison, 97 percent of 58 concept-scalings agreed in direction.

In summary Osgood says that

> The over-all similarities in synesthetic tendencies across these groups are impressive—when the synesthetic relationships that are significant (.01 level) intra-culturally are tested for cross-cultural agreement, approximately 90% of the relationships prove to be in the same direction. We can conclude with confidence, then, that the determinants of these synesthetic relations are shared by humans everywhere—to the extent that our sample of "everywhere" is representative.[23]

Thus two fundamental results emerge from the Osgood experiments which are relevant to our inquiry. First, when entities are "evaluated" on randomly composed lists of antonym scales, the Evaluative, Potency, and Activity factors persistently put in their appearance. Second, to a considerable extent the clustering of antonym scales with each other, and the direction in which they are clustered, remain stable even across cultures.

Now if one holds, as I do, that there are cross-modal similarities among qualities, then the significance of these results is obvious. In the three factors we have an answer to our first question—namely, in what respects do qualities resemble each other across modalities? The answer is that they resemble each other with respect to preferability (as I would rather call it), with respect to potency, and with respect to activity. Previously it was obscure in what respect *loud* resembles *large* more than it resembles *small*. Now there is clarity: with respect to *potency*. And now it is clear that it is with respect to

activity that a jagged line resembles restlessness, and an undulating one, tranquility. Secondly, in the results of the cross-cultural studies we have an answer to our other question—namely, to what extent is the perception of cross-modal similarities shared across cultures? The answer is *massively*. Of course the agreement is not total. But then neither is the agreement total within a culture on many *intra*-modal similarities. Yet it is hard to imagine anyone in any culture thinking that a jagged line fits better with tranquility and an undulating line with restlessness.

An alternative explanation of the Osgood results, to which most people in the contemporary world will be irresistibly attracted, is that in making the judgments which the experiments call for, we are making judgments as to which qualities just happen to come with which in our experience. Call this the "concomitance" explanation, on the ground that it attempts to explain the results by reference to the concomitance of qualities in our experience.

If we actually scrutinize the Osgood results, however, the concomitance explanation appears implausible. Look, for example, at some of the actual clusters listed in the footnote on p. 105. Are wide things generally rough, and narrow things generally smooth? Are sharp things generally red, and dull things generally green?

Secondly, if we were dealing here with mere happenstance concomitances of qualities in experience, there would then be no accounting for the perceived unity within each of the Osgoodian clusters, a unity which Osgood acknowledges by calling his factors not just X, Y, and Z, but Evaluative, Potency, and Activity—a unity of similarity. If one looks at the qualities belonging within each of these clusters, one can see why Osgood named the factor as he did. He noticed *similarities* among the scales belonging to each cluster and named the factor accordingly. He noticed that the scales in one cluster resembled each other in that the one pole was *preferable* to the other, and he named the factor "Evaluative." He noticed that the scales in a second cluster resembled each other in that the one pole might be described as more *potent* than the other, and he named the factor "Potency." He noticed that the scales in the third cluster resembled each other in that the one pole might be described as more *active* than the other, and he named the factor "Activity." In short, the emergence of these three identifiable factors, with their identifiably unified clusters, points straight at the conclusion that in performing these scalings the subjects were in the main judging similarities across modalities.[24] And the cross-cultural generalities indicate that to a considerable degree human beings of diverse cultures make the same judgments concerning these similarities.

The explanation that Osgood himself eventually preferred is also a perception-of-similarity explanation, though of a somewhat more complicated sort than the one I have proposed. He holds that we do not *directly* judge similarities among the qualities of our experience. Rather, we directly judge similarities among our affective responses and only indirectly judge the qualities which produce these affects. He says:

I suggest that the highly generalized nature of the affective reaction system—the fact that it is independent of any particular sensory modality, yet participates with all of them—is at once the mathematical reason why evaluation, potency, and activity tend to appear as dominant factors and the psychological basis for synesthesia and metaphor. It is *because* such diverse sensory experiences as a *white* circle (rather than a black), a *straight* line (rather than crooked), a *rising melody* (rather than a falling one), a *sweet* taste (rather than a sour one), a *caressing* touch (rather than an irritating scratch) can all share a common affective meaning that one can easily and lawfully translate from one modality into another in synesthesia and metaphor. This is also the basis for the high interscale communalities which determine the nature and orientation of general factors.[25]

Thus Osgood holds that what accounts for the EPA factors, as we may abbreviate them, is not direct similarities among the various qualities of reality but similarities in our affective responses to those qualities. There is something similar in our responses to white things, to straight things, to rising melodies, and to sweet things. In general, we respond similarly to the qualities clustered around some factor; and the factors themselves are then to be seen as deep-going commonalities in our affects. What led Osgood to this speculation was his noticing the striking similarity of his EPA factors to Wundt's three dimensions of feeling: pleasantness/unpleasantness, strain/relaxation, and excitement/quiescence.[26]

As to why our response to rising melodies should be similar to our response to sweet things, to straight things, etc., Osgood says this:

. . . by virtue of being members of the human species, people are equipped biologically to react to situations in certain similar ways—with autonomic, emotional reactions to rewarding and punishing situations (evaluation), with strong or weak muscular tension to things offering great or little resistance (potency), and so on. . . .[27]

The Osgoodian explanation for synesthesia/metaphor—that we are directly comparing our affects and only indirectly comparing the other qualities of our experience by reference to the sort of affects characteristically evoked by them—is a thoroughly plausible account for the Evaluative factor. Probably what is common to sweetness, to cleanliness, to kindliness, is that we feel positively toward them—that we have a preference for them over their contraries. But for the factors of *potency* and *activity* this explanation seems to me considerably less plausible. With respect to these factors is it not more likely that we discern a resemblance in the qualities themselves than that we discern it in our affective responses to them? Is it not more likely, for example, that we discern a deep-going similarity between loud/soft and large/small with respect to what one might well call *potency*?[28] It is interesting to note that Osgood himself slips into this "objective" explanation when, in the last passage quoted, he speaks of our reacting "with strong or weak muscular tension to things offering great or little resistance (potency)." Here he is obviously thinking of the qualities of our experience as having "great or little resistance." And what is this but "great or little potency"? Perhaps qualities

having great or little potency also characteristically cause affects having great or little potency. But this seems a gratuitous hypothesis.

In poetic language, Baudelaire's "Correspondences" describes the reality which Osgood has explored. The qualities of reality call out to and answer each other. Qualities call and answer in distinct timbres of voice; and only those who can answer in the timbre of the caller will reply. When they answer, some will speak loudly, some softly, others at gradations in between. Thus, pervading reality is a symphony of calls and answers. And unlike that unheard music attributed by the ancients to the spheres as they move in their heavenly paths, this is heard by all:

> Nature is a temple where living pillars sometimes allow confused words to escape; man passes there through forests of symbols that watch him with familiar glances.
>
> Like long-drawn-out echoes mingled far away into a deep and shadowy unity, vast as darkness and light, scents, colours, and sounds answer one another.
>
> There are some scents cool as the flesh of children, sweet as oboes and green as meadows,—and others corrupt, rich, and triumphant.
>
> Having the expansion of things infinite, like amber, musk, benzoin, and incense, singing the raptures of the mind and senses.[29]

b. Expressiveness: Theorists in our century have often acknowledged that *expressiveness* pervades the arts. Every work of art is expressive—of melancholy, of gaiety, of sadness, or whatever. What they are pointing to when they speak this way is an inherent, perceptible feature of the work of art. Thus expressiveness is not to be identified with the phenomenon of *being an expression of* some state of consciousness, of which I spoke earlier. For this latter phenomenon consists not in some perceptible feature of the work but rather in some state of consciousness being a factor in accounting for that work of art.

Though expressiveness has been widely acknowledged as pervasive in the arts, and though the concept has been widely discussed, the phenomenon has proved puzzling and the concept elusive to theoreticians. What is puzzling about the phenomenon is conveyed with deft humor in these words from the opening of O. K. Bouwsma's essay "The Expression Theory of Art":[30]

> And now I should like to describe the sort of situation out of which by devious turnings the phrase "expression of emotion" may be conceived to arise.
>
> Imagine then two friends who attend a concert together. They go together untroubled. On the way they talk about two girls, about communism and pie on earth, and about a silly joke they once laughed at and now confess to each other that they never understood. They were indeed untroubled and so they entered the hall. The music begins, the piece ends, the applause intervenes, and the

music begins again. Then comes the intermission and time for small talk. Octave, a naïve fellow, who loves music, spoke first. "It was lovely, wasn't it? Very sad music, though." Verbo, for that was the other's name, replied: "Yes, it was very sad." But the moment he said this he became uncomfortable. He fidgeted in his seat, looked askance at his friend, but said no more aloud. He blinked, he knitted his brows, and he muttered to himself. "Sad music, indeed! Sad? Sad music?" Then he looked gloomy and shook his head. Just before the conductor returned, he was muttering to himself, "Sad music, crybaby, weeping willows, tear urns, sad grandma, sad, your grandmother!" He was quite upset and horribly confused. Fortunately, about this time the conductor returned and the music began. Verbo was upset but he was a good listener, and he was soon reconciled. Several times he perked up with "There it is again," but music calms, and he listened to the end. The two friends walked home together but their conversation was slow now and troubled. Verbo found no delight in two girls, in pie on earth, or in old jokes. There was a sliver in his happiness. At the corner as he parted with Octave, he looked into the sky, "Twinkling stars, my eye! Sad music, my ear!" and he smiled uncomfortably. He was miserable. And Octave went home, worried about his friend.

So Verbo went home and went to bed. To sleep? No, he couldn't sleep. After four turns on his pillow, he got up, put a record on the phonograph, and hoped. It didn't help. The sentence "Sad, isn't it?" like an imp, sat smiling in the loud-speaker. He shut off the phonograph and paced the floor. He fell asleep, finally, scribbling away at his table like any other philosopher.

This then is how I should like to consider the use of the phrase "expression of emotion." It may be thought of as arising out of such situations as that I have just described. The use of emotional terms—sad, gay, joyous, calm, restless, hopeful, playful, etc.—in describing music, poems, pictures, etc., is indeed common. So long as such descriptions are accepted and understood in innocence, there will be, of course, no puzzle. But nearly everyone can understand the motives of Verbo's question "How can music be sad?" and of his impulsive "It can't, of course."

Easily the most common and tempting theory as to the nature of expressiveness is what might be called the *evocation* theory: An object O is expressive of a quality Q just in case O evokes Q in percipients. For example, a jagged line is expressive of restlessness just in case the line evokes restlessness in those who perceive it.

If this theory were satisfactory in all other respects, we would have to specify *in which percipients* the object O must evoke the state of consciousness Q if O is to be expressive of Q. In all who perceive O? In most? In all who are qualified in a certain way? But we need not even enter these questions, for the theory seems implausible on its face. Suppose we draw side by side an undulating line expressive of tranquility and a jagged line expressive of restlessness, and then focus our attention back and forth between the two. Are we by doing so cast first into tranquility, then into restlessness, then back into tranquility, etc.? Surely not. We can even *recognize* that the one line is expressive of tranquility without being

tranquilized, and that the other is expressive of restlessness without being made restless.

These brief remarks do not dispose of the evocation theory of expressiveness. Various qualifications are possible, each of which would have to be explored if the theory were to be fully discussed. However, the truth of the matter seems to me to be that the expressiveness of objects inheres not in their causal effects on percipients but rather in *the relations of fittingness* that the aesthetic characters of those objects bear to the qualities which those objects express. The mourning dove's song is expressive of melancholy just when the character of the song is *fitting* (to a significant degree) to melancholy. To put the matter generally: An object O is expressive of some quality Q when, and only when, the aesthetic character of O is fitting (to a significant degree) to Q. Expressiveness is grounded in fittingness.

Let me highlight some of the implications of this analysis of expressiveness. For one thing, on this analysis natural objects as well as man-made objects can be expressive. And surely that is as it should be. The mourning dove's song is expressive of melancholy.

Secondly, on this analysis an object may be expressive of a number of different qualities, since its character may be significantly fitting to a number of different qualities. That too is as it should be. I who claim that the dove's song is expressive of melancholy, and you who claim that it is expressive of some other quality, may both be right.

Thirdly, the *intent* of an artist that his or her work be expressive of some quality Q does not make it so; nor does his or her intent that it *not* be expressive of some quality Q prevent it from being so. In that way the expressiveness of works of art is independent of the intentions of their makers. Confronted with works of art from distant cultures, the critic and the art historian can determine their expressiveness without knowing the intent of their makers. In its expressiveness, unlike its intended uses, a work of art transcends the boundaries of culture and makes itself available to all. The voraciousness of our institution of high art is intimately connected with our critics' practice of ignoring the original intended use and concentrating on expressiveness.

Lastly, on the analysis offered, the expressiveness of objects is an objective matter, since fittingness is an objective matter (with the exception of fittingness grounded in preferability). Naturally that does not mean, however, that people will always agree in their attempts to capture in words the expressiveness of objects. I had heard some pieces of Scott Joplin as expressive of gaiety, my friend heard them as expressive of nostalgia. I thought he was imperceptive—until I listened again and gradually began to hear the nostalgia. I did not cease to hear them as expressive of gaiety; but now I heard the nostalgia as well.

Indeed, given the objectivity of fittingness, and given the fact that expressiveness is grounded in fittingness, the interesting question is no longer

why we agree as often as we do in our judgments of expressiveness but why we *disagree* as often as we do. It may be of interest to suggest some of the reasons.

(1) No doubt many disagreements about expressiveness have their root in the fact that the thing in question is perceived in subtly different ways. Chinese music sounds different to an Oriental than to a Westerner; Western music sounds different to a Westerner than to an Oriental. And Gesualdo's music sounds significantly different to us, who have experienced the collapse of tonality in our century, than it did to a nineteenth-century listener. So of course disagreements in judgments concerning expressiveness are to be expected. The absence of such disagreements would cast suspicion on our theory.

For such differences in how music sounds, in how paintings look, etc., there are of course many reasons. One, remarked on earlier, is that always when we approach a work of art we focus on some features and allow others to recede into the penumbra of our attention. We listen *for* something, we look *for* something. In part, these are matters of personal idiosyncrasy. But more fundamentally, distinct stylistic traditions call for distinct ways of looking and listening. One listens for different things in Webern than in Brahms. One looks for different things in Pollock than in Piero della Francesca. Harmonic relationships function structurally in classical Western music in ways for which there is no clear counterpart in most Chinese music; whereas timbre and rhythm function structurally in much Chinese music in ways for which there is no clear counterpart in classical Western music. Such structural differences call for different ways of listening. Then too, what makes our perceptions of things vary is the body of other works of art we have heard and seen. T. S. Eliot in his famous essay "Tradition and the Individual Talent" remarked that each new poem which enters the tradition changes its structure. In a similar way, what we have seen or heard in the past shapes our perception of the new things we see or hear, and our seeing and hearing of new things subtly changes our future perceptions of the old things. Once we have seen the German expressionists, Titian looks different to us. Once we have heard Berg, Bach sounds different. Once we have seen the chapel at Ronchamp, the baroque church of Vierzehnheiligen looks different.

What sometimes makes us aware that the very same work is being perceived differently are discussions with others about what a work is expressive of. I first heard no nostalgia in the piece by Scott Joplin; when I then tried to listen to it in such a way that it would sound expressive of nostalgia, I listened to it differently. Similarly, the exercise of trying to figure out why Messiaen attaches the texts that he does to the various movements of his *Et exspecto resurrectionem* shapes one's perception of the music.

(2) What also accounts for disagreements about expressiveness is the obvious fact that each of us works with ranges of comparison which differ to a greater or lesser degree. A piece of Chinese music fitted into the context of Western music suddenly gains a different significance than it has in its home

context. It may be among the most intense and anguished of all Chinese music; yet, when fitted into the context of Western music it may be far indeed from the most intense and anguished. And a Gregorian chant which in its original context was especially expressive of sorrow may now, in the presence of all the succeeding laments and requiems of Western music, be situated well toward the middle. So also the qualities that we regard works of art as potentially expressive of may vary. Probably most of us do not naturally regard timidity as a candidate for what music is expressive of, nor brashness as a candidate for what paintings are expressive of. Full agreement in judgments about expressiveness would require identity in ranges of comparison. For expressiveness, remember, comes in degrees.

(3) Yet a third source of disagreement is that inevitably many factors interfere with our attempt to make accurate judgments of fittingness. In particular, the fact that a certain object or type of object is regularly connected in our experience with some particular quality makes it difficult to decide whether we are confronted with a genuine fittingness between the character of some such object and that quality, or only a concomitance. Concomitance is an impediment in our attempt to judge fittingness.

(4) Lastly, people no doubt differ in their ability to discern fittingness. The ears and the eyes of some are ill-adapted for this purpose. Color blindness and tone deafness constitute obvious deficiencies. But imperceptivity is not limited to such gross defects. Furthermore, people can learn to become more discerning of fittingnesses. The shepherd has learned to tell his flock of sheep apart, though to us they all look alike. The trained musician hears a difference in expressive character where the untrained ear hears only sameness.

c. **Worker in Fittingness:** Every artist, I suggested, is a worker in fittingness. Before I could show that this is true, I had to explain what I meant by "fittingness." That done, let me now call attention to some of the many ways in which the artist works with fittingness.

(1) The artist's work will invariably and inescapably be expressive of one and another state of consciousness. In so far as it is that, the artist is a worker in fittingness; for expressiveness, as we have seen, is grounded in fittingness. Furthermore, if the work does not merely *happen* to be expressive of some state of consciousness but if it is so *by intent* on the part of the artist, and if in addition the state of consciousness of which the work is by intent expressive is one of the artist's own states of consciousness, then the artist has engaged in *self-expression*.

In his book *Concerning the Spiritual in Art*, Wassily Kandinsky gives the painter some advice on expressiveness: If you want to make a painting expressive of an aimless, manic form of brashness, put a lot of yellow in it. What he actually says is the following, set within the context of his discussion of the expressive qualities of colors:

> The first movement of yellow, that of straining toward the spectator (which can be increased by intensifying the yellow), and the second movement, that of

overrunning the boundaries, [has] a material parallel in that human energy which attacks every obstacle blindly and goes forth aimlessly in all directions. . . . Yellow has a disturbing influence; it pricks, upsets people, and reveals its true character, which is brash and importunate. . . . If we were to compare it with human states of mind, it might be said to represent not the depressive, but the manic aspect of madness. The madman attacks people and disperses his force in all directions, aimlessly, until it is completely gone.[31]

Similarly, in Deryck Cooke's book *The Language of Music* there's a passage from which can be derived some advice to the composer: If you want to compose a passage expressive of the sinister, of devilishness, consider using the diminished fifth (tritone). After citing a significant number of examples from the history of music in which composers, confronted with some words speaking of the sinister, have chosen to set those words by using the interval of the diminished fifth, Cooke says this:

> I shall be forgiven if for a moment I mention small music in connection with great. When I made a setting of Burns's poem *Tam O'Shanter*, I had led Tam as far as the church and reached the key of F; I expected some "inspiration" to descend on me to express the *diablerie* of the "witches and warlocks" dancing Scots reels in the house of God, and it descended in the shape of a bagpipe drone not of F and C, but of F and B natural. At that time, although the term *diabolus in musica* was of course familiar to me, I had not yet begun to investigate the properties of the augmented fourth or diminished fifth as an expressive tension, much less made the above collection of musical demonology. Hence, if it is admitted that the mysterious thing known as "inspiration" functions in the same way with composers of no account as with the great, the all-important difference lying in the quality of it and the ability to build on it, it would seem likely that composers have turned unconsciously to this interval to express the devilish, *for its actual sound*, which derives from the "flaw" in the harmonic series, just as they have turned instinctively to the major third for its naturally joyful sound.[32]

(2) It seems to be a matter of linguistic practice for critics and others to speak only of *states of consciousness*, and even more narrowly, only of feelings and emotions, as being what objects are expressive of. In my discussion I have gone along with this practice. But what must then be observed is that the aesthetic character of a work of art may bear relations of fittingness not only to states of consciousness, but to a wide variety of other qualities as well. Some of such fittingness is there by intent on the part of the artist, some not. But in either case, we have here a second way, closely related to the first, in which the artist is a worker in fittingness.

Probably Shakespeare did not aim to make the character of *Hamlet* bear a close fittingness to the color purple. But Flaubert, by his own testimony, did aim to make the character of the story of his *Madame Bovary* fit closely the color gray. And Olivier Messiaen in his "Colors of the Celestial City" consciously composed music whose character fits closely a succession of colors. No doubt the classic case of such "color fittingness," however, is to be found in Scriabin's "Prometheus." Having created a color organ, Scriabin

devoted the bottom stave in his orchestral score to instructions for the color organist, while the staves above it are given to the various instruments of the orchestra.

(3) From the experiments in synesthesia we have learned that the working of at least some metaphors is grounded in fittingness. A piece of (metaphorically) red music is a piece of music whose character is closely fitting to redness. Flaubert's (metaphorically) gray story is a story whose character is closely fitting to grayness. And a (metaphorically) serene painting by Raphael is a painting whose character is expressive of serenity, that in turn being a painting whose character is closely fitting to serenity. In so far as the literary artist uses synesthetic metaphors, whether individually or embedded in clusters constituting images, he is a worker in fittingness. His eye has caught, his ear has heard, some fittingness in the world in which we dwell; and he constructs a metaphor to capture for himself and all of us what eye hath seen and ear heard. Metaphors are often (if not always) renditions of perceived fittingness.

(4) Often there will be, and often the artist intends that there shall be, close fittingness between the character of his work and things outside his work (with respect to their dominant qualities). In so far as that is true, the artist is a worker in fittingness. Bach aimed at fittingness between the character of his music and cherubim; and Messiaen, whether he intended so or not, composed a piece whose character is closely fitting to archangels: majestic, splendid, brilliant, awesome.

This point has application in many different directions. For one thing, there can be fittingness, intentional or otherwise, between the character of works of art and a variety of human actions. The fact that this is so seems to me especially important to keep in mind when we address the question of the relation of art to liturgy. The Christian liturgy is a sequence of actions: confession, proclamation of forgiveness, praise, and so forth. And works of art—passages of music, for example—can be more or less fitting to these distinct actions. What fits the action of confession well may be quite unfitting to the action of praise. Indeed, we can go farther. Many of the actions constituting the liturgy can be understood in a variety of different ways. And sometimes the music, by virtue of fitting closely one such understanding and only distantly certain others, lends specificity to the action and even to the words by which the action is accomplished. With this point in mind, one could engage in a study of the many settings of the Roman Mass. The *kyrie eleison* can be a cry of utter despair, an act of humble contrition, a pleading, or a singing of calm faith. In his *Aesthetics* Monroe Beardsley gives two examples of settings of the *descendit* passage from the "Credo," one from Palestrina's *Pope Marcellus Mass*, the other from Beethoven's *Missa Solemnis*. In Palestrina, the musical line takes three measures to descend a sixth. In Beethoven, it descends an octave and a fourth in the span of two measures. What is one to say but that these passages of music are fitting to two different

theologies? Both settings fit the situation described by the words. But they do more than that. Each fits well a certain understanding of that situation. Each adds *specificity* to the words. Beardsley himself, after citing the two passages, remarks: "There are two descents, so to speak, but what different descents they are! In Palestrina the coming of Christ is a serene passage into the world from a realm not utterly remote; in Beethoven it is a dramatic plunge."[33]

Secondly, there can be fittingness between the character of works of art and the dominant quality or temper of human experience in a certain age. Perhaps it is to this that those critics are alluding who speak of works of art as being *expressive of* an age. At any rate, it is surely such fittingnesses that Wylie Sypher is largely concerned to trace in his *Four Stages of Renaissance Style*.

Could it be that here we are touching on something which in part accounts for variations in artistic taste? Could it be that people prefer those works of art which fit the temper of their experience, and that they are less inclined toward sustained contact with those which do not fit very closely the temper of experience in their age? Could it be that this in part accounts for the twentieth-century esteem for John Donne, or Matthias Grünewald, or Gesualdo, and the decline in esteem for Alexander Pope and Charpentier?

Thirdly, the fundamental thesis of Gerardus van der Leeuw's book *Sacred and Profane Beauty* is that works of art are capable of intrinsically expressing the holy. If he means by this, as it seems he does, that works of art—even works of abstract art—can be more or less closely fitting to the holy, then I think he is right. It seems possible to rate at least some artifacts of art decisively either to left or right on an Osgood antonym-scale for holy/unholy. Perhaps this is how we are to understand Mark Rothko's and Barnett Newman's abstract works for the chapel in Houston. Within music, two examples of works intensely fitting to the holy would be the "Sanctus" from Bach's *B minor Mass*, and the opening section from Messiaen's *Vingt regard sur l'enfant Jesus*, entitled "Contemplation of the Father."

It might be well to quote a bit of what Van der Leeuw says. In the introduction to his book he explains what he means by "the holy," referring especially to Rudolf Otto's discussion of the *numinous* and the *mysterium tremendum* in his *Idea of the Holy*. Then in his treatment of music, Van der Leeuw says such things as these:

> Nine-tenths of the "religious works of art" which we know evidence no inner, essential continuity between holiness and beauty, having only a purely external connection, which admittedly can be very refined, violating neither art nor religion, but not proclaiming their unity.
>
> I purposely choose my examples from great art. Bach's *St. Matthew Passion* and Wagner's *Parsifal* are both, in their own way, religious art of the first rank. But it would be false to believe that the organic connection between religion and art, the flowing together of the holy and the beautiful, can be found on every page of the score. On the contrary, we find complete interpenetration of both elements

in these works only on a very few pages. The lament of Jesus and the lament of Amfortas for the Grail have religious themes, but these laments are not, thereby, religious in themselves. Instead of being expressions of holiness, they can be expressions of purely human grief. The glorious duet from the Passion, "*So is mein Jesus nun gefangen,*" is surely one of the most compelling pieces of music ever written. But it could still refer to a theme which is not numinous. The only religious effect lies in the text. On the other hand, the small chorus, "*Wahrlich, dieser ist Gottes Sohn gewesen,*" brings the holy very near to us by the wonderful exaltation of its majestic line. . . . The somewhat crude deistic frenzy in the choral finale of Beethoven's Ninth is religious music, while the glorious adagio which immediately precedes it, which can be played with great effect in any church after the sermon, admits of doubt.[34]

Fourth, there can be fittingness, intentional or not, between the character of works of art and human convictions, whether the convictions be those of the artist, of his patrons, or whatever. People have often asked what connection there can be between the physical artifacts of art and human conviction, especially religious conviction. Many have rightly felt that often the connection is close and substantial. Yet attempts to say what the connection is, particularly in the case of abstract, nonrepresentational art, have produced deep perplexity and pervasive obscurity. Once we see, though, that there can be *fittingness* between works of art and human conviction, we have the key in hand to unlock the door.

There is fittingness between the naturalistic humanism of Frank Lloyd Wright and the character of his architecture—for example, the way in which Taliesin West echoes its surroundings in color, texture, and contour, the way in which the Kaufmann House at Bear Run is integrated into its extraordinary landscape, the way in which the refusal to close off vistas became a trademark of Wright's work. There is fittingness between the clean white interiors of the American colonial churches and the highly organized, rational character of the religious self-understanding of those who built them. And if Erwin Panofsky is correct in the major thesis of his book *Gothic Architecture and Scholasticism*, there is fittingness between the character of the scholastic treatises and the character of Gothic architecture (Panofsky speaks of "correlation" where I speak of "fittingness"). So too there is fittingness between the massive, man-diminishing character of ancient Egyptian temple architecture and ancient Egyptian religion—as there is between St. Peter's in Rome along with its Bernini colonnade and the thought and attitudes of the late Renaissance Catholic church. Or—to take an example of the opposite—there is to my mind and eye a radical *unfittingness* between the tour-de-force illusionistic character of Marcel Breuer's St. Francis de Sales church in Muskegon, Michigan, and the sober, lean character of post-Vatican II Roman Catholic thought and liturgy. There is fittingness between the nervous anguished religious thought of John Donne in his late poetry, and the tense nervous rhythms of the words, with strong beat following upon strong beat upon

strong; while there seems to be significant unfittingness between the highly rational and traditional form of Sartre's plays and novels and the existentialist thought conveyed thereby. And for a final example: If one thinks of the Christian Church fundamentally in terms of an army, then the tube-shaped space of the traditional basilica fits well; but if what principally shapes one's thought of the church is the image of the family, then something else is needed if fittingness is to be secured—a roughly square or circular tent-shaped space, perhaps.

Throughout his career, whenever Paul Tillich addressed the topic of art and religion (or as he would prefer to say, art and ultimate reality), his sole point was always that art is an expression of responses to, and understandings of, ultimate reality. Usually it remained unclear what he was claiming in speaking this way. For he wandered back and forth among the various concepts attached to the word "express," sometimes even apparently taking "express" as a synonym of "reveal." However, at least in one essay, called "Art and Ultimate Reality," he clearly makes the claim that various artistic styles closely fit various types of religion. He speaks of "those stylistic elements which are expressive for ultimate reality."[35] Expressive of religious sacramentalism, he says, is artistic primitivism; expressive of religious mysticism is "that stylistic element in which the particularity of things is dissolved into a visual continuum"; expressive of the prophetic-protesting type of religion is artistic realism; expressive of religious humanism is artistic idealism; and expressive of the ecstatic-spiritual type of religion is artistic expressionism. I do not wish to discuss either the clarity or the plausibility of Tillich's specific identifications, but simply to observe that an elucidation, and indeed validation, of his general strategy is to be found in my theory of fittingness. For there can indeed be a close fittingness between a certain artistic style and a certain complex of religious convictions.

(5) Lastly, the internal unity of a work of art is in various ways related to fittingness, so that, in so far as the work is unified, the artist is once again a worker in fittingness.

To see in what way this is true we must distinguish two fundamentally different types of unity in the arts. There is for one thing the unity of *coherence*, whereby the aesthetic qualities of the work cohere with each other. And there is secondly the unity of *completeness*, whereby the work has the quality of being rounded off, of genuinely beginning and genuinely ending instead of merely starting and stopping.

These two modes of unity are capable of varying independently of each other, with the result that a work may be high in the one mode and low in the other. Many of Raphael's paintings, with their centrally situated circular or triangular compositions, are intensely complete. By contrast, a late Jackson Pollock painting is extremely low in completeness—if it had gone on a foot farther in the same vein or if a foot of it were cut off, the effect would differ scarcely at all—but very high in coherence. The rather episodic dramas of

Dürenmatt are high in coherence, but when compared to the Shakespearean dramas, rather low in completeness.

Our century has witnessed, in all the arts, a lessening of interest in completeness and an intensification of interest in coherence. Accordingly, to the traditionalist it often looks as if contemporary art is lacking in unity. No doubt it sometimes is. But just as often, the traditionalist, looking for completeness, and failing to find it to any significant degree, and thus concluding that the work lacks unity, overlooks the unity secured by coherence. Looking for the rise and fall, the denouement and resolution, to be found in traditional drama and failing to find it, he immediately concludes that the work is lacking in unity. But often he is mistaken.

The basic strategy for securing coherence is that of having similarity among the aesthetic qualities of the work. Sometimes this will be straightforward intra-modal similarity, as when the same color is used at several places in a painting or the same melodic phrase at several points in a musical composition. In other cases, however, coherence will be secured by cross-modal similarity, as when there is fittingness between sound and sense in poetry. Coherence, then, is in part grounded on fittingness.

Can the same be said for completeness? Is it also, in some way or other, grounded in fittingness.? Yes, I think so. For what seems to me to characterize those compositional structures which we feel to be more complete, as compared to those which we feel to be less complete, is that they are more closely fitting to rest, to tranquility, to stability. The cadences in eighteenth-century music, which help to secure the completeness of phrases and sections and indeed of entire works, bear a close fittingness to rest—or strictly, to "coming-to-rest." And certainly a triangular composition of Raphael bears a closer fittingness to rest than do the whirling and upward-striving compositions of El Greco or the recessive, diagonal compositions of Rubens.

Some passages in Charles Rosen's book on Schoenberg fascinatingly illustrate these points. Rosen observes that already in relatively early compositions of Schoenberg the traditional consonance/dissonance contrast had lost its structural function. We can think of those intervals which the tradition regarded as the more consonant ones as being those more fitting to rest, and those which it regarded as the more dissonant ones as being those more fitting to restlessness. Then Rosen's point concerning early Schoenberg can be put by observing that Schoenberg no longer tried to secure completeness by moving from the more dissonant, tense, restless, intervals to the more consonant, relaxed, tranquil intervals. And yet, as Rosen observes, Schoenberg was not willing to give up on the search for completeness. It is fascinating to observe how Rosen intuitively identifies attaining completeness with coming to rest. Here is what he says:

> As long as no substitute had been found for the absolute final consonance of tonal music, the creation of large forms would remain a problem: absolute

consonance is a final demarcation of form. With it, the limits of the form are indicated: and they can be approached at the pace determined by the composer. No composer of the early twentieth century was willing to settle for musical forms whose outlines were vague or indeterminate, left to chance or to some force outside control. From Aristotle on, an artistic form was above all defined, its limits clearly discernible. . . .

The last page of *Erwartung* [Opus 17, 1909] has been so much imitated that it is hard to perceive its originality today, although it still makes an effect that is overpowering. "Oh, are you there," cries the woman about her dead lover, and then adds softly, "I searched," as the low woodwinds begin, triple *pianissimo*, a rising chromatic series of six-note chords. The other instruments enter with similar chords moving up or down the chromatic scale, each group moving at different rates of speed; the fastest speeds coming in the last three beats with the dynamics remaining between triple and quadruple pianissimo.

This massed chromatic movement at different speeds, both up and down and accelerating, is a saturation of the musical space in a few short seconds; and in a movement that gets ever faster, every note in the range of the orchestra is played in a kind of *glissando*. The saturation of musical space is Schoenberg's substitute for the tonic chord of the traditional musical language. The absolute consonance is a state of chromatic plenitude.

This concept of the saturation of chromatic space is a fixed point toward which the music moves, as a point of rest and resolution, lies behind not just *Erwartung* alone but much of the music of the period. . . .

In short, in tonality, the piling up of seconds creates tension; in Schoenberg's music after 1908, however, the filling out of the chromatic space is clearly a movement toward stability and resolution. The use of distant registers both brings in the textural play that has now so much greater weight than before, and also serves to imply the total chromatic space whose saturation is the strong form of cadence and resolution.[36]

The twentieth century, then, has witnessed the invention of radically new strategies for securing the rest and stability of completeness. But also, as I have already remarked, it has witnessed diminished interest in securing unity by means of completeness, and a willingness to make do with coherence. Could it be that this is connected with the quality of human experience in our age—restless and unsettled as it is? Could it be that here we find one more example of fittingness between the aesthetic quality of works of art and the dominant quality of human experience in a certain age?

In any case, Rosen seems right: mankind throughout the ages has wanted his art to come to rest. He has preferred Isaiah to Heraclitus. We in our century are exceptional.

CHAPTER THREE

The Action of World-Projection

1. INTRODUCTION

Wᴇ HAVE looked at some of *the given* with which the artist works. The artist always composes his artifact *out of* something, and thus is a worker in some medium; and the artist is always a worker in fittingness. Let us now turn our attention in a different direction and consider one of the actions that the artist performs *by means of* his artifact—the action of *world-projection*, as I shall call it.

In Part One, I made the point that one of the most basic things to be said about works of art is that they are instruments and objects of action, on the part of both the artist and the public. Our discussion in this chapter can be seen, then, as illustrative of that general point. The action I choose to discuss for illustration is not, however, arbitrarily chosen. Rather, world-projection is perhaps the most pervasive and important of the actions that artists perform by means of their artifacts. Not every artifact of art is used to project a world. "Pure" music and "abstract" art constitute exceptions. Yet a vast array of works of art are used to do so, works of high art and other art alike; and in their being so used, we human beings over and over find their fundamental significance and worth.

But what is world-projection? Perhaps the best way to get into the idea is from the side of fiction. A charge against the writer and teller of fiction which has flitted in and out of Western history is that he is a liar—one who says what is false knowing it to be false. David Hume's words are characteristic: "Poets themselves, tho' liars by profession, always endeavour to give an air of truth to their fictions. . . . [37] In a well-known passage from his *Apology for Poetry*, Sir Philip Sydney replied to this old charge with the following words:

> Now for the poet, he nothing affirms, and therefore never lieth. For, as I take it, to lie is to affirm that to be true which is false. . . . But the poet (as I said before) never affirmeth. . . . And therefore, though he recount things not true, yet because he telleth them not for true, he lieth not—without which we will say that

Nathan lied in his speech before-alleged to David; which as a wicked man durst scarce say, so think I none so simple would say that Aesop lied in the tales of his beasts; for who thinks that Aesop writ it for actually true were well worthy to have his name chronicled among the beasts he writeth of.

Sydney puts his finger on the heart of the matter. In setting down the individual sentences of his text the writer of fiction is not asserting things. He is not making claims about the actual world. And so of course he is not asserting things which are false. He is not claiming things to be the case which are not the case. Instead—and here we go beyond Sydney—he is projecting a world for us, presenting to us a world for our consideration. The *world of the work* we may call it.

This world of the work is normally incompatible with the actual world: the world of the work and the actual world cannot *both* occur. Though indeed some of the things comprised in the world of *Macbeth* occurred, the totality of them did not. But even when the world of the work is not incompatible with the actual world, that is, even when everything constituting the world of the work actually occurs, still the world of the work is only a *segment* of the actual world, never the whole of it. Thus the world of a work of art is always distinct from the actual world. And to understand a piece of fiction we must understand what it is to project, *fictionally* project, such a distinct world. To understand fiction, we must avoid getting hung up on actuality.

What makes fiction as we know it possible is not our human ability to make claims about the actual world but rather our ability to imagine a world distinct from the actual world, and then to project that world fictionally for the consideration and benefit of our fellows. We in the Western world have been so mesmerized by actuality that we have neglected the full scope and significance of man's powers of *envisagement*. Between the ancient classical vision of the artist as imitator of actuality and the Enlightenment vision of the artist as repudiator of actuality, a middle course must be found. Of course it is true that the situation in *Macbeth* bears *some* relations to actuality; later we shall see what some of those relations are. But to think of the artist simply as one who holds the mirror up to nature is to get things seriously askew.

This is a point perceived with clarity by J. R. R. Tolkien in his fine essay "On Fairy-Stories." A fairy story, says Tolkien, and indeed any story, is a "sub-creation," "rather than either representation or symbolic interpretation of the beauties and terrors of the world."[38] What he means by that is just exactly what I mean in speaking of the *world* of the work, emphasizing its distinctness from the actual world. He goes on to say that any story, if it is at all good, will be believable; we will find ourselves according it what he calls "Secondary Belief":

> That state of mind has been called "willing suspension of disbelief." But this does not seem to me a good description of what happens. What really happens is that the story-maker proves a successful "sub-creator". He makes a Secondary World

which your mind can enter. Inside it, what he relates is "true": it accords with the laws of that world. You therefore believe it, while you are, as it were, inside.[39]

On the other hand, many are the stories to which we never accord "Primary Belief "—fairy stories chief among them. We do not find them likely to have occurred. We do not find them, in that sense, plausible. Nor is it at all necessary to our enjoyment that we do so. Sometimes the opposite:

> Fantasy, the making or glimpsing of Other-worlds, was the heart of the desire of Faerie. I desired dragons with a profound desire. Of course, I in my timid body did not wish to have them in the neighborhood, intruding into my relatively safe world, in which it was, for instance, possible to read stories in peace of mind, free from fear. But the world that contained even the imagination of Fafnir was richer and more beautiful, at whatever cost of peril. The dweller in the quiet and fertile plains may hear of the tormented hills and the unharvested sea and long for them in his heart. For the heart is hard though the body be soft.[40]

I have suggested that the best way into the idea of world-projection is from the side of fiction—and conversely, I have suggested that the only way to understand fiction is to understand it as consisting in the fictional projection of a world distinct from the actual world. But though fiction is indeed a good ingress to world-projection, it is important to see the *full* scope of fiction in the arts. The examples of fiction to which I shall appeal will mainly be drawn from the literary, dramatic, and cinematic arts. But fiction in the arts extends well beyond these. We regularly find fiction in painting and sculpture as well (though here, as sometimes in lyric poems, the world composed and projected takes the form of a situation rather than a story). Venus never in actuality rose from the sea on a gigantic shell, nor did Botticelli assert that she did. But that's what she does in the world composed by Botticelli and fictionally projected with his *Birth of Venus*. And Christ was not born in a West European village, nor have many people thought or said that he was. But in the nativities composed and fictionally projected by the Renaissance painters he often was. Even in music the fictional projection of worlds distinct from our actual world sometimes takes place—witness Strauss's *Domestic Symphony* and Schoenberg's *Verklärte Nacht*. What we shall need, then, is a theory of fictional world-projection that is sufficiently general to apply to fiction in all the arts.

What must also be emphasized is that, although fiction may be a good ingress to world-projection, world-projection in general is not confined to *fictional* world-projection. Just as literary, dramatic, and cinematic fiction opens up to the wider phenomenon of fiction in general, so too, in turn, fictional world-projection opens up to the wider phenomenon of world-projection in general. Thus we shall need a theory of world-projection general enough to comprise other species of world-projection than *fictional* world-projection. The tellers of the Norse myths probably "told them for true," not for fiction. And the world of Lucretius' *De rerum natura*, though not to be found within our actual world, was surely told for true. Then too, it

seems clear that the worlds of Donne's *Divine Sonnets* were presented as true, not as fiction. All this our theory will have to take into account.

One more preliminary point must be made. Though fictionally projecting a world distinct from the actual world is not to be identified with making false claims about the actual world, still it is the case that *by way of* fictionally projecting his distinct world the fictioneer may make a claim, true or false as the case may be, about our actual world. By telling his story he may make a point; by presenting his situation he may put forth a message. In short, to pick up terminology we defined earlier, his fictional projection of a distinct world may *count-generate* his asserting something about the actual world.

Think for example of Aesop's tale "The Ass and the Grasshoppers." In telling this tale Aesop was not claiming that in our actual world an ass once spoke to some grasshoppers. Yet by way of fictionally projecting this distinct world containing a talking ass, he asserted about the actual world that *one man's meat is another man's poison*. In effect Aesop made his point twice over: first by telling his tale, then by appending his metaphorically expressed moral. Similarily the prophet Nathan, by telling his story about the rich man seizing the lamb of the poor man in order to entertain a traveller, told King David that he was guilty of thievery. And Chaucer's Pardonner asserted by telling his tale that *radix malorum est cupiditas*.

Two large tasks now confront us: one, to explain what constitutes the world of a work of art; the other, to explain what constitutes the projection of such a world, and in particular, the fictional projection.

2. IN AND OUT OF WORLDS

If we are to attain clarity on the nature of the worlds that are fictionally projected by way of the artifacts of art, we must first distinguish clearly between the action of fictionally projecting a world, on the one hand, and the action of describing the contents of an already projected world, on the other. That *describing* the world of a work is fundamentally different from *fictionally projecting* that world can be seen at once by noticing that we cannot evaluate the action of fictional projection by reference to the truth and falsehood of what was claimed. For nothing was claimed. On the other hand, when we *describe* the world of a work and its contents we make claims. Hence our action can be evaluated by reference to the truth or falsehood of what was claimed.

What makes it easy to overlook this crucial distinction between projecting a world and describing a world already projected is that both actions are customarily performed by uttering or inscribing sentences—and often the same sentences at that. Near the beginning of the Guerney translation of Gogol's *Dead Souls* one finds, for example, this sentence: "While the server was still spelling out the note, Pavel Ivanovich Chichikov himself set out to look the town over and, it would seem, was quite satisfied

with it." In putting down the Russian original of that sentence Gogol was engaged in the action of fictionally projecting a world. Accordingly it would have made no sense for him to blot out the sentence on the ground that what he had asserted by inscribing it was false. There are, of course, plenty of reasons he might have had for blotting out the sentence, but that is not one of them. But if *I* now assertively utter, speaking about the world of *Dead Souls*, "While the server was still spelling out the note Chichikov set out to look the town over," I am not fictionally projecting a world but rather making a claim, and a true one at that.*

Not only is it important, for attaining clarity on the concept of the world of a work, to distinguish between projecting a world and describing a world already projected. We must also have a sharp sense for the difference between a state of affairs' being true in some projected world and its being true in our actual world. On this matter too we are prone to fall into confusion. To diminish the possibilities of such confusion in my own discussion I shall henceforth not even speak of a state of affairs as *true in* some work's world, but only as *included within* it.

Take that familiar example of the philosophers, the state of affairs "Pegasus is a winged horse." Most assuredly this is included within the world of the Greek myth. But that very same state of affairs is true in the actual world. If there were an example of the Pegasus character in the actual world, it would be a winged horse. Not so, however, for that other familiar example, "Pegasus never existed." It is indeed true in the actual world that no example of the Pegasus character has ever existed. Most emphatically, however, what is included in the world of the myth is not that, but rather "Pegasus exists." In order for that world to occur there must exist an example of the Pegasus character. Or take "A melancholy disposition is caused by an excess of bile." Probably this is not true in the actual world. It seems quite clearly, though, to have been included in the world of certain of Shakespeare's plays.

We dig yet deeper into the matter if we consider states of affairs in which we are confronted with a "crossover" between some fictitious character and some actual, concrete entity. For example, "Gogol created the character Chichikov in the late 1830's or early 1840's." Apparently this is true in the actual world. But it is not included in the world of *Dead Souls*. For in that world Gogol nowhere puts in an appearance. He is not to be found among the *fictionis personae*. And so, of course, his creating that character is not included within that world. Or suppose that one of the incidents in *Dead Souls* had been Chichikov drinking vodka with Tsar Nicholas I. Then included within the world of *Dead Souls* would have been the state of affairs of someone named Pavel Ivanovich Chichikov drinking vodka with Tsar Nicholas. But

*Actually, the state of affairs Gogol fictionally projected with these words is distinct from that which I asserted with these words. Thus the difference does not lie merely in the difference between fictionalizing and asserting. See Part Three of my *Works and Worlds of Art*.

now suppose that I am writing a biography of Nicholas I, an exhaustive biography, if you will. Am I then to write down, "On one occasion at least someone named Pavel Ivanovich Chichikov drank vodka with Tsar Nicholas"? Probably not. And *certainly* not on account of Gogol's tale. The most accurate and exhaustive account of Nicholas' appointments would reveal no such encounter. What *could* correctly be written down about the Tsar was that he was portrayed by Gogol in *Dead Souls* as drinking vodka with someone named Pavel Ivanovich Chichikov. That is true in the actual world. But then, in turn, it would not be the case that included in the world of *Dead Souls* was the Tsar's being portrayed by Gogol in *Dead Souls* as drinking vodka with someone named Chichikov.

When we move to drama the distinction between what is included in some projected world and what is true in our actual world becomes even more subtle to make out and fascinating to observe. Suppose that I have gone to see a performance of *Hedda Gabler*. And suppose that I remark afterwards to someone that it was staged in such a way as to allow us to see Hedda shoot herself. How are we to understand this? Surely in some rather straightforward sense of the words one *can* see Hedda shoot herself. But suppose that I go again the next night. Then again I will see Hedda shoot herself. How odd. Did she not kill herself with that shot I saw her fire the night before? How does she come by these marvelous resuscitative powers? How often does Hedda shoot herself? How often has she shot herself in the world's history? But I—how could *I* see Hedda shoot herself? George could have seen her. And Løvborg. But I? Am I among the *dramatis personae* of Ibsen's play?

If we keep clear the distinction between the world of Ibsen's play and our actual world—and correspondingly the distinction between what is included in the former and what is true in the latter—then we are well on the way to unravelling this snarl. If the discussion concerns what is included in the world of drama, then certainly I did not see Hedda shoot herself, since my existing isn't even included in that world. And what's included in that world is that Hedda shot herself just once. What I can see is someone playing the role of Hedda. That is, it is true in the actual world that I see someone playing the role of Hedda, whereas that's not included in the world of *Hedda Gabler*. But of course those who play the role of Hedda do not customarily shoot themselves while so doing. Speaking strictly, I did not see anyone shoot herself. What I saw was someone playing the role of someone who shoots herself. By a sort of elision we speak of, say, Maggie Smith as Hedda, and then ascribe to this dual "person" attributes belonging to the two different members of the duality.

In performances of the drama *MacBird* one of the actors impersonated Lyndon B. Johnson. Now suppose Johnson had gone to a performance of *MacBird*. Would he then have been watching himself? Could he thus, for example, observe himself dying? Can one, in the theater, observe one's own funeral? Evidently not. And though this situation is more subtle than the one we have just analyzed concerning Hedda Gabler, the way to unravel it is the

same. In the actual world Johnson would not have observed himself from a distance but rather would have observed an *actor* from a distance.*

But what are we to say, then, about a *character* who realizes his or her own fictionality? Such a state of affairs is in fact included in the world of Pirandello's *Six Characters in Search of an Author*. Obviously, however, it neither is nor could be true in our actual world, just as it couldn't be true that a *person* realizes his fictionality. On the other hand, a person's realizing his fictionality is included in the world of John Barth's "Life Story."[41]

In a passage in Brecht's *Messingkauf Dialogues*, the following bit of dialogue occurs:

> *The Dramaturg:* What about the fourth wall?
> *The Philosopher:* What's that?
> *The Dramaturg:* Plays are usually acted as if the stage had four walls, not three; the fourth being where the audience is sitting. The impression given and maintained is that what happens on the stage is a genuine incident from real life, which of course doesn't have an audience. Acting with a fourth wall, in other words, means acting as if there wasn't an audience.
> *The Actor:* You get the idea? The audience sees quite intimate episodes without itself being seen. It's just like somebody looking through a keyhole and seeing a scene involving people who've no idea they are not alone.[42]

In objection to this fourth-wall theory of drama, the Philosopher, who is probably Brecht's spokesman in the dialogue, says that few people labor under the illusion the theory suggests they do and that it would be a mistake for anyone to do so. Surely the Philosopher is right in thus rejecting the illusionist theory of theater, so popular among realists earlier in our century. Yet the defect in the fourth-wall theory is deep and is not dispelled by the Philosopher's anti-illusionist comments. For the theory regards us as watching the *dramatis personae*. Thus in subtle fashion it confuses what is included in the world of drama with what is true in our actual world. What we actually see when we go to a dramatic performance is some real-life persons—the actors. What we also sometimes see is three rather flimsy walls. But what is *represented* is a room of four walls, and that we don't see. Likewise what the actors *represent* is the various *dramatis personae*, and these too we do not see. To regard *us* as watching the *dramatis personae*—that is just confusion.

It must not be concluded that the differentiation between what is included in the world of a dramatic performance and what is true in the actual world can always be clearly made out; nor must it be concluded that it *should* always be something that can be clearly made out. On the contrary, many important and subtle dramatic effects depend on allowing actors to slip in and

*A slightly different situation would obtain if Brecht had seen Günther Grass's *The Plebeians Stage an Uprising*. Grass insisted that the actor playing the playwright would not be impersonating Brecht. Maybe so. But there can hardly be any doubt that Brecht was Grass's *model* for the playwright-character in his play.

out of roles, on allowing it to remain ambiguous in certain passages whether actors are in or out of roles, and thus on obscuring the distinction between what is true in our actual world and what is included in some projected world. Most of the "asides" in Elizabethan drama are probably best interpreted straightforwardly as consisting of the actor slipping out of character and talking directly to the audience (either that, or as belonging to a residual play outside the main play). But consider the part of the Stage Manager in Thornton Wilder's *Our Town*. The person who plays this part begins by not playing a role, talking instead directly to the audience. His opening lines are these:

> This play is called "Our Town." It was written by Thornton Wilder; produced and directed by A. . . . (or: produced by A. . . . ; directed by B. . . .). In it you will see Miss C. . . . ; Miss D. . . . ; Miss E. . . . ; and Mrs. F. . . . ; Mr. G. . . . ; Mr. H. . . . ; and many others.

But then shortly and almost indiscernibly the actor has slipped into playing a role, the role of a guide to Grover's Corners. We find him saying such things as these:

> The sky is beginning to show some streaks of light over in the East there, behind our mount'in.

And

> We've got a factory in our town too,—hear it? Makes blankets.

What makes this structure especially fascinating is that when the actor playing the part of the Stage Manager slips into the role of town guide, then we the audience slip into the role of town observers. For example, when the person playing the Stage Manager says:

> Here comes Howie Newsome delivering the milk,

then he is playing the role of a town guide addressing his tour members—*we* playing the role of the tour members. The tourists we represent are, it must be conceded, of a rather godlike sort so far as their powers of observation are concerned. They are able to see and hear what goes on in the town without anyone in the town, other than the guide, being aware that they are doing so. But they are tourists nonetheless; and it is we the audience who play them.

Obviously this whole area constitutes a fascinating field for exploration—both artistically and theoretically. It would be interesting, for example, to consider those cases of one dramatic world nested within another which occur when there is a play within a play, and then to look for cases in which it remains ambiguous as to what is included in which of the two dramatic worlds. That fascinating Elizabethan play *The Knight of the Burning Pestle*, by Beaumont and Fletcher, would be interesting to analyze with this in mind, as would Macleish's *J.B.* and Pirandello's *Six Characters*, but most of all, Tom Stoppard's dazzling *The Real Inspector Hound*. Such investigations we shall have to forego, however, and get on with developing the theory.

3. THE ONTOLOGY OF WORLDS

We are ready now for me to say what I take the world of a work to be. The word "world" in the phrase "world of the work" is of course functioning as a metaphor. To what reality does this metaphor point?*

I begin with what I have been calling "states of affairs." I think there is no hope of communicating the concept of a *state of affairs* by way of explication. We shall have to make do with offering examples. *Napoleon's having invaded Russia, Carter's being President*, and *there being a crisis in energy* are three states of affairs.

These particular states of affairs all occur, all hold, all obtain. Napoleon *did* invade Russia, Carter *is* President, there *is* at present a crisis in energy. But in addition to states of affairs which occur there are also those which do not occur, examples being *Carter's being from Minnesota* and *Mondale's being from Georgia*. Though neither of these states of affairs occurs (holds, obtains), yet there are these states of affairs. We can refer to them, as I just did, reflect on them, wish they would obtain, be glad they don't, and so forth.

A feature of the two nonoccurring states of affairs just cited, *Carter's being from Minnesota* and *Mondale's being from Georgia*, is that though neither occurs, they *could* occur. It is possible that Carter should be from Minnesota and Mondale from Georgia. Let us call a state of affairs which can or could occur—makes no difference whether it does or doesn't—a *possible* state of affairs. *Actual* states of affairs are a subset of the *possible* ones—they are those states of affairs which not only can occur but actually do occur. And such states of affairs are what we customarily call facts. A fact is a state of affairs which is actually occurring. There are also states of affairs which cannot occur, which cannot possibly hold or obtain—impossible states of affairs we may call them. Examples are *my being married to someone who has no spouse* and *my having a brother who has no sibling*. Not only am I not married to someone who has no spouse. It is impossible that I should be. Yet there genuinely is this impossibility. I can refer to it, consider it, wonder whether it really is impossible, etc.

In order to understand the structure of these distinctions, it is of prime importance to distinguish between *existing (being)* and *occurring (holding, obtaining)*. We can divide up existing men into those who are bald and those who are not bald, thus making it clear that existence and baldness are distinct. So too, we can divide up *existing* states of affairs into those that *occur* and those that *do not occur*, thus making it clear that existence and occurrence are distinct. A possible states of affairs is not one which could *exist*; it is one which, existing, could *occur*. An impossible state of affairs is not one impossible of *existing*; it is one which, existing, is impossible of *occurring*. And an actual

*The points made in this section and the next two are treated much more elaborately, and their implications pursued much more thoroughly, in my *Works and Worlds of Art*.

state of affairs is one which not only exists but also *occurs*. Existence, being, reality, comprises impossibility and mere possibility along with actuality. The following diagram may help:

existing states of affairs
{
 states of affairs possible of occurring
 {
 states of affairs actually occurring
 states of affairs possible of occurring but not actually occurring
 }
 states of affairs impossible of occurring
}

A state of affairs may be described as *a way things can or cannot be*. So far as I can see, there *are* such ways.

My suggestion now is that the projected world of a work of art is a state of affairs—usually a rather complex state of affairs, sometimes an extraordinarily complex one. It is a way things can or cannot be. Normally it is a possible though nonactual state of affairs. The artist presents to us a way things could be but aren't. In some cases, though, it is clearly an impossible state of affairs. The artist presents a way things cannot be. The world of Pirandello's *Six Characters in Search of an Author* cannot occur. It's impossible that six characters—not six actors, six *characters*—should walk onto a stage and plead with a stage director that he compose a drama for them to occur in, and with six actors that they play them. Likewise the worlds of some of M.C. Escher's late prints cannot occur. It's impossible that one should walk up four flights of stairs, around the perimeter of a building, only to arrive at the same landing from which one began. The world of a work of art is a state of affairs, possible or impossible as the case may be.

I think it is the case that if a state of affairs ever exists, it *always* exists; and if this is correct, then to compose the world of a work of art is not to create that world. It is not to bring it into existence. Those states of affairs constituting the world of the work existed before and apart from the author. So here too the materials with which the artist labors belong to a reality given to him or her. From the infinitely expansive realm of possibilities and impossibilities the artist makes a selection, and so brings forth an ordered composition. He masters by selecting. Of course that state of affairs which Botticelli composed and projected was not the world associated with his painting until he made that painting, and that he did by putting pigment on canvas. Yet all the while, that state of affairs which is in fact the world associated with his pigment-on-canvas existed, awaiting his selection, waiting to become the world of the work. The painting is made and associated with the world rather than the world made and associated with the painting.

Though the composition of the world of a work is a mode of selection rather than of creation, there is of course room for *creativity*. The creativity of the artist with respect to worlds consists in his ability to envisage states of

affairs distinct from any that he knows or believes ever to have occurred or been selected by anyone else. It consists in his ability to envisage states of affairs distinct from any which he knows or believes his experience to have acquainted him with. God has created us with the marvellous ability to envisage states of affairs which we have never come across in actuality. It is that capacity for envisagement, not the capacity for imitating the actual, which lies at the basis of our fictional projection of worlds.

It is worth remarking in conclusion that no particular connection exists between the aesthetic excellence of the world of a work and the degree to which the selection of that world was creative. In realism the artist remains close to what his experience acquaints him with, though even then he almost invariably takes a few steps away. In fantasy he travels far off. But there are poor fantasies and good realisms—as well as poor realisms and good fantasies.

4. THE ACTION OF PROJECTION

With this understanding in hand of the nature of the world of a work of art, let us now turn our attention to the action of *projecting* such a world. The theoretical equipment necessary for understanding this action was presented already in Part One, when I introduced the idea of *count-generation*. All that is necessary here is to remind ourselves of some of the points made there, and then to apply them to the issue at hand.

Suppose I assert that the door is closed, and suppose that I do so by uttering, in appropriate manner and circumstance, the English sentence "The door is closed." As we saw earlier, I would then have performed the two distinct actions of uttering the English sentence "The door is closed" and of asserting that the door is closed. For action A is distinct from action B if it is possible to perform A without performing B or B without performing A. And the action of uttering can in fact be performed without performing the action of asserting, and vice versa. What we also saw earlier, however, is that although these actions are distinct, yet in this case they are intimately connected: by performing the former I count-generate the latter.

Now it is of fundamental importance here to notice that not only is the action of asserting that the door is closed distinct from the action of uttering by which it is generated, but that that very same action of asserting can be generated by a host of actions distinct from this action of uttering the sentence "The door is closed." It can of course be performed by uttering other sentences—both in English and in other languages. But for our purposes it is even more important to note that it can be performed by actions which don't at all consist in the uttering of sentences. One can make assertions with gestures, with winks, with smoke signals, with semaphores—and by doing one or another with nonverbal works of art. One can assert that the door is closed by displaying, in appropriate circumstance, a picture of a closed door. Here is a diagram of the situation.

uttering the sentence "The door is closed"

holding up a picture of a closed door → asserting that the
 door is closed

sending up a certain smoke–signal

Keeping this point in mind, let us now focus our attention for just a moment on that count-generated action of asserting that the door is closed. One's first inclination is probably to think that the action consists in doing something with, or to, the *sentence* "The door is closed." But once we see that that very same action of asserting can be generated without uttering that sentence, indeed without uttering any sentence at all, then it is apparent that that analysis will not do. To assert that the door is closed is not to do something with or to the sentence "The door is closed." But what then does that action of asserting consist in?

Well, in the immediately preceding section I introduced the concept of *state of affairs*. And though I did not emphasize the point at the time, a state of affairs is obviously something different from a sentence. A given state of affairs can be asserted with all sorts of different sentences, and with entities other than sentences, but it is not itself any one of those sentences. It is not a linguistic entity at all. One might explain it rather as something that can be accepted, or believed. And once we see this, then our question as to the nature of the action of asserting has a rather obvious answer. To assert that the door is closed is to perform some action on the *state of affairs* (proposition) of the door's being shut. Specifically, it is to perform on that state of affairs the action of asserting it. Or alternatively expressed, it is to take up to that state of affairs the assertive stance.

This insight leads right on to a new point. In addition to asserting that the door is closed I can *ask* whether the door is closed, I can *command* that the door be closed, I can *express the wish* that the door be closed, etc. It is evident that in each such case I would be dealing with the same state of affairs—that of the door's being closed. But I would be dealing with it in different ways. I would be performing different actions on that one state of affairs. I would be taking up different stances toward it. What Sidney said, in effect, was that the poet (fictioneer) does not take up an assertive stance toward the states of affairs with which he deals. Instead he takes up what we may call the fictive stance. Our analysis can be diagramed as follows:

taking up an assertive stance towards
taking up an interrogative stance towards } *the door's being closed*
taking up an imperative stance towards
taking up a fictive stance towards

We saw, just a few paragraphs ago, that one can take up an assertive stance toward some state of affairs not only by uttering some bit of language but by other means as well. What must now be noticed is that in exactly similar fashion one can take up some *nonassertive* stance toward some state of affairs by means other than uttering some bit of language. For example, by showing a

picture of a closed door to someone, in the appropriate circumstance, one can issue the command to close the door—that is to say, one can take up an imperative stance toward the state of affairs of the door's being closed. Equally, by showing a picture of a closed door to someone in the appropriate circumstance, one can take up a fictive stance toward the state of affairs of the door's being closed.

uttering the sentence "the door is closed"
in appropriate manner and circumstance taking up a fictive
 stance toward: *the*
drawing a picture of a closed door in *door's being closed.*
appropriate circumstance

uttering the sentence "the door is closed"
in appropriate manner and circumstance taking up an impera-
 tive stance toward:
drawing a picture of a closed door in *the door's being closed.*
appropriate circumstances

And there we have the basic elements for understanding the nature of the action of world-projection. By doing one and another thing with his artifact of art, the artist projects a certain world. He takes up a stance toward those states of affairs constituting the world of the work. It may be an assertive stance. It may in principle be an imperative stance. It may be an optative or an interrogative stance. But over and over what we discover is that it is a fictive stance. That is to say, over and over we discover that the artist invites us to *consider* the world of his work. For that, it seems to me, is what constitutes the fictive stance. To take up the fictive stance toward some state of affairs is not to *assert* that that state of affairs is true, is not to *ask* whether it is true, is not to *request* that it be made true, is not to *express the wish* that it be true. It is simply to invite us to consider that state of affairs. When a performance of Shakespeare's *Macbeth* takes place, we are then, by means of all those actions of role-playing, invited to consider a certain complex state of affairs—that which is the world of the performance. And when Botticelli painted his *Birth of Venus*, he in similar fashion invited us to consider that complex state of affairs which constitutes the world of his work.

5. POINT OF VIEW

For our project of understanding the nature of fictional world-projection, one crucial topic remains to be discussed—*point of view*, as it is customarily called. I think that this is a somewhat misleading name for the phenomenon in question; shortly I shall point out in what way I judge it to be misleading. But if we are thus forewarned, probably no harm will result from adopting the customary parlance.

The phenomenon in question is easily grasped. Consider a case of literary fiction. What I have argued thus far is that the author, by his particular use of the words of the text, projects a world. But what must now be noticed is that

there is more to the workings and significance of his use of those words than just that thereby he projects the world of the work. A simple way of putting the point is this: fictional discourse has significance beyond *story*, where "story" is understood as designating the world of the work. For one thing, not only does the discourse give us the story; it gives us the story *in a certain way*. But secondly, fictional discourse often bears a significance beyond even that of giving us the story in a certain way.

To make these points concrete, consider the following passage from Balzac's *Gambara*. The passage is cited by Jonathan Culler in his discussion of point of view in his book *Structuralist Poetics*:

> After a turn in the arcades, the young man looked at the sky and then at his watch, made an impatient gesture, entered a tobacco shop, lit a cigar, placed himself before a mirror, and glanced at his clothes, somewhat more elaborate than the laws of taste in France permit. He adjusted his collar and his black velvet waistcoat, which was crisscrossed by one of those large golden chains made in Genoa; then, throwing his velvet-lined coat onto his left shoulder with a single movement and letting it hang there in elegant folds, he continued to walk, without allowing himself to be distracted by the leers of passersby. When the lights in shops began to go on and the night seemed to him sufficiently dark, he made his way towards the square of the Palais Royal like a man who was afraid of being recognized, for he kept to the side of the square until the fountain so as to enter the rue Froidmanteau screened from the hackney cabs.[43]

For our purposes, three components in this passage are particularly worth noting. First, consider that clause "which was crisscrossed by one of those large golden chains made in Genoa." Balzac is here indicating one of the states of affairs included within the world of the work. But surely he is, at the very same time, doing something else as well. He is implying that in the actual world, certain large chains are made in Genoa. Furthermore, he is quite clearly presupposing that his readers know what those chains are like. Here then is a clear case of fictional discourse having significance beyond story.

Secondly, notice the following words near the end of the passage: ". . . for he kept to the side of the square. . . . " Here a bit of reasoning is taking place—an inference is being drawn. Who, though, is *doing* the reasoning? Evidently not anyone in the world of the work. No one in the world of the work is drawing the inference in question. The inference is being drawn by Balzac. So here, then, is a second clear case of discourse having significance beyond story.

A third example of significance beyond story occurs earlier in the passage, in the words "somewhat more elaborate than the laws of taste in France permit." Here the words function to tell us what is included in the world of the work; they contribute to the characterization of the young man's dress. But at the same time Balzac is surely implying that in the actual world there are laws of taste concerning dress in France which are capable of being transgressed.

In describing the significance beyond story of the discourse in this passage, I have spoken of *Balzac* as implying various things about the actual

world, and of *Balzac* as engaging in a small bit of reasoning. Most contemporary literary critics would protest this suggestion that Balzac is doing these things. On the evidence of the novel, they would say, we have no right to assume that Balzac actually believes that golden chains are made in Genoa or that the French have transgressable laws of taste in dress; neither have we any right to assume that Balzac would in fact be willing to infer from someone's keeping to the side of a square that he was acting like a person afraid of being recognized. Accordingly, most critics would postulate a *narrator* distinct from the author—for this and for all other works of fiction; and they would attribute to this postulated narrator the "implyings" and the "inferrings." The world of Balzac's fiction, they would say, has the fundamental structure of someone engaged in a lengthy narration. In that, it is like all other fiction. Never does the literary fictioneer straightforwardly tell us a tale of love and death, birth and war, jealousy and endeavor. Always his tale is the tale of a *narration* about love and death, birth and war, jealousy and endeavor.

Those who wish a full discussion of this canonical contemporary view should consult Part Three of my *Works and Worlds of Art* (London: Oxford University Press, forthcoming). Here let me just remark that the facts cited do not justify the conclusion drawn. It is perhaps true that on the evidence of the novel we cannot conclude that Balzac believed that certain large golden chains were made in Genoa. The fundamental reason for that is this: For the purposes of their fictions, authors often pretend various things to be true of themselves which are not in fact true. They put on a mask—a *persona*. They adopt a voice. But once we see clearly that this is what is going on, the postulation of a narrator distinct from the author is seen to be pointless. All the facts are accounted for if, instead of postulating a narrator, we simply acknowledge the obvious fact that an author may put on a *persona* for the purposes of his fiction, and if, in addition, we keep firmly in mind that the reader with literary intentions will not care in the least in which respects the mask of the *persona* is like the author's own face and in which respects it is different.

I have described the phenomenon under discussion here in this way: Literary discourse has significance beyond the story. I added that customarily the phenomenon is called "point of view." We can now see why it is thus called. The fact that discourse has significance beyond story leads the contemporary critic to postulate a narrator for every work of fiction, a narrator distinct from the author. And he then understands the significance of discourse beyond story as consisting in the *point of view* of this narrator on the remainder of the projected world. Indeed, in his classic book *The Craft of Fiction*, the literary critic Percy Lubbock remarked that "The whole intricate question of method, in the craft of fiction, I take to be governed by the question of the point of view—the question of the relation in which the narrator stands to the story."[44] Since I do not regard every work of fiction as having a fictional narrator, it can be seen why I regard the phrase "point of view" as a misleading name for the phenomenon in question—the phenomenon, namely, that fictional discourse has significance beyond story.

Nonetheless, for the sake of convenience I shall occasionally use this name.

I have suggested that in the passage from Balzac's *Gambara*, it is Balzac who infers and implies various things, not some postulated fictional narrator distinct from Balzac. I do wish to acknowledge, however, that the structure of some fiction is indeed such that we must "postulate" a fictional narrator for all the words of the text, and atrribute to him, rather than to the author, all the inferrings and implyings conveyed by the discourse.

Consider, for example, the opening sentences of Dickens' *David Copperfield:*

> Whether I shall turn out to be the hero of my own life, or whether that station will be held by anybody else, these pages must show. To begin my life with the beginning of my life, I record that I was born (as I have been informed and believe) on a Friday, at twelve o'clock at night. It was remarked that the clock began to strike, and I began to cry, simultaneously.

The *form* of these words is such that they might well function as the opening of an autobiography. And given that they were put down by Dickens, if they were functioning as an autobiography it would be as the autobiography of Dickens. Dickens would be using the "I" to refer to himself. But surely that is not how these words are functioning. For the autobiographer uses his words to assert; but *David Copperfield* is a work of fiction, and we have agreed with Sydney that the fictioneer "nothing affirmeth." How then are these words functioning?

Well, even if we agree that in *David Copperfield* Dickens is not engaged in telling his autobiography but rather in fictionally projecting a world, it is coherent to suppose that Dickens is using the "I" to refer to himself. For with the text that follows he may be putting forth an elaborate fiction about himself. Certainly there is nothing impossible in an author's fictionalizing about himself.

Yet this too does not seem the best way of understanding the structure of Dickens' novel. Better to construe *the character David Copperfield* as speaking those opening words, and indeed, as speaking all the words in the text that follows. These words do not give us what Dickens says—assertively or fictionally—about himself. They give us what David says. It is David's autobiography that we read, not Dickens'.

That is to put it somewhat imprecisely, however. It is only *persons* who speak. Characters are mute. For characters are not persons but, so it seems to me, *types* of persons. And *types* of persons do not speak. If we survey all who in the course of history have ever spoken, we shall not find the character David Copperfield among them. The situation is rather that *if* someone were to be an *example* of the David Copperfield character, he would have to inscribe all the words of Dickens' text.

We may put the point by saying that David is the *narrating character* of *David Copperfield*. A passage of a text will be said to have a *narrating character* if, and only if, the world of the work has among its components a

character such that for the world to occur there would have to be an example of that character who would utter or inscribe all the words of the passage and say thereby whatever the world of the work requires that he say. The novel *David Copperfield* is not Dickens' autobiography. Neither is it an elaborate fiction that Dickens has written about himself. Rather it is a novel so structured by its author that it has a single narrating character—namely, the character David Copperfield. And in such a case, all the inferrings, implyings, etc. conveyed by the discourse are to be attributed to the narrating character, not to the author. Whatever significance the discourse bears beyond story is significance borne by the discourse of the narrating character. For the text is entirely *his* discourse. The author has disappeared from view.

The central idea in this concept of the narrating character of a passage is that for the world of the work to occur, an example of the character would have to utter or inscribe all the words of the passage. To fix the idea in mind it may help to cite a passage which does not have a narrating character, thus conceived, but only an *authorial narrator*. The passage already cited from Balzac will do. The world projected by the text of which that passage is a part can occur without anyone's uttering all the words of that passage. But for good measure, here is another passage of the same sort, taken from Henry James's story "The Beast in the Jungle":

> "Well," she quickly replied, "I myself have never spoken. I've never, never repeated of you what you told me." She looked at him so that he perfectly believed her.

That this passage lacks a narrating character can be seen by noticing that the world of the work can occur without anyone at all uttering these words of the text:

> She looked at him so that he perfectly believed her.

or these:

> . . . she quickly replied.

It is not some character in the projected world who says that she looked at him thus, and who says that she quickly replied. It is *the author*, Henry James, who says this. The clue to a passage's having an authorial-narrator structure rather than a narrating-character structure will almost always be "he said's" and "she said's" which cannot be attributed to any character in the world of the work.

By and large, passages cast in the first person singular will be of the narrating-character structure, and passages cast in the third person will be of the authorial-narrator structure. But this holds only for the most part. And even if it did hold invariably, the grammatical distinction would still be only a superficial linguistic clue to the structural difference that I have tried to elucidate.

A few paragraphs back I said that in fiction of the narrating-character structure, the author has "disappeared from view." Apart from the obvious unity given to a work of this structure, I think it is especially this disappearance of the author that has attracted many novelists and short story writers, since the latter part of the nineteenth century, to this way of structuring their fiction. Automatically a certain immediacy of effect is gained. In the structure of such narration there is nothing between us, the readers, and the narrating character. All that stands in the text is what he said. Never does the author intrude with his inferrings and implyings, his "he said's" and "she said's."

This immediacy is bought at a price, however—the price of severe constrictions on the nature of the world projected. For consider a novel or story which has a *single* narrating character, and imagine the world of such a work obtaining. In the case of *David Copperfield* that means we are to imagine a person named David Copperfield as uttering or inscribing all those words to be found in the text of Dickens' novel. But under what circumstances would someone pour forth such a lengthy stream of words? He might do so if he were making a record of his life and experience; and that is quite clearly the situation envisaged for *David Copperfield.* Or he might do so if he were pouring forth a lengthy soliloquy (Poe's "The Cask of Amontillado") or a monologue to some audience which either never interrupts or whose interruptions are known to us only through the speaker's reports of them (Poe's "The Tell-Tale Heart"). But apart from such situations there seems nothing else. And such situations obviously constitute an exceedingly minor part of human life.

I have drawn the distinction between fiction of the narrating-character structure and fiction of the authorial-narrator structure so as to grant to the contemporary critic that sometimes, indeed, the world of a work involves a fictional narrator (narrating character) distinct from the author. But now let us return to the main point of this section—the fact that fictional discourse has significance beyond story. What are some of the important dimensions of this supra-story significance? And here it won't be necessary to distinguish the two structures. Just as the author's discourse, in the authorial-narrator structure, has significance beyond story, so too the narrating character's discourse, in the narrating-character structure, has significance beyond that of serving to project a world. And a certain dimension to the significance of the one will always have its counterpart in the other. Of course, throughout it should be remembered that, for the authorial-narrator structure, we may well be dealing with the author's *persona* and not with the author himself.

(1) A point often made by the contemporary critic is that a world can be projected with varying degrees of reliability and unreliability. Our entire access to the world of the work is through the words of the authorial narrator or the narrating character. We flesh out the world by drawing conclusions about decisive events, about the psychological makeup of various characters, about

features of the countryside in which the story is set, etc.; and all our inferences are based on the authorial narrator's or the narrating character's discourse. But how precarious the inferences sometimes are. The words of the narrating character, or of the authorial *persona*, may make it clear to us that he or she is demented, or neurotic, or a lying braggart, or unduly infected by eighteenth-century optimism, or trying desperately to block out unpleasant reality; and all of that must be taken into account as we try to find our way into the world of the work.

(2) Secondly, the particular way in which discourse projects a world for us often has a temporal dimension worth taking note of. In turn, this temporal dimension has a number of different facets. For one thing, narrations vary with respect to their *pacing*. Sometimes, as in Proust, the story is narrated with expansive leisureliness. Sometimes, as in Hemingway, with abrupt briskness. Then too, the events belonging to the projected world will always be narrated in a certain order—call it the *narrative temporal order*. And this order must be distinguished from the order in which they occur in the projected world—call that the *worldly temporal order*. These two orders may stay nicely in phase. But then again they may not. Something that happened earlier may be narrated later; that would be a flashback. And something that happened later may be narrated earlier; that would be a flash-forward. By combining the narrative and worldly temporal orders in different ways, a variety of different aesthetic effects is possible.

(3) An important facet of a narrating character's or authorial narrator's point of view is that he exhibits knowledge of just certain sorts of states of affairs in his projected world, while of others he exhibits ignorance. Further, the narrating character will often exhibit the fact that he acquired the knowledge he does have in some particular way. Thus the point of view will have what I shall call a *knowledge/ignorance contour*.

For example, unless we ascribe to our narrating character exceptional powers of ESP, of his own inner life the narrating character will have direct knowledge but of the inner life of others he or she will either have no knowledge or only knowledge indirectly acquired. Further, if he is an adult and the fiction is realistic he will know things a child typically does not know, and no doubt fail to perceive things a child typically perceives. But if, on the other hand, he is a child and the fiction is realistic, there will be characteristic lacunae in his knowledge. And so forth. In these and other ways the knowledge of the narrating character will be significantly different from that of the other characters. On this fact are grounded many of the striking effects, ironies, and surprising turns of fiction.

With respect to the knowledge/ignorance contour of point of view, it will be worth explicitly comparing the situation for authorial narrators to that for narrating characters. In authorial-narrator fiction of the old-fashioned sort, the knowledge/ignorance contour of the point of view is not *particularized* to any of the characters in the world of the work. The authorial narrator in

Fielding's novels, for example, exhibits *direct* knowledge of the inner life of all his characters. In the twentieth century, however, beginning especially with Henry James, authors have explored the possibility of telling the tale from the "point of view"—that is, with the knowledge/ignorance contour—of *one* of the characters, without making that character the *narrating* character, preserving instead the structure of authorial narrator. In this way the extreme constrictions of the narrating-character device, which I noted earlier, are skirted, while yet the tale is told with the knowledge/ignorance contour of one of the characters. Thus one of the considerable advantages of the narrating-character device is preserved—namely, that of securing unity by telling all from the perspective of one of the characters. In the words of Henry James, one of the characters is chosen as the *center* or the *reflector*; and then all is reported as he perceives and knows it. With the reflector's inner life, for example, the authorial narrator has unmediated acquaintance; but everyone else is described as perceived and known from the outside, as the reflector with all his idiosyncrasies and limitations perceives and knows them. Of course it is possible to take yet one step beyond the single reflector device, and to describe *everyone* from the outside. This would yield yet a different knowledge/ignorance contour.

(4) Another important facet of a narrating character's or authorial narrator's point of view is what might be called *focus*. He dwells on, stresses, focuses on, certain sorts of things and phenomena in the world of his work, and allows others to pass unnoticed or unremarked. In dealing with people, he focuses, say, on their psychological dynamics; in dealing with physical objects, he focuses on their colors or their shapes; in dealing with political matters, he focuses on the ethical dimensions; etc. A striking feature of Andre Bresson's films is his habit of often focussing on tiny physical details in the world of the work.

(5) A narrating character or authorial narrator will often evaluate, and exhibit an attitude towards, the characters, countries, events, etc., in his world. He may exhibit fondness or revulsion, admiration or disdain, for one of the characters. He may condemn, or he may approve, the structure of the society. If he sees God as underlying the reality of the projected world, he may urge obedience, or quest, or indifference, or defiance. If his world contains violence, he may delight or grieve therein, approve or condemn. Probably no writer has ever been so explicit in his evaluation of characters and incidents in his projected world as Thackeray.

It may be worth remarking once again that we are not automatically to attribute evaluations and attitudes of the author's narrating *persona* to the author himself. One facet of the authorial narrator's *persona* may be an attitude of scornful superiority to others; the author himself, however, may be afflicted with a deep inferiority complex.

It should be added that, nonetheless, the totality which is the work of fiction—discourse along with story—is *an expression of* the beliefs and

attitudes of the real, live author. The author may even have constructed that totality to perform the *intentional action of expressing* his beliefs and attitudes. What is more, the work may *reveal* those beliefs and attitudes to the perceptive reader.

(6) Over and over the discourse of narrating character, and even more often, of authorial narrator, will function symbolically or allusively without anyone in the projected world taking something as symbolic or allusive. Literature is filled with characters who function in the discourse as Christ-figures, without anyone in the projected world taking them as such. And the banquet scene in Bunuel's film *Viridiana* is clearly presented in such a way as to allude to da Vinci's painting of the Last Supper. Nobody in the projected world, however, catches any such allusion.

(7) Lastly, the discourse of narrating character or authorial narrator often serves to express various beliefs and attitudes concerning the *actual world*. That became clear in our analysis of the Balzac passage. With the very words whereby he projects a world, Balzac also expresses, or pretends to express, the belief that certain large golden chains are made in Genoa.

Although I have taken a few illustrations from film, this discussion has focused on point of view as it is found in literary fiction. It should be evident, however, that visual art—paintings and photographs, but even more, films—provides us with close analogues to point of view in literary fiction. Of course, in visual art it's not *discourse* which has significance beyond the projected world, but *the visual medium* which has significance beyond the projected world. But apart from this crucial difference, the analogues are very close indeed. (In film, we have a *combination* of discourse and visual medium, plus music, all of them bearing significance beyond story.)

It would be tedious to trace out in detail the analogues between the various dimensions of point of view in literary art and the various dimensions of points of view in visual art. I shall confine myself to comments on two points.

When the visual artist represents something—a horse, say—almost always he or she represents it as it would appear to someone viewing it from a certain angle—from left flank, head on, or whatever. And, sometimes at least, he represents it as it would appear to someone viewing it from a certain distance. We can put these two together and speak of *the implied visual vantage point* of a piece of two-dimensional visual representational art. In Mantegna's *Dead Christ*, the implied visual vantage point for the corpse is from feet on, just slightly above the toes, and from relatively near by. However, for the world of the work to occur, there needn't be someone who actually sees the dead Christ from such a vantage point. The particular look of the corpse in Mantegna's painting need not in fact be a look which it presents to anyone in the world of the work.

In general, the following is true: When the visual artist represents something, he or she represents it as it would appear from a certain vantage point, under certain physical conditions, to a person with a certain kind of

perceptual apparatus. In that way, the visual artist represents it as having a certain look. But there needn't be anyone in the projected world who is ever confronted with such a look. The representing look belongs not to the projected world, but to that part of the visual medium's significance which goes beyond projected world.

That was the first of the two points I wished to make. The second can be introduced by asking whether there is any close analogue, in visual art, to the narrating character phenomenon in literature.

I am told by a friend of mine in the film business that in the late 1940's some experimental films were made by strapping the camera to the head of an actor playing one of the characters and then allowing everything to be filmed from his perspective. One would never see the face of this actor, unless perchance he happened to look in a mirror; but one might well see his arms and legs floating into the perimeter of the picture. A variant on this would be a film in which each passage is shot "through the eyes" of one of the actors, but in which the actor in question is allowed to vary from passage to passage. In such films, and in paintings in which one sees the painter in a mirror, one gets as close an analogue in visual art as we are going to get to narrating characters in literary fiction.

The literal description of the analogue is this: The world projected by way of the painting or film has a character as component such that for that world to occur there must be an example of that character to whom things look just as the painting or passage of the film presents them as looking. Such a character may be called the *perceiving character* of that work, or of that passage of the work.

When a literary work has a single narrating character throughout, what is directly indicated by the author is just the state of affairs of someone of the requisite sort uttering the words of the text. The world of the work will of course be vastly more voluminous than that. But all else must be extrapolated from that. Now similarly, when a film has a single perceiving character throughout, what is directly indicated by the artist is just the state of affairs of someone of the requisite sort having things look to him that way. All else must be extrapolated from that. In this respect, perceiving characters in film bear a very close analogy indeed to narrating characters in literary fiction. In one case, our access to the projected world is entirely through what one of its characters says; in the other case, it is entirely through how one of its characters sees things.

I think we all sense, however, that the device of constructing one's film or painting so that it has a single perceiving character with respect to the work as a whole is likely to produce a very odd effect. No doubt it is for that reason that the use of the device is extremely rare. By contrast, the device of constructing one's literary work so that it has a single narrating character throughout is not at all odd in its effect and is eminently common.

As a result, there are many examples of exclusively narrative novels

constructed with a single narrating character which have been transcribed into films which do not have a single perceiving character throughout. Thereby a certain quality of interiority is often lost. In reading the novel one sees the world of the work from inside one of the characters. In watching the film one sees even *that* character from the outside. The loss of interiority seems to me especially strong in the film transcription of John Knowles' *A Separate Peace*. There are ways of diminishing the loss. For example, in Stanley Kubrick's film transcription of Burgess's *Clockwork Orange* the words of the novel are read aloud at various points on the soundtrack by the actor playing Alex. But even here there is a distinct loss of interiority.

6. THE BENEFITS OF WORLD-PROJECTION

I have emphasized that in its totality the world projected by the artist is almost invariably a world alternative to our actual world, not a world comprised within it; the outcome of envisagement, not just of reportage. But of course in its constituents it's a mixture. In some respects—that is, with respect to some of its constituent states of affairs—it is *true to* actuality, which is just to say that those states of affairs occur in the actual world. In other respects, it's *false to* actuality; certain of its constituent states of affairs do not actually occur. Some of the most important benefits to be derived from our immersion in the worlds of works of art are based on this phenomenon of these worlds' being true and false to actuality in various respects.

(1) Though our contemporary critics commonly overlook it, perhaps the most pervasive benefit of world-projection lies in what I shall call the *confirmatory* function of art. Over and over when surveying representational art we are confronted with the obvious fact that the artist is not merely projecting a world which has caught his private fancy, but a world true in significant respects to what his community believes to be real and important. Since in most communities it is the religion of the people which above all is important in their lives, this implies that much of the world's representational art is explicitly *religious* art. To understand the art of ancient and medieval South and Central America, the art of India, the art of medieval Europe, one must set off to the side our contemporary image of the alienated artist who has a prophetic insight to deliver or a stinging condemnation to issue to his fellow human beings, and one must instead see the artist as one who is allied in fundamental religious convictions with his community. The stories, the dramas, the paintings, the sculptures, serve more as an expression of the religious convictions of the artist's community, and to confirm that community in those convictions, than to lead it into new ones.

Important in the life of a people, in addition to its religion, is its self-image, including especially its remembered history, with its great figures, its decisive events, its crucial artifacts. Indeed, a community's self-image is most often inextricably interwoven with its religion. Thus much

of the world's art is national art, art which celebrates the nation, art which invokes the people's remembered (or fabled) history. The artist, counting himself as a member of his people, serves its cause by projecting worlds true in significant respects to his people's self-image, serving in that way, too, more to confirm than to illumine.

But even religious and national art do not, by any means, exhaust the examples of projected worlds which are true in significant respects to what the artist's community takes to be real and important. The wall paintings of Thera and Herakleion testify to the importance assigned to upper-class social life by those for whom these ancient artists were working. The Greek sculptures are evidence of the importance assigned by the Greeks generally to the human body. And the landscape painting of the West, from the late Renaissance on into the early twentieth century, reflects the fact that Western man for some four centuries now has been passionately interested in nature—*physical* nature. Indeed for many Westerners nature has been a matter of far more passionate interest than the Christian religion or the history of their own people. And this interest has been served by our artists. From Giorgione through Cézanne our painters have tried to capture the physical world surrounding us, to make their works true to Mont St. Victoire, to a lily pond in France, to the Dutch or English landscape.

But why? Why this persistent impulse of the artist to project worlds true in significant respects to what his community finds real and important? Obviously because his community finds it desirable and beneficial to have such works. But that just moves the question back one step. Why does the community find it desirable and beneficial? Why was medieval European man not content with Bible and sermon and devotional book? Why all those dramas? Why all those paintings? Why all those sculptures?

For one thing, one cannot escape the impression that there is in man a deep desire for *concreteness,* that there is in man a deep dissatisfaction with merely holding in mind his religion, his history of his people, his convictions as to what is important, and a passionate wish instead to make all this concrete, in story and play, song and dance, painting and sculpture. Aristotle sets us on the wrong track with his suggestion that the principal benefit of dramatic tragedy lies in the emotional purging we undergo by virtue of the fear and pity induced in us by the drama. Surely what above all gripped the Greeks in watching the tragedies of their dramatists was that there, before their eyes, were being unfolded the stories and histories so important to them as a people.

No doubt there are other reasons as well why societies have prized the availability of works of art whose worlds are true in significant respects to what the people regarded as real and important. One that we are inclined to overlook, because it no longer plays any role whatsoever in our thinking, is the conviction of people in earlier cultures that in representing something one somehow *realizes* it. A public drama was thought of not merely as a representation of certain sacred events but as a *reenactment* of those events.

And sacred visual representations were regarded as invocations of the presence of the represented being. The ancestor was "present" in the mask, the god in the idol, the saint in the icon.

(2) The benefit of world-projection to which most contemporary theorists would first of all call attention is not confirmation but *illumination*. Thereby the contemporary theorist reflects the practice of the contemporary artist. Whereas the traditional artist aimed to produce a work true in significant respects to what his community found real and important, our high-art artist in the modern West characteristically sets himself over against his society. He aims not to confirm them in their convictions, but to alter their convictions, by showing them how things are, illuminating them, so as thereby to awaken them from their somnolence, or release them from their self-indulgent ideologies, or energize them into action. Or perhaps it is no concern of some artists to alter the convictions of their compatriots. Perhaps their goal is simply to express their own vision—to give it concrete embodiment by composing a world true in significant respects to that vision. Nonetheless the consequence of the work of artists who aim to produce works true in significant respects to what they themselves in distinction from their society find real and important is often that others find their convictions altered.

To describe the difference between the traditional artist and the contemporary high-art artists as I have done above is, however, actually to paint the difference in starker tones than is justified. Our advanced contemporary societies are all, to a greater or lesser degree, pluralistic. In each there coexist a number of distinct and competing fundamental visions of life. And what is characteristic of our modern high-art artists is not that they with their private visions stand in agonized prophetic opposition to their society as a whole. What is rather the case is that they give expression to the vision of a certain *sub*-community. Characteristically they have given expression to the vision of the cultural elite, in opposition to that of the bourgeoisie. They have produced art which is true in significant ways to what the cultural elite regards as real and important. Structurally the situation is similar for Christian artists. Critical as they too may be of the bourgeoisie, and critical as they also may be of the cultural elite, toward their own Christian community they play a confirmatory role. Of course they will be critical of much that it does and thinks. Yet deep down, their work is confirmatory. The Christian, upon looking at Rouault or reading Flannery O'Connor, says, "Yes, that's how I've always thought it was"—perhaps adding immediately, "though I've never before seen it so clearly."

When illumination comes in the way described, it comes by virtue of the composed world *showing* us something about actuality, not by way of the artist *telling* us something about actuality. Several times now I have made the point that the artist's presenting to us his composed world may count as his asserting something about the actual world. But whether or not it does so count, and often indeed it's difficult to tell, his composed world inherently bears within it

the potential of *showing* us something of the actual world.

(3) The world of a work of art can be true, I have said, in various respects to actuality; likewise it can be true to what one and another person *takes* actuality to be. In these facts lies the potential of art for altering our convictions or for confirming us in the ones we already have. Over and over this potential is in fact, and by intent, realized by our artists. But the worlds of works of art can also be *false* to actuality in various respects, and false in various respects to one and another person's settled convictions about reality. And sometimes we prize the world of a work of art for its *falsehood* in various respects to what we believe actuality to be like. We want for a while to burrow into a world significantly different from our actual world. We want for a while to escape the drudgery and pain, the boredom, perplexity, and disorder of real life. There is that about our actual world which distresses us. And the artist presents us with a world which we judge to be, in one way or another, better. We wish things were actually like that. J. R. R. Tolkien speaks vividly on the matter in his essay "On Fairy-Stories":

> I have claimed that Escape is one of the main functions of fairy-stories and since I do not disapprove of them, it is plain that I do not accept the tone of scorn or pity with which 'Escape' is now so often used. . . . Why should a man be scorned, if, finding himself in prison, he tries to get out and go home? Or if, when he cannot do so, he thinks and talks about other topics than jailers and prisonwalls? . . .
>
> For a trifling instance: not to mention (indeed not to parade) electric street-lamps of mass-produced pattern in your talk is Escape (in that sense). But it may, almost certainly does, proceed from a considered disgust for so typical a product of the Robot Age, that combines elaboration and ingenuity of means with ugliness, and (often) with inferiority of result. These lamps may be excluded from the tale simply because they are bad lamps; and it is possible that one of the lessons to be learnt from the story is the realization of this fact. . . .[45]
>
> And if we leave aside for a moment 'fantasy,' I do not think that the reader or the maker of fairy-stories need even be ashamed of the 'escape' of archaism: of preferring not only dragons but horses, castles, sailing ships, bows and arrows; not only elves, but knights and kings and priests. . . .[46]
>
> But there are also other and more profound 'escapisms' that have always appeared in fairy-tale and legend. There are other things more grim and terrible to fly from than the noise, stench, ruthlessness, and aimlessness of the internal-combustion engine. There are hunger, thirst, poverty, pain, sorrow, injustice, death. And even when men are not facing hard things such as these, there are ancient limitations from which fairy-stories offer a sort of escape, and old ambitions and desires (touching the very roots of fantasy) to which they offer a kind of satisfaction and consolation. Some are pardonable weaknesses or curiosities: such as the desire to visit, free as a fish, the deep sea; or the longing for the noiseless, gracious, economical flight of a bird, that longing which the aeroplane cheats, except in rare moments seen high and by wind and distance noiseless, turning in the sun: that is, precisely when imagined and not used. There are profounder wishes: such as the desire to converse with all living things.

On this desire, as ancient as the Fall, is largely founded the talking of beasts and creatures in fairy-tales, and especially the magical understanding of their proper speech. This is the root, and not the 'confusion' attributed to the minds of men of the unrecorded past, an alleged 'absence of the sense of separation of ourselves from beasts.' A vivid sense of that separation is very ancient: but also a sense that it was a severance: a strange fate and a guilt lies on us. Other creatures are like other realms with which Man has broken off relations, and sees now only from the outside at a distance, being at war with them, or on the terms of an uneasy armistice. . . .

And lastly there is the oldest and deepest desire, the Great Escape: The Escape from Death. Fairy-stories provide many examples and modes of this—which might be called the genuine *escapist,* or (I would say) *fugitive* spirit. [47]

(4) The three benefits of world-projection to which I have thus far called attention all rest on the fact that the world of a work is true and false, in various respects, to the actual world. Let us now look at some benefits which do not rest, directly anyway, on that phenomenon.

In his discussion of the role of dramatic tragedy in human life, Aristotle gave central position to the fact that the projected worlds of tragedies evoke emotions in us—specifically, the emotions of pity and fear. And indeed it is true that our apprehension of projected worlds does, over and over, evoke emotions in us, and that often this contributes crucially to what we find gripping and compelling about them.

Almost everything about this phenomenon remains mysterious, however. Plato already insisted that representational art has some special impact on our emotions. This insistence has remained a persistent, though subdominant, theme in Western culture until, since the turn of our century, it has risen in influence to become a standard dogma concerning the arts. But in spite of the long tradition and the massive popularity of this conviction, virtually no theoretical illumination has been shed on the linkage between art and emotions. How does one explain the fact that the world of a painting, of a film, of a novel, of a play, moves one profoundly, inducing fear, grief, exhilaration, etc., all the while never stirring one from the conviction that what is represented never happened, and certainly is not happening now? Why do children weep over the fate of Pinocchio? Why do adult viewers feel terror in face of the blackbirds in Hitchcock's film *The Birds?* To these questions we have, I say, no good answers; in fact remarkably little attempt has been made to find answers. One must hope that this large untracked terrain will shortly be explored in depth by serious aestheticians.

(5) Another connection between world-projection and life—sometimes a benefit and sometimes not—lies in the phenomenon which psychologists have studied under the name of *modeling*. Repeatedly it has been shown that (under certain conditions) when person A observes a person B performing some action, that serves to develop in A the *ability* to perform that same

THE ACTION OF WORLD-PROJECTION

action, if he or she did not already have it, and in many cases it serves also to produce in *A* the *tendency* to perform that action in the relevant circumstances. Further, it has been shown that it matters very little whether the model is presented live or represented. In general, pictorially or dramatically represented models seem more effective than purely literary ones; but these latter are by no means without their effect. To be a bit more specific, it has been shown that violence in film tends to increase incidents of violence among certain sorts of viewers. Plato already warned against the effects of those works of art in which evil actions are represented. He was convinced that such works have a tendency to produce in viewers an inclination to act similarly. Contemporary psychology tells us that Plato's fears have a sound basis in fact.

(6) Probably the benefit of world-projection to which most writers would first of all call attention is this: By means of projecting a world, the artist *communicates* with his audience. No doubt the core of what is meant thereby is that by fictionally projecting an alternative world the artist makes an assertion about our actual world—a phenomenon to which I have several times called attention. Fiction can be used to present a message. I think that this happens less frequently in the arts than many people suppose; and I judge it to be less important than the other benefits to which I have called attention. But certainly what we often find significant about a work of representational art is that the artist thereby has communicated a message to us.

(7) Lastly, there is *consolation*. Perhaps this could be subsumed under one of my other categories. But I wish to single it out so as to let Tolkien speak about it:

> But the 'consolation' of fairy-stories has another aspect than the imaginative satisfaction of ancient desires. Far more important is the Consolation of the Happy Ending. Almost I would venture to assert that all complete fairy-stories must have it. At least I would say that Tragedy is the true form of Drama, its highest function; but the opposite is true of a Fairy-story. Since we do not appear to possess a word that expresses this opposite—I will call it *Eucatastrophe*. The *eucatastrophic* tale is the true form of fairy-tale, and its highest function.
>
> The consolation of fairy-stories, the joy of the happy ending: or more correctly of the good catastrophe, the sudden joyous 'turn' (for there is no true end to any fairy-tale): this joy, which is one of the things which fairy-stories can produce supremely well, is not essentially 'escapist', nor 'fugitive'. In its fairy-tale—or otherworld—setting, it is a sudden and miraculous grace: never to be counted on to recur. It does not deny the existence of *dyscatastrophe,* of sorrow and failure: the possibility of these is necessary to the joy of deliverance; it denies (in the face of much evidence, if you will) universal final defeat and in so far is *evangelium*, giving a fleeting glimpse of Joy, Joy beyond the walls of the word, poignant as grief. . . .
>
> The peculiar quality of the 'joy' in successful Fantasy can thus be explained as a sudden glimpse of the underlying reality or truth. It is not only a 'consolation' for the sorrow of this world, but a satisfaction, and an answer to that question 'Is it

true?' The answer to this question that I gave at first was (quite rightly): 'If you have built your little world well, yes: it is true in that world.' But in the 'eucatastrophe' we see in a brief vision that the answer may be greater—it may be a far-off gleam or echo of *evangelium* in the real world. . . .

The Gospels contain a fairy-story, or a story of a larger kind which embraces all the essence of fairy-stories. They contain many marvels—peculiarly artistic, beautiful, and moving: 'mythical' in their perfect, self-contained significance; and at the same time powerfully symbolic and allergorical; and among the marvels is the greatest and most complete conceivable eucatastrophe. The Birth of Christ is the eucatastrophe of Man's history. The Resurrection is the eucatastrophe of the story of the Incarnation. This story begins and ends in joy. It has pre-eminently the 'inner consistency of reality'. There is no tale ever told that men would rather find as true, and none which so many sceptical men have accepted as true on its own merits. For the Art of it has the supremely convincing tone of Primary Art, that is, of Creation. To reject it leads either to sadness or to wrath.[48]

<p style="text-align:center">* * *</p>

Writers on the arts are always tempted to reduce the richness and diversity of the ways in which world-projection enters beneficially into our lives—to say that the "real" benefit of art lies in *this* one thing, that the "real" purpose of art lies in *that* one thing. I have indicated a wide variety of ways in which world-projection enters our lives. But this is still only a selection. I have said nothing here, for example, about the aesthetic delight that we so often get from contemplating the world of the work. Nor have I said anything about the fact that representational visual art often leads us *literally* to see things differently: After our immersion in the world of Jacob Ruysdael's Dutch landscapes, the clouds in Michigan look different. And even where I have selected out some benefit for attention, my selection has been highly general and schematic. The purposes, the benefits, the consequences of world-projection in one of the arts are not the same in one age and culture as they are in another. But even in one art, in one age, in one culture, the projection of worlds enters in countless significant ways into the fabric of our human existence.

7. MARCUSE ON THE BENEFITS OF WORLD-PROJECTION

An instructive contrast to what I have said about the benefits of world-projection is to be found in Herbert Marcuse's recent book *The Aesthetic Dimension*.[49] Marcuse is himself a Marxist, and what he develops is recognizably a Marxist theory, for like all Marxists, he "ascribes to art a political function and a political potential" (p. ix). Yet when placed within the Marxist tradition of aesthetic reflection, Marcuse's theory is innovative, even radical. The burden of his book, to use the words of its subtitle, is "Toward a Critique of Marxist Aesthetics." He wishes "to contribute to Marxist aesthetics through questioning its predominant orthodoxy" (p. ix). And what

emerges is the thesis that in art lies man's saving liberation.

Marcuse focuses his attention exclusively on fiction—specifically on literary and dramatic fiction. He says he believes that what holds true for literature may also apply, *mutatis mutandis,* to the other arts (p. x). And perhaps this is true in so far as fiction puts in its appearance in the other arts. But the theory would have to undergo *fundamental* alteration if it were to have application to nonfiction. In essence, Marcuse's is a theory as to the social function not of art generally but of fiction—indeed, of high-art, elitist, fiction.

The standard Marxist view is that fiction, as well as the other arts, must express the consciousness of the ascending class in a given society if it is to be authentic. In capitalism that ascending class is the proletariat. Thus the Marxist view is that, among us, fiction must serve the proletariat's struggle for liberation. It must be an instrument in its revolutionary praxis.

To this view Marcuse expresses a striking alternative. It is *humanity* that fiction serves, not just the ascending class in a particular society, and certainly not just the proletariat class in capitalist society. And fiction serves the cause of humanity inevitably, at least if it is genuine art. No exhortation to the fictioneer is necessary other than just that he produce art, that he produce fiction which has artistic form. If he does that, then perforce he will be serving humanity.

The comprehensive goal of mankind is liberation from every form of social repression and natural constraint. The victory of the proletariat is at best a phase in the attainment of this goal.

> The permanent transformation of society under the principle of freedom is necessitated not only by the continued existence of class interests. The institutions of a socialist society, even in their most democratic form, could never resolve all the conflicts between the universal and the particular, between human beings and nature, between individual and individual. Socialism does not and cannot liberate Eros from Thanatos. Here is the limit which drives the revolution beyond any accomplished stage of freedom: it is the struggle for the impossible, against the unconquerable whose domain can perhaps nevertheless be reduced. (pp. 71-72)

Art, then, is called to serve, and does in fact serve, human liberation in all its dimensions—not just the cause of the proletariat. "If art 'is' for any collective consciousness at all, it is that of individuals united in their awareness of the universal need for liberation—regardless of their class position" (p. 31). "By virtue of its transhistorical, universal truths, art appeals to a consciousness which is not only that of a particular class, but that of human beings as 'species beings,' developing all their life-enhancing faculties" (p. 29).

But how does art serve the cause of human liberation in all its dimensions? It does so by its very *form*—by the very form of fiction. "We can tentatively define 'aesthetic form' as the result of the transformation of a given content (actual or historical, personal or social fact) into a self-contained whole: a poem, play, novel, etc. The work is thus 'taken out' of the constant process of

reality and assumes a significance and truth of its own" (p. 8). If this transformation "is to pierce and comprehend the everyday reality, it must be subjected to aesthetic stylization: it must be made into a novel, play, or story, in which every sentence has its own rhythm, its own weight. This stylization reveals the universal in the particular social situation . . ." (pp. 22-23). Thus the essence of aesthetic form consists in a transforming stylization of reality, the result being a unified entity having a significance of its own.

If the artist has succeeded in creating a genuine world for his work of fiction, by way of transforming ordinary reality, that world of his work then constitutes both a criticism of the established order and a sign of release from its dominance by its evocation of an alternative. "The aesthetic transformation turns into indictment—but also into a celebration of that which resists injustice and terror, and of that which can still be saved" (p. 45). At the same time, though, the world of the work serves to reconcile us to the actual world. Here it is best to let Marcuse speak at some length in his own words.

> The radical qualities of art, that is to say, its indictment of the established reality and its invocation of the beautiful image of liberation are grounded precisely in the dimensions where art *transcends* its social determination and emancipates itself from the given universe of discourse and behavior while preserving its overwhelming presence. Thereby art creates the realm in which the subversion of experience proper to art becomes possible: the world formed by art is recognized as a reality which is suppressed and distorted in the given reality. . . . The inner logic of the work of art terminates in the emergence of another reason, another sensibility, which defy the rationality and sensibility incorporated in the dominant social institutions.
>
> Under the law of aesthetic form, the given reality is necessarily *sublimated:* the immediate content is stylized, the 'data' are reshaped and reordered in accordance with the demands of the art form, which requires that even the representation of death and destruction invoke the need for hope—a need rooted in the new consciousness embodied in the work of art.
>
> Aesthetic sublimation makes for the affirmative, reconciling component of art, though it is at the same time a vehicle for the critical, negating function of art. (pp. 6-8)

In brief, the fictioneer's projection of a world alternative to the actual world, a world which is a stylized transformation of the actual world while yet a "recollection" of it (p. 73), functions as indictment of the actual world and invocation of a liberating alternative to the actual world, while at the same time serving strangely to reconcile us to the actual world.

> Art challenges the monopoly of the established reality to determine what is 'real,' and it does so by creating a fictitious world which is nevertheless 'more real than reality itself.' To ascribe the nonconformist, autonomous qualities of art to aesthetic form is to place them outside 'engaged literature,' outside the realm of praxis and production. (p. 22; see also pp. 54 and 72) The distance and estrangement from praxis constitute the emancipatory value of art. . . . (p. 19)

The service of art to liberation is thus that it alters our consciousness. "Art cannot change the world, but it can contribute to changing the consciousness and drives of the men and women who could change the world" (pp. 32-33; see also pp. 36-37). In part, art inspires revolutionary practice. "The autonomy of art contains the categorical imperative: 'things must change.' If the liberation of human beings and nature is to be possible at all, then the social nexus of destruction and submission must be broken" (p. 13; see also pp. 57-58, 41). But even when reality cannot be changed, even when revolutionary praxis is an impossibility, art serves the cause of human liberation by producing in us a sense of estranged reconciliation with reality as it is:

> . . . The strong affirmative tendencies toward reconciliation with the established reality coexist with the rebellious ones. . . . [T]hey are . . . due . . . to the redeeming character of the *catharsis*. The catharsis itself is grounded in the power of aesthetic form to call fate by its name, to demystify its force, to give the word to the victims—the power of recognition which gives the individual a modicum of freedom and fulfillment in the realm of unfreedom. The interplay between the affirmation and the indictment of that which is, between ideology and truth, pertains to the very structure of art. But in the authentic works, the affirmation does not cancel the indictment: reconciliation and hope still preserve the memory of things past. (p. 10).

What we saw Marcuse emphasizing, when he spoke of *aesthetic form*, was the transforming stylization which experienced reality undergoes when a world is fictionally projected. What should also perhaps be mentioned, before we leave him, is the presence of *beauty* in aesthetic form. For in part at least it is the presence of beauty which, on Marcuse's view, evokes an image of liberation. This is what he says:

> Aesthetic formation proceeds under the law of the Beautiful, and the dialectic of affirmation and negation, consolation and sorrow is the dialectic of the Beautiful. . . .
> [T]he idea of Beauty appears time and again in progressive movements, as an aspect of the reconstruction of nature and society. What are the sources of this radical potential?
> They are first in the erotic quality of the Beautiful, which persists through all changes in the 'judgment of taste.' As pertaining to the domain of Eros, the Beautiful represents the pleasure principle. Thus, it rebels against the prevailing reality principle of domination. The work of art speaks the liberating language, invokes the liberating images of the subordination of death and destruction to the will to live. This is the emancipatory element in aesthetic affirmation. . . .
> [T]he defiant remembrance is alleviated, and the Beautiful becomes part of the affirmative, reconciling catharsis. Art is powerless against this reconciliation with the irreconcilable; it is inherent in the aesthetic form itself. Under its law, 'even the cry of despair . . . still pays its tribute to the infamous affirmation' and a representation of the most extreme suffering 'still contains the potential to wring out enjoyment.' (pp. 62-66)

Much could be said by way of evaluating these thoughts of Marcuse. Here I want simply to call attention to the fact that in Marcuse's theory we once again find religious significance attached to art—all the more striking since it comes from the hands of a Marxist. Man's predicament in the world and in society is that his "life-enhancing" impulses are constantly thwarted. Thanatos wins out over Eros. Man is the victim of pervasive oppression. But art, and specifically fiction, is man's liberating savior from his predicament. Art works hand in hand with revolutionary praxis for man's liberation. But at a certain point it leaves even such praxis behind and moves on by itself, serving the cause of Eros:

> The affirmative character of art . . . is in the commitment of art to Eros, the deep affirmation of the Life Instincts in their fight against instinctual and social oppression. The permanence of art, its historical immortality throughout the millennia of destruction, bears witness to this commitment. (pp. 10-11)

Marcuse is of course a cognitivist in his approach to art. Art's fundamental function is to communicate "truths not communicable in any other language . . ." (p. 10). Art illumines reality for us. But in its very illumination of reality it presents to us an alternative of liberation. And moved as we all are by Eros, this alteration of consciousness is enough to alter our instinctual/impulsive structure as well, and to set in motion within us the impulses for and the consolation of liberation. For though we all suffer at the hands of Thanatos, Thanatos lies not in our inner depths but imposes itself on us from outside. Our hearts remain pure. Thus, on Marcuse's view, art is not caught up in the ambiguity of our human situation. There is not in it a mixture of the good and the bad, of that to which we must say Yes and of that to which we must say No. Art is pure, unsullied, always serving the cause of liberation, inherently so, *transcending* the social realities of our existence. On the hands of art there is no blood, in its heart, no hate.

And so we find in Marcuse nothing less than a surrogate for the Christian gospel of redemption and liberation, and for the Savior who is Jesus Christ. Where the Christian sees God in Jesus Christ, through the work of His Spirit, as our liberator from the shackles of sin and its consequences, Marcuse sees man's high-art fiction as that liberator, from the shackles of social and natural oppression. Where the Christian sees Christ as the manifestation of the transcendent God who enters our existence, Marcuse sees art as that perfect transcendent thing which rises above our existence. Is it man's art, or is it God in Jesus Christ, to whom we must look for the realization of our humanity?

There are two points, however, where the analogy fails between these two competing religious visions. For one thing, Marcuse's vision is for the elite, and he never conceals that fact. As he himself emphasizes, it is the art of the elite that he is talking about. He has no patience with the idea that this art must be eliminated in favor of an art of the people. But to what then must the nonelite look for liberating praxis and for consolation in the midst of the

unalterable? This question is never answered. It is, in fact, not even addressed. By contrast, the gospel of Jesus Christ is a gospel for all alike, elite and nonelite.

Secondly, underlying Marcuse's salvific vision is a deep note of despair. What hope there is in him floats on a sea of despond:

> The possible 'other' which appears in art is transhistorical inasmuch as it transcends any and every specific historical situation. Tragedy is always and everywhere while the satyr play follows it always and everywhere; joy vanishes faster than sorrow. This insight, inexorably expressed in art, may well shatter faith in progress but it may also keep alive another image and another goal of praxis, namely the reconstruction of society and nature under the principle of increasing the human potential for happiness. The revolution is for the sake of life, not death. Here is the perhaps most profound kinship between art and revolution. (p. 56)

But then he adds, "Art cannot redeem its promise, and reality offers no promises, only chances" (p. 48). And again,

> While art bears witness to the necessity of liberation, it also testifies to its limits. What has been done cannot be undone; what has passed cannot be recaptured. History is guilt but not redemption. Eros and Thanatos are lovers as well as adversaries. . . . Eros itself lives under the sign of finitude, of pain. The 'eternity of joy' constitutes itself through the death of individuals. For them, this eternity is an abstract universal. And, perhaps, the eternity does not last very long. The world was not made for the sake of the human being and it has not become more human. (pp. 68-69)

Our experience is indeed pervaded by a painful estrangement. That must not be overlooked. Yet it is the Christian conviction that the world and history are for mankind. For at the foundation of the world and history is God; and God is for man. In that lies our hope.

Norms in Art: Artistic and Aesthetic Responsibility

1. ARTISTIC EXCELLENCE

LIKE SHOVELS and sleeping pills, works of art are human artifacts, produced and distributed for a purpose—objects and instruments of intentional action. And like shovels and sleeping pills, some are good, some not so good.

Consider spades, made for the purpose of digging holes, and sleeping pills, made for the purpose of putting people to sleep. A good spade is one that serves its purpose well. And that in turn consists of two things: being effective for digging holes, and proving generally good and satisfying to use for this purpose. So too a good sleeping pill is one that serves its purpose well. It is, in the first place, effective for putting people to sleep; and, secondly, it does so in a generally good and satisfying way, that is, without annoying or dangerous side-effects.

Of course a certain way of using the artifact is presupposed. The finest spade can be used in ways such that it will not produce holes of any consequence whatsoever, or will do so at the cost of severe blisters. And the best sleeping pills can be used in ways that they will not yield sleep or will cause death.

The maker or distributor will have in mind a "proper" use of the artifact and may even give explicit instructions for that use. But of course it may happen that some significantly different use achieves the purpose better than the one the maker or distributor had in mind. Alternatively, when using it in the way intended by maker or distributor, we may find ourselves achieving something more valuable than that purpose for which the artifact was produced or distributed. And thirdly, by using it in some way quite different from that which the maker or distributor had in mind, we may find ourselves achieving something more prized by some than is the purpose for which it was made or distributed. It was (unfortunately) discovered that sniffing airplane glue can produce a "high."

But even if used in a way appropriate for achieving the intended purpose, a sleeping pill or spade may be a good one without achieving its purpose well *under all conditions*. When a person has drunk several shots of whiskey, some sleeping pills serve their purpose poorly; and perhaps some spades work well in clay and not in gravel. Further, even if used in a proper way and under proper conditions, a sleeping pill or spade may be good without achieving its purpose well *for all people*. Perhaps some good sleeping pills work well only for people of a certain constitution.

So when we say that a spade is a good spade, or a sleeping pill a good sleeping pill, there is in the background some idea of the *use* which must be made of them if they are to serve their purpose well, and *by whom,* and *under what conditions*.

It's a good spade or sleeping pill, I said, if it serves the intended purpose well, that in turn having two dimensions. But sometimes we find that we have to make trade-offs. One spade may be comfortable to handle but not very effective; another effective, but hard to manage. One sleeping pill may be very effective in putting one to sleep, but also yield a headache the next day; another may have no noticeable side-effects, but also not be very effective.

Suppose someone asks why a particular spade is good. One can then offer *reasons* for its being so. Those reasons will consist of facts about the spade, aspects of the spade, on account of which it digs holes efficiently and proves generally good and satisfying to use. It is experience, and sometimes shrewd intuition, that tells us which features to give our spades so as to make them serve their purpose well.

Not only can one offer reasons why a particular spade serves well the purpose of digging holes. One can also offer reasons why, at certain junctures, it is worthwhile digging holes. Obviously such reasons are of quite a different order, and it is important not to confuse the two types.

Sometimes it is helpful not just to attach some brief instructions to a certain implement but to have people available to instruct one in how to use the implement so as to achieve the intended purpose. No doubt a sheet of instructions could be offered young people when they learn to drive. But all in all driving instructors are much better. And if new models always required quite radically different modes of use, or if models imported from abroad required different modes of use, it would be good to have driving instructors to teach us not just the first time around, but whenever such a new model comes our way.

In all these ways, works of art bear close analogies to spades and sleeping pills and automobiles. A good hymn is one that serves well the purpose of hymns. A good concerto is one that serves well the purpose of concertos. A good piece of background music is one that serves well the purpose of background music. A good drinking song is one that serves well the purpose of drinking songs. Let us say that a work of art has *artistic excellence* if it serves well the purposes for which it was made or distributed. In the next section I

shall distinguish *artistic* excellence, thus conceived, from *aesthetic* excellence.

Sometimes it will be important to differentiate between the purpose of the maker and the purpose of the distributor. For since these purposes may diverge, the work may be a good one by reference to the one purpose and not a good one by reference to the other. It may be a good mask but not a very good aesthetic object; or vice versa.

2. AESTHETIC EXCELLENCE

Concertos are produced, and are presented or distributed to us, in order to provide satisfaction upon aesthetic contemplation. On the theory just offered, a good concerto is one that serves its purpose well. It is effective in yielding satisfaction when submitted to aesthetic contemplation and it proves generally good and satisfying to use in this way.

But as we all know, artifacts not produced for that purpose may nonetheless serve it well. So too may artifacts neither produced nor distributed for that purpose, and so even may objects which are not human artifacts but things of nature. All may be effective in giving us aesthetic satisfaction.

Because of these facts it will be useful to have in hand not only the concept of a good concerto, a good lyric poem, and so forth, but also the concept of *aesthetic excellence*. An aesthetically excellent object is one that effectively serves the purpose of contemplation for aesthetic delight. It makes no difference whether or not its use as object of aesthetic contemplation proves not only effective in yielding aesthetic satisfaction but also good and satisfying in general. If it effectively serves that use, even if it also gives one, say, a headache, then it is aesthetically excellent.

A theory of aesthetic excellence of such a sort is sometimes called an *instrumentalist* theory of aesthetic value; for it grounds the aesthetic value of objects in how effectively they *serve the purpose* of contemplation for aesthetic delight. To such a theory, the only options I can see are ones which imply the claim that criteria for aesthetic excellence are qualities that *ought to* give us delight in contemplating them aesthetically, whether they do or not. But I see no way of grounding such a claim, nor accordingly of developing such a theory.

I have also, be it noted, adopted a *qualified* instrumentalist theory of *artistic* value. For I have said that the quality of a work of art—like that of any other artifact produced or distributed for a purpose—inheres in how effectively it serves that purpose. Therein lies the instrumentalist component. But I have added that it also inheres in how good and satisfying it proves in general to use for the purpose intended (the side-effect clause). Therein lies the qualification.

3. ASPECTS IRRELEVANT TO AESTHETIC EVALUATION

On the theory presented, the critic who evaluates a work of art with respect to its aesthetic dimension is judging the work's effectiveness in yielding satisfaction upon aesthetic contemplation. Reasons for his evaluation, when positive, will be facts about (aspects of) the work's aesthetic character which in his judgment will contribute towards satisfaction in aesthetic contemplation. When negative, they will be facts about (aspects of) the work's character which in his judgment will contribute towards dissatisfaction in aesthetic contemplation. If the critic is right in the former case, he has succeeded in discovering an *aesthetic merit* in the work, that is, a fact about (an aspect of) the work which will contribute towards satisfaction in aesthetic contemplation. If he is right in the latter case, he will have succeeded in uncovering an *aesthetic defect* in the work. The critic's overall aesthetic evaluation will then be based on a complex weighing of what he judges to be aesthetic merits and what he judges to be aesthetic defects in the work's character.

A question well worth considering is whether the manifold aesthetic merits of things can be grouped together into a few very general types. I think they can be. But to get at what those general types are, we must first clear the ground, by setting off to the side certain large groups of facts about works of art which cannot ground aesthetic evaluation. They are neither aesthetic merits nor aesthetic defects, though the ones I shall attend to are apt to be mixed up with such. Their irrelevance is based on their not belonging to the aesthetic *character* (inscape) of the object, whereas aesthetic satisfaction, by definition, is satisfaction grounded in contemplation of the aesthetic character of an object.

(1) The fact that a proposition asserted by means of some work is *true* is not an aesthetic merit in the work, and neither is the fact that the world of some work is *true to* actuality in some respect. These may be cognitive merits in the work. And as observed earlier, even when engaged in disinterested contemplation of a work we may derive satisfaction from noticing that its world is true to actuality in some respect. But they are not *aesthetic* merits in the work. So too, the fact that a proposition asserted by means of the work is *false* and the fact that the world of some work is *false to* actuality in some respect are not aesthetic defects in the work. Actuality does not constitute an aesthetic demand on the artist.

The reason is as follows. The aesthetic qualities of things are confined to the qualities of the looks and sounds of things under canonical presentations. But "looks true" and "looks true to actuality" are never accurate characterizations of how a thing looks, nor "sounds true" and "sounds true to actuality" of how a thing sounds. Accordingly, *being true* and *being true to actuality* are not aesthetic qualities of things.*

*I doubt even that "sounds (looks) *as if* it's true" is ever an accurate characterization. But in any case, that is a different matter—as was pointed out in our discussion of *the aesthetic* in Part Two.

So the Christian may judge that the world of Graham Greene's novels is profoundly true to actuality as he perceives it. That cannot be a reason for his or anyone else's *aesthetic* evaluation of those novels. And the humanist may judge that the complex of propositions asserted by way of Donne's poetry is profoundly anti-humanist. That likewise cannot be a reason for his or anyone else's aesthetic evaluation of the work.

Obviously the cognitive merits and defects of a work can ground a *cognitive* evaluation of it. They may also be intensely relevant to an *artistic* evaluation of it—to an assessment as to whether, when used for the purpose intended, it serves that purpose effectively and proves generally good and satisfying to use. What they cannot ground is an *aesthetic* evaluation.

(2) The fact that a work of art has desirable *effects* of one sort or another on those who come into contact with it is not an aesthetic merit in the work, nor is the fact that it has undesirable effects an aesthetic defect. Neither can be a reason for an aesthetic evaluation of the work.[50]

Often works of art do in fact have such effects. Often they are meant to have them. Our contact with them alters our tendencies, our habits and commitments, our emotional life—sometimes for the better, sometimes for the worse. But since the effects of a work do not belong to its aesthetic character, they cannot be offered as reasons for an aesthetic evaluation. They will, though, be intensely relevant to an *artistic* evaluation. For a work which induces deterioration in the moral habits and commitments of those who make use of it for the purpose intended will not prove generally good and satisfying to use thus, though it may indeed prove effective in achieving that purpose.

(3) Thirdly, what may be called the *genetic* aspects of a work—aspects pertaining to the circumstances under which the work was created or composed—cannot ground an aesthetic evaluation of it. Often they will prove relevant to an evaluation of the *artist*. And often the evidence, say, of skill that a work or a performance displays gives us satisfaction even upon disinterested contemplation—the extraordinary skill manifested in Horowitz's playing, for example.* But since genetic aspects do not belong to the character of the work itself they cannot be *aesthetic* merits. I have in mind such aspects as these: that the work conforms to the artist's intent or that it does not; that it was made painstakingly or was made hastily; that it was made skillfully or was made carelessly; that what was said by way of the work was sincerely said or was insincerely said; that the work is original or that it is derivative. Some highly original works are only bizarre; others, magnificent. Some carefully composed works are labored and wooden; others, splendid. The laboriously worked-over drawing of the student is best awarded a grade and then in mercy destroyed. The dashed-off sketch of Rembrandt is priceless.

(4) Lastly, the fact that someone or other *likes* the work is not an aesthetic merit in it, and thus cannot ground an aesthetic evaluation; and the fact that

*Perhaps here is the place to observe that throughout our discussion I have assumed that *performances* of works of art may themselves be works of art.

someone or other *dislikes* it is not an aesthetic defect. For neither its being liked nor its being disliked belongs to its character. Indeed, we probably all discover ourselves liking works we acknowledge to be aesthetically inferior; they produce in us delicious, nostalgic reveries. And we probably all find ourselves disliking works whose aesthetic excellence we bring ourselves to acknowledge. When I look at the late works of El Greco I find the smell of the incense of counter-Reformation mysticism filling my nose to choking; and when I see all those yards of naked gesticulating flesh in Rubens I feel something near nausea. I recognize that these intense dislikes are not grounded in the aesthetic character of these works. As to their characters, I acknowledge that aesthetically they are rather good. But I simply don't like them.

4. BEAUTY

Popular belief has it that a good work of art is a beautiful one—that, as philosophers put it, a necessary and sufficient condition of a work's being aesthetically excellent is its being beautiful. And certainly it does seem that beauty is relevant to aesthetic excellence. If some object is beautiful, it seems relevant to cite that aspect of it as a reason for supposing it to be aesthetically good. A thing's beauty seems to be an aesthetic merit in it.

Yet we have our questions. Is a thing's beauty its *only* aesthetic merit? Is its beauty a *decisive* merit in it? Might not some beautiful object have other aspects which counterbalance its beauty so that in sum it is not aesthetically excellent? Is its being beautiful *necessary to* its being aesthetically excellent? Consider Beethoven's *Grosse Fuge*, a powerful and certainly aesthetically magnificent work; or Stravinsky's *Rites of Spring*, another powerful and magnificent work. Are these beautiful? Surely any of us could find more apt descriptions for them than that!

These last questions raise unavoidably the question, "What is beauty?" Sometimes it seems that "beauty" is used as a synonym of "aesthetically excellent." Whether a work is harsh and driving or sweet and gentle, whether it is depressing in character or sunny and light, some people, if they judged the work to be aesthetically excellent, would express that judgment by saying that it was beautiful. Now the large question that we still have before us is whether we can discover certain broad types of aspects of things which can be relevantly cited as reasons for those objects' being aesthetically excellent. And the proposal immediately at hand is that beauty by itself will do the trick. A thing's beauty is the necessary and sufficient condition for its aesthetic excellence—that is the suggestion. But if "beautiful" is used as a synonym for "aesthetically excellent," then obviously we are here going round in a very tight circle, contending truthfully, though unhelpfully, that the necessary and sufficient condition for something's being aesthetically excellent is that it is aesthetically excellent.

So suppose that when someone uses "beauty" he is not using it as a synonym for "aesthetically excellent" but rather to refer to some property of things distinct from that of aesthetic excellence. What might that property be? In his fine essay "The Great Theory of Beauty and Its Decline,"[51] Wladyslaw Tatarkiewicz argues that the abiding element in the classical theory of beauty was that "beauty consists in the proportions of the parts," with the result that in the tradition there was always a great deal of effort expended to discover what exactly the proportions yielding beauty are. To this ground theme of *proportion* one idea sometimes added was that the beautiful object is one which displays a *consonance* of distinct parts.* Another idea sometimes added was that the beautiful object has a certain *brightness* or brilliance about it. Yet another was that the beautiful object has integrity or *perfection*. And yet one more idea, weaving in and out, was that a beautiful object yields *pleasure* upon contemplation. All these ideas are nicely caught up in two formulae of St. Thomas Aquinas. In *Summa Theologica* I, Q. 5, art. 4, Thomas says: ". . . beautiful things are those which please when seen. Hence beauty consists in due proportion; for the senses delight in things duly proportioned. . . ." And in *Summa Theologica* I, Q. 39, art. 8, he says: ". . . beauty includes three conditions, integrity or perfection, since those things which are impaired are by the very fact ugly; due proportion or harmony; and lastly brightness, or clarity, whence things are called beautiful which have bright color."

Now I think Tatarkiewicz is right to speak of the tradition, in its concern with proportion, as offering a *theory* of beauty rather than a *definition*. Those in the tradition were theorizing that there are certain proportions of elements such that when one of those proportions is present in an object beauty ensues, and when none is present, beauty is absent. Yet I think that we do at the same time get a feeling for what was *meant* in the tradition by "beauty." A beautiful object was taken to be one whose parts fit together consonantly or harmoniously, which has a certain brightness or brilliance about it, which has a certain integrity or perfection to it, and which is pleasant to contemplate. Certainly this remains vague. Yet from each of these ideas we can derive an Osgoodian antonym scale: Consonant/dissonant, bright/dull, perfect/imperfect, pleasant/unpleasant. And if we then evaluated various works of art on this quartet of antonym scales, I daresay that the paintings of Raphael would be rated more decisively toward the left by most than would those of Picasso, Telemann's music more decisively toward the left by most than late Beethoven's, and Keats' poetry more to the left by most than Donne's. In short, as the tradition conceived *beauty*, we would judge the works of Raphael, Telemann, and Keats to be more beautiful than those of Picasso, late Beethoven, and Donne. And that, I think, nicely accords with our own contemporary use of the word "beauty" when we do not use it as a mere synonym of "aesthetic excellence."

*Tatarkiewicz regards consonance of parts as identical with due proportion. Some, at least, of those he cites seem to me not to have held this.

But is it then true that the works of Telemann, being more beautiful than those of late Beethoven, are therefore also aesthetically better? And is it true that for something to get up to the level of being aesthetically good, instead of being aesthetically indifferent or bad, it must be weighted more toward the left than toward the right on that quartet of antonym scales? It seems to me pellucidly clear that that is not the case. Bartok's Fifth Quartet is aesthetically magnificent but not beautiful. Beauty is most emphatically not the necessary and sufficient condition of aesthetic excellence. And as a matter of fact, Tatarkiewicz rightly observes, as does also Jerome Stolnitz in his essay " 'Beauty': the History of an Idea,"[52] that although a concern with beauty lives on in the public generally, it has virtually disappeared from the thought of artists, critics, and aestheticians. "We have to catch ourselves up," says Stolnitz, "in order to recognize that 'beauty' has receded or even disappeared from contemporary aesthetic theory. For, like other once influential ideas, it has simply faded away."[53]

5. TYPES OF AESTHETIC MERIT

I posed the question whether the aesthetic merits of things can be grouped together into a few very general types of merits. I then considered the bold though traditional suggestion that the presence of beauty in an object is by itself a necessary and sufficient condition of the object's having aesthetic excellence. What we saw is that while the presence of beauty in a thing is sometimes, perhaps always, an aesthetic merit in that thing, its absence is certainly not always an aesthetic defect.

One preliminary observation must be made before I attempt to answer my question. Aesthetic tastes apparently differ. Some aesthetic aspects of things may give one person satisfaction upon contemplation while giving another person no such satisfaction whatsoever, sometimes even causing him or her acute distress.

When I say that *aesthetic* tastes differ, I am not asserting the truism that tastes *in art* differ. One person prefers Ars Nova music, another bluegrass; one age prefers Shakespeare, another Ben Jonson. That is obvious. Now a great deal of what accounts for such variation in artistic taste is that, by virtue of differences in training and in broad cultural attitudes, different people attend to different things in the very same work of art. As observed earlier, aesthetic contemplation is always *focussed* contemplation. And since its focus for the same work varies from person to person, what delights or annoys one person in a work may be scarcely noticed by another. So of course they differ in their taste in art. But when I say that *aesthetic* tastes apparently differ, I mean that apparently even when two people perceive a single work in substantially the same way, sometimes *the very same aspect* that grounds one person's delight upon contemplation gives no delight whatsoever to the other, perhaps even annoys him. The buildup of dissonances at the close of a Bach fugue, attended

to with equal keenness by two listeners, is revelled in by one while making the other "feel edgy." Conceivably these variations in aesthetic taste among us are also due entirely to training and enculturation. But I think it more likely that some at least are due to differences in our native constitutions.

As I attempt to answer my question, this likelihood of variation in aesthetic tastes must be kept in mind. Accordingly, a more explicit phrasing of my question would be this: Can those aspects of things which for *someone or other* are aesthetic merits in those things be grouped together into a few very general types of merits?

I think the correct answer to this question is Yes. The heart of the answer I shall propose, though not its precise formulation, is suggested by Monroe Beardsley in his discussion on the matter in his *Aesthetics*.[54]

(1) First there is the fact of a work's *being unified* in its character, whether in the mode of coherence or in the mode of completeness. Now the first thing to be said about a work's being unified is that in either of the modes of unity its unity can be secured in countless different ways. Symmetrically composed buildings can be unified aesthetically, but so too can asymmetrically composed buildings. Thus for one work there will be not only the fact of its being unified but also the fact, which is really a specific determination of the first, of its being unified through symmetry; and for another there will be not only the fact of its being unified but also the more determinate fact of its being unified through asymmetrical balance. Of course unity comes in degrees; and what I mean when I say, for example, that a work is disunified is that it is significantly lacking in unity.

Now among the aspects of things which function for people as aesthetic merits we certainly find this thing's being unified, that thing's having such-and-such a specific determination of unity, and so forth. For often what critics say about a work, as a reason for their assessment of it as aesthetically excellent, are such things as that it is well-organized, that it is formally perfect, and that it has an inner logic of structure and style (these examples are borrowed from Beardsley). But I think we can go well beyond this rather weak claim, that certain merits can be grouped together under the heading of *unity*, to say something much stronger: namely, that for any object whatsoever which lacks unity to a significant degree, its lack of unity is for everyone an aesthetic defect in that thing. None of us finds a thing's disunity in character either a matter of indifference or a ground of satisfaction upon contemplation—though of course we may find that various other aesthetic merits in the thing compensate for the defect of its disunity. And possibly even those other merits can be achieved only at the cost of that particular sort of disunity.

Can we also go further and say that for any object whatsoever whose character is unified to a significant degree, its unity is an aesthetic merit in the thing? Obviously people differ widely in their preferences among unity-securing strategies, and thus among different sorts (determinations) of unity. The Renaissance architects uniformly preferred symmetrically composed

buildings, whereas most in the contemporary world strongly prefer asymmetrically composed ones. So when confronted with a building whose unity is secured by symmetry, a contemporary person may well not find its being unified by the strategy of symmetry to be, for him, a merit in the thing. He may in fact find it to be one aspect of the building that he thoroughly dislikes.[55] But though he will not find *its being unified by the strategy of symmetry* to be a merit in the building, yet I think he will find *its being unified* to be such. Towards that as such he is neither indifferent nor hostile.

And so I think that this rather bold claim is likely to be true: For any object whatsoever whose character has unity to a significant degree, its unity is for everyone an aesthetic merit in the object; and for any object whatsoever whose character lacks unity to a significant degree, its disunity is an aesthetic defect in the thing.

(2) Secondly, there is the fact of a work's being internally rich, varied, complex—of its having a variety of significantly differentiated parts. Obviously, internal richness, like unity, comes in degrees. And just as obviously it too can be secured in countless different ways. The extraordinary richness of some native African music is due almost entirely to the rhythms; the equally extraordinary richness of Anton Webern's music is due as well to variations in pitch and timbre. No doubt some people prefer internal richness secured in one way; others, in another way.

Consider a pure tone waxing and waning from inaudibility up to eighty decibels back to inaudibility. Such a sound has enormous unity, in regard both to coherence and completeness. All of us would regard it as minimal in aesthetic excellence, however. What is missing is internal richness. Or consider a uniformly white piece of uniformly smooth and glossy formica, surrounded by a uniformly black, smooth, and glossy frame also made of formica. Such an object also has enormous unity, in regard both to coherence and completeness. But it too is very low on the scale of aesthetically excellent objects. What is again missing is internal richness. So among the aspects of things which function for people as aesthetic defects are certainly to be found this thing's lack of internal richness, that thing's lack of internal richness, and so forth. Correlatively, it is equally clear that among the aspects of things which function for people as aesthetic merits are to be found this thing's internal richness, that thing's internal richness, and so forth. Critics standardly offer aesthetic praise to objects by saying of them that they are developed on a large scale, or that they are rich in contrasts, or that they are subtle and imaginative (these examples are also borrowed from Beardsley).

The much more interesting question is whether for internal richness we can make generalizations of the same sort as those we made for unity. I think we can. In the first place, for any object whatsoever whose character lacks internal richness to a significant degree, its lack of richness is for everyone an aesthetic defect in that thing. None of us finds a thing's lack of internal richness either a matter of indifference or a ground of satisfaction upon contemplation.

What must certainly be admitted, however, is that some aesthetic merits in things can be achieved only at the cost of a considerable simplicity in character.[56] We may then praise a work for what we call its simplicity. But I think that that is always an elliptical way of alluding to some other merit achieved at the price of simplicity.

The converse can also be said: For any object whatsoever whose character possesses internal richness to a significant degree, its internal richness is for everyone an aesthetic merit in that thing. In order to get hold of this point we must exercise the same caution that we did in the case of unity. Consider some work whose internal richness is secured mainly by extreme rhythmic complexity. *Its being internally rich by virtue of extreme rhythmic complexity* will certainly not function as an aesthetic merit for everyone. Some find rhythmic complexity bewildering, if not dizzying. But *that work's being internally rich* is a different aspect of it, a different fact about it, one of which that other is a specific determination. And I suggest that this latter aspect functions for everyone as an aesthetic merit in the work. Without offering any arguments for relevance, critics plunge ahead to praise works for their internal richness.

What we have seen so far, then, is this: The unities of specific things are all aesthetic merits for everyone, though the specific determination of those unities, what might be called the *specific* unities of things, are not, each of them, an aesthetic merit for everyone. Some people find that specific unity which is this work's unity by virtue of symmetry not to be a merit. In a wholly parallel fashion: The internal richnesses of specific things are all aesthetic merits for everyone, though the specific determinations of those internal richnesses, the *specific* richnesses of things, are not each an aesthetic merit for everyone.

(3) Clearly we are far from having caught all the aesthetic merits of things in our two nets. For the characters of objects are praised for such things as their vitality, their forcefulness, their tenderness, their gracefulness, their delicacy, their humor, and so forth. But these are matters neither of unity nor of internal richness. We shall have to go on, then, to single out at least a third general type of aesthetic merit in things.

Is there some significant similarity among those six merits cited immediately above which would justify us in putting them all together into one type? Let me suggest rather speculatively that there is. In my discussion of fittingness in the preceding chapter, I pointed out that the character of each work bears a complex structure of fittingnesses to qualities which are not themselves to be found among those in the character of the work—that is, are not themselves to be found among the aesthetic qualities of the work. To some of such outside qualities the character of the work will be closely fitting, to some, distinctly unfitting, and to many, neither. For example, if Flaubert was successful in his attempt, the character of *Madame Bovary* is close fitting to the color gray, though of course the color gray is not itself to be found among

the aesthetic qualities of this work. Flaubert's work is not literally gray in color. What is to be found in the work rather is just the quality of *being closely fitting to the color gray*.

Now consider some work's character, and then consider the set of all those qualities to which the work's character bears a relatively close fittingness. Some of those qualities will be rated decisively to the left or right on scales which have high loading on one or both of the Osgoodian factors of Potency and Activity, some will not. *Delicacy* will surely get decisive ratings on scales with high loading on the Potency factor (it is, as it were, decisively *im*-potent). And *brightness* will get decisive ratings on scales high on the Activity factor. Let us then call any aspect of a work's character which consists in the character's bearing a relatively close fittingness to some quality which gets decisive rating on scales with high loading, on either the Potency or Activity factors, a *fittingness-intensity* of that work's character. A work which is "delicate" in character will have its being delicate as one of its fittingness-intensities, and a work which is "bright" in character will have its being bright as one of its fittingness-intensities.

Now I suggest that when works are praised for their vitality, their delicacy, their tenderness, their gracefulness, and so forth, they are being praised for a particular fittingness-intensity of their characters. And if that is correct, then what can be said is that among the fittingness-intensities of things we find a great many of the aspects that function for people as aesthetic merits of those things. Of course, here too, perhaps even more than for unity and internal richness, taste varies widely. Some prefer the aggressive, some the graceful; some the abrasive, some the mellifluous.

But here too, I think we can perhaps be less cautious. Suppose we say that a work is *aesthetically bland* if its character is distinctly lacking in fittingness-intensities. And suppose we say that a work is *aesthetically intense* if its character is rich in fittingness-intensities. Then I think what can be said is this: For any object whatsoever which is aesthetically bland, its blandness is for everyone an aesthetic defect in that object. And conversely, for any object whatsoever which is aesthetically intense, its intensity is for everyone an aesthetic merit. And that will be true even though the various specific fittingness-intensities displayed by a given work will be to one person's taste and not to another's. No one finds blandness meritorious. Everyone finds intensity meritorious—though we differ on how we prefer that intensity to be secured. Some will find the intense propulsive "energy" generated by some of Bach's works to be to their taste, others will find it not to their taste. But those who find it not to their taste will not go for blandness instead but rather for some other specific fittingness-intensity than this particular one.

Could it be that when Aquinas spoke of the "brightness" of a work he had in mind the very same thing that I have called the work's *intensity*? And could it be that when our contemporary critics speak of a work's "expressiveness" they also mean the very same thing?

We have caught in our three nets a vast number of aspects of things that function for us as aesthetic merits in those things. But have we caught them all? What, for example, about beauty? I think beauty has probably been snared. It will be instructive to see how. The adjective "beautiful," unlike "graceful" and "bright," applies literally to paintings and other works of art. So whereas a work's being graceful consists in its character's being closely fitting to gracefulness, a work's being beautiful does not, in counterpart fashion, consist in its character's being closely fitting to beauty. It consists rather in its character's *having* beauty. But though "graceful" and "bright" do not apply literally to a painting, "being closely fitting to gracefulness" and "being closely fitting to brightness" do apply literally. And the tradition gives us some reason for thinking that the predicate "beauty" and the compound predicate "being unified and being closely fitting to gracefulness and to brightness" pick out the very same property. If so, then we have already dealt with beauty. Or to speak more precisely: Since *beauty* on this analysis is a complex concept, incorporating both the concept of *unity* and the concept of *fittingness*, we *could* easily deal with it by singling out those types of aspects which are combinations of aspects from two or more of the three types that we have already singled out.

Still, though beauty has not escaped our nets, there may well be other merits that have. Indeed, I have the feeling that unity, richness, and intensity all together are not the whole of what it is about a good melody, or a good rhythmic pattern, that holds us in its thrall. I think, however, that there would be little benefit to be gained here from engaging in the detailed exploration required to find out the full and solid truth on this matter. Though we may not have captured all the aesthetic merits of things, surely we have captured most of them. Best to leave it as this stage. Unity, along with specific unities; internal richness, along with specific richnesses; aesthetic intensity, along with specific fittingness-intensities—those constitute the bulk of what function for us human beings as the aesthetic merits in things.

One closing remark: To assess the overall aesthetic merit that an object has for us we must of course take the various aspects of the object that function for us as aesthetic merits, add to them the various aspects that function for us as aesthetic defects, and then weigh up the bunch. Usually, however, there is little point in proceeding to this final weighing-up. Our purposes will have been satisfied once we have uncovered merits and defects.

6. NORMS FOR THE AESTHETIC

We have just seen the sorts of reasons that can be offered for supposing that a given object will satisfy the purpose of aesthetic contemplation. They will be reasons that point to the aesthetic merits of things. But what is to justify that purpose itself? Why is aesthetic contemplation itself of worth? That is the fundamental question.

The answer has already been given—in our discussion of joy in *shalom*. Aesthetic delight is a component within and a species of that joy which belongs to the shalom God has ordained as the goal of human existence, and which here already, in this broken and fallen world of ours, is to be sought and experienced. That is why you and I are to pursue aesthetic delight, for ourselves and others, along with a multitude of other goals: justice, peace, community. Since it belongs to the shalom that God intends for each of us, it becomes a matter of responsible action to help make available, to ourselves and others, the experience of aesthetic delight. It becomes a norm for action—not of course the only norm, but certainly one among others.

And when the artist sets about to produce a work for aesthetic contemplation, another derivative norm is appropriate to his action: Seek aesthetic excellence in your work by an appropriate balance of unity, richness, and intensity. As to the particular strategies the artist is to use for securing unity, richness, and intensity, that is to be determined in part by what will give his (or her) audience delight upon contemplation, and in part by what gives fulfillment to himself. This varies from case to case. But what never varies is the artist's obligation, if producing a work for giving delight upon aesthetic contemplation, to exhibit in his work an appropriate balance of unity, richness, and intensity.

If the community of artists is truly to make a contribution to human welfare, however, they cannot each take a poll of what certain people say they like in art and then deliberately shape their work so as to satisfy them. Some, at least, must be an advance guard striking off in new directions, trusting that if they find something new in which they themselves can take aesthetic delight, others among their fellows will find this delight as well—but never really knowing, taking the risk. If a new land is to be discovered, some there must be who in stubborn integrity and unwarranted confidence sail westward. If human fulfillment is to be served and shalom established, artists cannot all be obedient followers and timid calculators. Explorers are needed too.

7. AESTHETIC EXCELLENCE IN WHAT IS NOT PRODUCED FOR AESTHETIC DELIGHT

A hymn is a *good* hymn if it serves its purpose effectively and then in addition proves good and satisfying to use for this purpose, that purpose being to enable a congregation to offer praise to God—*not, be it noted, to give delight upon aesthetic contemplation*. Thus the quality of a hymn is to be judged first of all by its effectiveness in serving its purpose. Likewise the quality of a concerto is to be judged first of all by its effectiveness in serving its particular purpose, that of giving delight upon aesthetic contemplation. In general, hymns serve aesthetic contemplation less effectively than do concertos. But that no more decisively determines their quality as hymns than does the fact that a concerto serves poorly the purpose of enabling a congregation to praise

God decisively determine its quality as a concerto.

I added, however, that if a hymn is to be good it must, like any other artifact, not only serve its purpose effectively, but also prove *good and satisfying to use for this purpose*. Can we say, then, that if a hymn is to prove good and satisfying to use for praising God, it must in general be aesthetically good? To prove generally good and satisfying to use for its intended purpose, must it be such that if it were contemplated aesthetically it would give us satisfaction, perhaps not as much as works made deliberately for this purpose, yet some satisfaction nonetheless, not just boredom or disgust? In brief, must a good hymn be *aesthetically* good?

I think the answer is Yes, and for the following reason. While those who sing the hymn do not *listen* to it, in the concentrated way in which one listens to a concerto, they nonetheless *hear* it. And between the hearing of those who sing and the listening of those who contemplate there is not a chasm of difference but only a slope of variation in the degree to which the sounds gain one's attention. Correspondingly, I think it must be allowed that those aspects of the hymn which *would* give aesthetic satisfaction to a listener do not pass the hearer by with no effect. They work on him, as well, producing in him a feeling of satisfaction, possibly even just as intense, but not as self-consciously noted. For the aesthetic merits in things to work in one's consciousness, there producing satisfaction, it is enough that one's awareness of them be peripheral. Ugly or vapid liturgical music, no matter how effectively it may serve its dominant purpose, is not *good* liturgical music.[57]

And so it is for human artifacts in general. Relatively few have as their dominant purpose to give delight upon aesthetic contemplation. But the rest do not simply escape our attention. With infinite gradations of degree they lure our awareness, or force themselves upon it. And the aesthetic merits in them produce their effects on us whether or not we submit them to aesthetic contemplation. There is no such thing as a *good* artifact—a good shovel, a good wheelbarrow, a good house—which is aesthetically poor. Or to put it more cautiously, and more accurately: If an artifact occupies a significant place in our perceptual field, then, it is a better artifact if it is an *aesthetically* better artifact. Perhaps the ugly concrete-block flats in lower-class housing developments serve rather effectively the housing needs of those who live in them. Yet they are not *good* houses—not as good as they could be. Something is missing, something of the joy that rightfully belongs in human life, something of the satisfaction that aesthetically good housing would produce in those who dwell there.

Just as fundamental as our responsibility to promote the cause of art intended for aesthetic contemplation is our responsibility to promote aesthetic excellence in works of art generally, no matter what their intended use. And more fundamental than either is our responsibility to promote aesthetic excellence in all our surroundings, in the knowledge that even when merely noticed and not explicitly contemplated, it works on us for joy and peace. The mission compound I saw set in the glorious hills of northern Kenya

was tawdry, ugly, hideous. No doubt those who built it thought they were acting in obedience to the mission injunction of our Lord. They were. But also they were acting irresponsibly. One could almost hear the hills groaning in protest at this blight upon their beauty.

By way of contrast, consider Lewis Mumford's description of the medieval city:

> In the main . . . the medieval town was not merely a stimulating social complex; it was likewise a more thriving biological environment than one might suspect from looking at its decayed remains. There were smoky rooms to endure; there was also perfume in the garden behind the Burghers' houses; for fragrant flowers and herbs were widely cultivated. There was the smell of the barnyard in the street, diminishing in the sixteenth century, except for the growing presence of horses and stables. But there would also be the odour of flowering orchards in the spring, or the scent of the new-mown grain, floating across the fields in early summer.
>
> Cockneys may wrinkle their noses at this combination of rankness and fragrance, but no lover of country ways will be put off by the smell of cow or horse dung. Is the reek of gasoline exhaust, the sour smell of a subway crowd, the pervasive odour of a garbage dump, the sulphurous fumes of a chemical works, the carbolated rankness of a public lavatory, for that matter, the chlorinated exudation from a glass of ordinary drinking water more gratifying? Even in the matter of smells, sweetness is not entirely on the side of the modern town; but since the smells are *our* smells, many of us blandly fail to notice them.
>
> As for the eye and the ear, there is no doubt where the balance of advantage goes. The majority of medieval towns in these respects were immensely superior to those erected during the last two centuries: is it not mainly for their beauty, indeed, that people still make pilgrimages to them? One awoke in a medieval town to the crowing of a cock, the chirping of birds nesting under the eaves, or to the tolling of the hour in the monastery on the outskirts, perhaps to the chime of bells in the new bell-tower in the market square, to announce the beginning of the working day, or the opening of the market. Song rose easily on the lips, from the plain chant of the monks to the refrains of the ballad singer in the market-place, or that of the apprentice and the housemaid at work. Singing, acting, dancing, were still 'do-it-yourself' activities. . . .
>
> If the ear was stirred, the eye was even more deeply delighted. Every part of the town, beginning with the walls themselves, was conceived and executed as a work of art: even parts of a sacred structure that might be unseen, were still finished as carefully as if they were fully visible, as Ruskin long ago noted: God at least would bear witness to the craftsman's faith and joy. The worker who had walked through the near-by fields or woods on a holiday came back to his stone carving, his wood working, his weaving or goldsmithing, with a rich harvest of impressions to be transferred to his work. The buildings, so far from being musty and 'quaint,' were as bright and clean as a medieval illumination, if only because they were usually white-washed with lime, so that all the colours of the image-makers, in glass or polychromed wood, would dance in reflection on the walls, even as the shadows quivered like sprays of lilacs on the facades and the traceries of the more richly carved buildings. . . .

Life flourishes in this dilation of the senses. Without it, the beat of the pulse

is slower, the tone of the muscles is lower, the posture lacks confidence, the finer discriminations of the eye and the touch are lacking, perhaps the will to live itself is defeated. To starve the eye, the ear, the skin, the nose is just as much to court death as to withhold food from the stomach. Though diet was often meagre in the Middle Ages, though many comforts for the body were lacking even for those who did not impose penitential abstentions upon themselves, the most destitute or the most ascetic could not wholly close his eyes to beauty. The town itself was an ever-present work of art.[58]

Sometimes the reason offered for seeking aesthetic excellence in the music of the church is that thereby one pleases God. I think that that is true. But not because we know what music God enjoys—though I suspect it must be music which is unified, rich, and intense! Rather, because it is in the joy of his people that God finds delight.

8. CONCERNING WORKS AESTHETICALLY GOOD AND MORALLY BAD

Works of art are complex multi-dimensioned objects. They participate in the aesthetic dimension by their configurations of aesthetic aspects, in the economic dimension when being bought and sold, in the psychological dimension when evoking feelings in beholders, in the moral dimension when altering for better or for worse the moral character of those who hold commerce with them, in the religious dimension when inducing change in the religious commitments of those who make use of them.

Faced with the decision as to what to do with a specific, concrete work of art, we find this multi-dimensionality of critical importance. The play is aesthetically excellent, but the royalties charged for performance are outrageous. Do we or don't we perform it? The proposed civic sculpture would be just the focal point needed in the plaza, but to buy it would put the city's art fund badly in debt. Should it or should it not be purchased? Though the film is undoubtedly of great aesthetic merit, it seems likely to affect adversely the moral character of some of one's young students. Do we show it or not?

While not denying the importance of the economic dimension in our decisions about works of art, I think it is the complex interaction between the aesthetic dimension on the one hand and the moral and religious dimensions on the other that causes our deepest perplexities and our sharpest controversies. Let us see if we can isolate some of the crucial factors in those interactions.

Down through the ages, pietists and radical social reformers alike have characteristically dealt with the arts by failing or refusing to acknowledge the aesthetic as a dimension independent of the moral and religious. Either they take no note of the aesthetic whatsoever; or they assume that aesthetic value is decisively determined by moral or religious value. Books are burned, statues

decapitated, paintings ripped, with never so much as a glance at their aesthetic quality. If we are to attain clarity on the interaction of the aesthetic dimension with the moral and religious dimensions, we shall first off have to acknowledge the *independence* of the aesthetic. Not only is beauty neither truth nor goodness. Truth and goodness do not determine beauty.

Secondly, though I would be among the last to deny that our contacts with works of art do in fact alter our commitments, one must beware of exaggerating the extent to which this is true, and one must acknowledge the vast differences among people with respect to their susceptibility. Not every incidence of violence in a film makes all its viewers more inclined toward violence, not every incident of racism in a novel makes the incidence of racism more likely.

Third, characteristically overlooked in discussions on these matters is the importance of *point of view* on the incidents depicted. In part, variations in point of view are what account for the fact that violence in one film has no deleterious effect on the moral character of viewers, whereas violence in another film does. But even when violence is celebrated in a film, as it sometimes is, still not all those who have viewed the film emerge more inclined toward violence or more indifferent to it.

Fourth, sadly but pervasively characteristic of Christians in the last century or two is extraordinary tunnel vision. Always it is the profane and the sexual that draw the fire of their attack—and then not only the illicitly and perversely sexual, but sometimes just any explicit acknowledgement of the sexual. Going unnoticed is the cultivation of greed, of militarism and nationalism, of sexism, of racism, of capitalism. Always it's the "dirty movies" and the "filthy books" that catch the bullets. Those "clean" hymns of praise to nation, to unbridled competition, to humanity walk the field unharmed. What a distorted understanding of the moral life such an outlook reflects! Not, of course, that the libertarian individualists in our society are any better. First racism, then militarism, then sexism, catch all their attention; a novel cultivating racism draws from the liberal a scorn no less withering than that drawn from the Christian by a "dirty" film. But the cultivation of unbridled lust finds him indifferent if not approving.

These comments are all preliminary to the question itself. Suppose it is one's considered judgment that the effect of some specific person's reading some specific novel would be that he or she would become more racist, or more sexist, or more authoritarian, or more exploitative in the expression of his sexuality, or more indifferent to the praise and worship of God. But suppose one also judges the novel to be aesthetically excellent, guessing that the person in question will get a good deal of aesthetic satisfaction from reading it. Should one advise the person to read it, or should one advise him not to read it?

Notice in the first place that in any such situation we are dealing with psychological phenomena of two quite different orders. To alter a person's

moral character is to alter his *habits and commitments*. It is to alter how he will *tend to act* in future situations. By contrast, aesthetic satisfaction is something one experiences *while engaged in contemplation*. It may or may not have consequences extending beyond the experience. But it itself is an experience of the moment.

What must be noted secondly is that moral habits and commitments are tendencies to treat *others* in certain ways; or if they are not confined to that, if they include tendencies to treat *oneself* in certain ways as well, the bulk of the moral life nonetheless certainly consists in how one treats one's fellows. By contrast, the delight that one gets in aesthetic contemplation is—so obviously as to make it scarcely worth saying—*one's own* delight. So the question before us is whether the *personal* aesthetic delight that one gets *on the occasion* of reading some novel can outweigh in importance the *tendency* that such reading induces to treat *others* henceforth in morally worse ways.

When the structure of the issue is thus perceived with clarity, the Christian hears the unmistakable voice of his Master. It speaks of self-sacrifice. It promises to mankind the joy of a perfect shalom and it says that the experience of that shalom is not, and need not be, and should not be totally missing from our lives now, here in this broken and fallen world. But it adds that to be an agent of that shalom one must be willing to surrender concern with self in favor of acting as a person for others. It says that if the choice confronts us we must be willing to sacrifice pleasures of self on the altar of love for others. Thus he himself will live. And thus he will guide and instruct those in his guardianship. That does not mean that by law or sword the Christian will *force* the same sacrifice on others. It means rather that by power of example he will call them to it.

Our Stance Toward the Institution of High Art

CHAPTER ONE

Liberation

I. 1. INTRODUCTION

IN THE Calvinist tradition appeal has often been made to the so-called
"cultural mandate," God's command to humanity at creation to develop
culture. The justification for art, for science, for technology has customarily
been grounded on this mandate. Though in this discussion I have not used the
traditional terminology, I have nonetheless participated in this tradition by
virtue of arguing that part of man's creaturely calling is to master the
world—the outcome of such mastering always being culture.

But to ponder the legitimacy of *art as such,* and to ground that legitimacy
on a creational mandate, is to deal with an abstraction of a high order. Nobody
ever confronts art as such. Our interaction with art always takes the concrete
form of participation in that social institution which is our society's institution
of art. And more specifically, the interaction with art of those of us who belong
to our society's cultural elite always takes the concrete form of participation
within our society's institution of *high* art. Each of us comes into contact with
culture, be it art or whatever, only within a specific society, at a definite point
in its history, within a specific social institution.

So the question confronting the Christian struggling to act obediently to
his Lord is the thoroughly concrete question of how, if at all, he or she should
participate in our social institution of high art. On the way to answering this
question the Christian may find it important to pose the abstract question: Is
there a place in the Christian life, and so in the fully human life, for art as such?
But answering Yes to that question leaves him far short of knowing how he
should participate in the institution of high art as it finds shape in our society
today.

To be able to formulate the question this way—How, if at all, should the
Christian participate in our social institution of high art?—is already to exhibit
a degree of liberation from that institution. For what we saw early in our
discussion is that all of us are so deeply embedded in our institution of high art
that we usually assume that what is true of the arts in that institution is true of

177

them generally. To break the grip of that institution on us, thus to be able to formulate a general perspective on the arts, I adopted the strategy of looking our institution of high art in the face, singling out its salient features and pointing out its idiosyncrasies. That done, I then went on to develop the rudiments of a Christian perspective on the arts generally. But surely the matter cannot be left there. We must go on to consider what would be an appropriate stance of the Christian toward our society's institution of high art.

I shall divide my answer into two main parts. First I shall discuss some of the results to be expected from being liberated from the thralldom of that institution—practical results, now, not results of theory. Then I shall make some remarks on how the Christian can nonetheless participate in that institution.

The liberation experienced as the result of looking head-on at our institution of high art and then going on to formulate a perspective on the arts generally is, in large part, the liberation of no longer carrying over to art outside the institution the attitudes and evaluations appropriate to the institution. Once we have seen the institution of high art for the idiosyncratic thing it is, and once we have developed a general perspective on art in human life, then we are in a position to acknowledge practically, and not just theoretically, that art is not all for the sake of the aesthetic and that not all of the aesthetic is to be found in art, certainly not high art.

But what consequences can such liberation be expected actually to yield in our lives? To stimulate the reader into arriving at answers to that question I shall first consider the city, which of course is not a work of art at all (i.e., not a product of one of the fine arts) and discuss briefly its aesthetic dimension; secondly, I shall consider the church, where we find art which is neither high art nor art intended for contemplation, and discuss briefly how art functions in the church's liturgy; and then thirdly I shall try to show how the liberation experienced can enable us better to apprehend and assimilate parts of our own cultural tradition in the arts.

2. CITY

When it comes to the city, we who participate in our institution of high art are always tempted to think that we have paid our dues to the aesthetic if we have made available to the citizens precious objects for their aesthetic contemplation—erected an art gallery and stocked it with paintings and sculptures, constructed a concert hall and developed a good orchestra, built a library and stocked it with good novels and books of poetry, constructed a theater and got a good company of actors installed. So intently do we focus on the precious objects—we the citizens, our governments, our arts councils, everybody—that we never consciously notice the aesthetic squalor amidst which these precious objects are set. Let us try for a while to shed this myopia and look afresh at the city, concentrating on the aesthetic dimension of the

whole. Of course that artifact which is the city was not made for the *purpose* of providing satisfaction upon aesthetic contemplation—at least very little of it was made for this purpose. And the primary evaluation of a city is to be made by reference to how effectively it serves the multitude of purposes for which it was made. Yet the city does have an aesthetic dimension. And its aesthetic quality profoundly affects whether we do or do not find it generally good and satisfying to use for its intended purposes. It affects all of us who live in the city, whereas those precious objects of high art installed in the city never affect more than a tiny proportion of the inhabitants. So, then, what is principally to be taken note of when one wishes to assess the aesthetic quality of a city?

A city consists of buildings, these buildings, along with trees and other objects, shaping space—*urban space,* we may call it. Think for a moment of a room, where the walls, ceiling, and floor shape space in a certain way, though indeed we usually allow the characteristics of the container to draw our conscious attention more than the character of the space contained. Even if the ceiling of a room, its "lid," were removed, space would nonetheless be shaped by the walls and the floor, though indeed less completely, for space would "leak out" the top. So too, then, the buildings and other objects of a city give definite characteristics to the space between them, characteristics which we note and feel as we move about in that space.

The aesthetic quality of a city, I suggest, is mainly determined by the quality of its urban space. The alternative view would be to think of a city as a giant sculpture gallery without walls, to think of the buildings as sculptures, and to hold that the quality of the sculptures determines the aesthetic quality of the city. This is how architects endemically think. But in fact those sculptures which are a city's buildings are much too large for that to be our dominant experience—much too large for us human beings, who rarely stand over seven feet tall.

Some of the space shaped by the buildings is like a channel. That is true particularly of the streets. Some of it, especially that of the squares and plazas, is more like an open bay. And between the channels and the bays there are all gradations. When the facades go high, as in Manhattan, the channels become like canyons of space and the bays like the space of a silo.

The space of the channels is inherently oriented end to end, axialized. That of the bays is much less so, or not at all. Thus the bays are expressive of tranquillity; the channels, of movement, restlessness. But in a bay too a certain directionality, or "arrowing," can be introduced by placing a sizeable conspicuous object within it. The object then tugs on one's attention, introducing, though, a centralizing instead of an axializing directionality, thus preserving the restfulness of the spatial bay as compared with the spatial channel. The dominant function of civic sculpture, at least of free-standing civic sculpture, is to introduce a centralizing orientation into a space. The sculpture may also be worth contemplating in its own right, but that is a secondary benefit, though not indeed to be ignored. Perhaps the most striking

example of civic sculpture is to be found in the plaza of the Capitoline Hill in Rome, designed by Michelangelo, where the equestrian sculpture along with the pattern in the pavement make what would otherwise be an indifferent space into a great one. Of course, just as a bay space can be given a centralized orientation, so too it can be given an axial orientation by a colonnade, a row of trees, a conspicuous entry in one of the facades, etc. And the axial movement of a channel can be slowed down at a certain point by inserting a centralizing element, as with the two churches, St. Clement Danes and St. Mary le-Strand, in The Strand in London.

Not only is the character of a bit of urban space determined by its shape, and by the directionality, if any, which has been inserted into that space. It is also determined by the degree of completeness with which the shape of the space is defined. A street whose space is shaped by continuous rows of red brick houses is a space whose completeness is much more intense than one of the same dimensions shaped by separate houses set twenty feet apart. And the fact that the plaza in Rockefeller Center is defined by buildings soaring high up above normal eye level gives it a much stronger completeness than any of the squares in London have. Whenever space is allowed to leak out through gaps in the container, its unity is weakened.

The characteristics that make for aesthetic excellence in urban space are no different from those that make for aesthetic excellence generally. Other things being equal, the more strongly unified the space, the better. When space is allowed to leak out all over, so that the degree of unity is very low, we can scarcely even experience it as shaped space. And other things being equal, the more rich, complex, varied, contrasting, the spaces, the better. When some spaces are distinctly bay-like and others distinctly channel-like; when some of the channels are narrow and others broad, ceremonial, and processional in character; when some of the channels are straight as an arrow and others are curved; when some are absolutely horizontal and others sway up and down; when the bays come in different shapes and when some are given a centralizing directionality toward dead center and others off-center; when some of the channels are given closure at the ends (the Mall in Washington) and others are allowed to stretch to the vanishing point—that's when the space of a city becomes rich, and so far good. And thirdly, a good space, other things being equal, has a certain intensity of character—whether agitated or serene, whether billowing (like the Spanish steps in Rome) or rigidly stately, whether fast or slow.

I have suggested that the main contribution of the buildings to the aesthetic dimension of the city lies in their all together functioning as containers for the various urban spaces. But it is true that their facades may be better or worse, individually and jointly. And so the aesthetic quality of the facades is a second component contributing to the overall aesthetic quality of the city. And sometimes when a building is set monumentally in a rather large bay of space it does in fact function as a large piece of sculpture rather than as a shaper of space.

Since none of us has to be reminded that the quality of the facades contributes to the aesthetic quality of the city, let me move on to a third contributing factor—the way light pervades the spaces. A space may be dimly lit or brightly lit, uniformly lit or varying in its lighting, varying in the lacy fashion of the light under a locust tree in strong sunlight or varying in the stark fashion of the light and shadow on the Acropolis, lit from above or lit from the level of street lamps. From the lighting within our own homes we are all aware of the way in which the character of a room changes drastically depending on how it is lit. When dealing with light in urban spaces, we are of course dealing with something in constant change. The shape of the space and the character of the facades is fixed; variations in light introduce slow but ceaseless movement.

I think there is yet another basic component of the city determining its aesthetic quality, though strictly this component pertains to us-in-the-city rather than to the city itself. As we move through a city we notice and are affected by the character of its spaces, its facades, and its lighting. But the city itself tends also to give to the very sequence of our movement through it a certain kinetic, dramatic, quality, a building up and relaxing of tension. It is true of course that we all have our own personal paths and goals as we traverse the city, quite independent of the structure of the city. But in addition, the channels of a city build up a tension within us—the more so the more constricted they are—and the bays of a city relax that tension. We move through the narrow, clotted streets of Bruges jostled by the crowds and then suddenly are sprung loose into that wonderful open plaza. That sequence, no matter what one's personal mission on a certain day, inescapably introduces a dramatic quality into the sequence of one's movements. When a city fails to impart dramatic sequence to one's movements through it, when it fails to build up and then relax tension and thus introduce variety and unity right into the sequence of one's movements, then it is, other things being equal, aesthetically poor.[1]

Most of us do not spend very much of our time engaged in the aesthetic contemplation of the city in which we live. We have other things to do. I argued earlier, however, that the aesthetic merits and defects of an object affect us whether or not we are explicitly taking note of them, inducing in us a vague feeling of satisfaction or dissatisfaction. And so it also is for cities—as anyone has witnessed who has compared the experience of London, or Paris, or Florence with the experience of Los Angeles.

When one takes note of the four factors I have suggested, and evaluates them with respect to unity, richness, and intensity, it becomes clear that most Midwestern American cities are aesthetically bad. What is almost invariably missing is any strong unit in the individual spaces and any significant variety among the spaces. Buildings are separated from each other to such a degree that the definition of space is minimal; and everywhere one gets the same feeling of openness and slackness. The streets are just as open as the plazas, the only significant difference being that they have a stronger axial

orientation. And lacking any significant degree of completeness, the spaces of these cities are singularly lacking in any intensity of character. They are bland, the *epitome* of blandness. Moving through them is anti-dramatic. It is as if there were a hatred of the city at work, a deep wish to be done with it as soon as possible.

I suspect that there is such a distaste at work, and that this explains the aesthetic blandness. For the spatial ideal especially of the Midwestern American is not at all the well-shaped urban space of the city. It is rather the space out in the country, out on the prairie, *unshaped* space, space as it comes from God's own hand, as it were, in which there is only a bit of directionality introduced by the roads and the sprinkled dwellings. To be out in the country, on the road, *free*—that is the Midwestern American's spatial ideal. Anyone who thinks and feels this way will regard the city in its entirety, no matter how many and how excellent its bays of space, as confining and constricting. He will think of the city as a place to get into and then to leave again as speedily and as comfortably as possible. And when he constructs his city he will see to it that it is as open in its spaces as possible, and, extraordinary in the history of man, that all its axial vistas lack closure and are open to the vanishing point.

The ideal of almost all urban Americans is to acquire enough money to live out in the country; failing that, to live in the suburbs; failing that, at least to escape from the city on weekends and holidays. Throughout the ages, mankind has wished to flee the city; but usually it was for a time only, and then mainly to escape its smells, its dangers, its busyness. The Midwestern American has an abhorrence for what is absolutely indispensable to a city—shaped space.

Here one is inclined to become hortatory, to remind us of what we all know: that most of us will have to live in the city, whether we like it or not, and that we had better overcome our longing for the unshaped space of the country and make the best of our urban spaces, and the facades, and the lighting, and the sequence of actions through those spaces. But there is another factor which helps to account for the aesthetic mediocrity of the American city, a factor which has an ineluctability about it that makes hortatory orations sound like naive romantic nonsense. I refer to the dominant means of transportation we have adopted for getting about in the city and for getting from city to country—the private automobile.

The automobile is a closed, windowed container in which one moves oneself about over considerable distances at considerable speed—though what strikes the city-dweller more than the speed is the peculiar rhythm of his progress through the city. He speeds forward for a stretch, then halts in the thick of traffic, then speeds forward again, then halts again, and so forth until he has arrived at his destination. In those stops between the forward lunges there is no sense of rest, of attainment, as there is when one emerges from a channel into a bay; there is only the exasperation that one's forward progress has been halted. The city is helpless to provide drama to the sequence of movements of those riding in automobiles.

Conversely, those who are lunging and halting in their automobiles find it almost impossible to get a sense of the aesthetic of the city, as I have spoken of it. It all passes them by. They couldn't experience its excellence even if it were there. But that is only to observe that the denizens of the automobile can be expected to be largely *indifferent* to the aesthetic of the city. What must be added is that since we have insisted that the automobile be allowed to get within roughly 400 feet of every spot in the city, the car has been positively destructive of the city's aesthetic quality. We have had to widen out the channels, decrease their quality of enclosure, diminish the contrast between channel and bay, and thus compromise both the unity and the variety, as well of course as the intensity, of the city's spaces. In addition, the pedestrian who might wish, against the grain, to savor the city on foot, is surrounded with ribbons of noise and mortal danger. In Los Angeles one sees the result when the automobile has its way. In what is happening to the lovely old cities of Euorpe and our own Eastern seaboard, one sees what occurs when, fighting against prior impediments, the automobile nonetheless slowly wins out.

A most interesting reaction is taking place. Across Midwestern America oases are being established where the automobile is not allowed to enter, sanctuaries against the car in the form of malls, some open to the sky, some enclosed. And private buildings are being constructed with immense interior spaces outdoor-like in their quality: the Ford Foundation building in New York City and the Hyatt Regency Hotel in Atlanta are two good examples. Inside the Renaissance Center in Detroit and the Bonaventure Hotel in Los Angeles, one actually finds restaurants simulating outdoor cafes, complete with umbrellas. This strategy of establishing oases is all in all a very poor substitute for the well-constructed city. Inevitably, the grand-processional quality of Regent Street in London, the Champs Elyssees in Paris, the Mall in Washington is missing. And between the oases there are not the pleasant passages of the aesthetically planned city through which space flows from bay to bay; but only arid strips of concrete and asphalt punctuated by the ubiquitous traffic light. So the hatred of the city continues unabated. The ideal is to travel in one's self-contained automobile from the sanctuary of one's home to a large public building, there to park underground and to emerge into an inner sanctuary without ever stepping out into the city. Yet it is no doubt better to have a city containing such oases than to have no public respite at all.

None of us knows at this time what will become of the automobile. So none of us knows whether this strategy of isolated sanctuaries is the pattern of the future; or whether the city will once again become a thing of joy aesthetically, making of God's assurance to us that we will one day dwell in a new city a beckoning invitation rather than a repulsive horror.

3. CHURCH

When we begin to think of art as instrument and object of action and to hold before our eyes the full sweep of the multitude and diversity of those actions,

thus lifting ourselves above the parochialism of our institution of high art, we are also freed to consider afresh and without distortion the role of art in the liturgy of the church.

It is habitual for musicians trained within our institution of high art to approach the music of the liturgy by insisting that it be good music, and to justify that insistence by saying that God wants us to present our very best to Him—all the while judging *good* music not by reference to the purposes of the liturgy but by reference to the purpose of aesthetic contemplation. And so, over the grumbling of the congregation, the organist playes a fine sonata or fugue as the prelude to the service. So too it's habitual for the visual artist trained by our institution of high art to paint in order to express his feelings, or to produce a fine visual design, to bring the work to the church and then to feel depressed and angry when the congregation seems not to appreciate the work, storming out with the charge that the church is against art. Of course the church is not against art. It never has been and never will be. In principle the liturgy could take place without any art's being present. In practice that happens only among Quakers. Liturgy without art is something the church has almost always avoided. Not grudgingly, because art was forced upon it. Rather the Christian liturgy has itself called forth and continues to call forth a stupendous quantity of art. But unless distortion creeps in, art in the liturgy is *at the service of the liturgy*. That is what our artists find it difficult to understand, or understanding, to accept. We saw that in the city aesthetic squalor ensues if we fail to extricate ourselves from our institution of high art. In the liturgy, *liturgical* squalor ensues if we so fail to extricate ourselves.

Liturgy is a sequence of actions; and right there, at the foundation, we have the connection between art, as instrument and object of action, and liturgy. When the church assembles to perform its liturgy, a meeting of the persons composing the congregation takes place. But the church has always insisted that another meeting takes place as well—a meeting of *God* with all those persons together, of God with *His people*, in the old sense of "a people." What is more, the church has always confessed that in that meeting of God with His people both parties act. They act reciprocally, chiefly by addressing and speaking to each other. Thus the main structure of the liturgy is that of a dialogue between God and His people. God greets the people, the people confess their sins to God; God pronounces the people forgiven, the people offer their thanks to God. And so it goes, back and forth. For the most part God acts through some human being acting on His behalf, principally the minister or priest; and to some extent the people also act by one or more of the members acting on their behalf. But normally the people also act by the members all together speaking the words of confession, all together singing the hymns of praise, and so forth.

The actions constituting the liturgy are such actions as offering thanks and making confession. But obviously such liturgical actions can take place only if they are *generated* by such other actions as uttering various words and making

various gestures. That is to say, they can be generated only by persons' performing various physical actions, those physical actions themselves often consisting of doing something with some physical object or stuff. Baptizing is a liturgical action. It is generated, however, by the minister's performing the physical action of taking up some water and sprinkling it upon the child, the water itself being a physical stuff. Thus we must distinguish between the liturgical actions themselves and the generating physical actions and objects. And we must distinguish both liturgical actions and generating physical actions and objects from the setting, visual and auditory, within which those actions take place.

Now works of art are to be found both among the generating actions and objects of the liturgy and within the setting of the liturgy. The people's singing of a hymn generates its performance of the liturgical action of offering praise to God; and, if for the moment we may regard architecture as a fine art, the building is part of the setting within which the entire sequence of liturgical actions takes place. So too banners hanging in the building belong to the visual side of the setting, and music which appears as background, introduction, or conclusion belongs to the auditory side of the setting.

The works of art are there to serve the liturgy. That is the purpose behind their presence. For it is in order to perform the liturgical actions that the people are assembled. If their purpose had been to engage in aesthetic contemplation, they would have gone instead to a concert hall or art gallery. And so, in accord with our discussion in the last chapter of Part Three, we can say that good liturgical art is art that serves effectively the actions of the liturgy and which we find generally good and satisfying to use in this way.

But what does serving effectively the actions of the liturgy amount to? For one thing, it implies enabling the actions to be performed with clarity. If the presence of some work of art somewhere in the generating actions or the setting obscures to the people what action is being performed—obscures what God is saying to the people or what it was meant that the people should say to God—then the art is not serving its liturgical purpose effectively. Secondly, it implies enabling the actions to be performed without tending to distract persons from the performance of the action to the work of art. When the music is so powerful, so striking, so novel, or so difficult to sing—or so bad in quality!—that the attention of the people tends to be drawn to it in itself, then it is no longer a humble servant of the liturgy. And thirdly, it implies enabling the actions to be performed without undue awkwardness and difficulty. If the architectural setting makes it awkward and difficult to perform certain liturgical actions, that is a serious count against it, no matter what its aesthetic merit.

I think this all implies, for a normal congregation at any rate, a considerable simplicity in the art of the liturgy. The aesthetic quality of liturgical art will lie in its unity and its intensity and only in a quite subsidiary way in its internal richness. There is good reason—lying in the difference of

purpose—for the music of the concert hall being characteristically more complex than the music of the liturgy. As the historian of music knows well, however, there have been waves of advance and retreat on this matter. Over a period of time the music of the church gradually becomes more complex, whereupon a new broom comes to sweep most of it away, and then the same process slowly repeats itself.

But good liturgical art is more than art which serves effectively the purposes of the liturgy. It is, beyond that, art which proves generally good and satisfying thus to use. And it is here that aesthetic considerations enter. For, as I have already argued several times, if some cultural object which occupies anywhere near a conspicuous role in our lives is to prove fully good and satisfying to use, it must have aesthetic merit.

In our attempt to assess the aesthetic merit of a liturgical whole, it is of prime importance not to take pieces and snatches from the liturgical sequence, from its generating actions and objects, and from its setting, and then to assess those items individually—a hymn from here, a banner from there. For what is aesthetically excellent considered in isolation may in context prove incongruous and jarring. A good many factors in a liturgical whole must be taken note of if its aesthetic value is to be assessed. Here I shall remark on only two.

Pervading the liturgical totality will be the phenomenon of fittingness in its varying degrees. And I think that what is perhaps of greater importance than anything else for the aesthetic value of the whole is that there be coherence secured by fittingness among the various parts.

For one thing, there can be degrees of fittingness between some specific liturgical action and its generating actions and objects. Of course before one can appraise a liturgical whole in this regard, one must know what liturgical action is being performed at a given point; one must, as it were, have conducted an "action analysis" of the liturgy. And it must be admitted that often it is thoroughly obscure just what action is being performed at a certain point. But suppose it is clearly confession. The character of some music is fitting to confession, that of other music is singularly unfitting; and contributing to the aesthetic value of the liturgical whole will be fittingness between music and actions. One can go deeper. The action of confession occurs in almost all liturgies. Yet it is understood differently in different congregations. One person understands it perhaps as an admission of guilt offered in the confidence of forgiveness, another as an abject pleading. And, as we noted earlier, in our discussion of fittingness, not only does one piece of music fit confession *as such* better than another piece; one piece will better fit confession understood in one way, and another will better fit confession understood in another way. Music in that way often lends specificity to the action performed. Ideally, then, the generating actions and objects will not only fit the liturgical action as such, but will fit that action as understood and performed by that specific congregation.

Fittingness appears at other junctures as well, not just between liturgical action and generating action. The liturgy for Pentecost is naturally different from that for Lent, and in good measure art which fits the one well does not fit the other well. And the Greek Orthodox liturgy as a whole is different from a Calvinist liturgy, in its structure, its components, and its theological underpinnings. Accordingly, generating actions and objects which fit the one well do not do so for the other, and the same for the setting. Then too, congregations differ significantly in their religious and theological self-understanding, and liturgical art which fits well one's self-understanding will not fit well another's. To a congregation's self-understanding as the army of God in the world the basilica shape is eminently fitting; to a congregation's self-understanding as the family of God in the world the basilica shape is profoundly unfitting. Far better a tent shape. In all these ways, and others yet unmentioned, degrees of fittingness pervade the liturgical whole, contributing coherence or incoherence, and are of prime importance in assessing the aesthetic merit of the totality.

Something at least of all this was recognized by John Calvin when he remarked in the preface to his 1545 Psalter that

> Touching the melody, it has seemed best that it be moderated in the manner we have adopted to carry the weight and majesty appropriate to the subject, and even to be proper for singing in the Church. . . . Care must always be taken that the song be neither light nor frivolous; but that it have weight and majesty (as St. Augustine says) and also that there be a great difference between music which one makes to entertain men at table and in their houses, and the Psalms which are sung in the Church in the presence of God and his angels.

When one surveys the history of liturgical art, one comes almost inescapably to the conclusion that human beings in deep, unconscious ways *seek* fittingness between their fundamental beliefs and the character of the art they use. It is as if there is in us a deep need for such fittingness. Of course counterbalancing factors may operate in a given case. But there is a profound fittingness between the elegant, sparse, white-interiored churches of the New England colonies and the religious self-understanding of those who built them; there is a deep fittingness between the ponderous, though sublime, majesty of St. Peter's and the religious self-understanding of the Renaissance papacy; there is a deep fittingness between the religious self-understanding of the American fundamentalist and such a song as

> Do Lord, oh do Lord,
> Oh do remember me;
> Do Lord, oh do Lord,
> Oh do remember me;
> Do Lord, oh do Lord,
> Oh do remember me,
> Way beyond the blue.

If it is indeed true that, other things being equal, men seek fittingness between their deepest convictions and the art of which they make use, then with fair reliability one should be able to infer the general character of those convictions from the art. And so it seems one can. To discover the general character of a congregation's understanding of the Lord's Supper, one can read their official form or liturgy. But it is probably better to listen to the music they use for communion. From a characteristically lugubrious tone, for example, one learns a great deal—often, that their *operative* theology of the Lord's Supper, in which the note of penitential sorrow is dominant, is quite different from their official theology.

Further, if it is indeed true that deep in human beings is a desire for fittingness between their deepest convictions and their art, then one can predict that the zealous young musician fresh from school who steps into a congregation determined to reform its musical taste is probably doomed to fail. If he is politically adroit and has powerful people supporting him, the music itself may change; but unless the religious self-understanding of the people is also reformed, their taste will alter less rapidly than their resentments build up. And one can predict that the architect who wishes to coax a congregation which dominantly understands itself as the army of God, assembling on Sunday to receive marching orders, into accepting a design for a tent-shaped building is probably also going to fail—unless he or she too succeeds in stimulating a religious reformation. Artistic reformation succeeds only where religious reformation paves the way.

A second factor closely relevant to assessing the aesthetic quality of a liturgical totality can be dealt with much more briefly. I have in mind the degree of completeness in the sequence of the litugical actions themselves. Sometimes one comes across liturgies which fall apart into pieces, the actions not flowing in dramatic fashion from one to another up to a point of culmination but just following one after the other, disconnected, the sequence as a whole neither beginning nor ending but just starting and stopping. When that is true, then too the liturgy is aesthetically defective.

We must return to the main point. Liturgical art, much of it participatory in character, is the art of a community, at the service of its liturgical actions and not at the service of aesthetic contemplation. For the purposes of aesthetic contemplation, much of it—maybe most of it—is inferior to a great many other works available in our culture. When it is not, its aesthetic magnificence tends to distract us from the liturgy. Bach's cantatas are a great exception, superb both aesthetically and liturgically. But concerning these we must be reminded that listening to them aesthetically is very different from listening to them in such a way that the choir sings to God on one's own behalf. Our great twentieth-century composers have produced a good deal of *religious* music. Of *liturgical* music they have produced almost nothing (Vaughn Williams being the exception).

A few days before writing these words I heard a marvellous performance

of Bach's *Magnificat*. For me the performance was as sobering as it was exhilarating, however. When Bach composed his work, it belonged to the art of the tribe; for, aesthetically glorious as it is, it was then a humble servant of the Lutheran liturgy. Now it sadly belongs almost entirely to the art of our cultural elite, who listen to it in concert halls, taking note only of its aesthetic qualities. Is it too much to hope that some day the church will once again find composers who are willing to turn their backs, for a time, on the institution of high art to compose works which are of aesthetic magnificence and yet of humble service to the liturgy?

4. TRADITION

If we rise above the parochialism of our institution of high art perhaps one more freedom will come our way, the freedom to understand and appreciate, if not to recover, some of our own tradition. I know of no better way to make this point than to cite a lecture of Donald Davie, "Old Dissent, 1700-1740."[2] Davie begins by quoting a poem:

I
O God, our help in ages past,
 Our hope for years to come,
Our shelter from the stormy blast,
 And our eternal home.

II
Before the hills in order stood,
 Or earth receiv'd her frame,
From everlasting thou art God,
 To endless years the same.

And so on, for nine stanzas all together.

About this poem—which some readers will recognize as written by the eighteenth-century English poet Isaac Watts—Davies remarks that it has entered so deeply into our oral culture that it must be counted as belonging to "a very ancient kind of poem, perhaps the most ancient kind that is known to us—from other cultures as well as our own. What we have here, it seems, is a lay, 'le chant du tribu', a kind of poem that predates not just the age of print but the age of script, a kind of poem from before writing was invented." Specifically it is that sort of tribal lyric which may appropriately be called a *hymn*.

Does it, he asks, seem perhaps lacking in seriousness to present "Isaac Watts . . . as a poet of the tribal lay, a true analogue in Augustan England of David the bard and warrior-king of ancient Israel? Calling Watts to mind, undersized and sickly, demure and grave and domesticated in Hanoverian London, the notion seems ludicrous." And yet, he says, the Dissenters for whom Watts wrote, conceived themselves as a tribe, "a chosen people just as

the ancient Israelites were chosen, in tension with their neighbors."
Moreover, he remarks, hymns like this were composed and sung from
manuscripts week by week in Watts' own congregation in Southampton.

> Watts was there in the congregation, hearing his hymns sung at sight and for the
> first time by his neighbours, every one of whom, no doubt, he knew and could
> name. Can we conceive of a more tribal situation, or of a relation more immediate
> and intimate between a poet and his public? And this happened at the very height
> of what we are taught to call 'the age of print', that sad interregnum in the history
> of poetry from which, we are asked to think, a Yevtushenko or an Allen Ginsberg
> or Leonard Cohen have come to save us, by reading their poems through massed
> microphones and thus (if you please!) reviving poetry as an oral art.

Yet, though this tribal lyric has sunk deep into the linguistic
consciousness of English man, it receives from our critics no attention. "For
the moment it seems we must say that if 'O God, our help in ages past'
represents a very ancient kind of poem, perhaps the most ancient kind of
which we have record, it looks as if this kind of poem is a great deal too ancient
for our self-applaudingly 'modern' criticism to be able to deal with it."

Why might this be? Perhaps because "it strikes us as merely *dull*. And
this may well be the case; for we have already found reasons why current
critical precepts, and the reading habits they inculcate, should be ill-adapted
to seeing anything responsible or sensitive or distinguished in verses like:

> A thousand ages in thy sight
> Are like an evening gone;
> Short as the watch that ends the night
> Before the rising sun.

But then we must look deeper. For *dullness* was one risk that Watts foresaw
and decided to take for the purposes he had in mind."

Speaking of such compositions as "O God, Our Help in Ages Past," Watts
himself said:

> In many of these composures, I have just permitted my verse to rise above a flat
> and indolent style; yet I hope it is every where supported above the just contempt
> of the critics: though I am sensible that I have often subdued it below their
> esteem; because I would neither indulge any bold metaphors, nor admit of hard
> words, nor tempt the ignorant worshipper to sing without his understanding.

And in his "A Short Essay toward the Improvement of Psalmody" Watts
speaks in similar fashion: "It was hard to restrain my verse always within the
bounds of my design; it was hard to sink every line to the level of a whole
congregation and yet to keep it above contempt." Evidently Watts knew
exactly what he was doing.

Davies then continues:

> Well, but (it may be said) we ask of a poetic style—of a style in any art, and indeed
> of a style of life—that it have more than negative virtues. It is a weighty point, and

one in fact that takes us at once to the heart of the Calvinist aesthetic. For that is what we are now concerned with. And in the first place a Calvinist aesthetic exists. 'In nothing perhaps has Calvin been more misjudged than in the view that he lacked an aesthetic sense. . . .' It was after all John Calvin who first clothed Protestant worship with the sensuous grace, and necessarily the aesthetic ambiguity, of song. And who that has attended worship in a French Calvinist church can deny that—over and above whatever religious experience he may or may not have had—he has had an aesthetic experience, and of a peculiarly intense kind? From the architecture, from church-furnishings, from the congregational music, from the Geneva gown of the pastor himself, everything breathes *simplicity, sobriety,* and *measure*—which are precisely the qualities that Calvinist aesthetics demands of the art-object. . . . And so, even if we admit for the sake of argument that Calvinism denies sensuous pleasure, we encounter time and again the question, when faced with a Calvinistic occasion: do we have here a denial of sensuous pleasure, or do we not rather have senuous pleasure deployed with an unusually frugal, and therefore exquisite, fastidiousness? It is peculiarly of the nature of Puritan art to pose just this question, though that is by no means the account of it that is normally given.

There is then a sort of Calvinist classicism in the tribal lay of Isaac Watts, adopted in part—though surely only in part—because he chose to "sink" his verses to the level of his congregation's understanding. If we are not open to that poetic sensibility, if we do not see it as artfulness rather than blundering—though artfulness in the service of an artistic end quite other than that of aesthetic contemplation—we shall have no way of dealing with the way in which such poetry "conditioned the sensibility of the English-speaking peoples."

CHAPTER TWO

Participation

Ⅰ N DELINEATING what I take to be an appropriate stance toward our institution of high art, I have spoken of the paths opened up to us by being liberated from its grip on our thought and practice. We are freed to act responsibly and appreciatively toward the aesthetic outside of art. We are freed to act responsibly and appreciatively toward art which is not for contemplation. We are freed to act understandingly and appreciatively toward otherwise overlooked or inscrutable parts of our own artistic tradition.

What remains now is to address ourselves to the question of our participation in the institution itself; specifically, to the question of the Christian's participation in that institution. There is in the world the body of those who have committed themselves to being disciples of Jesus Christ—Christians, the Christian community. There is also in the world our contemporary society's institution of high art. What do these two—this community and this institution—have to do with each other? What does Jerusalem have to do with New York?

Let me narrow the question. One could of course focus on the beholder of art, and then ask in what way one's participation *as beholder* in our institution of high art should be fitted into the life of discipleship. But in these remarks I shall instead focus on the artist. In what way (if any) can one's participation *as artist* in our institution of high art be fitted into the life of discipleship? How can the motions of discipleship incorporate the practice of a high-art artist?

Not just the individuals who work within it, but the institution of high art itself, shares fully in the fallenness of our human condition. The underlying dynamics of the institution constantly lead to oppression, to distortion of vision, to defection from responsibility. The institution's insatiable appetite for additional works drives its agents into acts of plunder and rapacity. The institution's system of distribution provides rich opportunity for those who are interested not at all in art but only in financial self-aggrandizement. The institution's emphatic insistence on stylistic innovation and whole-hearted devotion leaves behind it long trails of broken and maimed lives—lives

consumed by jealousy, lives in which humanity has withered away into neurotic or obsessive concern with art, lives judged failures because radical stylistic innovation or critical success was not theirs to achieve. The institution's interiorization leads it to repudiate or ignore the claims of mankind in general on the services of the artist.

Yet, strangely, in the face of its obvious fallenness the institution is constantly breaking out into claims of ultimacy. We heard those claims of ultimacy expressed by Bell and by Marcuse; we saw their presence observed by Weber and by Malraux. To the Christian, such claims of ultimacy are themselves a mark of fallenness.

The institution is also a profoundly secularized institution, partly in that it is today pervasively hostile to the explicit expression of religious conviction, but more fundamentally in that an artist's expression of religious conviction is utterly irrelevant to his or her position of esteem and influence within the institution. What counts is whether he has advanced the art, not whether he has used his art to serve God.

And yet, again strangely, beneath this secularity is the mystical conviction that the artist somehow rises toward Deity. Of course he does it not by serving the Deity. He does it by challenging the Deity, challenging Him in His own courts—seeking to create like unto the Divine Master.

It is this institution—fallen but pretentious, secular but mystical—that confronts us all. And the concrete question that faces any Christian in our society who is, or wishes to be, an artist is the stance that he must take toward this institution.

I have spoken of fallenness. But of course more must be said about it than that. Like almost everything else in our history, the status of our institution of high art is ambivalent. Our response to it must be a No *and* a Yes. From the resources of the institution has come forth a flood of great works which together have enriched and deepened our lives immeasurably. Without the presence of this institution, our existence would be drastically impoverished.

We can go deeper. I have suggested that at the very center of the institution is a passionate commitment to the importance of perceptual contemplation of works of art, and more particularly, to *aesthetic* contemplation. And I have argued that the delight attained in aesthetic contemplation is good. It constitutes, so far forth, a facet in the attainment of our human destiny. The attainment of that delight typically requires, I suggested, certain modes of separation of art from ordinary life. But even those modes of separation are not bad. There is nothing inherently wrong about concert halls and art galleries, about having the leisure available for contemplating art, about blocking out for a time one's other concerns and focussing on the work of art. So the Christian has no difficulties with the determinative center of our institution of high art. On the contrary, he affirms its importance.

But three things especially will concern him, as I see it.

(1) In the first place, he cannot divorce art from responsibility. He recognizes that responsibility belongs to the constitutive texture of human existence. Accordingly, he acknowledges that his participation in art must be an implementation of his responsibility.

What does this mean in practice? First, a good deal of what it means in practice is that the Christian artist must constantly be engaged in the difficult, precarious task of assessing priorities as he (or she) determines the direction of his endeavors—of assessing relative importance. He recognizes that art for contemplation can serve human fulfillment. But equally he recognizes that art for other purposes can serve human fulfillment. He refuses automatically to give priority to either of these over the other. Aesthetic contemplation is not always the best use to which art can be put; neither is it always the worst. And so the Christian artist must constantly be weighing his potential contribution to high art over against his potential contribution to art in one of its other manifestations.

But even when he is operating *within* the institution of high art, he must assess priorities as he determines the direction of his endeavors. He cannot simply go along with the trends and fads, nor can he simply do whatever happens to catch his fancy at the moment. Some movements in art are significant. They open up the future in promising ways and yield works of great significance. Others are insignificant. They are innovative, but trivially so; or they tread paths already so heavily trod that no living thing grows there. The Christian artist must constantly be making such judgments of relative importance.

I know, of course, that artists become nervous and skittish when one speaks of some movements in art as important and some as trivial, and of the need to choose by reference to one's judgments of importance. Yet in spite of their skittishness, artists themselves, when sitting on evaluation panels for, say, the National Endowment for the Arts, do in fact make such judgments of relative importance.

One point must be added to this discussion on responsibility in art. I have said that the artist who acknowledges his responsibility to God, to his neighbor, to himself, to nature, will find that he must constantly assess priorities as a way of determining the direction in which he turns his endeavors. It would be irresponsible, though, to determine these priorities by reference simply to what the public wants—to judge that what they want is always what is most important to do. Being a responsible artist is not the same as being a pandering artist. The two are in fact incompatible. Sometimes the artist must strike out on paths of exploration which, at the time, his public does not like, in the conviction that eventually his path will yield results more rewarding and enriching to his fellow human beings than would come by his simply giving them what at the moment they desire. The responsible philosopher does not determine what to say simply by reference to what people want him to say. Neither does the responsible artist determine what to

make simply by reference to what people want him to make. He strives to serve the needs and enrichment of his fellows, not necessarily their wants.

(2) Secondly, the Christian artist will constantly be struggling to achieve wholeness, integrity, in his life. He will not be content to let his life fall apart into pieces—religion as one piece, art as another. For he knows that to answer the call to be a disciple of Jesus Christ is to commit his life as a whole, not just some fragments thereof, to God's cause in the world.

What we have seen, many times over in this discussion, is that the artist does not simply gush forth works of art in a subhuman, irrational flow. Be it granted that images, harmonies, tunes, situations, come to him from he-knows-not-where. Yet always he works with artistic *goals and aims*—sifting through the images that come to mind, discarding some, keeping others, molding, shaping and revising them, encouraging yet others to come to mind. Though the wellsprings of images remain mysteriously hidden from us, yet composing a work of art is a deliberate action.

What can be said, then, is that the Christian artist will seek to bring his artistic goals into conformity with his Christian commitment. And he may indeed go the next step of seeking goals which are *appropriate to* his commitment, not just in conformity with it—as John Cage chose musical goals which he judged appropriate to his Westernized form of Zen Buddhism, as Michelangelo in his middle period chose artistic goals he judged appropriate to his Platonism. In the case of the Christian artist, the world behind his work, the world of which his work is an expression, will incorporate his Christian commitment. In this way his art will not be separated from life. It will be of a piece with it.

A few paragraphs above I said that our Western institution of high art is a profoundly secularized institution. With that in mind, someone might wonder whether it is *possible* to participate as an artist in our institution of high art and yet adopt artistic goals which conform, or are appropriate, to one's Christian convictions. The answer is clearly Yes. T. S. Eliot and W. H. Auden are examples, as is Georges Rouault; or to come up to our own day, Olivier Messiaen and Krzysztof Penderecki. For our institution of high art is secularized not primarily in the sense that it does not tolerate artistic goals selected because they conform or are appropriate to the Christian gospel, but rather in the sense that it makes no difference to the influence and esteem of the artist within the institution whether or not he thus selects his goals. The institution does provide at least some amount of open space for the religiously committed artist.

There are, indeed, others who see the situation differently. In his book *My Name Is Asher Lev,* Chaim Potok tells the story of a boy growing up in a conservative, intensely committed, Jewish community in Brooklyn who discovers that he has the gift of a painter. Finding it impossible to restrain himself from using the gift, Asher eventually comes into contact with the institution of high art in New York, particularly in the person of Jacob Kahn.

The picture presented is that to participate in this institution is incompatible with remaining a member of the conservative Jewish community. Eventually Asher leaves the community, filled with pained regret.

Part of the root of the conflict, in Asher's case, is that his community finds all forms of painting, other perhaps than the most elementary representations, offensive. But this is by no means the deepest source of the conflict. That can be seen from the following passage of dialogue. Jacob Kahn is the speaker at the beginning, then Asher:

> "You have a gift, Asher Lev. You have a responsibility." He stopped in front of me. "Do you know what that responsibility is?"
> I did not say anything.
> "Tell me what you think that responsibility is," he said.
> I was quiet. I did not know what to say.
> "Do you feel you are responsible to anyone? To anything?"
> "To my people," I said hesitantly.
> "What people?"
> "To Jews."
> "To Jews," he echoed. "Why do you think you are responsible to Jews?"
> "All Jews are responsible one for the other," I said, quoting the statement from the Talmud my father had years ago quoted to me.
> "As an artist you are responsible to Jews?" He seemed angry. "Listen to me, Asher Lev. As an artist you are responsible to no one and to nothing, except to yourself and to the truth as you see it. Do you understand? An artist is responsible to his art. Anything else is propaganda. Anything else is what the Communists in Russia call art. I will teach you responsibility to art. Let your Ladover Hasidim teach you responsibility to Jews. Do you understand?"

If it were indeed true that to participate in the institution of high art one must repudiate all responsibility except that to oneself and to art, then participation by the committed Christian in the institution of high art would be an impossibility. The community of Christians and the institution of high art would then be engaged in locked-horn combat. But Kahn has overstated the case. Though the Gauguin image of the artist, in which the repudiation of responsibility is a key element, is indeed pervasive within our institution, it is not essential to it. T. S. Eliot confirmed the community of his fellow Christians in their perception of reality and human existence while yet playing a towering role in high-art poetry of the twentieth century.

(3) Thirdly—and this goes almost without saying—the Christian must resist the claims of ultimacy which repeatedly erupt from our institution of high art. Art does not provide us with the meaning of human existence. The gospel of Jesus Christ does that. Art is not a way of rising toward God. It is meant instead to be in service of God. Art is not man's glory. It displays man's degradation as well as his dignity. The community of artists is not the new humanity. The community of Christ's disciples is that. Art is not man's liberating savior. Jesus Christ is that.

* * *

The church, the band of Christ's disciples, is the community of those who
have taken up the call of God to work on His behalf in His cause of renewing
human existence. The Christian knows indeed that God has never confined
His mode of working to the church. And conversely, he knows with painful
vividness that the church, with its splotches and blotches, often retards God's
work. Yet he believes that when our stretch of history is seen whole, the
disciples of Jesus will be seen to have played a decisive role in the coming of
the righteous shalom, that is, in the coming of what the New Testament calls
the Kingdom of God, where God is acknowledged as Lord. This Kingdom he
sees not as *escape* from our creaturely status. He sees it rather as the situation
where men acknowledge God's sovereignty and carry out the responsibilities
awarded them at creation. He does not think of this merely as the *restoration*
of some Edenic situation. For he believes that what has taken place in history
will play its constructive role in the character of life in the Kingdom. He sees it
rather as the *renewal* of human existence, so that man's creaturely vocation
and fulfillment may be attained, now already and in the future.

The task in history of the people of God, the church, the followers of Jesus
Christ, is in the first place to witness to God's work of renewal, to the coming of
His Kingdom—to speak of what God has done and is doing for the renewal of
human existence. Its task is, secondly, to work to bring about renewal by
serving all men everywhere in all dimensions of their existence, working for
the abolition of evil and joylessness and for the incursion into human life of
righteousness and shalom. Thirdly, it is called to give evidence in its own
existence of the new life, the *true*, authentic life—to give evidence in its own
existence of what a political structure without oppression would be like, to
give evidence in its own existence of what scholarship devoid of jealous
competition would be like, to give evidence in its own existence of what a
human community that transcends while yet incorporating national diversity
would be like, to give evidence in its own existence of what an art that unites
rather than divides and of what surroundings of aesthetic joy rather than
aesthetic squalor would be like, to give evidence in its own existence of how
God is rightly worshipped. And then lastly it is called to urge all men
everywhere to repent and believe and join this people of God in the world.

To be a Christian participating in this fourfold task of the church in the
world is not to repudiate one's creational responsibilities before God. Those
responsibilities have not been abrogated. One remains a human being, called
to master nature, called to love one's neighbor as oneself, called to render
praise to God. But those responsibilities have now all been set in a different
context and have acquired a new dimension. The Christian now lives and
works as member of a community which has said Yes to God's call to be His
agent of renewal, a community sadly alienated from those of mankind who do
not acknowledge Jesus Christ as Lord. That community now renders honor to
God not only as creator but also as redeemer. That community now serves its

fellow men not only with food and knowledge and political liberation but also with the message that in Jesus Christ there is freedom from bondage in all its forms.

It is in the context of this community that the Christian artist is also now called to do his work. He is called as artist to share in his people's task of being witness to God's work of renewal, its task of serving all men everywhere by working to bring about righteousness and peace, its task of giving evidence in its own existence of what the renewed life is like, its task of inviting all men everywhere to join the ranks of the people of renewal. Sharing in the task of this community is now the particular form which the artist's responsibility to God takes.

<p style="text-align:center">* * *</p>

When Ghislebertus carved the tympanum on the church of the Madeline in Vezelay he contributed to the art of his tribe as a whole. Bishops and serfs alike passed beneath his portal and felt its significance. So too when Bach composed his cantatas for the St. Thomas Kirche in Leipzig, teachers and bakers sat in pews together and listened to choir and orchestra, under direction by the master, praising God on behalf of all.

Today our celebrated artists, unless they are architects, no longer put themselves at the service of the tribe; and conversely, those artists who do put themselves at the service of the tribe as a whole, our commercial artists, are more faceless than the most anonymous carvers of the Romanesque cathedrals. Between our producers of high art and the human tribe is a vast gulf of mutual indifference, widening ever since the Christian church lost its hold on the mind and heart of Western man.

We long for those bygone days of wholeness—for those days when the religious substance of society was unified, when the artist saw it as his calling to give expression to that substance rather than to stand in prophetic, agonized opposition to it, and when, accordingly, the art of the tribe was art at its most profound instead of what so often it is today—mindless pandering drivel. But those days are gone; and there is nothing you and I can do to bring them back. Better to protect our religious pluralism than to lament our loss of religious unity. Better to respect the artist's integrity than to lament his alienation.[3]

But though we cannot recover the wholeness of our predecessors, what we can do is shed our parochialism. We can remove the blinkers which have led us to see only the arts as they operate in our institution of high art. And though we cannot recover an art of the tribe as a whole which has profundity and imagination, what we can do is repent ourselves of our elitism, dropping the assumption, so deeply ingrained in us by our institution of high art, that perceptual contemplation, and in particular aesthetic contemplation rewarding to the intellectual, is per se the noblest use to which a work of art can be put.

For those of us who are Christians one more thing lies within our reach: In the community of Christians as a whole, and more particularly in the liturgy

of the church, it is still possible to have an art of the tribe which expresses rather than alienates itself from our deepest convictions, and which does not pander to us but rather ennobles us by its self-conscious dedication *ad maiorem gloriam Dei*. Paradise is forever behind us. But the City of God, full of song and image, remains to be built.

Malraux's Humanistic Alternative

N O ONE has dealt more profoundly with many of the principal issues discussed in this book, particularly those in Part Two, than André Malraux in his book *The Voices of Silence*. It will prove illuminating to see where his interpretations coincide with mine and where they diverge. Unfortunately, what can hardly be communicated by my discussion, as I probe for the structure of his argument, is Malraux's richness of example, his eloquence of expression, his humane wisdom, his passionate concern for what is fundamental in human existence, and his *despairing* sense of living in an age when mankind, having rejected God and the gods, has lost its way.

Malraux agrees that a decisive change has occurred in the arts—he has only visual art explicitly in mind—within the last two centuries. That change he locates in an alteration both in the attitude of the public and in the attitude of the artist.

The basic change in the attitude of the public is that in the course of these two centuries we have all learned to regard works of art *as* works of art. It is true that we remain vaguely aware of the diverse functions these objects once served. Yet we abstract those objects from those functions, so that a portrait becomes for us a picture, a carving of our Savior a sculpture. This profound alteration in attitude is inextricably intertwined with the fact that the very concept of a work of art emerges for the first time in history among us.

> That (to quote a famous definition) a religious picture "before being a Virgin, is a flat surface covered with colors arranged in a certain order," holds good for us, but anyone who had spoken thus to the men who made the statuary of St. Denis would have been laughed out of court. For them as for Suger and, later, for St. Bernard, what was being made was a Virgin; and only in a very secondary sense an arrangement of colors. The colors were arranged in a certain order not so as to be a statue but so as to be *the* Virgin. Not to represent a lady having Our Lady's attributes, but to *be;* to win a place in that other-world of holiness which alone sponsored its quality. . . .
>
> The Middle Ages were as unaware of what we mean by the word "art" as were Greece and Egypt, who had no word for it. For this concept to come into being, works of art needed to be isolated from their functions. What common link

existed between a "Venus" which *was* Venus, a crucifix which *was* Christ
crucified, and a bust? But three "statues" can be linked together. . . . Thus, for
Manet, Giotto's *Christ* was to become a work of art; whereas Manet's *Christ aux
Anges* would have meant nothing to Giotto. (pp. 53-54)

The museum in Western society was both a result of, and a stimulus to,
this alteration. For in the museum, works of art are isolated from their original
functions and presented to us as works of art.

[Museums] bulked so large in the nineteenth century and are so much part of our
lives to-day that we forget they have imposed on the spectator a wholly new
attitude towards the work of art. For they have tended to estrange the works they
bring together from their original functions and to transform even portraits into
"pictures." . . . What do we care who the *Man with the Helmet* or the *Man with
the Glove* may have been in real life? For us their names are Rembrandt and
Titian. . . . The effect of the museum was to suppress the model in almost every
portrait . . . and to divest works of art of their functions. (pp. 13-14)

In fact, as Malraux observes, what has emerged in our century is not just
museums, but the "museum without walls." What finds its way into our
museums is what is portable. But what finds its way into our mind's eyes is the
whole scope of the world's art, portable or not. By virtue of the photograph
and inexpensive travel, our acquaintance with Chartres and *The Last Supper*
is as intimate as our acquaintance with *The Night Watch* and *Las Meninas*.

Not only do museums and the "museum without walls" divest the works
they present to us of their function. At the same time they bring together into
close proximity works of different, even competing, styles. "[T]he modern
art-gallery not only isolates the work of art from its context but makes it
foregather with rival or even hostile works. It is a confrontation of
metamorphoses" (p. 14). The museum forces works of radically different styles
to consort together. In our toleration of such consorting, indeed, in our
encouragement of and delight in it, lies a second fundamental alteration in the
attitude of the public. From the sixteenth to the nineteenth centuries the style
of the classical Greeks was held up as paradigmatic, and all other styles were
measured by their approximation to this paradigm. Further, within the
paradigm style certain artists—Raphael, Michelangelo—were held up as
ideal, and all others were measured by their approximation to those examples.
Accordingly, it was said that the Romanesque, Byzantine, and Primitive
artists were clumsy and unskilled, and their work consequently inferior.

Indigenous to our new attitude is a firm belief in the sovereignty of each
style, with the attendant conviction that each style has its own masterpieces,
and that the masterpiece in one style is not to be judged by its similarity or
dissimilarity to the masterpiece in another style. The Romanesque artist was
not aiming at the style of the classical Greeks and falling woefully short of his
aim. He was aiming at something totally different, and equally legitimate. As
the founders of the American Republic rejected the imperialism of any one

religion and affirmed the coordinate sovereignty of diverse religions—thus tolerating and even encouraging religious pluralism—so the modern art public rejects the imperialism of any particular style and affirms the coordinate sovereignty of diverse styles.

> The revision of values that began in the nineteenth century and the end of all *a priori* theories of aesthetics did away with the prejudice against so-called clumsiness. That disdain for Gothic art which prevailed in the seventeenth century was due . . . to the fact that the Gothic statue was regarded at that time, not as what it really is, but as a botched attempt to be something quite different. Starting from the false premise that the Gothic sculptor aimed at making a classical statue, critics of those days concluded that, if he failed to do so, it was because he could not. (pp. 19-20)
>
> . . . In our Museum without Walls picture, fresco, miniature and stained-glass window seem of one and the same family. For all alike—miniatures, frescoes, stained glass, tapestries, Scythian plaques, pictures, Greek vase paintings, "details" and even statuary—have become "colorplates." In the process they had lost their properties as *objects;* but, by the same token, they have gained something: the utmost significance as to *style* that they can possibly acquire. It is hard for us clearly to realize the gulf between the performance of an Aeschylean tragedy, with the instant Persian threat and Salamis looming across the Bay, and the effect we get from reading it; yet, dimly albeit, we feel the difference. All that remains of Aeschylus is his genius. It is the same with figures that in reproduction lose both their original significance as objects and their function (religious or other); we see them only as works of art and they bring home to us only their makers' talent. . . . Yet diverse as they are, all these objects . . . speak for the same endeavor; it is as though an unseen presence, the spirit of art, were urging all on the same quest, from miniature to picture, from fresco to stained-glass window, and then, at certain moments, it abruptly indicated a new line of advance, parallel or abruptly divergent. Thus it is that, thanks to the rather specious unity imposed by photographic reproduction on a multiplicity of objects, ranging from the statue to the bas-reliefs, from bas-reliefs to seal-impressions, and from these to the plaques of the nomads, a "Babylonian style" seems to emerge as a real entity, not a mere classification—as something resembling, rather, the life-story of a great creator. Nothing conveys more vividly and compellingly the notion of a destiny shaping human ends than the great styles, whose evolutions and transformations seem like long scars that Fate has left, in passing, on the face of the earth. (pp. 45-46)

Interacting with these altered attitudes on the part of the public, partly causing them and partly caused by them, is an equally fundamental alteration in the attitude of the artist. Rather than subordinating his artistic creation to the values of his community, as he once did, he finds in artistic creation itself his supreme value. Painting becomes for him an end in itself. Modern art substitutes "art's *specific* value for the values to which hitherto art had been subordinated" (p. 605). As a consequence, style becomes supreme. "The medieval fluting . . . is a calligraphy of Faith; the Renaissance arabesque is one of beauty. The modern 'distortion' " is in the service of style.

Thus, for us, a style no longer means a set of characteristics common to the works of a given school or period, an outcome or adornment of the artist's vision of the world; rather, we see it as the supreme object of the artist's activity, of which living forms are but the raw material. And so to the question, "What is art?" we answer: "That whereby forms are transmuted into style." (p. 272)

The modern artist's supreme aim is to subdue all things to his style, beginning with the simplest, least promising objects. And his emblem is Van Gogh's famous *Chair*. . . . The modern landscape is becoming more and more unlike what was called a landscape hitherto, for the earth is disappearing from it. (p. 119)

Speaking of the turn-of-the-century painters, Malraux says that "Artists had decided that henceforth painting was to dominate its subject-matter instead of being dominated by it" (p. 113). And he continues:

Painting's break with the descriptive and the imaginary was bound to lead to one of two results: either the cult of a total realism (which in practice never was attained . . .); or else the emergence of a new, paramount value—in this case the painter's total domination of all that he portrays, a transmutation of things seen into the stuff of pictures. . . .

Thus the painter, when he abandoned transfiguration, did not become subservient to the outside world; on the contrary he annexed it. And he forced the fruit to enter into his private universe, just as in the past he would have included it in a transfigured universe. The artist's centuries-old struggle to wrest things from their nature and subdue them to that divine faculty of man whose name was beauty was now diverted to wresting them once again from their nature and subjecting them to that no less divine faculty known as art. No longer made to tell a story, the world seen by the artist was transmuted into painting; the apples of a still life were not glorified apples but glorified color. . . . Thus the artist's will to annex the world replaced the will to transfigure it, and the infinite variety of forms, hitherto made to converge on religious faith or beauty, now converged on the individual.

So now it was the artist as an individual who took part in the now unending quest, and it was recognized—unequivocally at last—that art is a series of creations couched in a language peculiar to itself; that Cézanne's translucent water colors sound the same grave bell-notes as Masaccios' frescoes. (pp. 120-21)

In that last paragraph we catch a glint of the "Hegelianism" of Malraux's reading of the history of art. Artistic creation has always been a thing of value. Indeed, on Malraux's view it has always been one of the principal marks of man's glory. But until it happened in our century that the artist no longer subordinated his creation to other values, until for him it became an end in itself, until it happened in our century that artistic creation superseded for the artist all other values, this was hidden from consciousness. Art's breaking free in our century has shed light on all preceding centuries. Its breaking free has brought the significance of artistic creation, as we find it down through the centuries, into consciousness. Modern art is art becoming self-conscious, not only as to its significance in the modern world, but as to its significance through the ages.

In the past no art was viewed separately from the exclusive, not the specific, values which it served and which made all types of art which did not serve these become, so to speak, invisible. The conflict ceased once art came to be seen as constituting *its own value*. Though Khmer heads did not thereby become "modern," they became, anyhow, visible and, compared with other heads (or amongst themselves) some of them became what they actually are, i.e., works of art, even if the men who carved them had no inkling of our idea of art. Thus many works of vanished civilizations are acquiring for the first time their common language. (p. 610)

And since it was in the West that the sea-change occurred, Malraux is willing to say that "The first culture to include the whole world's art, this culture of ours, which will certainly transform modern art (by which until now it was given its lead), does not stand for an invasion but for one of the crowning victories of the West" (p. 640).

Malraux sees clearly the analogy between art, as it functions in the life of the modern artist, and religion: "[O]ur modern masters paint their pictures as the artists of ancient civilizations carved or painted gods" (p. 616). "Though this art is not a god, but an absolute, it has, like a god, its fanatics and its martyrs and is far from being an abstraction" (p. 600). Yet of course it is different from a religion proper. "It is not a religion but a faith. Not a sacrament, but the negation of a tainted world" (p. 601).

Likewise Malraux sees that as artistic creation becomes of supreme value for the artist, he is led to seek out others who live by the same faith:

[T]he coming of styles tending to make art an end in itself alienated the artist from his social environment and led him to foregather with his fellow artists. . . . Thus there came into being a sect of dedicated men, bent more on transmitting their values than on enforcing them; regarding its saints (and its eccentrics, too) as the salt of the earth; more gratified, like all sects, than its votaries admitted by the clandestine nature of their quest; and prepared to suffer, if needs were, in the cause of a Truth none the less cogent for its vagueness. (p. 494)

We must go on to consider the significance Malraux attaches to this act of artistic creation, a significance he sees as coming into consciousness for the first time in the modern world by virtue of the artist's having made that creation an end in itself. Before we do so, however, let me briefly contrast Malraux's reading of our modern situation with that proposed in Part Two of my discussion.

That there are deep similarities should be obvious. To cite but one: The aggressive Promethean image of the artist which I discussed in Part Two is, in all significant respects, what Malraux also sees as underlying the activity of the modern artist. But there are also disagreements. And perhaps it is worth spending more time on one or two of these.

Malraux speaks as if a great change has come over *art in general* in the modern world. By contrast, my contention has been that the great change in the last two centuries is in the astounding preoccupation of *our institution of high art* with art for contemplation. Outside that institution, art in its basic

functions has changed little. Thus Malraux, like almost all our modern critics, has allowed his own embeddedness within our institution of high art to obscure for him the role of art in our society outside that institution.

But further, we differ as to the precise nature of the change that has taken place within our institution of high art. Malraux's basic thought is that for the modern artist art has become an end in itself. Now I think it is indeed true that within our institution of high art there is a strong tendency for artistic creation to become for artists an end in itself—just as for many contemporary philosophers there is a strong tendency for philosophizing to become an end in itself. I have spoken of the interiorizing of the community of artists. Still, what is just as important is that in the modern world the artist (in our institution of high art) bends his efforts almost exclusively to provide something which will give satisfaction in contemplation, even satisfaction in *aesthetic* contemplation. The modern artist still has in mind an intended public use and function. His efforts are still devoted to the service of a value outside the action of artistic creation itself. For the striking fact is that no matter how much satisfaction the artist may derive from his creating, no matter how concerned he may be with the interior problems of art, he still almost invariably wishes to display his work. He still almost invariably wishes the public to put his work to use—namely, the use of contemplation. What has changed in the course of history is not that whereas artistic creation once served a value outside itself, it now no longer does so. What has changed, in our institution of high art, is that almost invariably the value that art serves today is contemplation, especially aesthetic contemplation. What needs explaining, if we are to understand our situation today, is why the passion for perceptual contemplation has become so all-consuming among Western men and women of the cultural elite within the last century or two.

But let us move on to consider what Malraux regards as the value, or perhaps better the *significance*, of the impulse to artistic creation, which, as we have seen, he understands as the impulse to style-formation.

A style for Malraux is always—and Malraux himself is somewhat vague at this point—a way of coping with, or dealing with, or filtering, or interpreting reality. It is not, he emphatically and repeatedly insists, a way of seeing the world. It is not a way of seeing peculiar to the artist. Nor is it a way of seeing peculiar to the artist's society. "Bretons do not 'see' themselves as figures in their wayside 'Calvaries.' A Ghent merchant probably found pleasure in imagining that his wife resembled a Van Eyck *Virgin;* it is more unlikely that a burgher of Chartres ever saw his as a pier statue" (p. 274). Neither is a style some idiosyncratic divergence from a straightforward copying of nature:

> . . . For many centuries it has been assumed that there exists a styleless, photographic kind of drawing (though we know now that even a photograph has its share of style), which serves as the basis of works possessing style, that style being something added. This I call the fallacy of a 'neutral style.' Its origin is the idea that a living model can be copied without interpretation or any self-expression; actually no such literal copy has ever been made. (p. 316)

In that last passage Malraux spoke of a style as an *interpretation* of reality (and as the self-expression of the artist). In another passage he speaks of a style as a *filter* for reality:

> Far from studying the visible world with a view to subjecting himself to it, the true artist studies the world with a view to 'filtering' it. His first filter, once he has got past the stage of the pastiche, is the schema or preconceived system, which simultaneously, if rather roughly, filters both the world of visual experience and the pastiche itself. . . . This schema acts like a sieve. . . . The schema becomes style only when it has segregated a coherent, *personal* whole. (p. 348)

It is far more characteristic of Malraux, however, to use various metaphors of aggression when speaking of the artist's manner of dealing with nature as he seeks to create a style:

> For thence it is that art is born: . . . from a desire to wrest forms from the real world to which man is subject and to make them enter into a world of which he is the ruler. . . . All those for whom art exists . . . share a faith in an immanent power peculiar to man. They devalorize reality, just as the Christian faith—and indeed every religious system—devalorizes it. . . . A style is not merely an idiom or mannerism; it becomes these only when, ceasing to be a conquest, it settles down into a convention. (pp. 320-21)

In thus subduing the world, man imposes meaning, significance: ". . . The visible world is not only a profusion of forms, it is a profusion of significances; yet as a whole it signifies nothing, for it signifies everything. . . . Thus styles are *significations*, they impose a *meaning* on visual experience" (p. 324).

What strikes us at once about this understanding of style is that it fits not at all abstract art—art in which the artist does not use his artifact to project a world. What also strikes us is that with respect to art in which a world *is* projected, this understanding short-circuits all attention to the projected world and goes immediately at the relation of the artist to reality. Tolkien, on this point, was more perceptive. But I do not think it worth dwelling on these particular defects. For what Malraux wants principally to say about style is yet to come.

The artist's creation of a style, says Malraux, is always wrought in conflict with his or her predecessors. No style ever emerges simply from the artist's contact with and response to nature. It arises only from his contact with and response to his predecessors. And that response, if he is a genius and a creator of masterpieces, always takes the aggressive form of struggling to break free from them and to overcome them:

> It is a revealing fact that, when explaining how his vocation came to him, every great artist traces it back to the emotion he experienced at his contact with some specific work of art: a writer to the reading of a poem or a novel (or perhaps a visit to the theater); a musician to a concert he attended; a painter to a painting he once saw. Never do we hear of a man who, out of the blue so to speak, feels a compulsion to "express" some scene or startling incident. . . . An old story goes that Cimabue was struck with admiration when he saw the shepherd-boy, Giotto,

sketching sheep. But, in the true biographies, it is never the sheep that inspire a Giotto with the love of painting; but, rather, his first sight of the paintings of a man like Cimabue. . . . Artists . . . stem . . . from their conflict with the achievements of their predecessors; not from their own formless world, but from their struggle with the forms which others have imposed on life. (p. 281)

Even a Rembrandt, a Piero della Francesca or a Michelangelo is not, at the dawn of his career, a man who sees more vividly than others the infinite diversity of things; he is a youth enraptured by certain paintings which he carried about with him everywhere behind his eyelids and which suffice to divert his gaze from the world of appearances. (p. 308)

The art school does not teach students to copy "nature"; but only the work of masters. Though the life-stories of great painters show us pastiches as being the starting point of their art, none tells of a transition from the art school to genius without a conflict with some previous genius. Any more than the history of art can show us a style born directly from nature, and not from a conflict with another style. (p. 316)

This contention, that the artist forges his style in conflict with his predecessors, certainly rings true for most contemporary artists, inspired by the wish to "create like unto our Divine Master." But Malraux insists that it holds true for all artists at all times:

The fact that our conception of the artist was something quite unknown in the Middle Ages (and for many thousand years before) and that a genius like Van Eyck was commissioned to design set pieces and to paint coffers, does not affect the fact that painters and sculptors, when possessed of genius, transfigured the art they had inherited. . . . [E]ven when the least sophisticated sculptor of the High Middle Ages (like the contemporary painter haunted by art's long history) invented a system of forms, he did not accomplish this by freeing his art from subservience to nature or to his personal emotions, but as a result of his conflict with a previous type of art. Thus at Chartres as in Egypt, at Florence as in Babylon, art was begotten of life upon an art preceding it. (p. 311)

In short, the forging of a style involves two conquests, in interaction: the conquest of nature and the conquest of one's predecessors. The theme of the artist as struggling for liberation, especially liberation from his predecessors, in his effort to produce something that will express himself and overcome nature, is used by Malraux to tell the story of the entire history of art, not just its history in the West since the Enlightenment:

Though his vocation has come to him under the aegis of another's genius, it gives him hopes of future *freedom*, if also an awareness of his present *servitude*. Hardly has he *broken away* from the passionately *servile* copy than he sets about incorporating the master's schema. But he soon understands that interpreting the world in another man's language also involves *servitude*, of a kind peculiar to the artist: a *submission* to certain forms and to a given style. If he is to win through to his artistic *freedom*, he must *break away* from his master's style. Thus it is *against* a style that every genius has to struggle, from the early days when he is dimly conscious of a personal schema, an approach peculiar to himself, until he attains

and voices the truth that is in him. Cezanne's architecturally ordered composition did not stem from dissatisfaction with nature as he saw it, but from his dissatisfaction with tradition. For every great artist's achievement of a style synchronizes with the achievement of his *freedom*, of which that style is at once the sole proof and the sole instrument. (p. 359)

We expect the work of art to be an *expression* of the man who makes it, because genius means neither fidelity to appearances nor a new combination of old forms; the original work of genius, whether classical or not, is an invention. (p. 374)

The history of art, so far as genius is concerned, is one long record of successive *emancipations*, since while history aims merely at transposing destiny on to the plane of consciousness, art transmutes it into *freedom*. (p. 623)

All art is a *revolt* against man's fate. (p. 639)*

And in this revolt against his fate lies man's glory:

Humanism does not consist in saying: "No animal could have done what we have done," but in declaring: "We have refused to do what the beast within us wills to do, and we wish to rediscover Man wherever we discover that which seeks to crush him to the dust." True, for a religious-minded man this long debate of metamorphosis and rediscoveries is but an echo of a divine voice, for a man bcomes truly Man only when in quest of what is most exalted in him; yet there is beauty in the thought that this animal who knows that he must die can wrest from the disdainful splendor of the nebulae the music of the spheres and broadcast it across the years to come, bestowing on them messages as yet unknown. In that house of shadows where Rembrandt still plies his brush, all the illustrious Shades, from the artists of the caverns onwards, follow each movement of the trembling hand that is drafting for them a new lease of survival—or of sleep.

And that hand whose waverings in the gloom are watched by ages immemorial is vibrant with one of the loftiest of the secret yet compelling testimonies to the power and the glory of being man. (p. 641)

Noble, eloquent words. But their nobility and eloquence must not obscure from us the profoundly elitist character of this humanistic understanding of man's glory. On this understanding you and I may participate vicariously in mankind's glory. Yet the glory of mankind resides in its artists, indeed, in those who are the *geniuses* among its artists—by virtue of their revolt against fate. Though you and I may swell with pride at belonging to a race which harbors such nobility, we ourselves have only a reflected glory. We are but satellites, for we, humble users of art, are not the rebels-against-fate of whom Malraux speaks. He himself is not among them. Malraux perceives accurately that our civilization "is not conditioned by our agnosticism but by our conquest of the world" (p. 481). He sees our Enlightenment vision of man for the parochial vision that it is. Yet, curiously and ironically, he regards that vision of man in the world as an accurate reading of, at least, man the artist throughout the ages. He is certainly not a myopic admirer of our aggressive Promethean civilization. Yet it is in the conquest of

* Italics mine in the quotations above.

nature and tradition by the genius-artist that he sees man's glory. Not in building community, not in cherishing nature, not in acknowledging God as Creator and Redeemer, but in aggression against one's predecessors and in the conquest of nature we see man at his highest.

But why, then, on Malraux's view, does one go to a museum? Curiously, one goes there not in the first place to enjoy and receive benefit from the art there assembled. One goes to the museum in order to see, concretely and vividly illustrated, man's revolt against his fate. It makes little difference whether one does or does not find enjoyment in the art, whether one does or does not derive benefit therefrom. For it is not the art produced in these diverse styles but *the fact that* there is art in these diverse styles that instructs and inspires us as we move from room to room in the museum, and from chamber to chamber in the "Museum without Walls" that we carry in our mind's eye.

> That thrill of creation which we experience when we see a masterpiece is not unlike the feeling of the artist who created it; such a work is a fragment of the world which he has annexed and which belongs to him alone. . . . And for us, too, this work of art is a fragment of the world of which Man has taken charge. The artist has not only expelled his masters from the canvas, but reality as well—not necessarily the outer aspects of reality, but reality at its deepest level—the 'scheme of things'—and replaced it by his own. (p. 461)
>
> We are at last beginning to discern what it is that such works have in common with so many others of their kind; in them the artist has broken free from his servitude with such compelling power that they transmit the echoes of his liberation to all who understand their message. (p. 464)
>
> Once civilization had ceased being under the sway of the gods, and the affinity of the various accents of the different arts was recognized, *all* art emerged as a *continuum*, a world existing in its own right, and it was as a whole that art acquired, in the eyes of a certain category of men, the power of refashioning the scheme of things and setting up its transient eternity against man's yet more transient life. This desire to hear the passionate appeal addressed by a masterpiece to other masterpieces, and then to all works qualified to hear it, characterizes every artist and every true art-lover; and likewise a desire to ally with new accents the echoes that each deep-sounding accent conjures up—from one Romanesque tympanum to another, from one Tuscan school to another, from style to style in Mesopotamia and, calling from archipelago to archipelago, the Oceanian figures. (p. 558)
>
> There *is* a fundamental value of modern art, and one that goes far deeper than a mere quest of the pleasure of the eye. Its annexation of the visible world was but a preliminary move, and it stands for that immemorial impulse of creative art: the desire to build up a world apart and self-contained, existing in its own right: a desire which, for the first time in the history of art, has become the be-all and the end-all of the artist. . . . In ceasing to subordinate creative power to any supreme value, modern art has brought home to us the presence of that creative power throughout the whole history of art. (p. 616)
>
> Though a Byzantine mosaic, a Rubens, a work by Rembrandt and one by Cézanne display a mastery distinct in kind, each imbued in its own manner with

that which has been mastered, all unite with the paintings of the Magdalenian epoch in speaking the immemorial language of Man the conqueror, though the territory conquered was not the same. The lesson of the Nara Buddha and of the Sivaic Death Dancers is not a lesson of Buddhism or Hinduism, and our Museum without Walls opens up a field of infinite possibilities bequeathed us by the past, revealing long-forgotten vestiges of that unflagging creative drive which affirms man's victorious presence. Each of the masterpieces is a purification of the world, but their common message is that of their existence, and the victory of each individual artist over his servitude, spreading like ripples on the sea of time, implements art's eternal victory over the human situation. (p. 639)

What has disappeared from Malraux's thought about the arts, notwithstanding its profundity and imagination, is any recognition that the artist is called to share in our human responsibilities. What is missing is any recognition that art can and should be of benefit to us the public, giving us delight and building community. What is missing is any recognition that art can and should be a component in our nonaggressive mastering of the world, our actualizing of its potential; that it can and should be an instrument by which the artist, along with the rest of us, acknowledges God. All that has fallen from view. Replacing it is the image of the artist struggling to express his individual self by fighting free from his predecessors in his attempt to overcome nature. There is benefit for us in observing the marks of this struggle, says Malraux. But when we look closely, we see that, for Malraux, the benefit is not benefit from the art, but benefit from the fact that by observing this struggle for liberation and self-expression we ourselves are inspired by the glory of man, a glory, however, which at best is only *reflected* by the rest of us, having its source alone in the geniuses who have illumined the human race. For in them one sees that "mysterious power, peculiar to great artists, of revealing Man upon his highest level" (p. 629).

How different the Christian vision, in which man's uniqueness among his fellow earthlings lies in his vocation and destiny, and in which his glory lies in carrying out that vocation. Man's obedience is his glory! In such glory all can share. It is open to all to do justice, to love mercy, and to walk humbly with one's God. It is in this glory of obedience that the artist is called to share.

"Every masterpiece," says Malraux, "implicitly or openly, tells of a human victory over the blind force of destiny. The artist's voice owes its power to the fact that it arises from a pregnant solitude that conjures up the universe so as to impose on it a human accent; and what survives for us in the great arts of the past is the indefeasible inner voice of civilizations that have passed away" (pp. 630, 631). But those masterpieces, in which yet today we find delight and benefit, tell us not of the stark cold fact of man's freedom. Mixed up though those masterpieces have been with confusion, perversity, and rebellion, they yet tell us that there man was (in part) fulfilling his vocation. That is the glory of which they speak.

Art is not to be man's revolt against his fate. Art is man's fulfillment of his calling.

APPENDIX
Expression and Revelation

IN DISCUSSIONS of the arts the English word "express" and its derivatives stand for at least three distinct concepts. Since these concepts are seldom differentiated, ambiguity and confusion is rife in those theories which give a central role to "expression." As we saw in the text proper, one of those theories is what I called the Protestant theory, according to which every artist, by way of his art, expresses his religion. I wish here, in this appendix, to unravel these three concepts.

(1) Sometimes when works of art, or artists, are said to express, what is meant is that the work is *expressive of* some state of consciousness. This concept of expressiveness I analyzed in Part Three, Chapter II. Expressiveness, I suggested, consists in a significant degree of fittingness between the aesthetic character of the work and some state of consciousness.

Here let it simply be remarked that the expressiveness of works of art is independent of the states of consciousness of their creators. For one thing, it is independent of their intentions. The interval of a diminished fifth may, as Deryck Cooke claims, be as expressive of deviltry as any other interval, without that fact's ever having crossed the mind of a composer who uses it. So from the fact that a work is expressive of a certain quality one cannot conclude that its maker intended it to be so. But equally, a work's being expressive of some emotion or attitude or conviction is independent of its maker's having had that emotion or attitude or conviction when he or she made it, or indeed ever. While at ease I may draw a line expressive of agitation; while nervous, a line expressive of tranquility. From my producing a work expressive of some emotion or attitude or conviction, it cannot be concluded that I had that state of consciousness, then or ever.

(2) Secondly, sometimes when works of art or artists are said to express one or another of the artist's states of consciousness, what is meant thereby is that the work exists and is the way it is *because of* those states of consciousness. The work is an outcome of those states. To account for its existence and character we must appeal to those. It was this concept that I was using when,

in Part Three, Chapter I, I spoke of the world behind the work and then said that we could, if we wished, say that the work was an expression of that world behind it.

Sometimes it is said that a work of art is an expression of certain beliefs, attitudes, and convictions in the society from which it sprang. The meaning is the same. Our highways are an expression of our American values. They are an outcome of our values. Their existence and character is (in part) to be accounted for by appealing to our values.

When I wish to use the concept delineated first above, I consistently speak of the work as *expressive of* something. And when I wish to use this second concept, I speak of the work as *being an expression of* something.

Notice that a work of art's being an expression of the artist's states of consciousness has nothing directly to do with its being expressive of those states. The student's composition may be an expression of his adulation for the master without being at all expressive of adulation.

(3) Thirdly, sometimes when works of art or artists are said to express, what is meant is that the artist has engaged in the intentional action of *self-expression*. To make clear what this is, and to differentiate it from the closely related but distinct phenomenon of self-revelation, we shall have to go on a brief philosophical excursus.

Before we do so, however, notice that neither expressiveness, nor being an expression of, is an *action*. *Expressiveness* consists simply in the relation of fittingness holding between the character of an object and some state of consciousness; it has nothing directly to do with action. And *being an expression of* consists simply in the fact that a certain relationship of accounting-for holds between the artist's (or the culture's) states of consciousness and the existence and character of the object. Those states of consciousness stand in the relation of *accounting for* the existence and character of the object. But what we shall now turn to, namely self-expression, is an action performed by human beings, though of course not performed exclusively by composing works of art.

As we shall shortly see, the artist who engages in the action of self-expression sometimes makes use of the phenomenon of expressiveness. So there is that connection to be noted. And no doubt also, if the artist has expressed his states of consciousness by means of composing some work of art, then that work is an expression of those states of consciousness. The converse, however, does not hold: the work may be an expression of those states of consciousness without the artist having engaged in the action of expressing those states of consciousness by means of the work of art.

To get at the nature of the action of self-expression, we can perhaps best begin with some examples drawn from outside art. Suppose that Rebecca has been nursed through a siege of pneumonia by Mary and now wishes to express her gratitude. She contemplates various ways of doing so:

(1) by saying that she is very grateful,

(2) by sending Mary a "Thank You" card,

(3) by taking care of Mary's children for a week,

(4) by sending over a favorite shrub from the local nursery.

These are all ways in which Rebecca can express her gratitude. She cannot discard one or more on the ground that her gratitude cannot be expressed that way. Her choice must be made by deciding which in the situation is the best way of expressing her gratitude.

What makes them all ways in which Rebecca can express her gratitude? For one who knows the etymology of "express" (Latin, *exprimere*, to squeeze or press out) the thought comes at once to mind that to express one's gratitude is to reveal it, to manifest it, to show it, to evince it. The thought is that for Rebecca to express her gratitude by taking care of Mary's children is for Rebecca to *reveal* her gratitude by taking care of Mary's children.

Now it is true that sometimes what is expressed by someone is also therein revealed by him. But self-revelation and self-expression are not identical actions. For it is possible that a person reveal some state of his consciousness without therein expressing it.* Consider this example: Suppose that someone is giving his first public speech and feels nervously apprehensive. He might then reveal his apprehension by gripping the podium so hard that his knuckles turn white. But he would not thereby have *expressed* his apprehension. Better to say that he has *betrayed* it. Then too one can reveal, though one cannot express, things about oneself other than one's states of consciousness. By speaking in the manner that he does, Jimmy Carter reveals that he comes from the American South.

We want to understand self-expression. But it will help immensely if first we look at self-revelation; for in seeing the contrast we shall attain clarity.

Go back once again to our white-knuckled, nervously apprehensive speaker. Suppose that nobody actually concludes on the basis of the white knuckles that the speaker is nervously apprehensive. Might he nonetheless have revealed his nervous apprehension by gripping the podium so hard that his knuckles turned white? Can revelation take place without someone's discerning what the revelatory action is revelatory of?

This is an issue which has been much debated among theologians under the guise of the specific question, "Has God revealed if nothing of His revelation has been apprehended?" But the debate is not a debate of substance. Rather, two different concepts are associated with the English word "reveal." On one of them—call it the *nontransmittal* concept—one can reveal one's state of consciousness without revealing it *to* anybody; on the other—call it the *transmittal* concept—that cannot be. On the transmittal concept, nothing is revealed until someone apprehends the revealed.

It is easy to see how to begin the analysis of the nontransmittal concept of self-revelation. In the first place, one can reveal one's apprehension only if one

* And conversely possible that he express some state of his consciousness without therein revealing it. See points (2) and (3) below, p. 220.

is apprehensive. One can't reveal what one isn't. Secondly, one can reveal some state of self by gripping the podium so hard that one's knuckles turn white only if one *does in fact* grip the podium so hard that one's knuckles turn white. One can't reveal something by doing something that one doesn't do.

But obviously something more is needed. The core of self-revelation consists in some sort of relation, some sort of connection, between the revealed state of self and the revealing act. What might that connection be? I suggest that it is a twofold relation: The revealer must perform the revealing act *because* he is in that state or *for the reason that* he wants someone to know that he is. And the revealing act must be *good evidence* for the existence of the revealed state. It is probably true that Rembrandt painted his *St. Paul* as he did because of his fondness for chiaroscuro. Yet Rembrandt's painting of *St. Paul* does not actually *reveal* this fondness, for Rembrandt's painting of this one picture is only very slim evidence, not good evidence, of his fondness for chiaroscuro. A whole series of paintings filled with chiaroscuro would of course provide good evidence.

We can put it all together this way: Peter reveals his apprehension by gripping the podium so hard that his knuckles turn white just in case

(i) Peter is apprehensive,

(ii) Peter does grip the podium so hard that his knuckles turn white,

(iii) Peter grips the podium so hard that his knuckles turn white *because* he is apprehensive or *for the reason that* he wants someone to know that he is apprehensive, and

(iv) Peter's gripping the podium so hard that his knuckles turn white is good evidence (to a suitably qualified observer) of Peter's apprehension.

From this example one can easily discern the general pattern of nontransmittal self-revelation, with just this explanation: Always the revealing act is perceptible.

It is but one step from this to an analysis of the *transmittal* concept of self-revelation. Peter reveals his apprehension *to Mary* by gripping the podium so hard that his knuckles turn white, just in case (i) through (iv) take place, and then in addition:

(v) Mary *infers* that Peter is apprehensive *on the basis of* her awareness that he is gripping the podium so hard that his knuckles turn white. (On the basis, actually, of that awareness plus suitable background beliefs.)

To the reader these two analyses of self-revelation may appear a somewhat unstructured clutter of elements. We want to know what constitutes the central idea. However, that can best be indicated by contrasting the analyses with the analysis of *self-expression*. So let us move on to that.

The beginning of an analysis of self-expression goes just exactly like the beginning of an analysis of self-revelation. To express her gratitude by saying that she is grateful, Rebecca must *in fact be* grateful and must *in fact perform*

the action of saying that she is grateful. So the difference between self-revelation and self-expression lies in the different connection, the different "hook-up," between the state of self and the act. What is the connection in the case of self-expression?

Well, one can say that one is grateful when not grateful. One can say so and lie, or perhaps one can say so absent-mindedly. But one cannot *knowingly and sincerely* say that one is grateful unless one is. In this "knowingly and sincerely" condition lies the clue to the analysis of Rebecca's expressing her gratitude by saying that she is grateful. Rebecca expresses her gratitude by saying that she is grateful only if

(i) Rebecca *is* grateful,

(ii) Rebecca *did say* that she is grateful, and

(iii) a person could not knowingly and sincerely *say* that she is grateful unless she *is* grateful.

But in one's expression of some state of consciousness one is not limited to actions which have the presence of that state as a "knowingly and sincerely" condition on the performance of the action. For consider our case (4), of Rebecca's expressing her gratitude by sending over a favorite shrub from the local nursery. The concept of knowingly and sincerely doing something does not even apply to the action of sending over a shrub from the local nursery. Or consider the fact that John Cage expressed his Buddhist convictions by adopting aleatory (chance) techniques in his music. The concept of knowingly and sincerely doing something also does not apply to the use of aleatory strategies in the composition and performance of music. In such cases, then, the connection between state of self and expressing action is different from what it is in the case of Rebecca's expressing her gratitude by saying that she is grateful. What might the connection in these cases be?

In these cases we have the phenomenon of someone wanting to do, and actually doing, something which he believes to be and which is in fact *fitting* to his state of consciousness. Rebecca fetched about for some action fitting to her feeling of gratitude, and hit on sending over a favorite shrub. Cage fetched about for some strategies in music fitting to his Buddhist convictions, and hit on chance techniques. I suggest this analysis: Cage expressed his Buddhist convictions by adopting aleatory strategies in his music only if

(i) Cage did have Buddhist convictions,

(ii) Cage did adopt aleatory strategies in his music,

(iii) aleatory strategies are fitting to Cage's Buddhist convictions, and

(iv) Cage adopted aleatory strategies because he wanted to do or produce something fitting to his Buddhist convictions and believed that the use of aleatory strategies would satisfy this goal.

I think we have covered the full range of strategies for self-expression. To express some state of one's consciousness one must either do or produce something fitting to that state of consciousness, or one must do something that

one cannot knowingly and sincerely do unless one is in that state. From this statement, and from my analysis of the particular cases, one can easily see the general pattern of self-expression, with perhaps this one additional comment: What is expressed is always a state of consciousness, not just some nonperceptible state of one's self. One cannot express one's being from the American South.

If these analyses are correct, then self-expression differs from self-revelation in at least four important respects.

(1) The action by which one expresses one's self must be done intentionally, or at least must be an action on which there are conditions of knowledgeability and sincerity. No such requirement holds for revelation. The revealing action may have been one done intentionally or one on which there are knowledgeability and sincerity conditions. But it need not have been of that sort. The speaker who revealed his nervous apprehension did not intend to grip the podium so tightly that his knuckles turned white, neither are there any conditions for performing that action knowingly and sincerely. Such nonintentionally performed actions as writhing in pain and grimacing may be revelatory; they cannot be expressive. In that difference lies the principal divergence between revelation and expression.[1]

(2) Self-revelation requires that the revealing act be *good evidence* for the revealed state of consciousness. There is no requirement that the expressing act be good evidence for the expressed state. Cage may well have expressed his Buddhist beliefs by using aleatory strategies even though the mere presence of those strategies in his music is not good evidence for his holding those beliefs.

(3) It is not required for self-expression that the expressing act be perceptible, whereas it is required for self-revelation that the revealing act be perceptible. What comes to mind here are the discussions of philosophers Benedetto Croce and R. G. Collingwood concerning expression, in which they claim that expressing may be done wholly in one's mind. That seems correct, though I think it happens far less often than Croce and Collingwood suggest. One can express one's gratitude to God by reciting mentally a prayer of thanksgiving. Revelation involves making perceptible, expression does not.

(4) Lastly, the only candidates for one's self-expression are one's states of consciousness—one's feelings, one's thoughts, one's attitudes, one's beliefs, etc. The scope of self-revelation is broader. Any nonperceptible state of oneself is a candidate for self-revelation—one's origins, one's having a sore knee, etc.

With this delineation in hand of three different concepts of expression—expressiveness, being an expression of, and self-expression—we can now return briefly to the Protestant thesis, which holds that the work of art always expresses the religion of its maker. In which of the three senses of "express," if any, is this thesis true?

What makes it difficult to answer this question is that there are also

ambiguities in what is meant by "religion," as we have discovered. Now usually the person who propounds the thesis will not have in mind religions according to what I take to be the usual sense of the word "religion." Accordingly, this interpretation can be set aside. Instead, he will usually mean by a person's religion his ultimate concern—or perhaps his *Weltanschauung*. But the former of these again gives us difficulty; for, as we also saw, not everyone has an ultimate concern. Some people have nothing more than a proliferation of partial concerns, and naturally among these people will be some artists. Perhaps, though, everyone has a *Weltanschauung*—at least if one means by this just a person's most fundamental beliefs about reality and human existence. So in what follows let us take a person's religion as his *Weltanschauung*.

It seems evident that the artist does not always compose his work of art so as thereby to perform the action of expressing his *Weltanschauung*. He does not always have it in mind to produce something which either he could not knowingly and sincerely produce unless he held that *Weltanschauung*, or which in his judgment is fitting to that *Weltanschauung*. On a given occasion he may wish simply to compose a work of music which will do nicely as a fanfare. But neither, it seems evident, are works of art always *expressive of* the *Weltanschauungen* of their makers. There is not always a close fittingness between the character of the work, and its maker's *Weltanschauung*.

What remains, then, is the possibility that works of art are always an *expression of* the *Weltanschauungen* of their makers—that we must appeal to the artist's *Weltanschauung* if we wish to account for the existence and character of his work. It does seem to me that this connection always will be present. Sometimes, admittedly, the connection will be rather thin; an appeal to the *Weltanschauung* helps account for the work only in the most general and nonspecifc way. On other occasions, though, the connection will be very intimate indeed, as is evident from some of Hans Rookmaaker's discussion in his *Modern Art and the Death of a Culture*.

As we have already observed, our institution of high art much prefers not to look at the world behind the work—and thus not at the *Weltanschauung* of the artist and the way in which it helps account for his or her work. The institution much prefers simply to stay on the surface and look at the resultant work, or to offer purely psychological accountings. Accordingly, I think a significant contribution which the Christian critic can and should make to contemporary criticism is this: without ignoring the artifact itself and the benefit and delight to be derived therefrom, to resist remaining forever on the surface, to dig down to fundamental issues by showing in detail how works of art are an expression of the *Weltanschauungen* of their makers, of their ultimate concerns (in case they have them), and of their religions (in case they have them). Still, we must remember that to account for a work is something different from giving an aesthetic analysis of it.

Notes

PREFACE

1. Dorothy Sayers, "Towards a Christian Aesthetic," in *Christian Letters to a Post-Christian World,* ed. Roderick Jellema (Grand Rapids: Eerdmans, 1969), p. 69.

PART ONE

1. In Harold Osborne, ed., *Aesthetics* (New York: Oxford University Press, 1972), p. 26.

2. Paul S. Wingert, *Primitive Art* (New York: Meridian Books, 1965), p. 18.

3. Raymond Firth, "The Social Framework of Primitive Art," in Douglas Fraser, ed., *The Many Faces of Primitive Art* (New York: Prentice-Hall, 1966), p. 12.

4. A splendid example of such role analysis is Chapter 3, "The Basilica," in F. van der Meer, *Early Christian Art* (London: Faber and Faber, 1967).

5. Paul Oskar Kristeller, *Renaissance Thought II* (New York: Harper Torchbooks, 1965).

6. *Ibid.,* p. 165.

7. This is suggested by Kristeller in the following passage:

"It is not easy to indicate the causes for the genesis of the system in the eighteenth century. The rise of painting and of music since the Renaissance, not so much in their actual achievements as in their prestige and appeal, the rise of literary and art criticism, and above all the rise of an amateur public to which art collections and exhibitions, concerts as well as opera and theatre performances were addressed, must be considered as important factors. The fact that the affinity between the various fine arts is more plausible to the amateur, who feels a comparable kind of enjoyment, than to the artist himself, who is concerned with the peculiar aims and techniques of his art, is obvious in itself and is confirmed by Goethe's reaction. The origin of modern aesthetics in amateur criticism would go a long way to explain why works of art have until recently been analyzed by aestheticians from the point of view of the spectator, reader, and listener rather than that of the producing artist" (*op. cit.,* p. 225).

8. George Thomson, "The Art of Poetry" in *Marxists on Literature,* ed. David Craig (New York: Penguin Books, 1975), p. 55.

9. *Op. cit.,* pp. 33-36.

10. The general formula is this. An agent P causally generates ψ-*ing* by φ-*ing* if and only if:

 (i) P generates ψ-*ing* by φ-*ing;* and

(ii) P's act of performing the action of φ-*ing* causes some event E such that the act of P's ψ-*ing* is identical with an act of P's bringing about E.

11. The general formula is this. An agent P count-generates ψ-*ing* by φ-*ing* if and only if:

(i) P generates ψ-*ing* by φ-*ing;* and

(ii) P's act of performing the action of φ-*ing* counts as an act of his ψ-*ing.*

12. A different approach to the matter of defining "work of art," and then more generally a discussion of some of the same phenomena to which we call attention in our opening three chapters but a different structuring of those phenomena, is to be found in Calvin Seerveld, "Modal Aesthetics," in *Hearing and Doing* (Toronto: Wedge, forthcoming).

PART TWO

1. In the following eloquent passage Malraux overlooks the fact that there is still an art of the tribe as a whole among us, but that it consists mainly of commercial art: "Talk of a modern art 'of the masses' is mere wishful thinking: the expression of a desire to combine a taste for art with one for human brotherhood. An art acts on the masses only when it is at the service of *their* absolute and inseparable from it; when it creates Virgins, not just statues. Though, needless to say, the Byzantine artist did not see people in the street like figures in ikons, any more than Braque sees fruit-dishes in fragments, the forms of Braque cannot mean to twentieth-century France what the forms of Daphni meant to Macedonian Byzantium. If Picasso had painted Stalin in Russia, he would have had to do so in a style repudiating that of all his pictures, including *Guernica.* For a modern artist any genuine attempt to appeal to the masses would necessitate his "conversion," a change of absolute. Sacred art and religious art can exist only in a community, a social group swayed by the same belief, and if that group dies out or is dispersed, these arts are forced to undergo a metamorphosis. The only 'community' available to the artist consists of those who more or less are of his own kind (their number nowadays is on the increase). At the same time as it is gaining ground, modern art is growing more and more indifferent to the perpetuation of that realm of art which sponsored it from the days of Sumer to the time when the first rifts developed in Christendom: the realm of gods, living or dead, of scriptures and of legends. The sculptors of the Old Kingdom and the Empire, of the Acropolis, of the Chinese figures hewn in the rock-face, of Angkor and Elephanta, no less than the painters of the Villeneuve *Pieta* and the Nara frescoes and, later, Michelangelo, Titian, Rubens and Rembrandt linked men up with the universe; as did even Goya, flinging them his gifts of darkness"—*The Voices of Silence,* tr. by Stuart Gilbert (Frogmore, St. Albans, Herts: Paladin, 1974), pp. 601-02.

2. Of course parts of the history have been written. To cite but one instance, see Chapter II of Michael Levey, *High Renaissance* (New York: Penguin Books, 1975). Note these words at the beginning of the chapter: "Because much was then produced which we now go to look at specifically as art, it might be supposed that Renaissance men looked at artistic products in the same way. This is not so. Often they will not have seen the 'art' for the subject-matter or for the utilitarian-cum-didactic purpose which had led to the object being created in the first place. Statues of saints and heroes, churches and palaces, altarpieces and fresco cycles—all were executed for purposes quite separate from, and much more urgent than, providing merely agreeable sensations for the eye."

3. *The Musical Experience of Composer, Performer, Listener* (Princeton: Princeton University Press, 1971), pp. 7-8. Compare Robert Craft in *The New York Review of Books* (July 15, 1976): " . . . Prior to the eighteenth century not much music

was composed to be heard in concerts. Until the late 1500's, it was written for the liturgy, for ceremonies sacred and secular, and for the recreation of a ruling class that sang and played it—passive listening being only a small part of musical life then, though now increasing to what threatens to become the eventual exclusion of active amateur participation."

And compare this passage from Curt Sachs, *The Wellsprings of Music* (New York: Da Capo, 1977), p. 124: "The growth of musical forms that we observe in Europe from the seventeenth century on seems to be connected with the growing separation of music from social life and extramusical claims. Contents, sizes, and forms underwent an obvious change when music became self-contained, to be listened to in public concert halls and opera houses by audiences wholly devoted to its artful elaboration."

4. *Op. cit.*, pp. 13-14.

5. Compare the following passage from Northrop Frye's *The Critical Path* (Lafayette: Indiana University Press, 1973): "As literature becomes assimilated to the mental habits of a writing culture, it comes to be thought of as an ornament of leisure, a secondary product of an advanced civilization. In the tenth book of Plato's *Republic*, Socrates asserts that the poet's version of reality is inferior, not merely to the philosopher's but to the artisan's or craftsman's as well. The artisan makes what is, within the limits of his reality, a real bed; the painter has only the shadow of a bed. Most devaluations of poetry ever since, whether Platonic, Puritan, Marxist, or Philistine, have been attached to some version of a work ethic which makes it a secondary or leisure-time activity; and when poetry has been socially accepted, it is normally accepted on the same assumptions, more positively regarded. This seems a curious conception of poetry in view of its original social role. In a technologically simple society preoccupied with the means of survival, like that of the Eskimos, poetry appears to be a primary need rather than a superfluous refinement. But increasingly, as Western culture becomes more complex, works of art came to be thought of as a series of objects to be enjoyed and appreciated by a liberalized leisure class" (pp. 79-80). My only substantial disagreement with what Frye says here is over the *cause* which he assigns to this shift of the bulk of poetry into our leisure time activity. I do not think it is due to the coming of print; for exactly the same phenomenon happens in the nonliterary arts at roughly the same time. We are here dealing with a phenomenon in Western culture whose roots are deeper even than the changes wrought by the coming of print.

6. The task of the critic as outlined in the text fits the practice of the twentieth-century critic, in whom respect for the diversity of styles is fundamental. It does not fit the practice of critics before our century. For critics of an earlier day operated with the notion of a paradigm style, even of paradigm works within a paradigm style, and judged everything by reference to its measuring up to or falling short of the paradigm. In sculpture, for example, the paradigm was for many centuries the sculpture of the classical Greeks, and primitive sculpture was universally judged as clumsy and "primitive." This now antiquated understanding of the critic's task is nicely discussed in Malraux's *Voices of Silence*. It would be helpful for someone someday to write the history of the changing practice of criticism. But in any case, the fact that we in our institution of high art find the presence of critics so necessary—criticism being understood as practiced along the lines suggested in the text—is only partly due to the factors cited in the text. For further discussion of this point, see Section 11 of this Part.

7. *Op. cit.*, p. 14.

8. New York: Dover, 1955, p. 9. See also Raymond Firth, "The Social Framework of Primitive Art," *op. cit.*; Harold Osborne, *Aesthetics and Art Theory*, (New York: Dutton, 1970), pp. 23, 26-27; and this passage from Paul S. Wingert, *Primitive Art*, p. 31: "In all the needs that motivated art objects, there is an accompanying desire common to all mankind from the earliest Paleolithic times

onward—the apparent need for aesthetic expression and creation of form. Rarely was the mask or figure for a given ceremony or rite required to contain any artistic quality for the successful fulfillment of its purpose; yet artists were commissioned to shape these objects, and in very few cases did they fail to give the forms an objective or external aesthetic expression and appearance beyond the demands of their subjective or internal content. Even the stone tools and a wide variety of weapons and purely utilitarian objects used by primitive man had an aesthetically satisfying shape and finish that did not purport to increase the efficiency of the implements. No matter how meager the development of a culture may be, there is invariably some evidence of the fulfillment of this universal need for aesthetic expression. . . ."

9. *Journal of Aesthetics and Art Criticism*, Winter 1961, pp. 131-43. Strictures against parts of Stolnitz's discussion are to be found in George Dickie, *Art and the Aesthetic* (Ithaca: Cornell University Press, 1974).

10 Cf. Oscar Wilde: "We can forgive a man for making a useful thing as long as he does not admire it. The only excuse for making a useless thing is that one admires it intensely. All art is quite useless"—in R. Ellmann and C. Feidelson, eds., *The Modern Tradition* (New York: Oxford University Press, 1965), p. 103.

11. Jerome Stolnitz, *Aesthetics and Philosophy of Art Criticism* (Boston: Houghton-Mifflin, 1960), pp. 33-34. Cf. John Hospers: "The aesthetic attitude, or the 'aesthetic way of looking at the world,' is most commonly opposed to the *practical* attitude, which is concerned only with the utility of the object in question. The real estate agent who views a landscape only with an eye to its possible monetary value is not viewing the landscape aesthetically. To view a landscape aesthetically one must 'perceive for perceiving's sake,' not for the sake of some ulterior purpose. One must savor the experience of perceiving the landscape itself, dwelling on its perceptual details, rather than using the perceptual object as a means to some further end"—"Aesthetics, Problems of" in *Encyclopedia of Philosophy* (New York: Collier-Macmillan, 1967), Vol. I, p. 36.

12. *Aesthetics and Philosophy of Art Criticism*, p. 137.

13. *Ibid.*, p. 142.

14. And if we take as our concept of work of art, that of artifact produced for the purpose of giving aesthetic satisfaction, then primitive societies contain few works of art, and probably all lack the concept of work of art. Cf. Roy Sieber, "Masks as Agents of Social Control" in Fraser, *The Many Faces of Primitive Art:* "Traditional African art for the most part was more closely integrated with other aspects of life than those which might be described as purely aesethetic. Art for art's sake—as a *governing* aesthetic concept—seems not to have existed in Africa. Indeed, the more closely an art form is related to a major non-aesthetic aspect of culture such as religion, the more distant it is from such separatist philosophical concepts.

"In fact traditional African sculpture might best be described as based on a concept of art-for-life's sake. It was, in most cases, closely allied to those cultural mechanisms dedicated to the maintenance of order and well being. In short, sculpture was oriented to those social values upon which depended the sense of individual and tribal security."

See also Curt Sachs, *The Wellsprings of Music*, p. 134: "The anti-individualistic coherence of primitive life and the purposeful character of music within a world of magic ideas seems to remove all primitive music from the concept of art that we hold in the modern world. The question of sufficient and insufficient skill and our complicated gamut of aesthetical values can not apply where a predominant part of music is meant to be powerful in a social, magic, or religious sense and to impress the good and the evil forces in nature much more than the audience on the village square. In a like manner, nobody would expect or wish the intoning priest in a Catholic church to strive for the laurels of opera tenors; nor is a congregation anywhere supposed to sing with the

discipline and tonal beauty of a well-trained concert chorus."

15. Roman Ingarden, "Aesthetic Experience and Aesthetic Objects," in Matthew Lipman, ed., *Contemporary Aesthetics* (Boston: Allyn and Bacon, 1973), p. 278.

16. From the well-known article "Aesthetic Concepts" by Frank Sibley, it is clear that only *some* of the qualities that by my definition turn out to be aesthetic qualities of things would by Sibley be regarded as aesthetic concepts. But I am as dubious as is Ted Cohen, in his article "Aesthetic/Non-aesthetic and the Concept of Taste: A Critique of Sibley's Position" (reprinted in Dickie and Sclafani, eds., *Aesthetics: A Critical Anthology* [New York, St. Martin's, 1977], pp. 838 ff.), that Sibley's distinction can be made out.

17. All of these citations are to be found in John Pick, ed., *A Hopkins Reader* (New York: Oxford University Press, 1953), pp. 46, 47, 56, 57, 182, 91, and 157 respectively.

18. *Op. cit.*, pp. 17-20.

19. Cleanth Brooks, "The Formalist Critic" in *The Kenyon Review* (Winter 1951), pp. 73, 74.

20. *Op. cit.*, p. 137.

21. "Poetry for Poetry's Sake" in Melvin Rader, ed., *A Modern Book of Esthetics* (New York: Holt, Rinehart and Winston, 1973), p. 238.

22. Alan Tormey, "Aesthetic Rights" in *The Journal of Aesthetics and Art Criticism* (Winter 1973), pp. 163-170. See the critique of Tormey's position by David Goldblatt, "Do Works of Art Have Rights?" in the same journal, Fall 1976, pp. 69-77. Tormey says, "Art works are the bearers of a special class of *rights;* that art works have, in virtue of their status as art works, certain determinable entitlements to be dealt with, or not to be dealt with in certain ways."

23. Clive Bell, *Art* (New York: Capricorn Books, 1958), pp. 44-46. Cf. Charles Baudelaire: "The unquenchable thirst for everything that is beyond and everything that life reveals, is the most living proof of our immortality. It is at once through poetry and *across* poetry, through music and *across* music, that the soul catches a glimpse of the splendors situated beyond the tomb; and when an exquisite poem brings tears to the eyelids, these tears are not proof of an excess of joy, but witness rather of a roused melancholy, of nervous strain, of a nature, exiled in the imperfect, which would like to take possession at once, on this very earth, of a heaven that has been made manifest" (in Ellmann and Feidelson, *op. cit.*, p. 102).

24. Stolnitz, "On the Origins of 'Aesthetic Disinterestedness,'" in *op. cit.*, p. 138.

25. In Hans Gerth and C. Wright Mills, eds., *From Max Weber: Essays in Sociology* (New York: Oxford University Press, 1946), p. 342. Weber continues as follows: "With this claim to a redemptory function, art begins to compete directly with salvation religion. Every rational religious ethic must turn against this inner-worldly, irrational salvation. For in religion's eyes, such salvation is a realm of irresponsible indulgence and secret lovelessness.

"The most irrational form of religious behavior, the mystic experience, is in its innermost being not only alien but hostile to all form. Form is unfortunate and inexpressible to the mystic because he believes precisely in the experience of exploding all forms, and hopes by this to be absorbed into the 'All-oneness' which lies beyond any kind of determination and form. For him the indubitable psychological affinity of profoundly shaking experiences in art and religion can only be a symptom of the diabolical nature of art."

26. "Statement: 1935," in James B. Hall and Barry Ulanov, eds., *Modern Culture and the Arts* (New York: McGraw Hill, 1972), p. 168.

27. Cf. Gustave Flaubert: "I am turning to a kind of aesthetic mysticism (if the two words can be used together), and I wish my faith were stronger. When no

encouragement comes from others, when the external world disgusts, weakens and corrupts, *honest* and *sensitive* people are forced to look within themselves for a fitter dwelling place. If society continues on its present course, we shall see mystics again, I think, as we have done in every dark age. Denied an outlet, the soul will retire into itself. Very soon we will see the reappearance of universal apathy, of beliefs in the end of the world, of Messianic claims. But lacking a theological foundation, where can this unconscious fervor find a basis? Some will seek it in the flesh, others in the old religions, and yet others in Art; and like the Children of Israel in the desert, humanity will adore all sorts of idols. Our kind have come a little too early: in twenty-five years' time the nodal point will respond magnificently to an artist's touch" (in Ellmann and Feidelson, *op. cit.*, p. 196).

One might also consider E. M. Forster. He says that "Art for art's sake does not mean that only art matters," and "Many things besides art, matter" (Ellmann and Feidelson, p. 198). But then he goes on to say: A work of art "is unique not because it is clever or noble or beautiful or enlightened or original or sincere or idealistic or useful or educational—it may embody any of those qualities—but because it is the only material object in the universe which may possess internal harmony. All the others have been pressed into shape from outside, and when their mould is removed they collapse. The work of art stands up by itself, and nothing else does. It achieves something which has often been promised by society, but always delusively. Ancient Athens made a mess—but the *Antigone* stands up. . . . Art for art's sake? I should just think so. It is the one orderly product which our muddling race has produced; it is the lighthouse which cannot be hidden" (p. 200).

28. André Malraux, *op. cit.*, pp. 600-01. There are no better examples of this religion of the aesthetic than Walter Pater and Gustave Flaubert. Here is Pater: "One of the most beautiful passages of Rousseau is that in the sixth book of the *Confessions*, where he describes the awakening in him of the literary sense. An undefinable taint of death had clung always about him and now in early manhood he believed himself smitten by mortal disease. He asked himself how he might make as much as possible of the interval that remained; and he was not biassed by anything in his previous life when he decided that it must be by intellectual excitement, which he found just then in the clear, fresh writings, of Voltaire. Well! we are all *condamnés* as Victor Hugo says: we are all under sentence of death but with a sort of indefinite reprieve—*les hommes sont tous condamnés à mort avec des sursis indéfinis:* we have an interval, and then our place knows us no more. Some spend this interval in listlessness, some in high passions, the wisest, at least among 'the children of this world,' in art and song. For our one chance lies in expanding that interval, in getting as many pulsations as possible into the given time. Great passions may give us this quickened sense of life, ecstasy and sorrow of love, the various forms of enthusiastic activity, disinterested or otherwise, which come naturally to many of us. Only be sure it is passion—that it does yield you this fruit of a quickened, multiplied consciousness. Of such wisdom, the poetic passion, the desire of beauty, the love of art for its own sake, has most. For art comes to you proposing frankly to give nothing but the highest quality to your moments as they pass, and simply for those moments' sake. . . .

"[T]he products of the imagination must themselves be held to present the most perfect forms of life—spirit and matter alike under their purest and most perfect conditions—the most strictly appropriate objects of that impassioned contemplation, which, in the world of intellectual discipline, as in the highest forms of morality and religion, must be held to be the essential function of the 'perfect.' Such manner of life might come even to seem a kind of religion—an inward, visionary, mystic piety, or religion, by virtue of its effort to live days 'lovely and pleasant' in themselves, here and now, and with an all-sufficiency of well-being in the immediate sense of the object contemplated, independently of any faith, or hope that might be entertained as to their

ulterior tendency. In this way, the true esthetic culture would be realizable as a new form of the contemplative life, founding its claim on the intrinsic 'blessedness' of 'vision'—the vision of perfect men and things" (Ellmann and Feidelson, pp. 184-85).

And here is Gustave Flaubert (to Louise Colet): "Yes, I maintain (and in my opinion this should be a rule of conduct for an artist) that one's existence should be in two parts: one should live like a bourgeois and think like a demi-god. Physical and intellectual gratification have nothing in common. If they happen to coincide, hold fast to them. But do not *try* to combine them: that would be factitious. And this idea of 'happiness,' incidentally, is the almost exclusive cause of all human misfortunes. We must store up our hearts' marrow and give of it only in small doses; and the innermost sap of our passions we must preserve in precious flasks. These essences of ourselves must be reserved as sublime nourishment for posterity. Who can tell how much is wasted every day in emotional outpourings?

"We marvel at the mystics, but what I have just said explains their secret. Their love, like mountain streams, ran in a single bed—narrow, deep, and steep; that is why it carried everything before it.

"If you seek happiness and beauty simultaneously, you will attain neither one nor the other, for the price of beauty is self-denial. Art, like the Jewish God, wallows in sacrifices. So tear yourself to pieces, mortify your flesh, roll in ashes, smear yourself with filth and spittle, wrench out your heart! You will be alone, your feet will bleed, an infernal disgust will be with you throughout your pilgrimage, what gives joy to others will give none to you, what to them are but pinpricks will cut you to the quick, and you will be lost in the hurricane with only beauty's faint glow visible on the horizon. But it will grow, grow like the sun, its golden rays will bathe your face, penetrate into you, you will be illumined within, ethereal, all spiritualized, and after each bleeding the flesh will be less burdensome. Let us therefore seek only tranquillity; let us ask of life only an armchair, not a throne; only water to quench our thirst, not drunkenness. Passion is not compatible with the long patience that is a requisite of our calling. Art is vast enough to take complete possession of a man. To divert anything from it is almost a crime; it is a sin against the Idea, a dereliction of duty. But we are weak, the flesh is soft, and the heart, like a branch heavy with rain, trembles at the slightest tremor of the earth. We pant for air like a prisoner, an infinite weakness comes over us, we feel that we are dying. Wisdom consists in jettisoning the smallest possible part of the cargo, that the vessel may keep safely afloat. . . .

"Humanity hates us; we do not minister to it and we hate it because it wounds us. Therefore, we must love one another in *Art*, as the mystics love one another *in God*, and everything must grow pale before that love. Let all life's other lamps (which stink, one and all) vanish before this great sun. In an age when all common bonds are snapped, and when Society is just one huge brigandage (to use official parlance) more or less well organised, when the interests of flesh and spirit draw apart like wolves and howl in solitude, one must act like everyone else, cultivate an ego (a more beautiful one naturally) and live in one's den. The distance between myself and my fellow men widens every day. I feel this process working in my heart and I am glad, for my sensitivity towards all that I find sympathetic continually increases, as a result of this very withdrawal" (Ellmann and Feidelson, pp. 195 and 197).

29. See E. N. Tigerstedt, "The Poet as Creator: Origins of a Metaphor" in *Comparative Literature Studies*, 5 (Dec. 1968), pp. 455-88.

30. In Herschel B. Chipp, *Theories of Modern Art* (Berkeley: University of California Press, 1971), pp. 172-74.

31. *Ibid.*, p. 214.

32. *Ibid.*, p. 539.

33. *Ibid.*, p. 186.

34. *Ibid.*, p. 273.

35. *Ibid.*, p. 552.

36. This "horror of the object," so characteristic of post-Enlightenment art, is a phenomenon quite distinct from the wish to surpass nature characteristic of those in the late Renaissance, though often the words used will sound the same. For the Renaissance wish to surpass nature, see Michael Levey, *High Renaissance*, Chapter VI.

37. Chipp, p. 106.

38. *Ibid.*, p. 553.

39. *Ibid.*, p. 573.

40. In John Cage, *Silence* (Middletown, Conn.: Wesleyan University Press, 1961), p. 59.

41. In Chipp, p. 574.

42. *Ibid.*, p. 292.

43. *Ibid.*, p. 575.

44. *Ibid.*, pp. 287-88.

45. In Cage, *op. cit.*, p. 44.

46. In Chipp, p. 570.

47. *Ibid.*, pp. 393-94.

48. *Ibid.*, p. 297.

49. Cage, *op. cit.*, p. 84.

50. *Ibid.*, p. 69.

51. "Tradition in Perspective" in *Perspectives of New Music* (Fall 1962), pp. 27ff.

52. In Ellmann and Feidelson, *op. cit.*, pp. 49-53.

53. In Chipp, *op. cit.*, pp. 563-64.

54. Charles Rosen, *Schoenberg* (London: Fontana Books, 1976), pp. 40-41.

55. *Ibid.*, pp. 64-67.

56. Harold Rosenberg, *The De-Definition of Art* (New York: Horizon, 1972), p. 29.

57. Quoted in Rosenberg, *op. cit.*, p. 28.

PART THREE

1. In *Christian Letters to a Post-Christian World*, pp. 77-79.

2. Rudolph Schwartz, *The Church Incarnate* (Chicago, 1958), pp. 26-27.

3. Gerardus van der Leeuw, *Sacred and Profane Beauty* p. 35.

4. Edinburgh: T. and T. Clark, 1961.

5. Speaking of what he calls "the atrophy of religion in modern man," Hendrick Kraemer in *Religion and the Christian Faith* (Philadelphia: Westminster Press, 1956) says: ". . . It becomes a . . . disturbing riddle that as regards religion, modern man is seemingly so largely atrophied. This demands an extensive and penetrating treatment. Is the *cor inquietum* dying out? Is the opium of religion replaced by the opium of obtuseness? Or is this condition best expressed in the language of Psalmists, Prophets and of Jesus, who talk of 'the people's heart' that is 'as fat as grease' and 'is waxed gross'? Is Luther's statement: 'Der Mensch hat entweder Gott oder Abgott' (Man has either God or an idol) no longer universally applicable? What is there behind this increasingly prevalent attitude towards religion expressed in the words 'I am simply not interested', entirely 'ruhend im Endlichen' (resting in the finite) as they are? So-called militant atheism or godlessness, systematically organized, is transparent compared with this opaque godlessness of spontaneous religious indifference.

"This seemingly a-religious character of modern man does not even take the trouble to make a theory to justify its lack of interest, nor does it reflect the least bit on what is expressed by the strange heroes of Dostoievski's novels in the destructive

adage: 'If God does not exist, everything is permitted'. On the contrary, they are, generally speaking, sedate, law-abiding, good-natured people. Is it the last and most dangerous form of escape from God, to feign death as animals do? . . . Do not the prophets speak the mysterious language that *God*, in certain situations, makes the heart fat, so that they neither see nor hear?

"The answering of these questions—more could be put—would demand a book in itself. We ask them only in order to call attention to the great theological significance of modern mass a-religiosity. . . . The question becomes moreover still more intriguing, because we know by experience that many of these seemingly atrophied people (in a religious respect) are often suddenly caught in the nets of weird, religoid forms of religion." (pp. 313-14).

6. Speaking of the semi-dome at the east end of Santa Sophia, Procopius said that it was "admirable for its beauty but the cause of terror from the apparent weakness of its structure"—quoted in Steven Runciman, *Byzantine Style and Civilization* (New York: Pelican Books, 1975), p. 53.

7. Cf. Stravinsky, in *New York Review of Books*, March 17, 1977, p. 27: "The workmanship was much better in Bach's time than it is now. One had first to be a craftsman. Now we have only 'talent.' We do not have the absorption in detail, the burying of oneself [in craftsmanship] to be resurrected a great musician."

8. W. H. Auden, in Ellmann and Feidelson, eds., *The Modern Tradition*, p. 209.

9. Gustave Flaubert in Ellmann and Feidelson, *op. cit.*, p. 7.

10. See Karwoski and Odbert, "Color Music" in *Psychological Monographs*, 50 (1938), pp. 1-60. The best recent discussion of synesthesia is Lawrence E. Marks, "On Colored-Hearing Synesthesia," Cross-modal Translation of Sensory Dimensions," *Psychological Bulletin*, 82(3) (1975), pp. 303-31.

11. M. Collins, "A Case of Synesthesia," in *Journal of General Psychology*, 2 (1929), pp. 12-27.

12. Riggs and Karwoski, "Synesthesia," in *British Journal of Psychology*, 25 (1934), pp. 29-41.

13. Karwoski and Odbert, "Color Music" in *Psychological Monographs*, 50 (1938), pp. 1-60. See also Karwoski, Odbert, and Osgood, "Studies in Synesthetic Thinking: II. The Role of Form in Visual Response to Music," *Journal of General Psychology*, 26 (1942), pp. 199 ff.

14. Lundholm, "The Affective Tone of Lines: Experimental Researches" in *Psychological Review*, 28 (1921), pp. 43-60. See also Poffenberger and Barrows, "The Feeling Value of Lines" in *Journal of Applied Psychology*, 8 (1924), pp. 187-205.

15. Karwoski, Odbert, and Osgood, "Studies in Synesthetic Thinking: II. The Role of Form in Visual Response to Music," *Journal of General Psychology*, 26 (1942), pp. 199 ff. More recently, Wexner has studied the degree to which hues are connected with mood tones in "The Degree to which Colors (Hues) Are Associated with Mood-Tones," *Journal of Applied Psychology*, 38 (1954), pp. 432-35. And to reduce the factor of cultural conditioning, Simpson, Quinn, and Ausubel in "Synesthesia in Children: Association of Colors with Pure Tone Frequencies," *Journal of Genetic Psychology*, 89 (1956), pp. 95-103, have explored the pitch-hue associations in children. Their results were these: "Definite pitch-hue associations were exhibited which in general conform to the results reported for adult subjects. *Yellow* and *green* were predominantly chosen following higher tone frequencies. The preponderance of *red* and *orange* selections occurred in relation to middle-pitched tones. *Blue* and *violet* were selected most in response to the lower sound frequencies . . ." (pp. 102-03).

16. Odbert, Karwoski, and Eckerson, "Studies in Synesthetic Thinking: I. Musical and Verbal Associations of Colors and Mood" in *Journal of General Psychology*, 26 (1942), pp. 153-73.

17. *Ibid.*, p. 172.

18. Karwoski, Odbert, and Osgood, *op. cit.*, pp. 220-21.

19. Osgood, Suci, and Tannenbaum, *The Measurement of Meaning* (Urbana: University of Illinois Press, 1957), p. 21.

20. Karwoski, Odbert, and Osgood, *op. cit.*, p. 217.

21. *Ibid.*, p. 204.

22. Reprinted in J. G. Snider and C. E. Osgood, eds., *Semantic Differential Technique* (Chicago: Aldine, 1969), pp. 561-84.

23. *Ibid.*, p. 581.

24. This also explains why the factors prove more constant across subjects than they do across stimuli. Though the subject is normally making judgments concerning cross-modal similarity, sometimes, as we saw earlier, the conjunction of stimulus with scale is such that the antonyms of the scale apply literally to the entity named by the stimulus word; then no doubt the subject will normally fall back from making a cross-modal similarity judgment and make a straightforward literal judgment. And secondly, in a few cases there may be straightforward cases of concomitance at work. Thus literalness and concomitance sometimes capture a particular scaling away from its normal cross-modal similarity basis.

25. C. E. Osgood, "Generality of Affective Meaning Systems" in *American Psychology*, 17 (1962), p. 21. See also Osgood, "On the Why's and Wherefore's of E, P, and A" in *The Journal of Personality and Social Psychology*, 12(3) (1969), pp. 195-97.

26. C. E. Osgood, "Generality of Affective Meaning Systems" in *op. cit.*, pp. 19-20.

27. C. E. Osgood, "Cross-Cultural Generality of Visual-Verbal Synesthetic Tendencies" in *op. cit.*, p. 583.

28. See Simpson *et al.*, in *op. cit.*, pp. 102-03.

29. Charles Baudelaire, *Correspondances*

> La Nature est un temple ou de vivants piliers
> Laissent parfois sortir de confuses paroles;
> L'homme y passe a travers des forêts de symboles
> Qui l'observent avec des regards familiers.
>
> Comme de longs echos qui de loin se confondent
> Dans une tenebreuse et profonde unité,
> Vaste comme la nuit et comme la clarité,
> Les parfums, les couleurs et les sons se repondent.
>
> Il est des parfums frais comme des chairs d'enfants,
> Doux comme les hautbois, verts comme les prairies,
> —Et d'autres, corrompus, riches et triomphants,
>
> Ayant l'expansion des choses infinies,
> Comme l'ambre, le musc, le benjoin et l'encens,
> Qui chantent les transports de l'esprit et des sens.

30. In *Philosophical Analysis*, ed. Max Black (Ithaca: Cornell University Press, 1950).

31. Wassily Kandinsky, *Concerning the Spiritual in Art* (New York: Wittenborn, 1970), p. 58.

32. Deryck Cooke, *The Language of Music* (New York: Oxford, 1959), p. 89.

33 Monroe Beardsley, *Aesthetics* (New York: Harcourt Brace Jovanovich, 1958), p. 347.

34. Van der Leeuw, *op. cit.*, p. 231.

35. In *Art and the Craftsman*, eds. J. Harned and N. Goodwin (New Haven, Conn.: Yale University Press, 1961), p. 188.

36. Rosen, *op. cit.*, pp. 64-69.

37. David Hume, *Treatise*, I, iii, 10.

38. J. R. R. Tolkien, "On Fairy Stories," *Essays Presented to Charles Williams*, ed. C. S. Lewis (Grand Rapids: Eerdmans, 1966), p. 51.

39. *Ibid.*, p. 60.

40. *Ibid.*, p. 63.

41. In John Barth, *Lost in the Funhouse* (New York: Bantam Books, 1969).

42. Berthold Brecht, *The Messingkauf Dialogues*, tr. J. Willett (London, 1965), p. 51.

43. Jonathan Culler, *Structuralist Poetics: Structuralism, Linguistics and the Study of Literature* (Ithaca: Cornell University Press, 1976), p. 198.

44. Percy Lubbock, *The Craft of Fiction* (New York: Viking, 1957), p. 251.

45. *Op. cit.*, pp. 75-76.

46. *Ibid.*, p. 78.

47. *Ibid.*, pp. 79-81.

48. *Ibid.*, pp. 81-84.

49. Herbert Marcuse, *The Aesthetic Dimension* (Boston: Beacon Press, 1978).

50. For this and the following point, cf. Beardsley, *op. cit.*, pp. 457-61.

51. In *The Journal of Aesthetics and Art Criticism* (Winter 1972), pp. 165-80.

52. In *The Journal of the History of Ideas*, 22 (1961).

53. The theory has played its role also in those of the Calvinistic tradition who in the last century have reflected on the arts. See for example Abraham Kuyper's lecture on "Calvinism and Art" in his *Lectures on Calvinism* (Grand Rapids: Eerdmans, 1931), esp. pp. 207-08; Herman Dooyeweerd in his *New Critique of Theoretical Thought*, Vol. II (Nutley, N.J.: Presbyterian and Reformed), esp. p. 128; Hans Rookmaaker in his *Modern Art and the Death of a Culture* (London: InterVarsity, 1970), and his "Ontwerp ener Aesthetica op Wijsbegeerte der Wetsidee" in *Philosophia Reformata*, 1946 (3-4, pp. 141-67) and 1947 (1, pp. 1-35).

54. Pp. 462-64. See also Beardsley's "On the Generality of Critical Reasons" in *Journal of Philosophy*, 59 (1962).

55. Compare this passage from Meyer Schapiro's "On Perfection, Coherence, and Unity of Form and Content" in *Art and Philosophy*, ed. Sidney Hook (New York: New York University Press, 1966): "Judgments of coherence and completeness . . . are often guided by norms of style which are presented as universal requirements of art and inhibit recognition of order in works that violate the canons of form in that style. The norms are constantly justified in practice by perceptions—supposedly simple unprejudiced apprehensions of a quality—which are in fact directed by these norms. This is familiar enough from the charge of formlessness brought against modern works and especially the Cubist paintings that were criticized later from another point of view as excessively concerned with form. It is clear that there are many kinds of order and our impression of order and orderliness is influenced by a model of the quality. For someone accustomed to classic design, symmetry and a legible balance are prerequisites of order. Distinctness of parts, clear grouping, definite axes are indispensable features of a well-ordered whole. This canon excludes the intricate, the unstable, the fused, the scattered, the broken, in composition; yet such qualities may belong to a whole in which we can discern regularities if we are disposed to them by another aesthetic. In the modern compositions with random elements and relations, as in the works of Mondrian and the early Kandinsky and more recent abstract painting, are many correspondences of form: the elements may all be rectilinear, of one color or restricted set of colors, and set on a pronounced common plane; however scattered they appear, these elements are a recognizable family of shapes with an obvious kinship; the density in neighboring fields is about the same or the differences are nicely balanced. In time one comes to distinguish among all the competing models of chaos those which have the firmness of finely coherent forms like the classic works of the past.

"I may refer also to a striking medieval example of a long misjudged order, the

Romanesque relief at Souillac, with the story of Theophilus, the Virgin, and the Devil. It had seemed to critical observers, sensitive to this style of art, an uncoherent work, in spite of its clarity as an image. Its defect was explained by its incompleteness, the result of a loss of parts when the large monumental relief was moved from its original place to the present position. Study of the jointing of the sculptured blocks of stone has shown that no part is missing; and a more attentive reading of the forms has disclosed a sustained relatedness in the forms, with many surprising accords of the supposedly disconnected and incomplete parts. It was the radical break with the expected traditional mode of hierarchic composition in this strange and powerful work that made observers feel it to be chaotic and incomplete."

56. Likewise certain *artistic* merits can be achieved only if the work is simple and repetitive—as when, for example, the purpose of the work is to induce frenzy or hypnosis. Consider what Curt Sachs says in *The Wellsprings of Music,* p. 125: "This last example draws our attention to another probable cause for at least some cases of primitive shortness and repetition. The enervating, ceaseless recurrence of an identical sense perception no longer interesting in itself, affects, indeed intoxicates us in either one of two opposite ways, as a potent stimulus or, inversely, as a narcotic. Such impairing or even deadening removal of man's unfettered volition is appropriate in cultures whose thoroughly magic orientation assigns to much of their music the role of depersonalization and release from normalcy. Widely known examples are the trance and ecstasy of Derwishes and other Muhammedan brotherhoods under the impact of musical monotone and Koran reading."

57. Cf. Mikel Dufrenne, "The Aesthetic Object and the Technical Object" in Beardsley and Schueller, *Aesthetic Inquiry* (Dickenson, 1967), p. 195: " . . . The technical object cannot without denying itself, identify itself with the aesthetic object, i.e., to an object intended solely for contemplation. It becomes an aesthetic object only when devitalized, useless, torn from its proper milieu, as when it is transferred to a museum for the sake of knowledge as well as of aesthetic pleasure. Nevertheless it may aspire to be beautiful according to its nature in its use.

"But experiencing its beauty supposes, at least, that it be aestheticized by us. Now, can we be both agents for doing justice to its usefulness and spectators for doing justice to its aesthetic aspiration? Has the sail, blown by the wind, the same beauty for the sailor as for the landlubber? Is the machine which is beautiful for the engineer when he observes it also beautiful for the workman who uses it? Is it beautiful in the same way for the engineer who knows it and for the layman who merely admires its form? The same problem appears, moreover, for the consumer's good: Is a palace in the same way beautiful for the prince who lives in it and for the tourist who visits it, the church for him who prays in it and for him who just walks in it? The same for the natural object: is the mountain equally beautiful for the climber and for the one who contemplates it? It is clear what provokes these questions: it is the idea that everywhere contemplation of a work of art furnishes the norm for aesthetic experience. I accept this idea. But this does not exclude the actuality and the value of certain marginal experiences, more ambiguous, more uncertain, but perhaps richer—where beauty is revealed to us in a contact, sometimes more intellectual and sometimes more sensual, with the object. It is in such experiences that the technical object can be aestheticized by us: just as the Alpinist communicates best with the mountain when he both climbs it and observes it, so we can at times both use and observe the technical object."

58. Lewis Mumford, *The City in History* (New York: Penguin Books, 1961), pp. 342-44.

PART FOUR

1. See Lewis Mumford, *The City in History*, pp. 320-23, concerning the medieval city: "No sedentary student, viewing this architecture in pictures, no superficial observer, taking up a position and attempting to plot out axes and formal relationships, is in a state to penetrate this urban setting even in its purely aesthetic aspect. For the key to the visible city lies in the moving pageant or the procession: above all, in the great religious procession that winds about the streets and places before it finally debouches into the church or the cathedral for the great ceremony itself. Here is no static architecture. The masses suddenly expand and vanish, as one approaches them or draws away; a dozen paces may alter the relation of the foreground and background, or the lower and upper range of the line of vision. The profiles of the buildings, with their steep gables, their sharp roof lines, their pinnacles, their towers, their traceries, ripple and flow, break and solidify, rise and fall, with no less vitality than the structures themselves. . . .

"From almost any part of the city, the admonitory fingers of the spires, archangelic swords, tipped with gold, were visible: if hidden for a moment, they would suddenly appear as the roofs parted, with the force of a blast of trumpets. What had once been confined within the monastery's walls, was now visible within the whole medieval town.

"The short approaches to the great buildings, the blocked vistas, increase the effect of verticality: one looks not to right or left over a wide panorama, but skyward. This ambulatory enclosure was such an organic part of the processional movement and of the relation of the structures to each other that it did not need the extra emphasis the perpendicular Gothic of England actually gave it. Horizontal banks of windows were common in houses and horizontal string courses, boldly emphasized, break the vertical movement of the towers in Salisbury or Notre Dame de Paris, not less than in the Duomo in Florence. But, for all that, the usual movement of the eye is up and down, and the direction of the walker's movement, always changing, would constantly help to create dynamic, three-dimensional spatial forms through every farther passage, with a feeling of constriction in the narrow streets and of release as one suddenly came out into the parvis or the market-place. Though the architectural details are so different in Lübeck, with its gables and pinnacles, and in Florence, with its low pitched or flat roofs and its wide overhangs, the total aesthetic effect, produced by the plan of the town itself, is of the same order.

"Those who walked about the city on their daily business, who marched in a guild pageant or in a martial parade or who joined in a religious procession, underwent these aesthetic experiences, and, in the very twisting and turning of the procession could, as it were, see themselves in advance, as in a mirror, by observing the other parts of the procession: thus participant and spectator were one, as they can never be in a formal parade on a straight street.

"Let us look at a medieval procession through the eyes of a late contemporary, who left behind a detailed picture of the occasion. Outside the pages of Stow, I know no description that gives one a more living sense of the medieval town. The time is early sixteenth century: the place is Antwerp: the witness is Albrecht Dürer.

"On Sunday after Our Dear Lady's Assumption, I saw the Great Procession from the Church of Our Lady at Antwerp, when the whole town of every craft and rank was assembled, each dressed in his best according to his rank. And all ranks and guilds had their signs, by which they might be known. In the intervals, great costly pole-candles were borne, and three long old Frankish trumpets of silver. There were also in the German fashion many pipes and drummers. All the instruments were loudly and noisily blown and beaten.

"I saw the Procession pass along the street, the people being arranged in rows, each man some distance from his neighbor, but the rows close behind the other. There were the Goldsmiths, the Painters, the Masons, the Broderers, the Sculptors, the Joiners, the Carpenters, the Sailors, the Fishermen, the Butchers, the Leatherers, the Clothmakers, the Bakers, the Tailors, the Cordwainers—indeed, workmen of all kind, and many craftsmen and dealers who work for their livelihood. Likewise the shopkeepers and merchants and their assistants of all kinds were there. After these came the shooters with guns, bows, and crossbows, and the horsemen and foot-soldiers also. Then followed the watch of the Lord Magistrates. Then came a fine troop all in red, nobly and splendidly clad. Before them, however, went all the religious orders and the members of some foundations, very devoutly, all in their different robes.

"A very large company of widows also took part in the procession. They support themselves with their own hands and observe a special rule. They were all dressed from head to foot in white linen garments made expressly for the occasion, very sorrowful to see. Among them I saw some very stately persons. Last of all came the Chapter of Our Lady's Church, with all their clergy, scholars, and treasurers. Twenty persons bore the image of the Virgin Mary with the Lord Jesus, adorned in the costliest manner, to the honour of the Lord God.

"In this procession very many delightful things were shown, most splendidly got up. Wagons were drawn along with masques upon ships and other structures. Behind them came the Company of the Prophets in their order, and scenes from the New Testament, such as the Annunciation, the Three Holy Kings riding on great camels, and on other rare beasts, very well arranged. . . . From the beginning to end, the Procession lasted more than two hours before it was gone past our house."

"Note the vast number of people arrayed in this procession. As in the church itself, the spectators were also communicants and participants: they engaged in the spectacle, watching it from within, not just from without: or rather, feeling it from within, acting in unison, not dismembered beings, reduced to a single specialized role. Prayer, mass, pageant, life-ceremony, baptism, marriage, or funeral—the city itself was stage for these separate scenes of the drama, and the citizen himself, even while acting his varied roles, was still a whole man, made one by the cosmic vision and held in tension by the human drama of the Church, imitating the divine drama of its founder. Once the unity of this social order was broken, everything about it was set in confusion: the great Church itself became a contentious, power-seeking sect, and the city became a battleground for conflicting cultures, dissonant ways of life."

2. In *Times Literary Supplement*, November 26, 1976.

3. Compare this passage from Curt Sachs, *The Wellsprings of Music*, pp. 221-22:

"A second, sobering fact is the limited social significance of this venerable art. High civilization, in all its facets drives of necessity to diversification, and diversification leads to estrangement—estrangement from person to person, from group to group, and hence from audience to audience. Statistically speaking, our art music, with all its concerts, recordings, and radios, reaches but a small, almost insignificant layer of mankind, and even within this limited stratum its impact is very uneven. Side by side with art music, and numerically to an essentially higher degree, we are daily exposed to all shades of popular and non-descript sheet music for shallow entertainment; and the total suppression of these characteristic products is probably a pious fraud. An annex in our accounts of modern music also should indicate the enormous percentage of persons unmusical or indifferent who have no part in the delight and edification that 'high-brow' music gives its devotees. Our music is, alas, a marginal phenomenon.

"To this sketch of music in western society we have opposed the picture of primitive music—a picture certainly poorer when drawn from the viewpoint of art, but always meaningful, dignified, and hence never vulgar. Primitive music is not compelled to fight the indifferent and the unmusical with 'appreciation' or to appease critics, board members, and managers with tame and carefully balanced programs. Everyone in a tribe is part of this music; everyone sings, and many enrich the inherited stock by creations of their own. No rite in religious services, no secular act can be performed without the appropriate songs; and as a vital part of social existence music is firmly integrated in primitive life and an indispensable part of it. The awareness of this deep-rooted contrast will not change our destined ways. We cannot escape from the culture that we ourselves have made. But seeing and weighing the differences between the two musical worlds might help us in realizing that our gain is our loss, that our growth is our wane. It might help to understand that we have not progressed, but simply changed. And, when seen from a cultural viewpoint, we have not always changed to the better."

APPENDIX

1. Incidentally, once we see that self-expression requires intention, or at least the performance of an action for which there are conditions of knowledgeability and sincerity, then we can make some sense of R.G. Collingwood's claim that the expression of emotions involves clarification of those emotions. "When a man is said to express emotion, what is being said of him comes to this. At first he is conscious of having an emotion, but not conscious of what this emotion is. All he is conscious of is a perturbation or excitement, which he feels going on within him, but of whose nature he is ignorant. While in this state, all he can say about his emotion is: 'I feel . . . I don't know what I feel.' From this helpless and oppressed condition he extricates himself by doing something which we call expressing himself "—*The Principles of Art* (New York: Oxford University Press, 1970), pp. 109-10.

Collingwood is excessive when he claims that clarification is a necessary condition in expressing one's emotions. It is not even an invariant antecedent. But it's true that often in trying to express one's emotional state—whether by trying to do or produce something fitting to that state or by trying to do something whose knowing and sincere performance requires that one be in that state—one is forced to clarify that state.

Selected Bibliography for Introduction to Aesthetics

GENERAL ANTHOLOGIES ON AESTHETICS

Albrecht, N. C., Barnett, J. H., and Griff, M., *The Sociology of Art and Literature* (New York: Praeger, 1970).

Dickie, G., and Sclafani, R. J., *Aesthetics: A Critical Anthology* (New York: St. Martin's, 1977).

Hospers, John, *Introductory Readings in Aesthetics* (New York: The Free Press, 1969).

Kennick, W. E., *Art and Philosophy*, Second Edition (New York: St. Martin's, 1979).

Margolis, Joseph, *Philosophy Looks at the Arts,* Revised Edition (Philadelphia: Temple University Press, 1978).

Rader, Melvin, *A Modern Book of Aesthetics*, Fifth Edition (New York: Holt, Rinehart and Winston, 1979).

Scott, Nathan A., Jr., *The New Orpheus* (New York: Sheed and Ward, 1964).

Weitz, Morris, *Problems in Aesthetics,* Second Edition (New York: Macmillan, 1970).

BOOKS ON AESTHETICS AND ART THEORY

Beardsley, Monroe, *Aesthetics* (New York: Harcourt, Brace, 1958).

Bell, Clive, *Art* (New York: Capricorn Books, 1958).

Collingwood, R. G., *The Principles of Art* (Oxford: Oxford University Press, 1958).

Croce, Benedetto, *Aesthetic* (Boston: Nonpareil Books, 1978).

Dufrenne, Mikel, *The Phenomenology of Aesthetic Experience* (Evanston: Northwestern University Press, 1973).

Gombrich, Ernst, *Art and Illusion* (Princeton: Princeton University Press, 1969).

Goodman, Nelson, *The Languages of Art* (New York: Bobbs-Merrill, 1968).

Ingarden, Roman, *The Literary Work of Art* (Evanston: Northwestern University Press, 1973).

Malraux, André, *The Voices of Silence* (Frogmore, St. Albans, Herts.: Paladin, 1974).

Marcuse, Herbert, *The Aesthetic Dimension* (Boston: Beacon, 1978).

Rookmaaker, Hans, *Modern Art and the Death of a Culture* (Downers Grove, Ill.: Inter Varsity, 1970).

Seerveld, Calvin, *Hearing and Doing* (Toronto: Wedge, forthcoming).

Van der Leeuw, Gerardus, *Sacred and Profane Beauty* (New York: Holt, Rinehart and Winston, 1963).

HISTORY OF AESTHETICS

Beardsley, Monroe C., *Aesthetics from Classical Greece to the Present* (Tuscaloosa: University of Alabama Press, 1975).

Osborne, Harold, *Aesthetics and Art Theory* (New York: E. P. Dutton, 1970).